A TASTE FOR ANGELS

A
TASTE
FOR
ANGELS

Neapolitan Painting

in North America 1650–1750

Yale University Art Gallery · New Haven · Connecticut

This catalogue accompanies an exhibition held at the Yale University Art Gallery, New Haven, Connecticut, between September 9 and November 29, 1987; at the John and Mable Ringling Museum of Art, Sarasota, Florida, between January 13 and March 13, 1988; and at the Nelson-Atkins Museum of Art, Kansas City, Missouri, between April 30 and June 12, 1988.

Publication of this catalogue was made possible by a grant from the Barker Welfare Foundation in memory of Catherine Barker and Charles V. Hickox and by the Robert Lehman Exhibition and Publication Fund.

Library of Congress Catalogue Card Number
87−50866

International Standard Book Number
0−89467−046−8

Copyedited by Elise K. Kenney

Design & Typography by Howard I. Gralla

Composed in Bembo and Michelangelo Titling
by Finn Typographic Service

Printed by Eastern Press

Bound by Mueller Trade Bindery

COVER:
Luca Giordano
Judith with the Head of Holofernes
detail of cat. 17

FOREWORD

Neapolitan paintings of the seventeenth and eighteenth centuries were among the first Old Masters to be brought to North America by private collectors in the early nineteenth century. The generosity of European royal and papal patrons in giving such works enriched a number of newly established Roman Catholic parishes on this side of the Atlantic. Interest in works of the period entered a century-long decline, however, during which Neapolitan painting, when discussed at all, was held up to scorn. Thankfully, while Neapolitan painting's reputation was slow to recover, there has recently been a surge of interest in the period which prepared the way for the current exhibition.

Professors Judith Colton and George Hersey of the Department of the History of Art at Yale first proposed A Taste for Angels as a means of studying the vicissitudes of collecting Neapolitan paintings in North America. A number of major exhibitions have been held in this country and abroad in the last several years, yet both public institutions and private collectors on this continent have assembled a significant body of important and handsome Neapolitan paintings that largely escaped the scrutiny of these earlier ventures. This exhibition seeks to explain and to remedy that unjustified obscurity. Professors Colton and Hersey themselves wrote a substantial share of the catalogue, as well as having edited it and overseen the whole. From its inception, however, they embarked on their project as a collaborative one, inviting the participation of other scholars and graduate students. The results of their combined research are a testament to their vision and scholarly acumen.

We are grateful to the many private and public lenders whose generosity has made this exhibition possible, and to the Barker Welfare Foundation in memory of Catherine Barker and Charles V. Hickox, which provided vital financial support. A. Bartlett Giamatti, Yale's former president, also contributed his discretionary funds at a critical moment of the exhibition's inception. Without their generous assistance, it would have been impossible to present to the public this exhibition of vivid, powerful works.

MARY GARDNER NEILL
The Henry J. Heinz II Director
Yale University Art Gallery

LAWRENCE J. RUGGIERO
Director
The John and Mable Ringling Museum of Art

MARC F. WILSON
Director
The Nelson-Atkins Museum of Art

ACKNOWLEDGMENTS

THE *organizers are first of all grateful to A. Bartlett Giamatti, who during his presidency of Yale encouraged our project with a substantial financial contribution from the University and with valuable politico-cultural counsel. We are also much beholden to three successive directors of the Yale University Art Gallery: Alan Shestack, who carefully administered equal doses of encouragement and warning as our first thoughts on the subject took shape; Anne Coffin Hanson, who with warm and resourceful assistance saw us through the middle stages, and Mary Gardner Neill, who was a tower of strength as we approached the final deadlines. Also at the Yale Art Gallery, Michael Komanecky and Anthony G. Hirschel worked closely with us to coordinate the exhibition. Lawrence Kenney gave us much-needed help with the manuscript. For heroic last-minute labors before the catalogue deadline, our appreciation in particular goes to Elise K. Kenney. Howard Gralla has made it possible for us to present our work in a most handsome book. Many members of the Yale University Art Gallery staff, the Department of the History of Art, and the University Library have helped us in countless ways. We would also like to thank Nicola Spinosa, Soprintendente per i beni artistici e storici, Naples, for many favors, counsels, and for friendship, and Mary Jane Harris, one of our lenders, for innumerable kindnesses and suggestions. We remember with great fondness the late Raffaello Causa, who with his characteristic generosity welcomed us to Capodimonte. Irene Cioffi, Thomas Willette, and Irving Lavin were kind enough to read portions of the text and to suggest changes, and Roger Ward of the Nelson-Atkins Museum was most helpful during the preparation of the exhibition. There are many others, both family and friends, to whom each of the authors owes special obligations. To our regret, we cannot mention them all here. Nor can we dwell on the fact that we gave each other many ideas, much support, and a good deal of practical assistance over the last three years.*

The following people have in various ways assisted us with suggestions, encouragement, information, and other kinds of help: Barbara B. Adams, Jan E. Adlmann, Stanley Anderson, Bruno Arciprete, Katharine Baetjer, Colin B. Bailey, Elaine Banks, Maurizio Barracco, Mirella Barracco, Marimar Benitez, Robert Bergman, Jeffrey Blanchard, Ada Bortoluzzi, Yvonne Bowkett-Kavanagh, Edgar Peters Bowron, Arnauld Brejon de Lavergnée, Richard S. Brettell, Franco Broegg, Jonathan Brown, E. John Bullard, James D. Burke, Jean Cadogan, Edward P. Caraco, Dawson W. Carr, Richard Caspole, Andrew Ciechanowiecki, Clifford T. Chieffo, Helen Chillman, Roger Clisby, Silvia Cocurullo, Mimi Cole, Richard Collins, Piero Corsini, Ileana Creazzo, Fintan Cullen, Christy Cunningham, Louisa Cunningham, Robert Dance, Renato de Simone, Charles A. DiSabatino, Denise English, Hilarie Faberman, Linda S. Ferber, Franco Filipucci, Karen Finlay, Susan Frankenbach, Thomas Freudenheim, Ernani Gambardella, Patricia Garland, Adelheid M. Gealt, Creighton E. Gilbert, Laura Giles,

Catherine Gilje, Laura Giusti, Sidney M. Goldstein, Edward C. Goodstein, Marco Grassi, Sheldon Grossman, Bob P. Haboldt, Ann Sutherland Harris, Gregory Hedberg, Patricia Hendricks, Ariel Herrmann, John Herrmann, Shirley Hibbard, Terrell Hillebrand, Marion Hirschler, Rosamond Hurrell, William Hutton, Anthony F. Janson, Angela Jodice, Mimmo Jodice, Lawrence Kanter, James D. Kenney, Andrea Kirsh, Michael Kitson, Jan Klein, Robert H. Klein, Penny Knowles, Nancy Lambert, Joseph LaPalombara, Myron Laskin, Jr., Carol Lewine, Iva Lisikewycz, Ann T. Lurie, Denis Mahon, Stephanie Maloney, Roger Mandle, Jean-Patrice Marandel, Peter Marzio, Laura Mascoli, Patrick Matthiesen, Judy Metro, John Miller, Sally Mills, Charles S. Moffett, Richard Mühlberger, Rossana Muzii, Pinckney Near, Ethel Neumann, Andrea S. Norris, Antonio Nunziata, John D. O'Leary, Hannelore Osborne, Denise Maria Pagano, Pamela Palmer, Renato Pancione, Phoebe Peebles, Marie-Félicie Pérez, Alfonso E. Pérez Sánchez, Marina Causa Picone, Daniel Piersol, Donald Posner, Anne Poulet, Nancy L. Pressly, Wolfgang Prohaska, Rev. Giovanni Recupido, Rosalie Reed, Donald A. Rosenthal, Mr. and Mrs. Wilbur L. Ross, Susan F. Rossen, Wendy W. Roworth, Renato Ruotolo, Matthew Rutenberg, Susan Ryan, Julia Sagraves, Spencer Samuels, Angela Schiattarella, George Shackelford, Nelson Shanks, Roanne Shriver, Lisa Siegel, Antonio Silvestri, Amanda Slavin, Thomas Sokolowski, Thomas T. Solley, Thomas Spalding, Richard E. Spear, Catherine L. Spence, Stephen B. Spiro, David Steadman, David Steel, Michael Stoughton, René Taylor, Elizabeth S. Telford, Martha Thomas, Rev. Aldo Tos, Gennaro Toscano, Henry Trubner, Marie Monique Turgeon, Evan H. Turner, Georges Vallet, John Walsh, Wendy Watson, James Welu, Clovis Whitfield, John A. Wilkinson, Paula H. Wolf, Eric M. Zafran.

LENDERS

Didier Aaron, Inc., New York

The Art Gallery of Ontario, Toronto

The Art Institute of Chicago, Illinois

The Sarah Campbell Blaffer Foundation, Houston, Texas

The Chrysler Museum, Norfolk, Virginia

The Cleveland Museum of Art, Ohio

Piero Corsini, Inc., New York

The Currier Gallery of Art, Manchester, New Hampshire

The Fine Arts Museums of San Francisco, California

The J. Paul Getty Museum, Malibu, California

Mr. and Mrs. Marco Grassi

Mr. and Mrs. Morton B. Harris

The High Museum of Art, Atlanta, Georgia

The Archer M. Huntington Art Gallery, The University of Texas at Austin, Texas

Bob Jones University, Greenville, South Carolina

Memorial Art Gallery of the University of Rochester, New York

The Metropolitan Museum of Art, New York

The Minneapolis Institute of Arts, Minnesota

Museo de Arte de Ponce, Puerto Rico

The Nelson-Atkins Museum of Art, Kansas City, Missouri

The New Orleans Museum of Art, Louisiana

Dr. D. Stephen Pepper

The John and Mable Ringling Museum of Art, Sarasota, Florida

The Saint Louis Art Museum, Missouri

The Seattle Art Museum, Washington

The Snite Museum of Art, The University of Notre Dame, Indiana

Richard and Athena Spear, Oberlin, Ohio

The Toledo Museum of Art, Ohio

The Vassar College Art Gallery, Poughkeepsie, New York

The Virginia Museum of Fine Arts, Richmond, Virginia

The Wadsworth Atheneum, Hartford, Connecticut

The Walters Art Gallery, Baltimore Maryland

Private Collections

CONTENTS

AUTHORS OF ENTRIES

CBC Carmen Bambach Cappel
JC Judith Colton
JDC James D. Clifton
GH George Hersey
JJI Joseph James Inguanti
EL Evonne Levy
DN David Nolta
SO Sheila O'Connell
JTS John T. Spike

Except when noted, all works are oil on canvas.
In citing measurement, the height is given first.

INTRODUCTION

Recently there has been a renewed interest in Italian seventeenth- and eighteenth-century art (see Bibliography under Naples 1979, Naples 1980, Princeton 1980, Detroit 1981, Gaeta 1981, Fort Worth 1982, New York 1982, Washington 1983, Naples 1984, Cleveland 1984). Major exhibitions and books have been devoted to works of this period now being studied and collected as never before. Among the great centers of the period Naples takes its place along with Venice, Rome, Genoa, and Bologna.

However the overwhelming majority of the works that have been displayed and published so far have come, as is to be expected, from European collections. Few realize that North America possesses its own store of this art. Many of these paintings have never been fully published; many, indeed, have never been exhibited outside their native institutions. At the same time our great national collections at the Metropolitan Museum of Art, the National Gallery of Art, and the Art Institute of Chicago have always been weak in this area. While that situation is now being remedied there are still no important south Italian pictures at all in the National Gallery, and only four currently (October 1986) hang in the Metropolitan. To find Preti, Giordano, and Solimena in North America one must go to the smaller public collections and to private ones.

In all these ways the strength and history of North American holdings in the field have been obscured. The purpose of our exhibition is to dispel that obscurity (in part by explaining it) and to explore the qualities of some of the best of these pictures.

But perhaps we had better explain, as well, how the present group of investigators happened upon their task, and why. The project began as a graduate seminar at Yale. The instructors were George Hersey and Judith Colton; the students, Carmen Bambach Cappel, David Nolta, and Joseph Inguanti. We also managed to attract a Fellow of the British Art Center at Yale, Sheila O'Connell, and two graduate students from Princeton, Evonne Levy and James D. Clifton. Inevitably this means that it was conceived as an educational enterprise for all concerned, including the two instructors, neither of whom had worked before in the field of connoisseurship, though each had done research in other aspects of the period.

Our library research began with a fundamental book, *Census of Pre-Nineteenth-Century Italian Paintings in North American Public Collections* by Burton B. Fredericksen and Federico Zeri

(1972). From this we discovered that the major Neapolitan figure painters who had been collected in North America were Mattia Preti, Luca Giordano, and Francesco Solimena. Since that book's appearance, meanwhile, three other artists have consistently shown up in lists of new acquisitions: Paolo de Matteis, Francesco de Mura, and Corrado Giaquinto. These six are preeminent in American collecting both in quantity and quality, and we have therefore limited our exhibition to their work (and in a very few instances, to that of their studios).

From our base in New Haven we first contemplated an exhibition of paintings in New England, but quickly found that many of the best things were beyond New England's borders. That sent us into the South and Midwest and eventually to the West Coast. Another sort of foray was made into New York, where we were able to gain useful insights into the art market — so different both from academic art history and from the museum world, yet so essential to both. Individual and joint trips to Naples, Madrid, and other European cities, as well as to the towns and cities whose museums and collectors are lending to the show, made all of us peripatetic.

Our exhibition cannot be said to be a textbook representation of the great art produced in Naples or by Neapolitan artists in our period. Key figures such as Salvator Rosa, the Vaccaros, Sebastiano Conca, Giacomo del Po, and Giuseppe Bonito are omitted. But otherwise the six artists we present were interlocked in all sorts of ways. Though two of them spent major parts of their careers outside their homeland, each of the six was well aware of his contemporaries and predecessors in the exhibition. Many of the pictures are in a sense "about" each other, so that there are echoes and reflections from one wall to the next. This intense atmosphere makes the exclusion of other painters, like Rosa, whose art, though Neapolitan, is mostly very different, an advantage. This also explains why we have played down portraits and excluded landscapes and still lifes.

This exclusion is justifiable on other grounds. First of all the artists themselves looked upon the multifigure mythology or religious picture — preferably including at least one bravura nude — as the highest challenge that art could offer. Second, the earliest Neapolitan pictures to arrive in North America were pictures of this type. If later collectors have not hewed exclusively to this line, they have done so sufficiently to make it worthwhile for us to follow this genre through the variations in the collecting climate that extend down to our own time.

The preponderance of Christian subject matter in our show is another reflection of history. The artists themselves were overwhelmingly painters of religious subjects. And, as collected in North America, that religious emphasis in the art seems until recently to have been maintained. Indeed, a discerning art-lover is often said to have the taste of an angel. We hope that our taste in this exhibition has occasionally reached the angelic level. In any event, given the subject-matter in so many of these paintings, they do exhibit, at least, a taste "for" angels: hence the title of our show.

Given these limitations, which may be called interpretative, the exhibition has its own story to tell. It maps the development of Neapolitan painting from a local, Caravaggio-influenced high baroque, imported from Rome by Mattia Preti and Luca Giordano and established as a strong local style, to a *barocchetto* drawn from later Roman influences: from the shadowed and powerful pictures of the 1650s and 1660s, in other words, to De Mura's clearer and lighter art, and thence to Giaquinto's feathery scenes, which trespass on the rococo.

A word about our catalogue. The introductory essays, we hope, explain themselves: after a look at the Bolognese origins of the baroque style that came to prevail in Naples (D. Stephen Pepper), there is a survey of the period 1650–1750, emphasizing developments that the exhibition has had to omit (John T. Spike). Especially haunting, in its absence not only from the exhibition but from the Neapolitan scene, of course, is the great pantheon of Neapolitan seicento and settecento art: the abbey of Montecassino (Robert Enggass).

A particularly problematical element in our subject is the controversial eighteenth-century art historian Bernardo De Dominici, who bequeathed to posterity a rich mélange of true and false information about Neapolitan art (Judith Colton). There is also a discussion of the waning, and only just recently waxing prestige, in later times, of the art itself (George Hersey).

We have endeavored to make our biographies and entries fairly full. This, we hope, will encourage visitors to study these extraordinary pictures at length and will introduce serious students to the many fascinating problems raised by these painters. That not all the problems are yet solved, or even properly posed, is suggested by the fact that not all our contributors are in total agreement. There are inconsistencies of emphasis. There are different ideas not only about precisely what happened but about how it should be described. We have thought it best not to try to iron out these differences. Each author has been left to speak his or her own mind, creating what the Italians would call a "choral" effect. Nonetheless our catalogue will serve — until more definitive studies appear — as the only full-length attempt in English to deal with this key phase of Italian art.

JC
GH

A TASTE FOR ANGELS

A BOLOGNESE-ROMAN PRELUDE, 1600-1625

D. Stephen Pepper

In recent years new attention has been paid to Neapolitan art of the sei- and settecento, as the introduction to this catalogue notes. Accordingly, a fuller picture of Neapolitan art has emerged as it developed from relative provinciality at the end of the sixteenth century on to the end of the seventeenth, by which time Naples had become perhaps the preeminent art center in Italy. Yet Italian baroque painting, in origin, was a phenomenon of Bologna and Rome, and more especially of Bolognese artists working in Rome and other cities. In this essay, therefore, I want to focus on the role that the Bolognese artists Annibale Carracci, Guido Reni, and Domenichino seem to have played during the first quarter of the seventeenth century in the development of the Neapolitan school. I limit myself to this earlier period since the later, which involves the activities of Domenichino and Lanfranco in Naples, has recently been described by Erich Schleier (Schleier in Washington 1983, 45ff.) and is referred to again by John T. Spike in the present volume.

In Rome during the first two decades of the seventeenth century there were many competing tendencies. In his famous letter (Holt 1947, 329ff.), the Marchese Vincenzo Giustiniani established twelve categories of artists, with Annibale Carracci and Caravaggio in the highest places. By contrast the Bolognese savant G. B. Agucchi in his *Trattato* exalted Annibale and attacked Caravaggio (Mahon 1947, 176ff.).

The most important style of the period, for modern historians, has been that of Caravaggio. This history of seicento painting as written in recent years has emphasized this artist's supposedly liberated attitude and his and his followers' desire to introduce realistic observation into the treatment of sacred subjects. Conversely, Agucchi's reassertion of Renaissance values including a hierarchy of genres, an insistence on decorum, and narrative canons of representation — all of which principles Agucchi attributed to Annibale — has been slighted.

Within this debate, furthermore, Neapolitan painting has been treated as a bastion of support for Caravaggio. Active in 1606–07 and again in 1609, Caravaggio did indeed paint several extraordinary works in Naples that greatly appealed to local artists such as Battistello Caracciolo. In short it has been accepted that the emergence of Naples as an important center begins with Caravaggio and that his spirit and outlook continued to impose themselves there even after his influence had elsewhere disappeared.

I believe this view is partly mistaken. It derives from an anachronism, from our contemporary thought about art and about the communication of ideas among artists. We talk about the makeup of styles as if we were comparing two kinds of pasta in which the mix of ingredients constituted the essential defining feature. This in turn arises from our desire to exaggerate the importance of appearances — that is, the way art looks — and, dating and comparing these appearances, to establish precedence and the direction of influence. Thus we call Neapolitan painting Caravaggesque because of its preference for tenebrism, for dark settings illuminated by dramatic lighting (e.g., fig. 38).

But two artists who in this sense create "appearances" that are very different could in fact have profound influence on one another. A case in point is the relation between Reni and Jusepe de Ribera. This is a matter not of visual influence but of conceptual. Ribera, in fact, seems to have grasped Reni's intent to create an exalted artistic style — one that is superhuman, *sovrumana* — thereby revivifying the mysteries of the Catholic faith so as to overwhelm the intellectual skepticism and doubt that assailed the age. Ribera's mature works seem to aspire to this lofty goal. Yet it is also as if Ribera were saying, "I see what Reni is doing and I will match him, but I will do it my way." In this case, therefore, influence is not primarily on the level of appearances but instead is the highest form of dialogue in which one mind penetrates to the core and intent of another through the medium of the latter's work and, grasping the ideas embedded there, absorbs and transforms them for its own ends.

I can think of no greater homage to Reni than Ribera's *St. Jerome and the Angel,* Capodimonte (fig. 1). The elegance and order of the composition testify to Ribera's reflection on Reni's angelic grace. Whereas earlier Ribera had used the opaque shadows fashionable in Neapolitan painting, here he has been careful to make the shadows transparent, so that despite dark areas the outline of the figure is completely visible. The modeling of highlight into darkness has been exquisitely modulated. There is no sharp break of the light; rather, the eye slides gradually through the areas of velvety shadow. Indeed one of the glories of this work is the richness of the color in the dark areas. I will call this tenebrism but not Caravaggism. Instead it testifies to Ribera's meditation on Reni's *grazia,* which he could have found admirably displayed in Reni's *Encounter of St. John and the Christ Child* now in the sacristy of the Girolamini, Naples, apparently painted in 1626–28 (fig. 2). Whether this work or others that Ribera could have seen is the direct stimulus for his reflection on Reni's aesthetic intent I cannot say, but the very order of the saint's upward gesture and glance to the distant angel in Ribera's masterpiece is proportioned in such a way as to lift the scene above the level of mere depiction to that of exalted sentiment. Reni's influence on Ribera was to inspire the Spanish-Neapolitan painter with such an ambition and to demonstrate that it could be fulfilled.

I spoke above of the distance between saint and angel. This is a relation of the greatest importance for the religious art of this period. The upward-flowing, diagonal composition is Emilian, that is, Bolognese, in origin; one may identify it with the votive image of the Madonna della Ghiara from Reggio Emilia, and contrast it to the iconic frontality of the central Italian Madonna di Loreto image. According to Schleier this upward diagonal composition was "introduced by Lodovico Carracci and adopted by Reni, Lanfranco and others." Reni's best-known composition of this type would have been the vision of St. Philip Neri painted for the

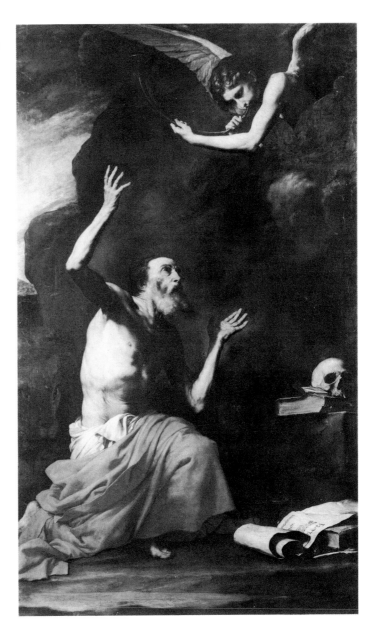

FIG. 1. Jusepe de Ribera, *St. Jerome and the Angel*, Museo di Capodimonte, Naples

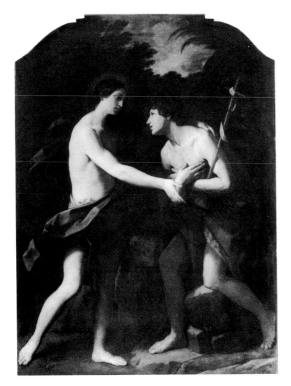

FIG. 2. Guido Reni, *Encounter of St. John and the Christ Child*, Chiesa dei Girolamini, Naples

Chiesa Nuova, Rome, by 1614, of which a contemporary copy existed in the Girolamini, Naples. Ludovico's *Vision of St. Hyacinth* (Louvre) meanwhile exemplifies his conception of the proximity of earth and heaven, for the figures are large and close to the viewer, and the Virgin and Child are placed near the figure of the kneeling saint. Reni, on the other hand, in his treatment of the same subject known through a drawing (Pepper 1984, no. 8), is clearly emphasizing the distance separating the two realms. Reni's mortal figures — the kneeling saints — in their humility appear as Christian cavaliers making profound submission to the Virgin.

In direct contrast to Reni's hierarchical vision is Caravaggio's treatment of the mortal-immortal relationship. The "heresy" committed by Caravaggio in his treatment of the first altarpiece of *St. Matthew and the Angel* for the Contarelli chapel, San Luigi dei Francesi, Rome, is not, as is often claimed, his treatment of the saint as a rough-hewn, simple person, which after all corresponds to Church tradition. It was not this that caused the painting to be withdrawn. Rather, his treatment of the angel created the difficulty. The heresy is that the angel physically touches the saint. For Caravaggio's patrons, churchmen guided by the Neoplatonic Augustinian traditions of the early Church, especially those regarding the writing of the gospels, the reduction of the inspiration of a spiritual being such as an angel to the actual physical guidance of the apostle's hand could only be offensive. How, in truth, could an immaterial entity such as an angel affect a mortal? Only through enlightening his mind and uplifting his soul. In the second, accepted altarpiece, Caravaggio conceded the point (fig. 3). The angel addresses and informs the mind of Matthew but does not touch him.

Therefore the issue underlying these works is the relation of spiritual to mortal being. Ludovico represents what may be described as a north Italian approach, that is, the direct communication of proximate heavenly figures to the mortal. Reni's outlook may be described as exalted and hierarchical. And Caravaggio's is radical, encompassing the spiritual realm entirely within the mortal. And of these three approaches Ribera's *St. Jerome* is really closest to Reni. The distance that separates saint and angel in proportion to dimensions of the entire painting is truly notable. The saint is striving to rise to the occasion, to comprehend the message from on high. Interestingly, Reni in his final treatment of this subject, the work in the Detroit Institute of Arts (Pepper 1984, no. 202, pl. 238), brings the angel to the eye level of the saint.

But if Ribera's approach is derived from Reni it transforms its source. Whereas Guido in his actual method of painting suppresses all suggestion of the material substance of the mortal being, Ribera subtly emphasizes it. And whereas Reni, especially in his later work, actually suppresses tonal modeling and tries to avoid shadows altogether, Ribera insists on the corporeal presence of the being through his emphasis on tonal modeling. His very application of paint emphasizes this. The brushstrokes are visible and underscore the paint's texture. In this way Ribera challenges Reni: Guido's exalted vision tends to be ideal and incorporeal but Ribera achieves an exalted vision without sacrificing the corporeality that is humankind's hallmark. This is the interchange that takes place between these two giants of seicento painting. While Reni was probably unaware of the direct effect of his work on Ribera, the relationship nevertheless was a true dialogue because Ribera entered into an active discourse with Reni's mind through the medium of his work.

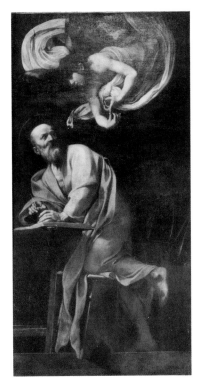

FIG. 3. Michelangelo Merisi
da Caravaggio, *St. Matthew
and the Angel*, Contarelli
Chapel, San Luigi dei
Francesi, Rome

Among other artists who contributed to this interchange on the relationship of physical to
spiritual realms, none was more concerned than Annibale Carracci. In one sense his whole
reform of painting was to posit a single canon of representation, faithful to the physical laws of
the universe, that would unite the human and superhuman. This was a wholly novel idea in the
1580s when he introduced it. It was certainly in contrast to late mannerist art and indeed also to
the later outlooks both of Reni and of Caravaggio.

Annibale's attitude can be exemplified by his *Resurrection* (Louvre). In it Christ ascends from
the tomb under his own power, exerting obvious physical effort. The muscles of his arm that
grasp the pennant are carefully articulated. Such verisimilitude makes all the more effective the
fact that he rises from a tomb on which the seal remains unbroken while the soldier on top of it
sleeps undisturbed. It is a naturalistic conception; but in appearance it is neither realistic nor
even naturalistic. Indeed, especially in his Roman work, the *appearance* of Annibale's paintings
is artificial; nevertheless his Roman work *is* naturalistic in that transcendent phenomena are
represented according to the known physical laws of the time. This in turn was the essence of
the Renaissance theory of *storia,* a tradition refreshed by Annibale and identified by Agucchi
with the doctrine of *affetti,* the visual realization of otherwise invisible emotions. The late *Pietàs*
by Annibale (National Gallery, London; Louvre) demonstrate the conception. Each gesture,
each expression, is predicated on the underlying emotional content, in this case grief at the loss
of the Saviour. Yet that overwhelming grief points to an irony central to the role and identity of
Christ: while death is the boundary of mortal existence it is equally the transition to eternal life.

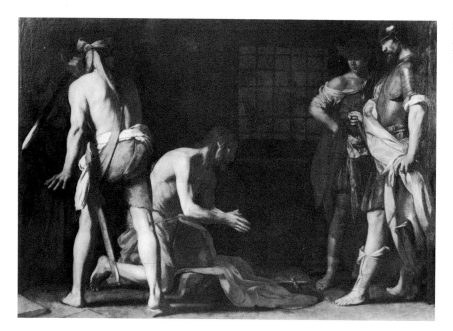

FIG. 4. Massimo Stanzione, *Beheading of John the Baptist*, Prado, Madrid

Since the meaning of Christ's life is that reality lies with eternal life, the grief attendant on his death is misplaced. But the mourners with their grief nonetheless remind us of the frailty of our understanding, limited as it is to our mortal existence.

Because of his rigorous attention only to those features that expressed his underlying intent, and his concentration on drawing, or disegno, to render that intent, Annibale was able to achieve compositions in which the affetti were the consequence of the underlying emotion. A placement of hands, a turn of head, an intensity and concentration of color are determined by an emotional field generated by the storia. This is in contrast to the interpretation of Annibale that we find in the widely disseminated views of the later seventeenth-century Roman theorist G. P. Bellori, whose views are often erroneously treated as if they were identical with Annibale's. In contrast to Annibale, Bellori believed individual actions and gestures were the primary facts, and that the affetti grew out of them.

Reni was also on a different track from Annibale, for in Reni's work the domains of heaven and earth are not continuous but qualitatively different. Meanwhile Albani, in his Roman work, soon showed himself more interested in picturesque details than in rigorous exposition of *storie*. Domenichino, however, in his own early Roman work, was directly affected by Annibale and stuck closely to the kind of visual concentration necessary to meet Annibale's standards. In his frescoes at the abbey of Grottaferrata, in the oratory of St. Andrew, San Gregorio Magno, Rome, and in the chapel of Santa Cecilia, San Luigi dei Francesi, he successfully based himself on Annibale's exacting method. It was through these accessible pictures that Annibale's late Roman style was disseminated.

One artist for whom Annibale's method became fundamental was the Neapolitan Massimo Stanzione. Stanzione was in Rome during at least two periods, 1617–18 and 1625–30, when he

was in a position to absorb these influences from direct exposure to the works of Domenichino and Annibale. His magnificent *Beheading of John the Baptist* in the Prado may be described as a painting based on the principle of *affetti* transcribed into a Neapolitan idiom (fig. 4). The artist has sought a clarity of composition permitting each action of the scene to be visible. In keeping with Neapolitan taste the lighting is more dramatic than it would be in a Bolognese or Roman setting, but the light and color have also been modulated so as to concentrate attention on the entire setting. The figure of the executioner has for its source the tormentor about to flagellate St. Andrew in Domenichino's fresco in the oratory of St. Andrew. While Annibale might have felt that Stanzione's use of dark shadow obscured too much of the gradation of space and action necessary for a fully realized work, one feels, nevertheless, that he would have been in sympathy with the artist's intent. Stanzione had a genuine grasp of the emotional gesture and of the effect rigorously derived from a cause, as his *Pietà* for the Certosa di San Martino demonstrates. One can sense in each of the extravagant gestures of Stanzione's figures the transformation of Annibale's models into the emotionally voluptuous Neapolitan idiom.

Stanzione's transpositions of Annibale's models are like the change of scale from chamber music to symphony. In Salvator Rosa's art Annibale's approach to *affetti* is more closely adopted once one has learned to recognize it. Many examples, such as the beautiful *Infant Erichthonius Discovered by the Daughters of Cecrops* at Christ Church, Oxford (Byam Shaw 1967, 144) or the *Angel Leaving the House of Tobias* in the Musée Condé, Chantilly, could be adduced. The staccato gesture of Tobias's father in the foreground of the latter painting is inspired by St. Peter's gesture in Annibale's *Domine, quo vadis?*, National Gallery, London. Here again an artist who looks different from his source, and indeed had a different temperament, has grasped that great master's intentions and used them for his own purposes.

These examples of relations between individual Bolognese artists working in Rome and individual Neapolitan artists can hardly claim to constitute a full study of the influence of the Bolognese on Naples. But what now must be done is to turn around and look at the whole of this process rather than the individual strands discussed so far.

The Bolognese artistic current emerged during the first two decades of the seventeenth century to dominate the Roman art scene. At the time, then-provincial Naples depended on Rome for inspiration, and this Bolognese influence was felt. It was preceded, first, by the influence of the Cavaliere d'Arpino at the end of the sixteenth century, followed in the first decade of the seventeenth century by Caravaggio. It was only in the next decade that the Bolognese current began to emerge. This is evident in the shift to increasingly clear, rational compositions of lighter tonality that characterize the work of Stanzione, and in Ribera's work after 1620. It has also been remarked that Caracciolo, the artist most directly moved by Caravaggio, underwent a change toward clear, light compositions after his visit to Rome around 1614. His frescoes for the Certosa di San Martino illustrate the change. In his case it seems to follow a pattern set by Orazio Gentileschi and Carlo Saraceni, both of whom were profoundly affected by a brief and intense exposure to Caravaggio in Rome during the first few years of the century, though both shifted in the second decade, partly in response to the growing Bolognese influence, particularly of Reni. The term "ennobled Caravaggism," invented by Longhi, applies.

Bolognese naturalism, either through Annibale's and Domenichino's intense rationalism or through Reni's exalted *grazia,* provided the path toward a new Christian art over the term of the seventeenth century. Set against the background of a crisis of consciousness widely felt at the end of the sixteenth century, it exerted an increasingly powerful impact on the way religious truths were given a convincing naturalistic setting. Obviously this Bolognese current is not enough to explain everything. For instance it has little to do with illusionistic decorative painting; here and elsewhere other factors, such as Rubens's work for royal courts, were equally influential. But even for Rubens and Luca Giordano the Bolognese language of figure studies, gestures, and compositions was of consequence. It was indeed Bolognese naturalism that became the international language of art in the seventeenth century.

And what, finally, of Caravaggio and Caravaggism? Caravaggio's art was also a response to the crisis of belief at the end of the sixteenth century. In his work the images of reality had a shocking effect, which had its impact first on Rome and then on Naples. Caravaggio's example caused artists such as Gentileschi and Caracciolo to shake off adherence to late Mannerism. But in neither case did it form the basis of a long-lasting language.

There are two reasons for this tempestuous but short-lived effect of Caravaggio's art in Italy. The first is that the conceptions that underlie it, insofar as they denied the possibility that transcendent causations could be made visual, attacked the basic doctrine of storia. It is arguable that Caravaggio personally did not believe in transcendence. And it is certainly evident from his art that he did not believe in its depiction. Nowhere in his art do the hierarchical levels of reality appear that, as we have seen, otherwise form the basis of the Italian artistic tradition.

The second reason Caravaggio could not provide a long-lived development is that his affetti were too violent. Not only physically, as in the case of his *Judith and Holofernes,* but psychologically, as where he represented his own features on the bloody stump of Goliath's head. The emotions he raised were too disturbing, too threatening, to the fabric of Counter-Reformation society. At the same time, like forbidden fruit, they exerted a great attraction for an artist as different from Caravaggio as Guido Reni, who permitted himself to dabble in them. Meanwhile it may be the very shortness of Caravaggio's life that turned it into one of the most powerful and attractive of historical art movements for our own century — but that is another matter.

We return to Neapolitan early seicento painting. While Caravaggio had an undoubted impact, Neapolitan art was to develop much like that of the other Italian centers. There were those who never outgrew Caravaggio's spell and became sterile painters of the picaresque. But Caracciolo, Stanzione, and Ribera, by the mid-1620s and perhaps earlier, were already carefully exploring the examples of Bolognese naturalism available to them. Their task in part could be described as transforming these Bolognese ideas with tenebrist effects and voluptuous and excited emotion. They thus developed a range comparable in music to that of Gesualdo and Corelli. Their work is seldom touched by residual Caravaggism. And ultimately, around 1650, when strong new currents, Venetian and Flemish in origin, were joined by Preti and Giordano to this Bolognese-Roman tradition, the result was the explosion of an art that was as varied as it was brilliant, and which served until the end of the eighteenth century to make Naples one of the jewels of European culture.

PAINTING IN NAPLES, 1653-1747

John T. Spike

"Most of the perfections described in the other biographies of famous painters can be said to be united in the admirable paintings by Signor Cavalier Francesco Solimena" (De Dominici 1742–45, 3:579). In the adoring eyes of Bernardo De Dominici Neapolitan painting achieved its apotheosis in Francesco Solimena (1657–1747). To prove his point De Dominici set about compiling the lives of the Neapolitan painters: he made his essay on Solimena, which opens momentously as above, the culmination of his three-volume *Vite de'pittori, scultori ed architetti napoletani,* published between 1742 and 1745.

As a historian De Dominici had his faults; countless errors in his *Lives* (and some outright fabrications) have come to light in the intervening years.[1] No one doubts, however, that De Dominici faithfully reported the artistic attitudes held by Solimena at the close of the great man's long, much-honored career. And, if we overlook De Dominici's propensity to hyperbolize, it is clear that his judgment of Solimena's place in Neapolitan painting has withstood the test of time.

When Luca Giordano died in 1705 Francesco Solimena, aged forty-eight, was prepared to assume the role of *caposcuola.* Indeed, as early as 1701 Solimena had received a commission that seems in retrospect to have been an implicit recognition of his ascendancy among Neapolitan painters. Two canvases by Giordano, two of the portraits of saints that can be seen high along the walls of the nave and transept of the Duomo, had been damaged in the earthquake of 1688. Solimena was called on to paint replacement canvases representing SS Athanasius and John Damascene.[2] In 1701 Giordano had been absent in Spain for nearly a decade, and the archbishop must have concluded that there was no use waiting any longer for his return. If simple adherence to Giordano's manner had been the cleric's chief criterion for this assignment any number of Giordano's pupils would have sufficed — and at a lower fee. Paolo de Matteis, for example, was a productive and highly regarded artist whose style was much closer to his absent master's than Solimena's had been for more than a decade. Yet Solimena was chosen and, most remarkably, he painted his two saints in a monumental and expressive style that was unmistakably conceived in respectful homage to Giordano's greatest rival, Mattia Preti (1613–1699).

Looking up in the Duomo at Solimena's two saints Giordano, who, as fate would have it, left Spain and returned to Naples in 1702, must have wondered for an instant whether these two

canvases might not be the shades of Preti, his old rival, vanquished fifty years before, come back to haunt him. Giordano was aware, of course, that Solimena's development had taken this turn: during the 1680s Solimena, although never strictly speaking a member of Giordano's *équipe,* had been the most intelligent practitioner of Giordano's style, which was a sweet amalgam of Venetian colorism and the handsome figure types invented by the Roman Pietro da Cortona (1596–1666). But Solimena's cycle of frescoes in the sacristy of San Paolo Maggiore, of which the centerpiece is his *Conversion of St. Paul* dated 1690 (fig. 5), had abruptly announced his independence from Giordano's decorativeness. His new mode of composition was lucid, serious, and emphatically premeditated — nothing at all like the hyperprolific *Luca fa presto.* (Years later Solimena made sure that De Dominici recorded his comment that "when looking at the work of great painters, never has he asked himself in how much time it had been painted."[3]) Solimena's new sources of inspiration in 1690, it was evident, were the highly dramatic and expertly composed paintings of Preti, who had not been in Naples since 1660.

Preti, called il Cavalier Calabrese, had arrived in Naples in 1653 three years before a famous catastrophe: in 1656 more than half the city's population, perhaps as many as two hundred thousand people, would die in a plague and ensuing famine. Preti survived this threat — to which a tragic total of Neapolitan artists fell victim — but then had to contend with the hostility of Luca Giordano, the local prodigy who, barely twenty years old, was determined that he and not this interloper would assume the leadership of the Neapolitan school. After seven years Preti abandoned the field and removed himself to the isles of Malta, where he passed the last four decades of his life as the principal painter to the Knights of St. John of Jerusalem. De Dominici devoted the final four hundred pages of his *Lives* to telling the legends, as if this were an epic battle between titans, of the rivalry between Giordano and Preti, and of Giordano's triumph; then of the rise of Solimena to a victory still more glorious, and of Preti's ultimate vindication in the reverence shown him by his champion, Solimena:

Thus the cavalier Calabrese made his way to glory by means of grand labors that won him the esteem and applause of the whole world and the veneration of the most famous painters, as the celebrated Francesco Solimena bears witness in our own days. We can call Solimena the pupil of Preti's works because he admits that he derived from these his beautiful chiaroscuro, and ennobled Preti's style to avoid the defect [of crude realism] *of which the cavaliere was capable. This is why Francesco Solimena came to be called* il cavalier Calabrese nobilitato, *the "enobled Calabrian knight"* (De Dominici 1742–45, 3:385).

At the present time we have only De Dominici's testimony as to Giordano's antagonism for Preti, which, according to the same source, consisted of unrelenting criticism — a campaign of intimidation directed against Preti's patrons. Whatever the personal relations between the artists, scholars are agreed that the competitive interaction between Preti and Giordano changed the course of Neapolitan painting. Although a generation of painters perished in the plague of 1656, Nicola Spinosa has rightly observed that the event that triggered the radical transformation in Neapolitan painting midway through the seventeenth century was not the plague but rather the entrance of Mattia Preti into the unimaginative and enervated situation that Massimo Stanzione and his followers had wrought during the 1640s (Spinosa in Washington 1983, 49). More than fifty years ago, in 1932, Nikolaus Pevsner wrote a landmark article, originally

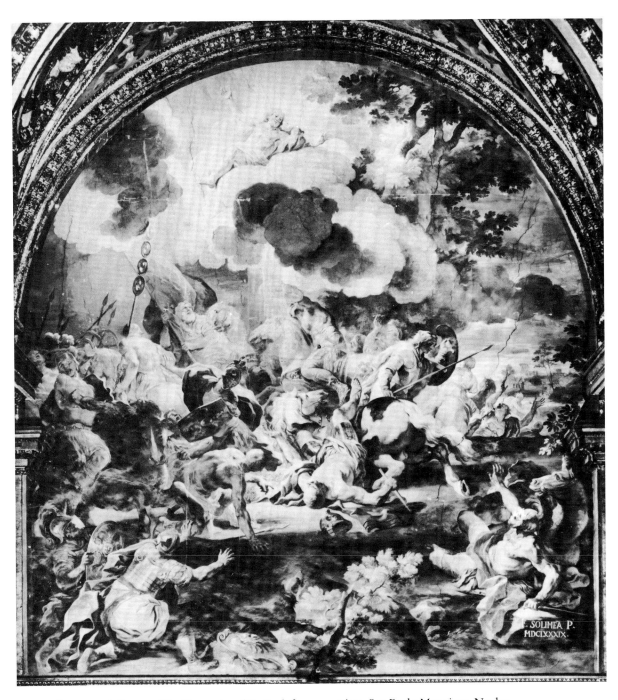

FIG. 5. Francesco Solimena, *The Conversion of St. Paul*, fresco, sacristy, San Paolo Maggiore, Naples

entitled "Die Wandlung um 1650 in der italienische Malerei," in which he astutely observed that Preti's paintings from his Neapolitan years pioneered the evolution of the late baroque style, of which Luca Giordano became the nonpareil exponent (Pevsner 1968, 57–76). The Calabrian thus inaugurated a phase of development that would last a hundred years, concluding, with remarkable historical symmetry, with the death of Solimena in 1747.

In recent years the study of Neapolitan painting has been distinguished for the vigor with which a host of scholars have, with exemplary cooperation, conducted research into the ecclesiastical, family, and bank archives of the city. Thanks to the success of these efforts it is now possible for the first time to examine Preti's stylistic exchange with Giordano on the basis of a documented chronology of their works. Earlier, only Giordano's development during the period 1656–60 (the years of Preti's residence in Naples, according to De Dominici) could be discussed with any confidence, due to the artist's helpfulness in signing and dating many of his paintings. For Preti's activity, on the other hand, scholars have had only De Dominici's reconstruction to rely upon. The archival documentation that has been discovered regarding Preti's principal commissions, namely his ex-voto frescoes over the seven city gates (1656–59; Capasso 1878) and his ten canvases in the ceiling of San Pietro a Maiella (1657–59; De Conciliis-Lattuada 1979) have shown up the inaccuracy of De Dominici's suppositions about the dates of these important works.

Indeed the essential circumstances, as we have hitherto understood them, of the encounter between Preti and Giordano must be radically modified in the light of James Clifton's recent discovery in the Archivio storico del Banco di Napoli of the records for a bank account that Mattia Preti opened in the Banco della Pietà in March of 1653 with a deposit of 250 ducats (Spike-Clifton Forthcoming). Preti's regular transactions in this account until he closed it in 1656 (after which time his presence in the city is well documented in other sources) reveal that he was continuously resident in Naples three years earlier than De Dominici believed. Scholars had universally assumed that he was active elsewhere: Modena, presumably — anywhere but Naples. In his forthcoming article (written jointly with the present author), Clifton demonstrates that the documentation published by D'Addosio (D'Addosio 1913) concerning the payment to Preti in December 1653 for his *St. Nicholas of Bari* formerly in San Domenico Soriano (fig. 6) already unequivocally attested to Preti's presence in Naples at that early date, although scholars had always misinterpreted this notice as evidence to the contrary.

Preti's financial accounts, most of them monthly withdrawals of small sums to pay his living expenses, provide little specific information other than confirming his whereabouts. The most interesting exceptions are the *St. Nicholas of Bari,* 1653, already cited, and payments of 100 and 200 ducats by Gaspare Roomer to Preti on December 17, 1655, and of 220 ducats by the duke of Maddaloni to Preti for five paintings in May 1656 (this last document was discovered by Eduardo Nappi; Nappi 1980, no. 159). But the knowledge that Preti was actively employed by Neapolitan collectors (he made deposits totaling about 2,000 ducats) during a span of time, 1653–57, in which Giordano's development remained essentially fixed in the stylistic shadow of his master, Jusepe de Ribera (1591–1652), radically affects our understanding of Preti's and Giordano's relationship. It now appears clear, for reasons that I shall outline, that Preti's Neapolitan development must have been influenced by stimuli other than Giordano, thirty

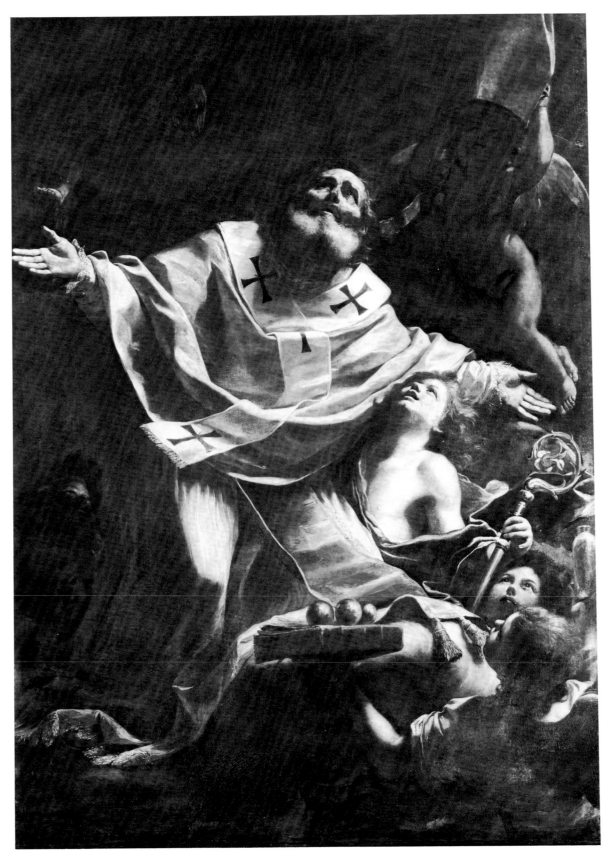

FIG. 6. Mattia Preti, *St. Nicholas of Bari*, Museo di Capodimonte, Naples

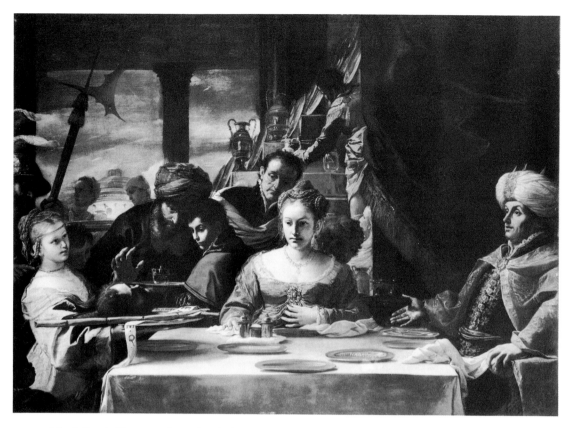

FIG. 7. Mattia Preti, *The Feast of Herod*, Toledo Museum of Art, Ohio

years his junior; on the other hand we shall also see that Preti evidently played a determining role in Giordano's maturation into a baroque painter.

Since the time of De Dominici 1656 has been the earliest certain date that could be assigned to any of Preti's works in Naples, specifically his altarpiece of the *Madonna di Costantinopoli,* Sant'Agostino degli Scalzi, and his bozzetti at Capodimonte for the ex-voto frescoes over the city gates. Now that his presence in Naples is known to have begun in 1653, however, it becomes possible to add to this sphere of his activity works that on the basis of stylistic comparison I had considered to be a few years earlier than 1656. Preti's Veronesian banquet scene of the *Feast of Herod* (fig. 7; Toledo Museum of Art) is the most notable picture in question, for which an estimated date of 1653–56 can now be reconciled with its apparent relationship to Rubens's famous painting of the same subject in the collection of Gaspare Roomer (known to have employed Preti in 1655), and provides some support for the possibility that the Toledo *Feast of Herod* (another version, somewhat later in date, is in the museum at Kassel) may be the painting of this subject that was mentioned in the 1688 inventory of the collection of Ferdinand Vandeneynden in Naples, and cited by De Dominici.[4]

Mariella Utili has recently suggested that Preti's *Return of the Prodigal Son* (fig. 8), which reportedly came to Capodimonte with a Maddaloni provenance, is identifiable as one of the five

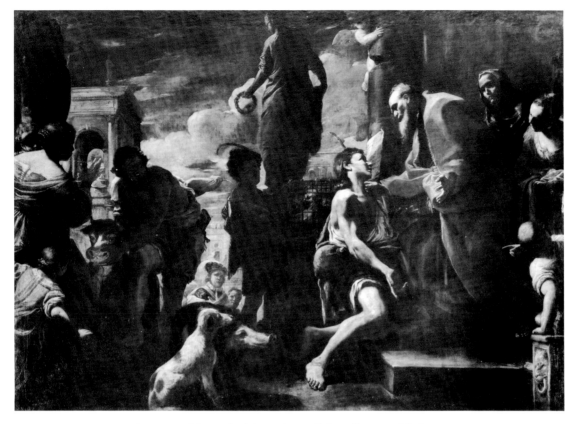

FIG. 8. Mattia Preti, *The Return of the Prodigal Son*, Museo di Capodimonte, Naples

paintings for which Don Diomede Carafa, duke of Maddaloni, paid Preti in May of 1656 (Utili in Washington 1983, no. 107). If in fact this picture was executed as early as 1656 then the debate as to whether Preti influenced Giordano or vice versa would be clinched in favor of Preti. The Capodimonte *Prodigal Son* is an exercise in late baroque pictorialism par excellence. In place of a unifying expressive diagonal — so characteristic of Preti's works — the motifs in this *Prodigal Son* are positioned in a restless, swirling pattern, their colors varied for maximum decorative effect.

There is no trace of comparable developments in Giordano's style prior to 1658, when he unveiled his Venetian-inspired *maniera dorata* in the two altarpieces for Sant'Agostino degli Scalzi (fig. 9; Ferrari in Washington 1983, no. 64). In 1655 Giordano painted an altarpiece of *St. Nicholas of Bari Rescuing the Cupbearer* in Santa Brigida, which was his first attempt to forge a fully baroque style of his own. De Dominici and all subsequent writers have commented on the Veronesian qualities of Giordano's Santa Brigida altarpiece (De Dominici 1742–45, 3:398), but his inspiration was clearly Federico Barocci: the painting is virtually a paraphrase of the *Madonna del Popolo* in the Uffizi. De Dominici elsewhere (De Dominici 1742–45, 3:397ff.) records that Gaspare Roomer advised Giordano to give up his new manner and return to the style of his master, Ribera. Whether or not this interview ever took place, Giordano must have

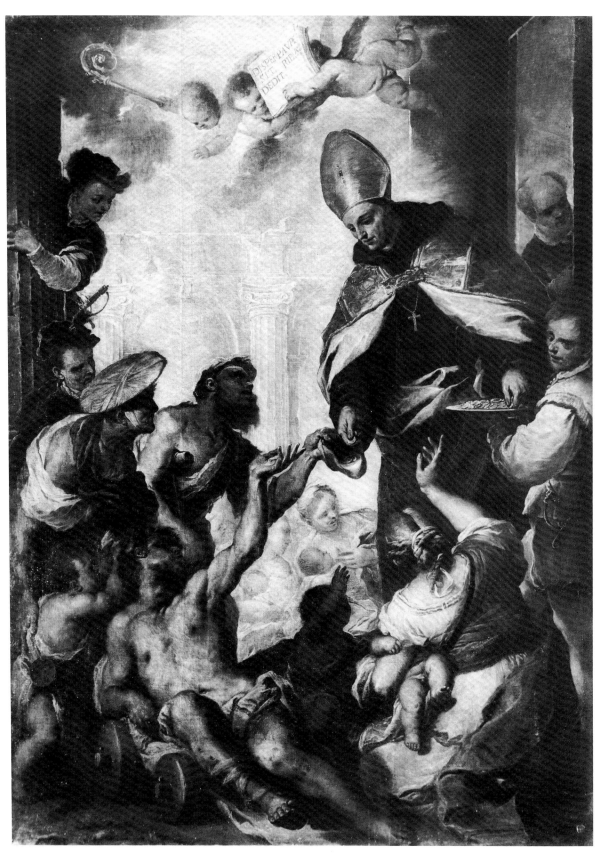

FIG. 9. Luca Giordano, *St. Thomas of Villanova Distributing Alms*, Sant'Agostino degli Scalzi, Naples (on deposit in the Museo di Capodimonte)

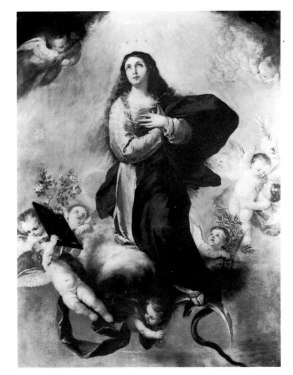

FIG. 10. Luca Giordano,
Immaculate Conception,
Cintas Foundation, Florida

received some advice to this effect following the *St. Nicholas,* because in 1657 he signed and dated five paintings, all of them couched in a pietistic vocabulary adopted from Ribera's late works of the previous decade. The best known of these pictures is the *St. Anne and the Virgin* in the church of the Ascensione a Chiaia. An addition to this group is the Riberesque *Immaculate Conception* (Cintas Foundation, Florida; fig. 10), the date of which has up to now been misread as 1682.[5]

Giordano, confronted with Preti's neo-Venetianism, now knew that he would have to come up with something more exciting than tepid recollections of Ribera. Preti was winning the approval of the foremost private collectors and the lion's share of major public commissions. At the end of 1656 he executed the altarpiece for the Schipani family (they were relatives on his mother's side) in Sant'Agostino degli Scalzi. He composed his *Madonna di Costantinopoli,* as it is called, as a *sacra conversazione* in the early manner of Guercino, whose works in this vein were not to be seen in Naples. Nonetheless everyone would have understood what Preti was doing. This picture may well have inspired De Dominici's insistence on a Guercino apprenticeship for Preti, a fact that no Bolognese writer or document has ever confirmed.

In 1658 Giordano received the opportunity to execute altarpieces dedicated to St. Thomas of Villanova (fig. 9) and St. Nicholas of Tolentino for Sant'Agostino degli Scalzi, creating an ideal occasion for the public to judge him and Preti face to face. It is the measure of Giordano's genius that neither of these paintings betrays the slightest hint of the previous year's Riberism. Overnight, so to speak, Giordano brought himself up to date with Roman painting and then

FIG. 11. Mattia Preti, *St. Peter Celestine in Glory*, nave ceiling, San Pietro a Maiella, Naples

forged an entirely original style by tinging all the forms, and even the air itself, with golden highlights: hence his maniera dorata. The source for this golden palette was the late Titian, represented in Naples by an *Annunciation* in San Domenico Maggiore that Giordano copied more than once (Wethey 1967, 685ff.). Oreste Ferrari has pointed out that Giordano borrowed the figure of one of the beggars in the *St. Thomas of Villanova Distributing Alms* from Titian's *Martyrdom of St. Lawrence* in the Gesuiti, Venice (Ferrari in Washington 1983, no. 64). The composition as a whole, however, is so close to a contemporary altarpiece by Giovan Francesco Romanelli, a pupil of Cortona, in Sant'Agostino, Rome (Spike in Princeton 1980, no. 39), that one wonders whether the Augustinian fathers might not have sent a drawing to Naples to instruct the artist in the newly canonized saint's iconography.

To Giordano's dismay, no doubt, Preti did not pause in his own development to make it any easier for the younger man to close the distance between them. Preti's seven ex-voto frescoes on the city gates were proceeding apace and making a lasting impression for their forceful and even heroic interpretation of the plague's devastation. These works were already being seriously eroded by the elements when De Dominici was writing, and now are lost except for a few traces over the Porta San Gennaro (see biographical essay by George Hersey, below). Preti's contemporary cycles of canvases on the ceilings of the Gothic church of San Pietro a Maiella, representing St. Peter Celestine (in the nave; fig. 11) and St. Catherine of Alexandria (transept; fig. 12) allowed him freer play to explore the stylistic formulations in such canvases as the Maddaloni *Return of the Prodigal Son* (fig. 8). Preti designed the decoration as *da sotto in sù* illusionism on the model of Veronese's paintings in San Sebastiano, Venice. But his expressively contorted, prodded, and modulated figure style, not to mention the grayish complexions, reveals his appreciative interest in the acres of frescoes that Lanfranco had painted on the vaults and cupolas of the Certosa di San Martino, SS Apostoli, and the Cappella del Tesoro in the

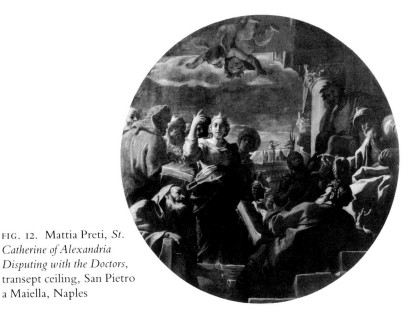

FIG. 12. Mattia Preti, *St. Catherine of Alexandria Disputing with the Doctors*, transept ceiling, San Pietro a Maiella, Naples

Duomo between 1637 and 1644 (Schleier in Florence 1983 and in Washington 1983, 187, and in Turin 1983, 73–83). According to De Dominici, Giordano defended the San Pietro a Maiella cycle against the complaints of conservatives who were nonplussed by their unprecedented pictorialism, saying, "These [will] be the school for the studious youth of the future" (De Dominici 1742–45, 3:352).

Although Lanfranco was one of the great painters of the century, the works he left in Naples had constituted, to his contemporaries, a mighty tree that fell unheard deep in the forest. Ferrari rightly observed that Giordano never saw Lanfranco until Preti made him look (Ferrari in *Storia di Napoli* 1970, 6:1246). The story takes its significance, of course, from what Giordano (twenty-six years old in 1660, Preti then being forty-seven) was able to do with the knowledge. No sooner had Preti finally departed from Naples in 1660 than Giordano produced his master-piece in a Lanfranco/Preti mode. Magnanimous now that Preti was safely away, Giordano paid homage to Preti's city gates in an altarpiece, *San Gennaro Frees Naples from the Plague* (fig. 46), that was in place in the church of Santa Maria del Pianto by 1662. In more general terms the Correggesque breadth of Lanfranco's compositions induced Giordano to break away from the rigidity of mid-seventeenth-century Neapolitan painting.

The Roman-Bolognese character of Giordano's San Gennaro altarpiece represented a mo-mentary excursus in his development between 1658 and the mid-1660s, during which time he was mostly concerned to paint baroque interpretations of Venetian Renaissance models. Al-though not in Preti's style these works drew upon the inspiration that Giordano had originally taken from pictures like the former's *Feast of Herod* (fig. 7). Toward the close of the 1660s Giordano's Venetian-style canvases depict figures that indicate, in their billowy softness and lethargic expressions, that his attention had been distracted by contemporary Venetian paint-ing — specifically by the escapist eroticism that Pietro Liberti had made his specialty (Palluc-

chini 1981, 241). From a close reading of documents published by Strazzullo in a different context (Strazzullo 1978, docs. 179, 240–41), we can deduce that Giordano traveled outside Naples during the first half of 1664 (Baldinucci 1975, 345, refers to a visit to Florence in 1665). Presumably Giordano went again to Venice at this time, because three years later he had a circle of Venetian patrons who arranged for him to send to and exhibit an altarpiece in Santa Maria della Salute and thereby steal the commission from the Florentine Volterrano (Goldberg 1983, 64ff.; Meloni Trkulja 1976, 78ff.).

As to Giordano during the 1660s, it should also be noted that he continued to find it profitable to paint more than a few pictures in his purest imitation of Ribera's baroque style of the 1630s (fig. 13). His deliberateness in this exercise is proved by the 1688 inventory of the collection of Ferdinand Vandeneynden, which Giordano compiled and in which he attributed several paintings to "Luca Giordano alla maniera del Spagnoletto" (Ruotolo 1982; Colonna di Stigliano 1895). These paintings are extremely difficult to date, but several factors make it certain that Giordano painted Riberesque pictures well after 1656. The chief factor is the mature technique employed in many of these. X-ray examination has revealed that Luca's Riberesque *St. Sebastian Cured by St. Irene* in the Philadelphia Museum of Art (fig. 14) was painted over a completely finished composition, *Christ Disputing among the Doctors,* which is known from other versions to have been in his maniera dorata.[6]

Naples after Preti was an open field for Giordano, given the low quality of his competition, but he could not immediately step into the role of caposcuola. For the first decade at least the honorary dean of Neapolitan artists remained the indefatigable Andrea Vaccaro (1605–1670) who, De Dominici writes, was liked by everyone. Vaccaro was elected the first head of the Corporazione dei pittori on its founding in 1665 (Strazzullo 1962). A prolific painter, Vaccaro always had important clients for his well-mannered and competently drawn figure paintings based on Stanzione and graced by a prettiness observed from Van Dyck (who had passed through Sicily in the 1620s).

Two younger painters contested Giordano's authority as best they could. Francesco di Maria (1623–1690) was a mediocre painter who made a niche for himself as the "classicist" of the Neapolitan school, having assisted Domenichino during his visit in 1630–34. De Dominici reserves praise for Di Maria's drawings, which are rare today, and for his portraits, none of which has as yet been identified. Di Maria was one of the few painters openly to ally himself with Preti — no doubt he approved of any draftsman trained in Rome — and the young Francesco Solimena first heard Preti extolled in Di Maria's studio in the late 1670s. Finally, Giacomo Farelli (1624–1705), a pupil of Vaccaro, gave signs in the 1660s of independence from the outdated tradition of the Stanzioneschi, but he soon subsided into crypto-Giordanism.

During the 1660s and thereafter Neapolitan collectors remained in close contact with Mattia Preti. De Dominici did not distinguish among Preti's phases of development during his four decades on Malta, other than to comment on the weakness of the late works, but he was keenly aware that many of Preti's pictures in Naples had been made in Malta, so much so that he wrongly assumed this for some of the canvases in San Pietro a Maiella. It is my view that Preti's two famous *conviti* at Capodimonte, *The Feast of Absalom* and *Belshazzar's Feast,* were painted in Malta ca. 1668 for export to Naples, though most writers have placed these works in his

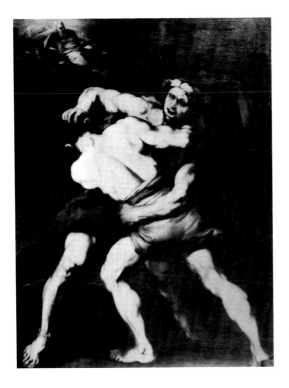

FIG. 13. Luca Giordano, *Hercules and Antaeus*, ex Chrysler Collection, New York

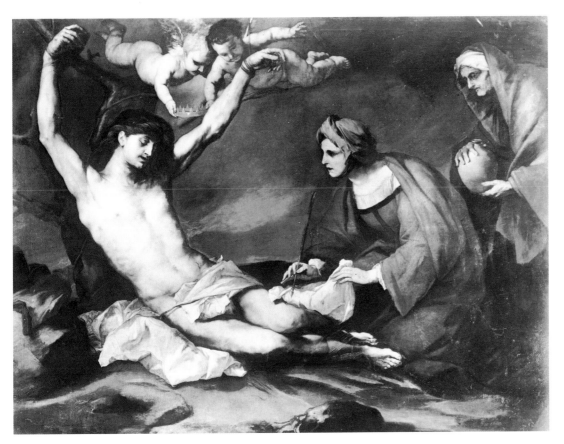

FIG. 14. Luca Giordano, *St. Sebastian Cured by St. Irene*, Philadelphia Museum of Art, Pennsylvania

FIG. 15. Francesco Solimena, *SS Francis of Sales, Francis of Assisi, and Anthony of Padua*, San Nicola alla Carità, Naples

Neapolitan period (Spike 1979b, 8ff.; Utili in Washington 1983, no. 106; *contra,* Spike 1979c). The revival of Lanfranchesque painting that Preti had launched received significant momentum from the numerous works of G. B. Beinaschi, Lanfranco's close follower, who arrived in 1664 in order to paint the cupola of San Nicola alla Dogana, destroyed in World War II. Over the next twelve years Beinaschi received numerous public commissions, especially in the church of Santa Maria degli Angeli a Pizzofalcone (1672–73).

The 1670s witnessed the emergence of three critical aspects in the career of Luca Giordano. About 1672 he painted two more altarpieces for Santa Maria della Salute, Venice, and in the mid-1670s he established ties with Florentine collectors other than the Medici, which eventually led to the commission for the cupola of the Corsini chapel in Santa Maria del Carmine (see biography by Judith Colton, below). Giordano's regular activities for clients in Venice and Florence are the best documented instances of his status as the first painter since Ribera to win a reputation outside Naples (Spanish patronage of Stanzione and Vaccaro constituting a special case). Second, it was toward the close of this decade that the references to the figure style of Pietro da Cortona, which had previously been scattered in Giordano's work, now coalesced into the definitive style of Giordano's maturity, one that employed Cortonesque types with astonishing fidelity for a non-Roman artist.

Finally, and with less credit of course to the artist, the importance of Giordano's workshop as coexecutants of his commissions and as copyists came to the fore during the 1670s. Ferrari and Scavizzi point to extensive workshop participation in Giordano's *Saints, Apostles, and Doctors of the Church,* completed for the Duomo in 1676–78 (the same series would require Solimena's replacements in 1701) and in the cupola fresco of Santa Brigida, 1678 (Ferrari-Scavizzi 1966, 2:88, 94). De Dominici criticizes Giordano's excessive speed of execution and quotes him as saying that he painted with three kinds of brushes — gold, silver, and copper, thus varying the quality of his work in accordance with the client's social class and the price (De Dominici 1742–45, 3:433). There are clear indications, however, in the recently published inventory of the Guglielmo Samueli Collection, Samueli being a Venetian merchant in Naples mentioned by De Dominici, that the uneven quality of Giordano's oeuvre probably had more to do with the degrees of workshop practice than with the master's reputed unevenness. Dating from 1680, the Samueli inventory lists no fewer than seventy-six paintings by Luca Giordano in whole or in part, or copied after him. The autograph originals composed the smallest part of the group. The majority of the paintings were divided between titles that are described as "copia di Giordano" or as "copia ritoccata da Giordano." From the sheer numbers involved it is evident that all three categories were produced for purchase in the Giordano workshop (Labrot in De Vito 1984, 135–42).

Around 1680 a young painter named Francesco Solimena began to make a name for himself: his frescoes in San Giorgio in Salerno (1680) and his altarpiece in San Nicola alla Carità, Naples (1681; fig. 15), revealed his attraction to Giordano's Cortonesque vocabulary of forms and to a lush neo-Venetian colorism learned from Giordano and, seemingly, from the works executed in Naples during 1640s by Charles Mellin, a follower of Poussin (see also Spinosa 1984, pls. 526–28). Early in the 1680s Solimena received commissions for an altarpiece for the Benedictine abbey at Montecassino (see essay by Robert Enggass, below) and for frescoes in Santa Maria

Donnaregina. Solimena thus enjoyed the benefit of the success of Giordano's new style without actually having been his pupil. Since his arrival in Naples five years before, Solimena had been improving himself, studying drawing with Di Maria, but mainly on his own. The basis of his style had already been formed under the influence of his father, Angelo Solimena (1629–1716), a painter in the provinces near Avellino who, fortunately for Francesco, was more than a provincial talent, being the pupil of the excellent Francesco Guarino in nearby Solofra (Pavone 1980). Francesco Solimena therefore descended from the most interesting line of the Stanzione tradition. Guarino was a careful draftsman who enlivened the familiar Stanzione figure types with his elegant sensibility for color. Thanks to the precedent of Giordano and to his own studies of Lanfranco and Cortona (in prints; Princeton 1980, no. 45) the young Solimena was able to abandon the Stanzione compositional formulas that his father had taught him and to fashion a modern style.

Solimena's growing appreciation for Pietro da Cortona was but one aspect of the pervasive tendency among Neapolitan painters of the 1680s to turn more and more for inspiration to the contemporary Roman school. Of course only the protean Luca Giordano had the option to paint as though he were the very reincarnation of Cortona, an option that he exercised in his frescoes in the gallery of the Palazzo Medici-Riccardi, Florence (1682 and 1685), undoubtedly the finest late baroque fresco decoration by anyone and still the cornerstone of his reputation (figs. 16, 17). Back in Naples in 1684 Giordano painted *Christ Expelling the Moneychangers from the Temple,* a fresco of cinematic dimensions, and dynamics, that covers the inside facade of the Girolamini. This tour de force kept Giordano's mature style ever present in the imaginations of his colleagues well into the next century.

The arrival of Roman painters naturally fueled the pro-Roman bias in Neapolitan painting of the 1680s. After working alongside Giacinto Brandi in San Carlo al Corso, Rome, Beinaschi resumed his prolific production in Naples with fresco cycles in many prominent churches including SS Apostoli (1680), the Girolamini (1681) and Santa Maria delle Grazie a Caponapoli (1681–86). Beinaschi died in 1688.

In 1683 Giacomo del Po, aged thirty-one, came to Naples. The son of Pietro del Po, a Sicilian painter and printmaker, Giacomo had been born in Rome and was thoroughly grounded in contemporary Roman painting. He had been a member of the Roman Academy of St. Luke since 1674, and his first decade, at least, of work in the south is still related to the second generation of the Roman followers of Cortona, for example, Giacinto Gimignani, with occasional references to the Genoese-Roman style of G. B. Gaulli, called il Baciccio.

About 1675, the relocation of Abraham Breughel, Flemish expatriate and grandson of Jan Bruegel de Velours, from Rome to Naples spelled a fundamental change in the course of Neapolitan still-life painting. The local specialists, G. B. Ruoppolo and Giuseppe Recco, could not resist Breughel's decorative splendor. Thus ended the unpretentious naturalism of Neapolitan still lifes, which had constituted one of the most vital and distinctive expressions of the Neapolitan genius.

Finally, the influx of Roman tastes and tendencies during this decade received the whole-hearted support of the most important collector to appear since the deaths of Gaspare Roomer and Ferdinand Vandeneynden in 1674. Indeed, the new arrival was one of the great collectors of

FIG. 16. Luca Giordano, *Commerce and Navigation*, fresco, detail from gallery vault, Medici-Riccardi Palace, Florence

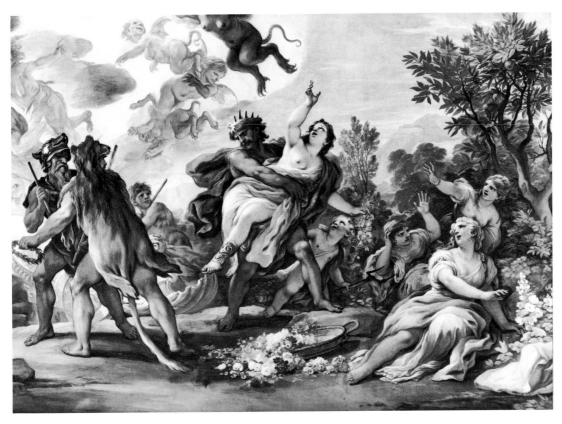

FIG. 17. Luca Giordano, *Rape of Proserpina*, fresco, detail from gallery vault, Medici-Riccardi Palace, Florence

FIG. 18. Paolo de Matteis, *Allegory of the Arts*, J. Paul Getty Museum, Malibu, California

the century: Gaspare de Haro, marchese del Carpio, who ruled the kingdom of Naples as viceroy from 1683 to 1687 following his tenure as Spanish ambassador to Rome (Haskell 1963, 190–92). Del Carpio was a connoisseur of many schools and styles — he did not ignore Velázquez, for instance — whose collection at his death totaled nearly two thousand pictures. Del Carpio was followed to Naples by the twenty-year-old Paolo de Matteis, a Neapolitan whose studies in Rome Del Carpio had encouraged (see biographical essay by Evonne Levy, below). Originally a pupil of Luca Giordano, De Matteis reentered Giordano's circle. His earliest known painting, an *Allegory of the Arts* (fig. 18), now in the J. Paul Getty Museum, Malibu, with the fragmentary date "168–," contains Marattesque facial types that De Matteis had learned in Rome. But the compositional scheme has all the casualness preferred by Giordano, and could never have been painted by a Roman. In this way De Matteis and Del Po are already quite distinct, notwithstanding their Roman experiences.

The marchese del Carpio employed Giordano extensively, and it was no doubt during his viceroyalty that the idea was first broached to Charles II to bring Luca Giordano to Spain in order to let his blue skies shine down from the stony vaults of the Escorial. De Dominici refers on several occasions to an outstanding episode in Del Carpio's innovative patronage. It seems that Del Carpio instructed Giordano to organize an exhibition of fourteen still-life paintings in conjunction with the annual feast of the Corpus Domini.[7] Giordano was authorized to commission huge canvases, eighteen palmi in breadth (one palmo equals about ten inches), from the leading masters of still life in Naples and to complete these compositions with the addition of figures by his own hand. The available evidence suggests that this event took place in 1684. Although Giordano had painted a fisherman in a Giuseppe Recco still life as early as 1668,[8] such collaborations between figure painters and still-life specialists had hitherto been as rare in Naples as they were common in Rome. One of the chief exponents of this practice had been, in fact, Abraham Breughel, who had worked with Carlo Maratta, Guglielmo Cortese, and Giacinto Brandi (Graf-Schleier 1973, 46ff.; New York 1983, no. 34).

Luca Giordano went to Spain in 1692, no doubt to the immense relief of his colleagues, but depriving Naples of his leadership and hundreds of works. Several other important developments can be dated to the beginning of the 1690s. Solimena completed his frescoes in the sacristy of San Paolo Maggiore, a cycle that seemed in retrospect to have been as important a declaration of his outlook as had been Giordano's Girolamini fresco of 1684 for his. In effect Solimena declared that study, study, and study were to be his guide, not the virtuoso improvisations of Giordano. More and more Solimena turned to Preti for alternatives to Giordano's repertory of poses, and the 1690s also witnessed the first hints of Solimena's interest in Preti's somber palette. Early in this decade is the probable date for a group of cabinet pictures (a pair on copper formerly at Chatsworth; see also fig. 65) that are especially close adaptations of Cortona compositions, which Solimena evidently admired for their Roman clarity (see also entry for cat. 20, below).

The artist who most benefited from Giordano's absence was perhaps not Solimena but Paolo de Matteis. As early as 1692, when he signed and dated his *Galatea* now in the Brera, De Matteis had sloughed off his Roman indoctrination and donned the mantle of Giordano. Had De Matteis been planning ahead he could not have made a better career decision: during

Giordano's ten-year absence, and thereafter, De Matteis was constantly employed by Neapolitan church institutions for altarpieces and, even more, for fresco decorations. Two works dating from 1696, his fresco of the *Madonna Consigning the Scapular to St. Simon Stock* in Santa Teresa degli Scalzi and an altarpiece representing *San Gregorio Taumaturgo* (Seminario, Lecce), document the continuation of De Matteis's happy immersion in orthodox Giordanism.

In works executed toward the end of the decade, however, for example, his famous fresco on the ceiling of the pharmacy of the Certosa di San Martino (1699; fig. 19) and *Olindo and Sofronia* (cat. 28) with the fragmentary date "169–," De Matteis shows a new influence, namely, the adaptation of the elongated and mannered figure style invented by the best young painter to emerge in this decade, Domenico Antonio Vaccaro (1678–1745).

An authentic prodigy, Domenico Antonio Vaccaro was independent of the major masters of his school. Even as a teenager in the early 1690s he was given the extraordinary opportunity of painting a canvas of *St. Bonaventure* for the basilica of San Lorenzo Maggiore. Nicola Spinosa has identified diverse aspects of Giordano, Preti, and even contemporary Genoese painting (Baciccio) as the sources for Vaccaro's stylistic idiosyncrasies (Detroit 1981, 1:152). His style represented a brave attempt to erect an anticlassical bulwark against the incoming tides of Roman classicism. Although he quickly made a name for himself, Vaccaro seems eventually to have tired of the effort of competing with Solimena. The present evidence suggests that he all but gave up painting from 1708 to 1720 and concentrated on his architectural and sculptural work.

The other notable protagonist of this anticlassical current of the 1690s was, unexpectedly perhaps, the Roman-born Giacomo del Po. In 1693 Del Po signed and dated a dynamic and dramatically illumined *Annunciation* in Sant'Agostino degli Scalzi. It would seem that at just the moment that Solimena was putting his foot onto the well-trodden path of Cortonesque classicism, Del Po, who was trained in that style, was discovering the baroque expressionism of Beinaschi and Giordano. Del Po had anyway an extravagant imagination that probably felt constrained by the decorum of sacred histories — during this decade he began to cultivate a reputation for decorative cycles in private palaces. He is first documented working for his principal patron, the duke of Maddaloni, in the latter's villa near Santa Lucia a Mare, in 1694 (Cantone 1979, 35, 61n. 90).

The end of the seventeenth century was a turning point no less important for Solimena's development than had been his San Paolo Maggiore frescoes of 1689–90. In 1700 Solimena made his sole trip to Rome in order to attend the Jubilee. De Dominici, however, does not record this visit more specifically than to imply that it occurred before 1702 (1742–45, 3:588). Solimena attracted influential patronage in Rome: for Cardinal Fabrizio Spada Veralli he painted an erudite story from antiquity, *The Abduction of Orithyia* (cf. cat. 22), in which he made a determined effort to evoke the dignity of classical statuary and stoic philosophy. Naturally he was also looking hard at the work of the Roman caposcuola, Maratta, whose classicizing style was the recognized standard.

Solimena's visit to Rome took place during the execution of six canvases for the transept of Santa Maria Donnalbina (1699–1701; Naples 1980, nos. 33a–f). A surprising gulf extends between the Cortonesque pictorialism of the largest painting in the series, the *Adoration of the*

FIG. 19. Paolo de Matteis, *St. Bruno Interceding with the Madonna for the Suffering*, fresco, pharmacy, Certosa di San Martino, Naples

Shepherds (fig. 20) and the Marattesque *Visitation,* based on the artist's altarpiece in Santa Maria della Pace, of which Maratta made an etching (Bartsch 21.3; Bellini 1977, no. 7). Into this framework of late seicento Roman classicism Solimena has inserted figures — especially for the prophetlike characterizations of Joseph (e.g., fig. 21) in the Donnalbina cycle — that are his truest homage to the grand expressionism of Mattia Preti.

By the end of the Donnalbina series, as in the two replacement saints for the Duomo cited earlier, Solimena had reached the threshold of his definitive style, which proved to be a tenuous but ingenious equilibrium of three contradictory impulses: a baroque vivacity ultimately derived from Giordano and Cortona; a dignified and occasionally profound figural expression based on Preti; and the legibility of Roman classicizing compositions.

Only a few years previously Sarnelli, in the 1697 edition of his Naples guidebook, was compelled to write that the Cappella del Tesoro at San Martino remained undecorated because the fathers could not find a painter to equal the quality of the art in that noble sanctuary (Sarnelli 1697, 324). After 1702 the fathers must have felt that their cup was running over: Luca Giordano came home from Spain following the death of Charles II and they awarded the commission to him. His fresco of the *Triumph of Judith,* completed before the end of 1704, was the masterpiece of his last years (fig. 59). In the meantime, besides, Solimena had clearly emerged as Giordano's heir apparent. Solimena could console himself, while waiting his turn, with the honor of being called from Montecassino to paint Philip V's portrait on the occasion of the new Spanish king's visit to Naples in 1702 (Spinosa 1979, 211ff.).

Paolo de Matteis responded to the accolades now being directed toward other quarters by accepting an opportunity to remove himself to France, where he passed some productive years (1702–05) under the protection of the duc d'Estrées (Lehmann in Kassel 1980, s.v. "Paolo de Matteis"). It appears that this voyage abroad allowed him to reach a firm conclusion about his development once and for all: in the quarter-century remaining to him following his return to Naples, De Matteis worked in a recognizably Marattesque idiom, rendered Neapolitan by a decorative bias and a certain superficiality of expression based on Luca Giordano. This can be said even of *The Choice of Hercules,* his famous exercise in Neoclassicism painted under the direction of Shaftesbury in 1712 (fig. 22). That De Matteis enjoyed enormous success with this style is attested by the abundant notices in the *Gazzetta di Napoli* of the unveilings of his new frescoes and altarpieces. It is difficult to distinguish the dates of De Matteis's works over this period, but recent archival research has established that he became the painter of preference for Apulia after 1713, executing many works in Taranto, Bari, and elsewhere (Mongelli 1978, 105ff.).

Recently Donald Rabiner has argued on the basis of De Matteis's favorable reviews in the *Gazzetta di Napoli* that Solimena did not predominate in Naples until the 1720s, when De Matteis, Del Po, and other competitors had reached the end of their careers (Rabiner 1978b, 325ff.). According to Rabiner the traditional view that Solimena became the preeminent Neapolitan artist immediately following Giordano's death in 1705 is an anachronism first advanced in 1733 in the Neapolitan edition of the *Abecedario pittorico* of P. A. Orlandi and then perpetuated by De Dominici. I cannot agree with Rabiner's analysis. The acid test of a caposcuola must be the quality, quantity, and influence of his pupils. In this regard Solimena

FIG. 20. Francesco Solimena, *Adoration of the Shepherds*, Santa Maria di Donnalbina, Naples

FIG. 21. Francesco Solimena, *The Flight into Egypt*, Santa Maria di Donnalbina, Naples

outdid De Matteis decisively. The history of Neapolitan painting in the eighteenth century turns on the issue of Solimenism just as the seventeenth century did on Riberism and Giordanism. De Matteis's importance was just not equivalent, notwithstanding his enviable reputation. It is true that Solimena's name appears less often than De Matteis's in the *Gazzetta*. But that is only because Solimena executed fewer commissions for Neapolitan churches. And Solimena's authority is recognized by this very source: in the 1713 notice describing the *vernissage* of two canvases by De Matteis in SS Apostoli, Solimena is cited as being firmly enshrined in the pantheon to which De Matteis has only just gained admittance. The latter is praised because his works are worthy to be placed beside "the most famous paintings of Lanfranco, Giordano, Solimena, and other similar excellent men" (quoted by Rabiner 1978b, 327).

Certainly Giacomo del Po was a more interesting artist than De Matteis. As previously remarked, Del Po had established a specialty in fresco decoration for princely residences, and the Austrian viceroys who, after 1707, succeeded the Spanish as rulers of the kingdom acquired Del Po's work for their residences in Vienna. A generation earlier than Filippo Falciatore — contemporaneously with Watteau in France, in fact — Del Po invented a Neapolitan version of the rococo. Most of these frescoes have been lost to later remodelings or demolitions, but a good number of preparatory sketches have survived and can be identified through De Dominici's descriptions. About 1705 Del Po painted elaborate, fancifully imagined allegories in two rooms in the palace, still extant, of the duke of Positano. A bozzetto for his Maddaloni scheme of 1710 is in the museum at Rennes (Spinosa in Naples 1979, 1, no. 65). Although Preti has been

cited as an influence on Del Po's mature style the most obvious precedents are Giordano and Beinaschi, both of whom painted sketchily and took plenty of anatomical liberties.

Typically it was Del Po who received from an unknown patron an extraordinary commission for two scenes from Milton's *Paradise Lost* representing *The Gates of Hell* and *The Sleep of Adam and Eve* (The Art Museum, Princeton University; Princeton 1980, nos. 34, 35; Detroit 1981, 1, nos. 41a, b). In these whimsical paintings Del Po's doll-like figurines flit to and fro like spirits surrounded by thunder and lightning. It is a pity no traveling Englishman thought to commission scenes from *A Midsummer Night's Dream*. On a monumental scale Del Po displayed his talents for illusionism in grisaille memorials of the Milano family on the sacristy walls of San Domenico Maggiore (1712; Causa Picone in Naples 1979, 1, no. 203).

During the first decade of the new century Solimena operated at the height of his creative powers and organized a studio that would train the next several generations of Neapolitan painters. In 1709 he painted his most fully realized work in fresco, the *Triumph of the Dominican Order,* on the vault of the sacristy of San Domenico Maggiore (fig. 72). Here the decorative values and spiritual subject matter are finely balanced. His arrangement of the figures in ascending steps became at once the standard for ceiling frescoes in Naples. For the cathedral at Sarzana, toward the end of the first decade, Solimena painted an altarpiece of the *Vision of SS Clement, Philip Neri, Lawrence, and Lazarus*. It pulses with all the pictorial and religious excitement of a great Preti of the 1650s. Very near it in time is the 1710 altarpiece *St. Bonaventure Receiving the Banner of the Holy Sepulcher from the Madonna* (Aversa, cathedral), which is a magnificently controlled exercise in Venetian Renaissance revivalism (Titian's *Pesaro Madonna*) as practiced by Preti (Spinosa in Naples 1979, 1, nos. 73, 74). It is for reasons such as this that Solimena earned the sobriquet il Cavalier Calabrese nobilitato.

As we have said De Dominici's biographies of Preti and Solimena are fueled by the latter's unbounded admiration for the older master's genius for draftsmanship and composition. Preti's representations of the male nude, powerful and commanding, were especially admired by Solimena, who extolled their realism. De Dominici describes, for example, a particularly fine motif in one of Preti's plague frescoes:

On the same stairs appears a great nude who drags a cadaver, half-wrapped in a cloth, with a rope. These events [Preti] *told of having seen with his own eyes on the stairs of the nearby church of Santo Spirito, and he remarked that the nude man had been a slave of great stature whom Preti had observed in this very act by looking through an opening in the door. It is certain, however, that this figure is excellently painted with such intelligent and masterly contours that no painter could do it better. Our famous Francesco Solimena has many times spoken to exactly this effect, pointing out that as many times as he has passed by that* [fresco] *he has never tired of admiring it* (De Dominici 1742–45, 3:334).

It is paradoxical but demonstrable that Solimena's admiration for Preti's drawings from life eventually led Solimena away from his own observations of nature and into a kind of mannerism, as a result of which his paintings from the second and third decades of the century lack the vitality of his earlier work. Not that his reputation suffered — quite the contrary. But like the mannerists of the sixteenth century he became convinced that perfection could be obtained through the repetition of proven models: stock figures, many of them overt borrowings from

FIG. 23. Francesco Solimena, *Martyrdom of the Giustiniani at Chios*, bozzetto for painting, now destroyed, made for the Sala del Consiglio, Senate Palace, Genoa, Museo di Capodimonte, Naples

Preti or Maratta, begin to be used again and again. De Dominici makes several references to Solimena's collection of Preti drawings and specifies paintings in which Solimena inserted figure studies by Preti so as to take advantage of their "perfect contours."

The earliest works to display this piecemeal approach to composition, so far as I know, were three immense canvases commissioned in 1715 by the Republic of Genoa. The paintings, illustrating *The Landing of Christopher Columbus in the New World* and two other events involving Genoese history, were destroyed in a fire of 1777 (see fig. 75; Wunder 1961; Causa Picone in Detroit 1981, 2, no. 92; the datings in Naples–Paris 1983, no. 48 are garbled). De Dominici remarked about Solimena's *The Martyrdom of the Giustiniani* that "in this painting he truly demonstrated all that he had studied and drawn from the works of the Cavalier Calabrese. He placed in front a boat with sailors nude to waist, painted with an awesome disegno and forceful chiaroscuro in imitation of that great man" (De Dominici 1742–45, 3:591). In point of fact we can see from the modello (fig. 23) that the painting was virtually a compendium of recycled motifs, including, as one of the principal episodes (the kneeling victim and executioner at upper right), the unexpected transmigration of Preti's *Martyrdom of St. Catherine of Alexandria* from the transept of San Pietro a Maiella. Solimena's *Last Supper* of 1715 in the basilica of San Francesco, Assisi, is a deliberate re-creation of Leonardo's composition.

In the 1730s Solimena, who liked the challenge of composing on a gigantic scale (excepting cupolas and other formats that would have demanded an unclassical illusionism), self-consciously set out to create a masterpiece in his *Expulsion of Heliodorus from the Temple* in the Gesù Nuovo, 1725 (fig. 87; see also cat. 26). Even the theme invited comparison with Giordano's Girolamini fresco of 1684. Critical opinion treated Solimena's tour de force with respect until recently, when Oreste Ferrari pointed out its deficiencies (in Detroit 1981, 1:52; see also below, essay by Carmen Bambach Cappel).

If later developments are any indication — within a few years Solimena would banish nearly every semblance of color from his palette — the problem with such works as the *Heliodorus* is actually the suppression of "decorative intent" in pursuit of the chimera of academic perfectionism. In this connection Ferrari had compared Francesco de Mura's *Adoration of the Magi* in the Nunziatella favorably to the *Heliodorus*. This serves to introduce Solimena's greatest pupil, Francesco de Mura (1696–1782). He dominated Neapolitan painting during the second half of the eighteenth century. De Mura's individual style did not emerge until the *Adoration,* which dates from 1732 (fig. 110), and his contemporaneous canvases for Montecassino (cat. 34). He had entered Solimena's workshop at a felicitous moment, 1708, and had closely followed his master's style after beginning his own career in 1713 at the age of seventeen. The bulk of De Mura's career falls outside the purview of this essay, but it can be summed up as a triumphant realization of "decorative intent."

In retrospect, the successive phases of Solimena's development from the 1690s, as reflected in the careers of his pupils, were formative influences on most of the major currents of eighteenth-century painting in Naples and even in Rome. For instance, Sebastiano Conca, who brought a Solimenesque style to Rome about 1707 and vied with Trevisani for preeminence in that school, undoubtedly became attuned to Roman style when he was in Solimena's workshop during the latter's Cortonesque period of the early 1690s. De Mura studied with Solimena late

FIG. 24. Francesco Solimena,
*The Triumph of Carlo di Borbone at
Gaeta*, Hall of Alexander, Royal
Palace, Caserta

in the first decade of the new century, at which time he assimilated his master's sophisticated
interplay of decorative and expressive content (in the end, De Mura leaned toward the former
of these qualities, but a balance was preserved). From 1717 to 1723 Corrado Giaquinto studied
with Nicola Maria Rossi, a Solimenista in the same graduating class as De Mura, and some
scholars believe that he eventually transferred to the master's studio (see biographical essay by
George Hersey below). Giaquinto's inbred stylizations of drapery and his habit of repeating
figures and compositions only reflected the training he had received. Finally, to move forward
in time, Solimena's latest style with its somber tonalities appears in the early works of Giuseppe
Bonito, and the anachronistic subjects and style of Gaspare Traversi were meanwhile obviously
inspired by the aged Solimena's determination to revive the baroque in the most faithful way
possible.

 The late style of Solimena is traditionally associated with the Bourbons, who ruled Naples
as an independent kingdom after 1734. Carlo di Borbone, the first Bourbon ruler, employed
Solimena constantly. In a letter to Madrid of September 1735 Solimena accepted a royal
commission for a *Battle of Darius and Alexander* for the palace at La Granja, Spain, and informed
Filippo Juvarra, his correspondent, that he had already completed three canvases, one of them
25 x 20 palmi, representing *The Triumph of Carlo di Borbone at Gaeta* (Spinosa in Naples 1979, I,
no. 79). The work exemplifies this late style: the atmosphere is brooding and nocturnal, yet the
forms remain substantial, vigorous and neobaroque (fig. 24). As somber as his manner had
become, there seemed no hesitation in assigning to Solimena in 1737 the most important parts
of the campaign to redecorate the private apartments of Carlo's queen, Maria Amalia, in the
Palazzo Reale in Naples. In 1741, now eighty-four years old, Solimena executed an immense
altarpiece, *The Trinity with Saints,* for La Granja near Segovia, which turned out to everyone's
satisfaction, especially in view of widespread concern that the artist might not live to complete
the work (Urrea Fernández 1977, doc. 138).

These last years also saw the publication of De Dominici's authorized biography of the master. De Dominici noted that in recent years Solimena had acquired three paintings by Preti, although he marveled (and for some reason could not comprehend) that all three of these pictures were in Preti's late style, which was almost as colorless as Solimena's last manner. De Dominici provides an interesting epitaph that quotes the master as complaining that his work has been overvalued and that he will die wishing he knew more (De Dominici 1742–45, 3:625ff.).

About three years after De Dominici's book appeared Solimena died. With this event a soaring arc of Neapolitan painting completed its course. The glory of Naples did not diminish, thanks to the achievements of De Mura and Giaquinto, but these painters worked in an epoch of international styles and absorbed influences from France and elsewhere that Solimena would hardly have recognized.

1. See essay by Judith Colton. In a lecture, "Mattia Preti, Luca Giordano, and the Emergence of Francesco Solimena," given at Yale on January 14, 1986, I argued that De Dominici's reliability as a chronicler falls off rapidly as he discusses events that occurred earlier than his own time, and that his chief contributions are his aesthetic opinions about Solimena and descriptions of Neapolitan collections.

2. Two bozzetti for Solimena's canvases in the Archivio Diocesano, Naples, were shown at the Palazzo Reale in the exhibition organized by Nicola Spinosa (Naples 1980, nos. 63a and b). The present essay owes an inestimable debt to this catalogue and to Spinosa's and Raffaello Causa's contributions cited in the Bibliography of the present volume.

3. De Dominici 1742–45, 3:615. The remark can also be seen as a disparagement of De Matteis, who claimed to be able to paint even faster than Luca (*idem.*, 526ff.).

4. This identification for the Toledo version was advanced most recently by Utili in Washington 1983, no. 107, q. v. for relevant bibliography, to which should be added Lehmann in Kassel 1980, 210ff.

5. Apparently the date was misread when the Cintas picture appeared at auction at Parke-Bernet, New York, in 1963, and the wrong date thus found its way into Ferrari-Scavizzi 1966, 2:368.

6. Photographs are on file at the Philadelphia Museum of Art. I would like to thank Oreste Ferrari for informing me of this discovery, which I have discussed in detail in a lecture, "Mattia Preti and Luca Giordano: Riberesque Painting in Naples after the Plague of 1656," given in 1983 in the Ribera symposium at the Kimbell Art Museum, Fort Worth, Texas.

7. New York 1983, 19n. 26. Causa Picone in Naples 1984, 2, no. 322 publishes a large drawing of a still life with fish by Della Quosta with figures by Giordano (National Gallery of Art, Edinburgh) which, I suggest, might have been preparatory to one of the Corpus Domini paintings.

8. New York 1983, no. 33. Spinosa 1984, pl. 618 has attributed the picture to Beinaschi but Roberto Middione, in a catalogue curated by Spinosa, accepts my attribution (Naples 1984, 2:396).

MONTECASSINO

Robert Enggass

Monasticism, as we know it within the context of Western civilization, was born at Montecassino. There almost fifteen hundred years ago, about 529 A.D., on a spot that up to then had been occupied by a temple of Apollo, St. Benedict built the first monastery.[1] Then as now, and for all centuries in between, it has housed Benedictines. When Dante encounters St. Benedict in the seventh circle of paradise, he has the saint tell of the event:

That mountain on whose slope Cassino lies was of old frequented on its summit by folks deceived and perverse. I am he who first bore up there His name who brought to earth that truth that so uplifts us; and such grace shone on me that I drew away from the surrounding towns and impious worship that seduced the world. These other spirits were all contemplative men, and kindled by the warmth that gives birth to holy flowers and fruit. Here is Macarius, here is Romaldus, here are my brethren who stayed their feet within the cloisters and kept a steadfast heart.[2]

St. Benedict's aim, as Dante points out, was not only to provide a suitable retreat for those dedicated to the contemplative life, but also to stamp out pagan worship and encourage the spread of Christianity.[3] Excavations demonstrate that for more than a thousand years before Benedict's time the site had been used as an acropolis, in a dual sense: as fortress and as sanctuary. St. Benedict cut down the pagans' sacred groves and overturned their temples. It was on these foundations that the first monastery was built. He chose a splendid spot. The mountain on which his buildings stood rises up steeply to a point some fifteen hundred feet above the surrounding plain. Below on one side the land stretches out across gently rolling hills toward the sea. On the other side, sharply outlined on a clear day, are the tall mountains of the Abruzzi, often capped with snow.

St. Benedict's church survived, though no doubt with modifications, into the eleventh century. In 1066 the abbot Desiderius determined to replace it with one that was much larger and more splendid.[4] It was a major undertaking. The top of the mountain had to be leveled to provide for needed space. Columns, capitals, and bases, for the most part taken from ancient temples, were shipped from Rome by sea and then hauled overland from the nearest port. Artists were brought in from as far away as Lombardy. Desiderius had the panels of the great bronze portal cast and worked in Constantinople.

In September 1349 an earthquake destroyed Desiderius's basilica. It was rebuilt in the Gothic style, incorporating parts of what remained of the Romanesque structure, by Pope Urban V (1363–70), but of this new building little is known. We do know, however, that during this period the monastery lost much of its independence (the pope assumed the title of abbot) and entered into a period of decline. Occasional embellishments were added during the Renaissance, most notably an elegant cloister attributed to Antonio da Sangallo. But the last great flowering of the monastery, from an artistic point of view, came about during the age of the baroque.

In the 1620s the decision was made to enlarge and rebuild the basilica. Cosimo Fanzago, then the most famous architect in Naples, received the commission. Work began with the east end. A fresco with a self-portrait of Fanzago (who was also a painter) depicted a vision in which St. Benedict appeared before the architect and explained to him how to relocate the high altar — a move made necessary by the enlargement of the basilica — and how at the same time to provide for the liturgical needs of a multitude of clergy within the elevated sanctuary.[5]

The contract of 1654 called for the demolition of the entire church then standing, a medieval structure with Renaissance modifications. What took its place was a totally baroque building filled with baroque paintings and decorations. The eye was dazzled by a display of the richest marbles and semiprecious stones: verd antique, porphyry, lapis lazuli, malachite. Paintings, both in fresco and oil, well over a hundred of them, seemed to fill every space. The lavish, intricately worked picture frames were everywhere covered with gold leaf.

The effect did not please everyone. In 1870 Caravita, influenced no doubt by the prevailing preference for Neoclassicism, wrote, "The heart weeps at the thought of those works of the eleventh, fourteenth, and sixteenth centuries that were destroyed to make way for something new, something which, even if one grants that it is attractive and bright, filled as it is with all those marbles, giltwork, and frescoes, is yet decisively less beautiful and of lesser interest for the history of the arts" (Caravita 1869–70, 3:295). But such sentiments are part of the anti-baroque attitude of the later nineteenth century (see the essay by George Hersey, below). Thus only a generation earlier Tosti had written: "Complete in all its parts, rich and radiant with gold and shining marbles, the church has the air of an unending celebration, and he who sets foot within it is filled with wonder and delight" (Tosti 1842, 308).

By the middle of the seventeenth century only a small part of the decorative program had been completed. Before that time Belisario Corenzio, a late mannerist artist, had painted the frescoes of the pendentives and the dome, which was divided by heavy frames into four panels. Charles Mellin, a French artist from Nancy, did the vault fresco in the choir.

Most of the paintings, however, belong to the later seventeenth and early eighteenth centuries. Luca Giordano got the lion's share. By a contract of April 24, 1677, he agreed to paint the entire vault of the nave. The project included five large narrative panels that ran in a row along the top of the barrel vault, ten lunettes that filled the triangular penetrations of the vault in the areas above the clerestory windows and, in the spaces flanking the windows, twenty colossal figures of Benedictine popes (fig. 25). The contract makes no mention of the twenty allegorical figures of virtues that Giordano painted on either side of the lunettes because these he did as a gift to the abbey.[6] By the terms of the contract Luca was to be at the monastery by April 25. He promised not to leave it even for a short time until the work was completely

FIG. 25. Luca Giordano, frescoes, nave vault, Abbey Church of Montecassino. Destroyed 1944

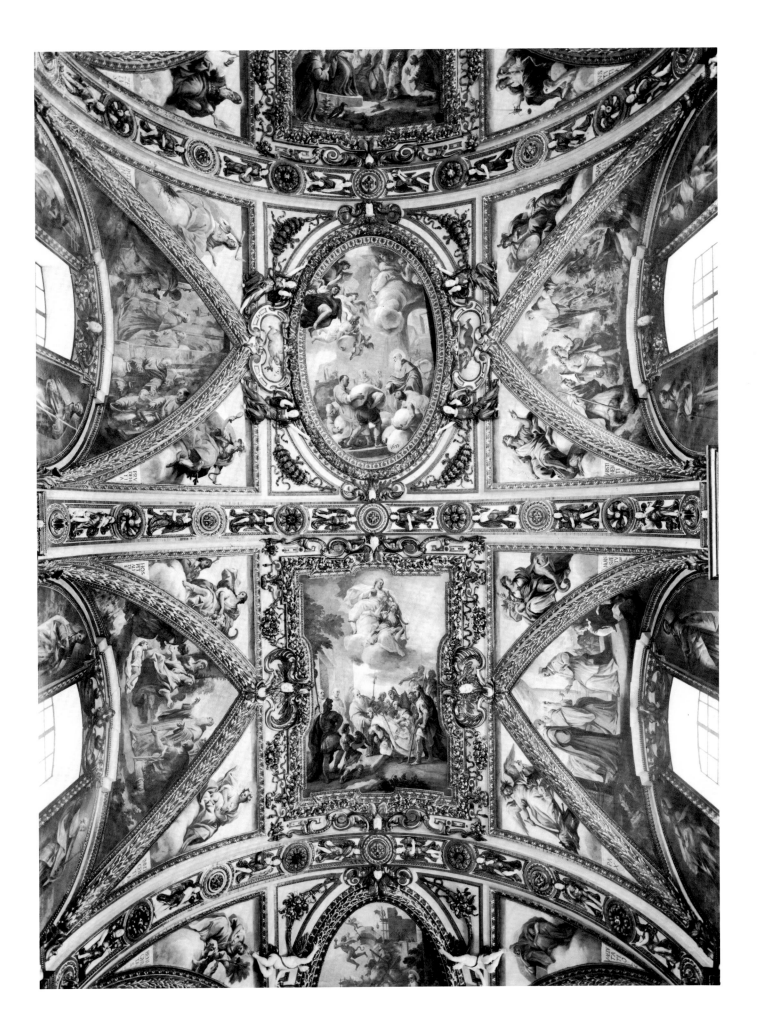

finished. He also pledged that the entire work would be by his own hand without the intervention of any assistants except for the backgrounds. The monastery agreed to pay for his travel expenses, provide for his board and room, and furnish all the workmen and materials he needed, this last by implication a reference to the elaborate scaffolding that had to be erected, and probably the plastering as well. For his efforts Luca was to receive 2,500 ducats, not a large sum in view of the size of the project. Heavy complex white and gold stucco frames divided the vault and the upper part of the clerestory into no fewer than fifty-five panels, each one of which Giordano filled with a separate painting. The result, as Oreste Ferrari has pointed out, was a late mannerist design that effectively blocked any attempt to produce a dynamically unified composition of the type used so successfully in Rome by Pietro da Cortona in the great hall of the Palazzo Barberini and by Baciccio on the vault of the Gesù (Ferrari-Scavizzi 1966, 1:75ff.).

But even allowing for these difficulties the results, if we can judge from photographs taken before the war, are disappointing. The individual compositions tend to be archaistic, looking backward to the Bolognese classicism of the early seventeenth century: to artists such as Domenichino and Andrea Sacchi rather than forward to the bold, innovative pictures, such as the *Triumph of Judith* in the Cappella del Tesoro, San Martino (fig. 59), that Giordano himself would paint at a much later date. On the vault at Montecassino, in the fifteen large multifigure frescoes in which Giordano illustrated scenes from the life of St. Benedict, nothing is foreshortened. Each picture is a *quadro riportato,* painted to look like a framed easel picture hanging on the vault. Many of the scenes are surprisingly static, the more so if we consider that they were painted by a baroque artist during the floodtide of the high baroque. In the *St. Benedict Reviving a Peasant's Son* and the *St. Benedict Saving a Debtor* the figures are arranged in planes parallel to the picture plane and divided symmetrically on either side of the central axis (figs. 26, 27; Ferrari-Scavizzi 1966, 3, pls. 157–58).

A major work by Giordano, which is undated but stylistically closely related to his vault frescoes, is the enormous mural done in oil on plaster that covers the entire entrance wall of the nave from the cornice to the portal.[7] It contains a totally imaginary representation of the papal dedication, in the year 1077, of the new basilica that had been built by Desiderius (D'Onorio 1982, fig. 115; Ferrari-Scavizzi 1966, 3, pl. 159). Its appearance can be partially reconstructed from a prewar photograph and a bozzetto. From the photograph it seems to be a dull, retardataire composition, laid out as it were on a grid pattern with almost everywhere something on the right to balance something on the left, and filled up with half a hundred or more static, standing figures.

But this is not the whole story. The brilliant hues of Giordano's frescoes, and the mural as well, impressed early writers. Fortunately we still have today in the museum of Montecassino three of his bozzetti (two for the vault and one for the mural) which confirm this view (D'Onorio 1982, figs. 120ff.). In them we see the glowing Venetian colors that made such an impression on Giordano: lessons learned from Titian and Veronese, and from both as absorbed by Rubens, and perhaps most of all, at this stage of his career, from the Neapolitan Venetianism of Preti.

All three bozzetti are greatly enlivened by the use of the same bold orange-red in the costumes of one or more of the figures. This hue, laid on rapidly and set against the darks, is

FIG. 26. Luca Giordano, *St. Benedict Reviving a Peasant's Son*, fresco, nave vault, Abbey Church of Montecassino. Destroyed 1944

FIG. 27. Luca Giordano, *St. Benedict Saving a Debtor*, fresco, nave vault of Abbey Church of Montecassino. Destroyed 1944

always the area of highest intensity and can be seen from a considerable distance. Giordano probably used it in all his vault frescoes. In the bozzetto for the *Dedication* it appears prominently in the figure of the halberdier in the front center but also in the vestments of several of the priests. In *The Miraculous Sacks of Grain* it is used for the billowing cloak of the angel in the upper left; and in *Totila before St. Benedict* for the soldiers' capes on both right and left. These last two canvases, which are studies for the large frescoes at the top of the vault, are strongly influenced by Preti, especially in the use of a dark ground out of which parts of the figures are drawn by raking light. This tenebrist effect is abandoned in the fresco (fig. 28), probably in part because of the limitations of the medium. Of all Giordano's narrative vault paintings *The Miraculous Sacks of Grain* is the only one with a composition that could be called fully baroque. The scene is filled in the upper left with the aerial movements of the angels sweeping down from the sky, and this is countered on the lower right by the vigorous actions of the workmen moving the heavy sacks of grain. Most of the other compositions are flaccid and unimaginative. Even so, the colors on their own must have generated a certain sense of movement and excitement.

The vault frescoes finished, Giordano returned to Naples, but a dozen years later he was back again for the paintings in the lateral chapels. In a contract that he signed on February 10, 1691, he agreed to fresco the vaults of the chapels of St. Victor, St. Apollinaris, and San Guinizzone, and also to provide each chapel with three oil paintings, an altarpiece and two laterals (Caravita 1869–70, 3:36off.). For this work he was to receive 1,600 ducats. If we compare this amount with what he had been paid for the paintings of the vault, which was a much more time-consuming project, we can see that the market value of his work had gone up a good deal — as it was bound to in response to his rising reputation. We know from the contract that Giordano was to be at the monastery by Easter. An addendum of June 12 of the same year states that by that date all the paintings had been finished to the "full satisfaction" of the authorities, who notified the bank to make final payment. Twelve large, complex narrative paintings in about three months! Once again *Luca fa presto* proved an apt nickname.

We also know from the contract that before the agreement was signed Giordano had sent disegni to Montecassino for the monks' approval and that he agreed to make changes and alterations in the compositions in accordance with their suggestions. This is an especially significant piece of information, not because it demonstrates that the patron played a role in formulating the compositions, something that is quite customary at this date, but rather because it indicates that for each of the paintings Giordano made drawings (and perhaps even oil sketches), many of which may survive.

By the mid-nineteenth century Giordano's work in these three chapels was beginning to deteriorate. Today nothing survives. Even the titles of the individual paintings are not to be found in the principal monograph on Giordano, nor do they appear, so far as I can determine, anywhere in the literature on the artist. They are however to be found in Della Marra's eighteenth-century guidebook.[8] But since this small volume is hard to come by, it seems worthwhile to make the information more widely available in the hope that it will bring to light drawings and perhaps even bozzetti previously unidentified.

In the third chapel on the right, which was dedicated to both San Guinizzone and San Gennaro, the altarpiece showed the two saints in glory. In the lateral on the right an angel

FIG. 28. Luca Giordano, *St. Benedict and the Miraculous Sacks of Grain*, fresco, nave vault, Abbey Church of Montecassino. Destroyed 1944

returned San Guinizzone's staff while the lateral on the left depicted San Gennaro and the miracle of the blacksmith shop. In the vault Giordano painted an angelic choir.

The third chapel to the left is dedicated to St. Apollinaris Martyr, abbot of Montecassino from 817 to 828. Here the iconography is more complex. The altarpiece showed St. Apollinaris walking on the waters of the river Liri. In the left lateral the prayers of the saint cause the Saracens to turn away from Montecassino and sail instead for Sicily. The canvas on the facing wall showed St. Peter and St. Benedict in a small boat intercepting the infidels and invoking a great storm that caused their fleet to sink. In the fresco on the vault Radelchi, count of Conza, received the Benedictine habit.

In the chapel of St. Victor, the last on the left, the altarpiece represented the abbot Desiderius (later to become Victor III) attempting, in the midst of imploring cardinals, to refuse the papal tiara. The lateral on the right served to illustrate a vision in which St. Benedict beckoned Desiderius to come sit beside him. In the canvas on the opposite wall St. Benedict appeared once more before Desiderius to tell him that the violent storm that had brought great destruction to the abbey had been caused by the spirits of pagan gods who were enraged at having been cast out of their sacred site on the mountaintop. In the vault, the saint, now enthroned as Victor III, gave the assembled cardinals word of a great victory of the Christian forces over the Saracens in North Africa.

Della Marra also assigns to Giordano the altarpiece in the chapel of St. Michael, which represented the warrior saint driving the rebel angels down to hell (see also the entry for cat. 8).[9] We have no date for this work, nor for the frescoes by Giordano in the chapel of St. Benedict in the crypt: the *Four Evangelists* on the pendentives and *St. Benedict in Glory before the Trinity* on the vault.[10]

Francesco Solimena's work at Montecassino seems to have begun about the time Giordano's left off. We do not know the exact dates, but Caravita published the extensive correspondence that Solimena had with the abbey, which runs from August of 1697 to August of 1708 (Caravita 1869–70, 3:371ff.). Compared to Giordano his commissions were few. In the chapel of St. Carloman he painted the two lunettes and the vault.[11] For the chapel of St. John the Baptist he did an altarpiece, *The Baptism of Christ,* and two lunettes with scenes from the life of the saint. His most important commission, however, was for four large narrative compositions in oil on canvas for the walls of the choir.

For this group we have one large, important finished modello: *Ratchis, King of the Lombards, Becoming a Monk at Montecassino.*[12] It is just the sort of subject Solimena loved: a scene teeming with figures, with high-ranking personages accompanied by a great retinue, an ambient redolent of panoply and pomp. Pope Zacharias surrounded by ecclesiastics is enthroned on a high dais. Before him kneels the Lombard king who has cast aside his ermine cloak and is about to put on the coarse Benedictine habit. Behind him are the queen, Tasia, and the Princess Ratrude, both still dressed in finery but soon to take monastic vows. Crowded around them are soldiers, officers, noblemen, and ecclesiastics. In striking contrast to Giordano's work at Montecassino, Solimena's composition is high baroque. The figures, most of which are in motion and arranged in a variety of poses, are drawn tightly together in a vigorous elongated

serpentine that curves, both on the surface and in depth, across the whole length of the canvas from the middle distance in the upper left to the foreground plane in the lower right. The red Solimena uses is deeper and more intense than Giordano's, and instead of being confined sometimes to one spot, at most two or three, it is distributed throughout the composition. It catches the eye immediately in all the major areas: in the pope's cloak, the robe of the handmaiden with the platter who kneels beside the queen, and especially in the large foreground figure of the soldier in a plumed helmet with his back turned toward us who wears a brilliant rose-red cape that turns to pale blue where the light strikes it. We admire also the figure of the kneeling queen who wears a white tunic that vibrates with many shades of off-white impasto, and the king too, the cynosure of the assemblage, in brilliant light blue set off against Benedictine black.

There are also in the abbey museum two bozzetti that Solimena painted for the lateral lunettes of the chapel of St. John the Baptist: a *Feast of Herod* and a *Decapitation of St. John*. Both are damaged by extensive flaking in the thinly painted background areas but are still spectacular in composition and color. In the *Decapitation* the scene is introduced by a large turbaned figure who lunges up in the immediate foreground, half cut off by the bottom of the frame. Close by, foreshortened and projecting toward us, is the headless body of the saint lying on a red cloth. In the *Feast of Herod* the center of attention is Salome, radiant in golden yellow that falls in richly convoluted folds and turns bright red in the shadows. Certainly from what we can tell from the prewar photographs and the surviving bozzetti it is Solimena, not Giordano, who was the hero at Montecassino.

Numerous documents attest to Paolo de Matteis's extensive activity at the monastery between 1692 and 1708 (Caravita 1869–70, 3:365ff.; see biographical essay by Evonne Levy, below). He was responsible for the frescoes of the eight shallow domical vaults above the side aisles, the five canvases in the chapter hall, and two oils in the chapel of the Annunciation: an *Immaculate Conception* and an *Assumption of the Virgin*. This last is the only one of the original paintings from this period that is still left in the basilica. It does not show this productive and interesting, but uneven, artist at his best.

The work of decorating the side chapels extended well into the eighteenth century and included the services of Solimena's principal follower, Francesco de Mura. Documents and other evidence dating from 1730 on credit De Mura with over thirty paintings, both oils and frescoes, in the various lateral chapels, including five large canvases for the chapter hall (Caravita 1869–70, 3:456ff.; Ceci 1933). There are a number of black and white photographs of these paintings that were taken before the war, as well as a few surviving bozzetti. Both groups indicate that De Mura's work at Montecassino was transitional. Some of the paintings, for example the bozzetto for the lunette above the sacristy portal that shows pagan priests performing ablutions before offering sacrifices, have relatively static compositions but are strongly under the influence of Solimena in the use of sharp contrasts of light and shade (Enggass 1964, 133ff.). In others, such as the large *Rebecca and Eliezer* for the chapter hall, De Mura emerges with his own distinct, immediately recognizable version of the Neapolitan barocchetto (1735–37; fig. 29). He treats the subject as if it were a scene from an eighteenth-century opera. Both

the principals are fashionably dressed, Eliezer especially, in a tunic with puffy slashed sleeves and an elaborately convoluted, casually draped cloak. The two figures face one another as if in a minuet, their bodies turning, curving, gently swaying.

In the midst of a corpus of work that is so overwhelmingly Neapolitan it comes as something of a surprise to find that the commission for two of the paintings was given to Jacopo Amigoni, a Venetian (Della Marra 1775, 118). Their presence has been used as corroborative evidence to support the thesis that Amigoni was born in Naples, but recently it has been demonstrated conclusively that he was Venetian. At Montecassino he was recognized as such; the early sources consistently refer to him as "Amiconi Veneziano" (Hennessey 1983).

With Sebastiano Conca of Gaeta, whose paintings are done in the manner of the later barocchetto, the final phase of the baroque at Montecassino comes to a close. Conca did several paintings for the lateral chapels and a large fresco, *Christ Washing the Feet of the Apostles,* for the sacristy. The fresco is lost, but in the abbey museum there is a large finished modello for it (D'Onorio 1982, fig. 129). The subject is conceived in the grand manner with a multitude of figures in a large vaulted hall. On either side there are great columns wrapped with fluttering drapery. Conca interprets this old formula in an up-to-date way. All the figures are in light easy movement. Their abundant garment folds are gracefully arranged in a series of shallow curves. The colors are bright and clear, and much lighter than had been the fashion heretofore. Christ, at the center, is dressed in shimmering rose, but this is not the point of greatest intensity. Rather it is the seated apostle on the right who wears a pale green tunic that turns to yellow in the light and a brilliant rose-red mantle shot through with dull green shadows. The draperies around the columns are a pale powdery blue set off with pink. These are eighteenth-century colors, sharply at variance with the high baroque. With the architectural setting we go one step further. In the great hall the stairs, piers, and wall surfaces are all set parallel to the surface of the picture plane. Moldings are extremely simple. There is no architectural sculpture. This then is an announcement of an incipient Neoclassicism but, brought into contact with the barocchetto, it blends harmoniously (Enggass 1982). The era ends on a high note.

In late October of 1943, when it appeared likely that Montecassino would be engulfed in war, all the movable artistic and historical treasures of the abbey were taken, with the help of a German army convoy and at the direct intervention of both Pope Pius XII and the Italian government, first to Spoleto and then to Rome. As the Allies advanced the Germans took up positions on the lower slopes of the mountain. It is now an undisputed fact that, on the orders of the German High Command, there were no German soldiers inside the monastery. On February 15, 1944, however, at the insistence of General Bernard Freyberg of New Zealand, the American Fifth Army bombarded the monastery, reducing it to ruins (fig. 30). The Germans then occupied the site, digging into the rubble and holding out with such tenacity that even after several dozen aerial bombardments, which destroyed whatever was left standing, they remained entrenched at the summit for three months, blocking the Allied advance until finally waves of infantry, chiefly the Poles, rooted them out at great loss of life (Majdalany 1957).

Not long after the war the entire monastery was rebuilt. It stands today as it did before, a great stone pile rising broad and high from the leveled top of the mountain. The reconstruction

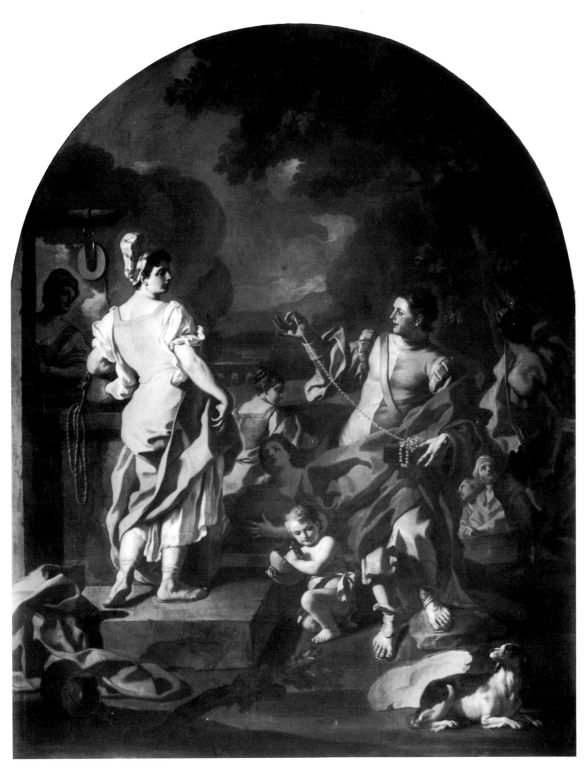

FIG. 29. Francesco de Mura, *Rebecca and Eliezer*, Chapter House, Montecassino. Destroyed 1944

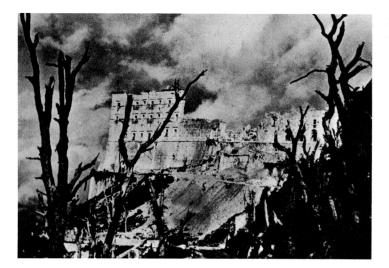

FIG. 30. The Abbey Church of Montecassino immediately after the bombardment of 1944

FIG. 31. Pierre Le Gros the Younger, *St. Gregory the Great*, marble, inner cloister of the Abbey at Montecassino. Destroyed 1944

was to be carried out in strict adherence to the principle of *dove era, come era,* but this of course was only partly possible. The great outer walls had been built over many centuries with many different courses and different shapes of weathered stone. In its place are bright machine-cut blocks of virtually identical size stretching for hundreds of feet. Near the entrance three arches are left open to provide a glimpse of the original: rough-hewn stone blocks of vast dimension, stained and flaking, each a different shape, piled irregularly one on another as if with huge effort.

So it is throughout: the overall shapes are the same but the details are all wrong. The entrance courtyard, stripped of its original decoration, now has one large mosaic made in 1967, a *Christ Enthroned,* done in an awkward, unsuccessful imitation of the Italo-Byzantine style.

The forecourt and inner cloister at the entrance to the basilica originally contained a score of life-size and over-life-size marble statues. All were made in Rome in the first third of the eighteenth century, shipped to Gaeta, and from there sent overland to the monastery. All the sculptors involved were sound, competent artists but none except Pierre Le Gros could be called a major figure.[13] After the war all the statues were "rebuilt," incorporating parts of the originals if any could be found, a piece of a leg here or a hand there, but in their present state they give little idea of the originals.

In November of 1714 Le Gros signed a contract to execute statues of Henry II, Carloman, and Gregory the Great, for which he was to receive 1,200 scudi (Enggass 1976, 128). At the time of his death in July 1719 only the *Gregory the Great* had been completed. Le Gros's widow, Marie Houasse, arranged to have Paolo Campi, his chief assistant, finish the others.

We know what the *Gregory the Great* looked like from a prewar photograph, here published for the first time (fig. 31). Though the statue must have been made with studio assistance — Le Gros was old by then and his health was failing — it still retains much of his characteristic flair. The aged saint looks upward with great intensity. His body is in gentle torsion, the hips turned one way, the chest another. His cloak, extended outward by his arms, surrounds his body with long, sweeping curves. Vigorous cascades of folds, recalling a Gothic tradition that French sculptors even in the eighteenth century were unwilling to give up, descend in abundance on the left. Beside these large emphatic curves Le Gros places as a counterpoint the light delicate rhythms of the tunic, which is made up of soft loose convolutions that change direction every few centimeters.

A new statue of Gregory the Great now stands in the place of Le Gros's. The modern sculptor obviously worked from a photograph of the original but the result is sodden and lifeless. Everything has been made simpler, heavier, stiffer, thicker. The crumpled contours of the soft linen tunic have been replaced, in the section above the waist, by large, parallel, vertical pleats. The cloak is now a stiff blanket awkwardly draped around the standing figure, who gazes out blankly.

Of the eighteen statues that were part of the original program, Paolo Campi made eight, far more than anyone else (Enggass 1974). They must have pleased the monks for in 1733 he was given the commission for two colossal marble statues to flank the great stairway in the forecourt: a *St. Benedict* and a *St. Scholastica,* completed in December 1735 (Caravita 1869–70, 3:519). Good photographs taken before the bombardment show that by this time Campi had abandoned his earlier attempts to imitate Le Gros's delicately modeled surfaces. He returned

instead to a pallid but not unpleasing version of the Roman barocchetto in which, in both figures, the heavy garments are activated by long slow shallow curves.

The first impression we receive, on entering the basilica as it is today, is probably not much different from what it would have been in the late seventeenth or early eighteenth century. The richest marbles, the most lavishly gilded surfaces (which Caravita noted with disapproval) are all back in place. Even the allegorical stucco figures in the spandrels, which are meant to be seen at a distance, are reasonably convincing. But when we look up into the nave vault and the spaces beside the clerestory windows, what we see are empty gray stucco panels set in heavy gold frames. All of the fifty-five frescoes by Giordano are gone. Gone too are the frescoes that were once on the vaults of the side aisles, and all the original frescoes and canvases that were in the lateral chapels, except for the one surviving altarpiece by De Matteis. Gradually the basilica is being filled with new paintings done in a more modern manner, but since these are placed within reconstructions of the old setting it is not a happy solution. In the four panels of the dome and in the pendentives beneath there are frescoes done in 1980 by Pietro Annigoni in a style derived from the Pre-Raphaelites together with faint overtones of surrealism. Still less adapted to their setting are the paintings by Steffanelli in the choir.

One more thing is new at Montecassino: the soldiers' graves. There are hundreds and hundreds of them, set in the valleys on the slopes of the mountain. Each nation has a separate site for its dead: Germans, Canadians, English, and Poles. As in military cemeteries everywhere the crosses are arranged in orderly rows in an absurd attempt to disguise the disorder of violent death.

1. The literature on Montecassino is large, extending back to the brief description given by Gregory the Great in the latter part of the sixth century. An excellent summary of the bibliography, including many unpublished manuscripts, is to be found in Pantoni 1972 and, for the period that concerns us, Della Marra 1751 and Caravita 1869–70. Della Marra discusses the subject matter of the paintings at great length, thus providing us with ample explanations of unusual and seemingly recondite themes. Caravita, who served as chief archivist of the abbey, makes available a large quantity of previously unpublished documents which often provide dates for previously undated works and frequently confirm the accuracy of Della Marra's attributions.

2. Dante, *Paradiso* 22.37ff., trans. Charles Singleton, Princeton, 1977, 1:248ff.

3. For St. Benedict see Schuster 1953. Virtually everything we know about him comes from Book 2 of the *Dialogues* of St. Gregory the Great (ca.540–604 A.D.). Gregory's information, in turn, comes from three of Benedict's immediate followers and is generally considered reliable.

4. A detailed description of the Romanesque basilica appears in Leone Marsciano's *Chronica monasterii cassinensis* which gives a history of the abbey up to 1075. The narrative was extended by Pietro Diacono up to the year 1138. The most recent study is D'Onofrio-Pace 1981. A brief but excellent summary that covers the whole history of the monastery is given by the present abbot in D'Onorio 1982.

5. Della Marra 1775, 159ff.; Caravita 1869–70, 3:273ff. The fresco, which was in the church, now no longer exists but perhaps a bozzetto or drawing will be found which will tell us more about this extraordinary subject.

6. The contract is given in full in Caravita 1869–70, 3:354ff. The names of the popes and the virtues are given in Della Marra 1751. However, since this book is rare and since the names, to the best of my knowledge, appear nowhere in the literature on Giordano, it seems worthwhile to list them here. The popes are: Gregory the Great, Aeodatus, Gregory II, Stephen III, Pascal I, Leo IV, Sergius IV, Gregory VII, Pascal II, Celestine V, Boniface IV, Agatonus, Zachary, Stephen IV, Gregory V, Leo V, Leo IX,

Urban II, Gelasius II, and Urban V. The twenty virtues in the triangular panels flanking the lunettes, whose identification is not without interest from an iconographical standpoint are, on the right side, Penitence, Vigilance, Prayer, Justice, Wisdom, Abstinence, Meekness, Peace, Meditation, and Magnanimity; on the left side, Discretion, Benignity, Innocence, Hospitality, Prudence, Patience, Zeal, Perseverance, Profession [of Faith], and Constancy. The virtues were all given appropriate attributes but could also be identified by their Latin names, written in letters large enough to be read from the floor. Some can still be made out in the photographs of the vault that were taken prior to the bombardment.

7. There is no mention of it in the contract of 1677 because it was paid for separately by Don Romualdo Apicella, one of the monks of Montecassino.

8. Della Marra 1751, 61ff. I have tried to summarize the material in Della Marra which, while extensive, focuses on the event in the life of the saint, not the way in which the artist represents it.

9. The vault painting in the chapel of St. Michael, a *St. Michael in Glory,* is given to Giordano by Ferrari-Scavizzi 1966, 2:281, following De Dominici 1742–45, 3:404, but to De Mura by Della Marra 1751, 65, who says the subject is Jacob's ladder.

10. Apart from the bozzetti which we have already discussed there were in the nineteenth century several small canvases, mostly half-length figures, attributed to Giordano (Caravita 1869–70, 3:252ff.) but these can no longer be traced. The monastery probably acquired them as gifts and sold them in times of need.

11. Della Marra 1775, 138 says that most of the paintings in the chapel were done during the rule of Abbot Penna (1697–1704). While Della Marra is not always reliable when it comes to dates, in this instance his information jibes with Caravita's.

12. Montecassino, Museum. There are at least three other painted versions of this event in Ratchis's life. One is at the Musée des Beaux-Arts, Toulon, another at the Museum of Fine Arts in Budapest and a third, closer to the Toulon painting, is at Washington University, St. Louis (Bologna 1958, 109ff.; St. Louis 1976–77, 77). Other bozzetti by Solimena for his paintings at Montecassino include: two paintings done for the chapel of St. Carloman: *Pope Zacharias Persuades Ratchis to Abandon the Siege of Perugia* (Bologna 1958, fig. 144) and *St. Willibald Blessed by Gregory III Before Carrying the Gospel to the Saxons* (ibid., fig. 145); and three more bozzetti for the paintings in the choir: *St. Maurus in France Miraculously Cures the Sick* in the Musée des Beaux-Arts, Toulon; and two more bozzetti at Budapest: *St. Maurus Healing the Sick* and *St. Placidus and His Family Slain by Saracens.*

13. Besides Le Gros there were Francesco Moratti, Paolo Campi, Pieter Verskefeld (from Liège), Lorenzo Ottoni, and Giovanni Maini (Caravita 1869–70, 3:495ff.).

THE FALL AND RISE OF
BERNARDO DE DOMINICI

Judith Colton

Bernardo De Dominici (1683–1759) was a specialist in *bambocciate*, roughly painted scenes of harbors, landscapes, and lower-class life. He was an artist whom even the all-inclusive Thieme-Becker dictionary calls "without significance." Without significance, that is, as an artist. As the biographer of other artists, however, and the author of the *Vite de'pittori, scultori ed architetti napoletani*, Naples, 1742–45, he was of the utmost importance for our present enterprise.

The renewed interest in Neapolitan art which has accompanied the spate of recent exhibitions has made it increasingly clear that we need a serious reassessment of Bernardo De Dominici's *Lives* of the Neapolitan artists. Ferdinando Bologna, the person who has probably done the most to lay the groundwork for such a reassessment, made a special plea in 1969: "It grows more and more necessary to point out that no scholar, ancient or modern, has attempted, along with the necessary stripping away [of fiction], to bring out and analyze the rich critical problems offered by the Neapolitan 'falsario'" (Bologna 1969, 7).

What are the problems brought out by De Dominici's *Lives*? How does the biographer carry forward a tradition founded almost two hundred years earlier by Vasari, and how does he depart from it? What issues are raised by his belatedness in that tradition and what links are there between this belatedness and other aspects of the cultural life of mid-eighteenth-century Naples? While I will not attempt to answer these questions here, I will suggest ways of proceeding toward answers. To begin with I shall briefly explore the literary conventions De Dominici utilized and then look at the biographer's extraordinary *fortuna critica*; finally I shall show how these things help us understand his treatment of some of the artists in the present exhibition.

The tradition Vasari founded in 1550 fused two entirely different ways of writing artists' lives. One had had to do with encomia, essays and books praising famous people, usually the author's fellow countrymen. One of Vasari's earliest aims was accordingly to glorify his native city, Arezzo. But for Vasari, of course, Florence had an even greater importance. In celebrating both his birthplace and his adopted city, Vasari attaches his *Vite* to a second tradition, that of the guidebook, or *cicerone*.

But by the time of his second edition, 1568, Vasari's mission had become enlarged. He now wished to provide historical sweep, to create, out of the varying amount of information

available to him, a true history of Italian art (Schlosser 1964, 311–12). Vasari's further goal was to present this history in the form of a logical construction (Previtali 1964, 7). To this end, in order to tell the full story, he allowed himself recourse to his inductive spirit, even sometimes to his own fantasy — in other words, to the writing of fiction (Previtali 1964, 12; Schlosser 1964, 312–13). This process of filling out a story is what Ernst Kris and Otto Kurz have called "history faking" (Kris-Kurz 1979, 24). Their example is Vasari's making Cimabue Giotto's teacher. The act "springs from the urge to provide a genealogy for the achievement [of] the great man who revived Italian art" (Kris-Kurz 1979, 24). Vasari's use of such genealogies provides something like aristocratic origins for an artist or school; what is being claimed is its "antichità del sangue," its "nobiltà" (Previtali 1964, 54). This remained a key issue in the seicento and settecento among authors who carried on Vasari's tradition.

De Dominici put himself squarely in this Vasarian tradition. In his introduction to the third volume of the *Vite* he speaks of Vasari as "a man not sufficiently praised for the untold value of his work, for the innumerable facts he has preserved for us about so many famous professionals in the arts, who were through his labor and diligence brought forth from the shadows where they were buried." But Vasari paid too little attention to the Neapolitan schools, De Dominici felt — hence his own book.

In the century following Vasari, Baldinucci and Malvasia are the two writers of artists' biographies who, it seems to me, prepare the way most directly for De Dominici. Whereas Baglioni, Passeri, Pascoli, and Mancini, to name only those, continued Vasari's practice of writing biographies, they did not carry forward his great historical scheme. They were basically chroniclers. Bellori, of course, was no chronicler, but his decision to speak only of certain artists according to predetermined criteria, to be highly selective and polemical, separates him from Vasari's, and De Dominici's, universalism. Only Baldinucci and Malvasia, in their period, created grand historical schemes. Schlosser, speaking of Baldinucci, makes the point that it is his "express intention to revive and continue Vasari on a broad modern base" (Schlosser 1964, 466).

Not surprisingly, then, De Dominici saw himself as continuing and in some sense correcting both Baldinucci and Vasari. Though he commends Baldinucci eloquently, stating that his *Notizie de'professori del disegno* is "worthy of the highest praise and immortal glory," he points out that Baldinucci could not include Neapolitan artists because like Vasari before him he lacked material. Again, De Dominici will make up for this. He is inspired to do so, he says, by three impulses: honor to the country, love of virtù, and, interestingly, zeal for truth. But Baldinucci may have been more than a model; De Dominici may at first have thought of him as a kind of collaborator — or, at least, he may have thought of himself as collaborating with the Baldinucci enterprise. After Filippo Baldinucci's death in 1696 his son, Francesco Saverio, aided by Anton Francesco Marmi, decided to publish the material that Baldinucci had collected but not used. This became three volumes printed in 1702 and 1728. In the manuscripts for this project examined by Ceci, it seems that De Dominici's interest was sparked by a request from Marmi for a life of Luca Giordano as well as more material on Naples. De Dominici sent two sets of *notizie* on Luca; and he replied that he would have ready the life of Preti as well as "molte

memorie" of Solimena, "pittor oggi celebratissimo" (Ceci 1899, 168; Petraccone 1919, 24–25; Willette 1986b, 258 and n. 38).

I have not yet spoken of Carlo Cesare Malvasia, the seicento biographer of Bologna's artists. If, as noted, De Dominici sets himself up in the lineage of Vasari and Baldinucci, he has at least as many affinities with Baldinucci's great rival, the author of *Felsina pittrice*. Malvasia deliberately sought to make up for what Vasari had left out and not only to put his native Bologna on the map but to give it a position of priority over Florence (and Rome). It was this latter claim that in part encouraged Baldinucci, the Florentine, to enter the fray. Malvasia celebrated Bologna's flowering in the seicento, of course, but he also demonstrated the aristocratic origins of the local school and gave it the *antichità del sangue* called for by the literary conventions he was invoking.

It is worth noting that the parallels I am making between De Dominici's book of the 1740s and two works of some sixty years earlier, Malvasia's and Baldinucci's, underline the seicento — that is, the retardataire — aspect, indeed the belatedness, of De Dominici's text. Is this belatedness a unique phenomenon in eighteenth-century Naples? Or, to put it another way, what else was happening in the 1740s that sheds light on the work we are considering?

One set of events, of course, surrounded the excavations of the buried Roman city of Herculaneum. These activities engendered great tomes by Baiardi and Mazzocchi which were far more than mere excavation reports. They sought to do nothing less than elucidate truths about the beliefs and ruling institutions of early man (Hersey 1983, 26–27). For these historians, as for the great contemporary philosopher Giambattista Vico, whose principles they were applying, strong patterns existed throughout history that all historical data made apparent. There was a definite succession of ages and institutions in all societies. Because of their belief in these preexisting structures these Vichian archaeologists, so to call them, considered themselves at liberty — indeed, bound — to supply any fact that might be missing but that was called for by the pattern. The process was little like reconstructing a sonnet from a set of sonnet fragments.

De Dominici's *Vite* were published beginning in 1742, on the eve of the third, fullest edition of Vico's great *Scienza nuova seconda* (1744). The ideas in this work had been in circulation for years, both in earlier editions and in Neapolitan intellectual circles. They had already informed the work of many of Vico's contemporaries. But the 1744 edition did not merely announce, it actually comprised the great patterned pageant that Vico saw in history. In other words it was "an attempt. . . at a comprehensive science of human society" (Bergin-Fisch 1970, xiii). De Dominici had more modest aims than this; yet he too, clearly believed in the patterns of the past. The idea of noble descent from father to son, master to pupil, in unbroken succession and leading through set cycles to a climax of artistic excellence, was one of his patterns. This I have traced back to Vasari but it was reinforced by Vico. Indeed De Dominici cites Vico as one of those who contributed to his book; and I shall continue in the following pages to link Vico's wish to "read the real world and the world of art as moral histories" (Hersey 1983, 2) with some of De Dominici's most central aims.

A further source or model for De Dominici's book lies in the most abundant of all the biographical literatures being produced in Naples at the time: the lives of the saints. Here there

was little enough *nobiltà di sangue*. But there was plenty of "fiction" of the kind for which De Dominici was to be berated. Romeo de Maio has written eloquently of these hagiographies (De Maio 1971, 157ff.). His description of them reads exactly like the accusations made against De Dominici: "As if the lessons of the Bollandists [who rewrote the lives of the saints from a rigorous scholarly viewpoint] had never been given, edifying biographies continued to be fabricated, utterly without recourse into sources and checking as to the authenticity of facts." Whatever their fictional content, these tales did observe conventions and patterns; the facts that were invented, like Vico's invented facts, were put in place, indeed, in order to embody those patterns. The miraculous workings of the saints, so to speak, become, in De Dominici, the miraculous works of artists. And, given the intensely religious, not to say monastic, nature of Neapolitan artists' sodalities, for example the Corporazione dei pittori (Strazzullo 1962), and given that Luca Giordano identified himself with St. Luke while Solimena dressed like a priest, De Dominici's use of saints' lives as models for the lives of artists is not inappropriate. Furthermore, historical fiction in eighteenth-century Naples was not limited to sacred litera- ture. In 1769–72 Giovanni Gravier published *Raccolta di tutti i più rinomati scrittori dell'istoria generale del regno di Napoli* in twenty-two volumes. These innumerable works, written over the past centuries and on into the eighteenth, do not hesitate to put long speeches in the mouths of long-dead kings and generals and are rife with invented incident.

Let us turn now to the problem of De Dominici's fiction, and to the lamentable *fortuna critica* that resulted from this fiction. We should keep in mind as we do so that there were clear parallels between De Dominici's reputation and the fortunes of the artistic school — Solimena's school — which he championed.

De Dominici's inaccuracy has absorbed the energies of his critics for the last 150 years and has disguised the other historiographical problems his work raises. The first to take up the cudgels was a pupil of Solimena's named Onofrio Giannone. Giannone was born in 1698 and was still alive in 1773. De Dominici himself tells us that Giannone was one of Solimena's most talented pupils, especially in matters of architecture and perspective (Ceci 1908, 620). Earlier he had studied with Paolo de Matteis. In the latter's studio he had copied works by De Matteis himself and those of other masters such as Preti and had made copies of antique statues of which De Matteis had plaster casts or copies. At some point Giannone prepared a manuscript with the title "Ritratti e giunte sulle vite dei pittori napoletani raccolti e dati in luce da Onofrio Giannone pittore napoletano." This was preceded by a letter to his readers in which he directly attacked De Dominici. In it, Giannone speaks of "forged manuscripts" and calls for a return to historical tradition. He adds that De Dominici's work is uncritical, gossipy, and full of inventions (Percy in Cleveland 1984, 3). But Giannone himself lacked the weapons, both intellectual and practical, to carry out his attack. And he is absurdly anti-Solimena, underplaying that great artist's achievements and accenting his avarice. He adds that Solimena never praised his pupils and was jealous of their success. Perhaps we have here the explanation of Giannone's venom, at least as far as his old teacher was concerned.

Although it was not published until 1941, Giannone's manuscript was read by certain nineteenth-century scholars. Most important for us, it was known to De Dominici's next

important detractor, Luigi Catalani, who wrote in the 1840s. Yet, for nearly one hundred years, with two minor exceptions, Giannone stood alone. In 1788, Angelo Comolli criticized De Dominici's accuracy, methodology, and critical integrity (Percy in Cleveland 1984, 29n. 11; see Comolli 1788–92, 2:244–53). And Giuseppe Maria Galanti, in his *Breve descrizione della città di Napoli* of 1792, regretted that De Dominici did not include "more information, better method, [and] fewer words" (Galanti 1792, 253n. 1; cited by Percy in Cleveland 1984, 3). Indeed, during this period, De Dominici was cited widely in descriptions of Naples, biographies of southern Italian artists, and in both general and more specialized histories (Ceci 1908, 618). Lanzi based his history of the Neapolitan School almost exclusively on De Dominici, as did Cicognara, Seroux d'Agincourt, Kugler, and Perkins after him (Croce 1892, 140). Guidebook writers like Napoli-Signorelli found what they needed in the *Lives* for their shorter summaries. Not only was De Dominici cited, he came in for a considerable amount of praise for his research and diligence (Croce 1892, 140). In 1840, introducing a reprint of the *Vite,* the prince of Cassaro listed the main reasons for the biographer's fame. The first was "his respect for veracity," and the second, less controversially, was "his warm love for his country" (Croce 1892, 141).

But by the time this edition of De Dominici appeared in print in 1846, De Dominici's achievement had come in for harsh criticism from a Neapolitan architect and a Scottish archaeologist. In 1842, Luigi Catalani, professor at the Real Istituto di Belle Arti, wrote a *Discorso sui monumenti patrii* in which he offered an overview of the artistic patrimony of the kingdom of Naples. He criticizes De Dominici's book, whose title he gives as *Vite de'professori del disegno napoletani* (a curious conflation, speaking of the "respect for veracity," of Baldinucci's and De Dominici's titles, and of the latter's dedication of volume 3). He also prints a long letter written in 1840, presumably to him, by his Scottish friend George Cuming Scott, a member of the Archaeological Academy of London. The story of the arts in Naples has not yet been written, Cuming Scott claims. The voluminous work of De Dominici is only a little less "favolosa" than Ovid's *Metamorphoses.* Catalani then devotes most of the rest of his *Discorso* to pointing out errors and discrepancies in De Dominici's biographies, especially those devoted to the earliest artists and architects.

Benedetto Croce discusses some of the minor critics of De Dominici who come along after Catalani, notably Bartolommeo Capasso and Nunzio Federico Faraglia. I will turn to Faraglia, who wrote two long articles in 1882 and 1883 (and who actually introduced the idea of De Dominici as a "falsario," a falsifier or even forger), and to Croce himself. In the first of his articles Faraglia paraphrases De Dominici's sketch of the noble origins of the Neapolitan school, beginning with the artists commissioned by Constantine the Great to decorate churches in Naples: artists such as Pietro and Tommaso de Stefano, born ca.1230, and finally in the fifteenth century Colantonio, who, we are told, outdid them all. But De Dominici's aristocratic succession only reminds Faraglia of the fictitious accounts of noble families establishing descent from the Argonauts, the Seven Against Thebes, or the heroes of Troy. Faraglia accuses De Dominici not only of inventing names and facts but of adding uncertainty and confusion even to his inventions (Faraglia 1882, 342). De Dominici is referred to as "il falsario" on every page and occasionally even as "il ciarlatano" (e.g., Faraglia 1882, 351). And the many names of artists that

fill De Dominici's pages constitute only "il solito miracolo della moltiplicazione dei pittori" (Faraglia 1883, 91). Faraglia concludes: "This discourse is an argument against De Dominici and 'i dominicani.' My aim was to show how history, as it is found in documents, is entirely different from the story De Dominici has woven together. The result is a true dilemma: either De Dominici has invented, or the documents lie" (Faraglia 1883, 284; cf. also Willette 1984 and 1986b, 256, 261).

A decade later, Croce wrote an article on De Dominici entitled "Il falsario," repeating and enlarging on Faraglia's attack. This article, it seems to me, plays a more crucial and complex part in the perception of De Dominici than has hitherto been brought out. Its ostensible purpose is to bring to light the full extent of De Dominici's falsifications — to expose the "poisoner of the sources [or wells — *fonti*] of this history" in order to clear the way for the proper treatment of the art of his beloved region. Why is Croce's anger so vehement? This is not a question I can really answer here; but I would like, in summarizing the main points of the article, to point to ways in which the great Neapolitan writer undercuts his own argument and sets the stage for De Dominici's rehabilitation.

Unlike earlier writers on Neapolitan art such as Capaccio, d'Engenio, and Celano, says Croce, who are "scrittori di buona fede," De Dominici is a kind of demon who laughs at his readers behind their backs. Yet even before he gets to the business of demolishing De Dominici, as he puts it, Croce has a lot to say about the biographer that makes him seem rather admirable: first of all, De Dominici's response to Vasari was much more effective than that of the writers just mentioned (Croce 1892, 125). As to his sources, that is, the manuscripts De Dominici relied on, often questioned than as now (Willette 1984), by Giovanni Agnolo Criscuolo, Massimo Stanzione, Paolo de Matteis, and also as to the viva voce testimonies by living artists, Croce does not, like Faraglia, simply dismiss all these as imaginary. He makes them part of what he calls a "meravigliosa costruzione" (Croce 1892, 125). Ironically, yet with a relish that betrays a certain complicity, he re-presents the "noble patterns" and genealogies of artists, fictional and otherwise, with which De Dominici had populated the history of Neapolitan art. "O dolce spettacolo!" he cries, adding that De Dominici thereupon attributes all Neapolitan architecture, sculpture, and painting visible, or once visible, to these artists. It is an exercise in sympathetic hostility. With it, Croce thought he had sounded the death knell for De Dominici's reputation.

Antonio Filangieri di Candida expanded Croce's method of attack in 1898, showing how De Dominici was in touch with his artists at each moment of their lives, penetrating to the depths of their souls, scrutinizing their most recondite thoughts, and making them speak, act, love, and hate — moving them, in fact, like a company of marionettes on a great stage which begins in the thirteenth century and ends in the eighteenth (Filangieri 1898, 172). (Though meant pejoratively, this is not far from what De Dominici thought a historian was supposed to do.)

But, operatically, just at the point of death, De Dominici began to undergo an unexpected reanimation. Enzo Petraccone, a friend of Croce's who was killed in World War I, was the author of a posthumously published book on Luca Giordano. It is a serious attempt at rehabilitation. Petraccone begins with an allusion to the grand historical tableau: the hierarchies of masters and disciples, whether fictional or real, have after all provided an organic history of

Neapolitan art, without gaps, without a doubt or an uncertainty, written in the pompous style of the settecento, exacting admiration, cited, stolen from, ever afterward. And yet "after all the discredit and all the ridicule thrown on De Dominici, personally and as an author, to defend him and to use his book could seem a risky and dangerous undertaking" (Petraccone 1919, 20). Petraccone adds that although De Dominici did most of his inventing when writing about the older artists, about whom nothing is known, unquestionably there is conscious fiction in the lives of the more recent artists, too. A partial explanation is the biographer's powerful affinity for the dramatic and the romantic. Another equally partial but equally likely explanation is that De Dominici must have been given all sorts of contradictory and fantastic information which often was neither confirmed nor provable. In some cases, of course, this information did turn out to be true. Indeed, Petraccone adds, so much that De Dominici says about recent artists is correct that he cannot be called a falsifier. And his final comments clinch the matter: "On what foundations could the study of the history of Neapolitan art be based if we were deliberately to decide that we no longer believed in De Dominici?" (Petraccone 1919, 22).

Bernardo
De Dominici

De Dominici's practice of interspersing invented information with actual facts was not unique; indeed, it was common among his predecessors. Julius von Schlosser, writing first in 1924, has a lot to say about this with regard to Vasari:

When it comes to the problem of Vasari's veracity we must never forget the origins of his work, already discussed, and his point of view. To do him justice we cannot, as would be natural, . . . apply the standards of a modern historian, but rather those of the older art history or even of the technique of the historical novel. When he is guilty of what to us moderns appear to be falsifications of history . . . we cannot prove that this was done in bad faith or as a form of conscious lying; rather, he shaped his material as seemed best to him for his special aims, aims that were very different from modern ones (Schlosser 1964, 307).

On Malvasia Schlosser is even more forceful: "With such a fiery writer extreme prudence is certainly necessary. Suspicion of explicit falsification of sources weighs on him as on the Neapolitan fabulist De Dominici" (Schlosser 1964, 530). Yet Malvasia, even if we agree with those who hold that he invented a document (Enggass-Brown 1970, 86–87; Grassi 1973, 2:48), like Vasari, is hardly criticized at all.

Why, then, has De Dominici been singled out? After all, he would have known the artists of his day much more intimately than Malvasia had (even though Malvasia had done some painting: cf. Enggass in Malvasia 1980, 19). De Dominici was an integral part of the art scene he wrote about. He had, we recall, a connection to Solimena's studio; and his father had been close both to Preti and to Giordano. Yet Schlosser says of him,

The phenomenon we have already observed in the learned Malvasia repeats itself here in an almost grotesque manner, under the splendor of the South Italian sun. . . . De Dominici is in fact a falsifier in grand style, a Tartarin of the literature of art, who forthrightly invented entire artists out of nowhere and enveloped, for the greater glory of his city, the history of older art in Naples in a scandalous web of lies, whose stitches are only beginning to be unraveled in modern times (Schlosser 1964, 533).

Interestingly, Schlosser closes by reassuring us that De Dominici offers invaluable contempora-

neous material. This final statement opens the way for an attitude toward De Dominici which takes into account the different treatment he accords more recent masters from that given to artists of the distant past.

It was not for another thirty-five years that Petraccone's challenge, to reread De Dominici *in forma positiva,* was taken up. In 1958 Ferdinando Bologna wrote in his monograph on Solimena,

The critic of things Neapolitan who continues to amuse himself with the idea of De Dominici as an inventor of fairy-tales and a falsifier has completely missed the opportunity to appreciate the real merits of his work. It is certain that as long as we continue to demand scientific correctness of this historian, and the scrupulosity of an archivist, and even footnotes, as well as the record of the times that he himself lived through, we cannot expect to receive much illumination from his book. But when we understand that, often, these inventions and apologias are in a certain sense psychological allegories in the style of the artist the historian describes, and when, above all, we decide to listen to that voice when it is in immediate reaction to a work of art, then it will be impossible to deny De Dominici his proper place in the esteem of modern criticism (Bologna 1958, 158–59).

Bologna was of course primarily interested in De Dominici as the biographer of sei- and settecento artists — of artists, that is, who were more or less De Dominici's contemporaries, some of whom he actually knew in person and in any case about whose existence there could be no doubt. Eleven years later, however, he took on a more difficult and more controversial task. Now he set out to look back over the whole of De Dominici's achievement, not just the biographies of recent artists, to see if "beyond the fabric of inventions there were not some convincing critical discourse" (Bologna 1969, 5).

Bologna builds on a notion put forward in 1584, ironically enough, by a Florentine writer, Leonardo Salviati, in a dialogue called "Il lasca." Addressing the issue of rhetorical ornament, Salviati declares that "lies are permitted insofar as they seem more useful than the simple truth, because the historian, like the poet, must aim at the depiction of men as they ought to be" (Bologna 1958, 5; Schlosser 1964, 304; Bologna Forthcoming [for which I am grateful to Nicola Spinosa]). De Dominici, by allowing lies and truth to coexist, shows especially the early, more fictional artists not as they were but as they should have been. He arranges them within noble genealogies.

Bologna's contribution was reinforced in 1972 by Mario Rotili in *L'arte del cinquecento nel regno di Napoli.* Rotili's discussion of De Dominici is actually fuller than Bologna's of 1969 (Rotili 1972, 15–19 and relevant bibliography). And another Neapolitan writer, Felice de Filippis, brought out an annotated but incomplete edition of the *Vite* in 1970. De Filippis also discusses another detractor, Ulisse Prota-Giurleo. As late as 1955 Prota-Giurleo had lashed out at De Dominici for relying on documents purportedly by Massimo Stanzione, Paolo de Matteis, and others, which he, Prota-Giurleo, considered to be forgeries (Prota-Giurleo 1955, 25, 31; cf. Willette 1986b, 255ff.). As De Filippis puts it in his introduction, "Giurleo wanted De Dominici dead"; we are told he needed only to hear De Dominici's name mentioned and this mild-mannered man became a wild beast (De Filippis 1970, 10). But today the very

documents that seemingly incriminated De Dominici are being reassessed with interesting results by an American scholar, Thomas Willette.

De Filippis's introduction also constituted the first attempt I know of to look at De Dominici's intellectual milieu and the ways in which some of his close associates might have had a part to play in the evolution of his manuscript. He mentions Giuseppe Valletta, Matteo Egizio, Vico, and others. (De Dominici's circle has also been studied by Willette [1986a].)

Another, and a formidable, defender is Roberto Pane. In 1977 he contributed an introduction to a new edition of Catalani's *Discorso sui monumenti patrii.* He writes, "As noted, the subject [of De Dominici's falsehoods] has been discussed and re-discussed so often that people have become satiated. Nor would I be right to take it up again had not Bologna, in his *Francesco Solimena,* advanced a total rehabilitation of De Dominici, recently discussed by Rotili" (Pane in Catalani 1977, 9). Pane talks about "the trial" of De Dominici in *Napoli nobilissima.* It seems curious to Pane that a historian as acute, prudent, and ironic as Croce could in fact have been blind to De Dominici's real qualities. In any event, Pane asks, how could Croce have adopted Faraglia's word "falsario," a word used for forgers of paintings and sculpture? De Dominici was no forger, he argues, but a mythomaniac, a storyteller. He may, as Pane suggests, have exaggerated more than most; nonetheless, he and practically all other historians of that age were spinners of tales. The thing to do, then, is to understand the conventions that forged these tales.

Ann Percy brings out another of De Dominici's positive aspects. In the catalogue of the Cavallino exhibition held in 1984 she writes, "De Dominici's *vita* . . . is the single attempt at an extensive treatment of Cavallino's artistic personality before the twentieth century. While it should be used with care, it offers a certain amount of biographical information and, more interestingly, a provocative assessment of the artist's formation and of the market situation within which his style matured" (Percy in Cleveland 1984, 3). More significant still, she adds, "De Dominici's sources may be suspect or obscure, his facts occasionally wrong, and his anecdotes embellished, but his perception of Cavallino's art, when held up against the paintings themselves, works" (Percy in Cleveland 1984, 5). This is an important point, one that so far as I know previous writers on De Dominici have missed: his sense of style, his actual discussion of the paintings, is superbly visual. He helps us immensely to see this art as his century saw it.

More recently still, we are witnessing reversals, or at least partial reversals, on the part of scholars once openly hostile to De Dominici. A case in point is John T. Spike. In his Ph.D. dissertation on Preti, written in 1979, he sets out to treat the artist "without recourse to De Dominici" (Spike 1979a, 3) or, at least, with recourse to him "only in instances where his information contributes a valid explanation for what is otherwise known" (Spike 1979a, 18). Building on Croce, Spike explains that the biographer "blurred the distinction between history and mythology." Further, he "carefully assembled authentic tradition and known facts and wove them into a single narrative using fictitious connectives and embellishments" (Spike 1979a, 17). Placing himself in the detractors' camp, Spike "retire[s] Bernardo De Dominici as historian" (Spike 1979a, 11). In a lecture given at Yale in January 1986, however, he modified his attitude somewhat. Spike emphasized that De Dominici's *Vite* had great value for the study of artists who were strictly his contemporaries. He also suggested that De Dominici might have

been the *porte-parole* of Solimena. But he continued to deny to the settecento biographer the status of historian in the sense that Vasari was one. The fact that "a breathtaking percentage of De Dominici's accounts are imaginary" is still a source of frustration and even amusement.

I will end by going back to a point introduced at the beginning, this time to illustrate the sort of positive reading of "dominican" mythology I have in mind. There are certain conventions — encomiastic, ciceronic, hagiographic — in De Dominici. I propose now to look at a few passages bearing on artists in the present exhibition that illustrate his use, in particular, of the ecomiastic convention. I have in mind the tension De Dominici habitually sets up between rivalry and praise, or better still what we might call the rivalry of praise. In his chapters on Preti, Giordano, De Matteis, and Solimena, De Dominici includes a "life within a life." These are passages about a given artist purportedly written by a contemporary or immediate predecessor, indeed often one of the subject's fellow artists, who could be seen as a rival. In these passages, De Dominici seems to use the authority of others to supplement, or reinforce, or occasionally to contradict, what he himself has said. They are strategically placed. They are used to say things not only about the person whose life we are reading but about the author of the inserted text.

Let us look at the life of Preti. At the end of his own detailed account De Dominici brings in the opinions of Paolo de Matteis and Solimena. In each case he first calls on the artist to help him reinforce the point he is making and fill out his assessment. De Matteis is first mentioned in a passage (De Dominici 1742–45, 3:384) in which De Dominici describes Preti's heroic style and speaks of his *terribilità*. It is about the power of the artist to move the spectator by starting with correct drawing, perfect chiaroscuro, and nobly conceived parts. These were brought together in a heroic mode appropriate to magnificent and especially tragic subjects, for which Preti had a particular genius. De Dominici goes on to say that the artist calculated expression so accurately that when he stirred up the passions he caused terror in his audience. "As our Paolo de Matteis wrote of him . . . this is the reason that it is nearly impossible to imitate him."

Then, in what follows, De Dominici appears to be speaking alone. But Bologna, Spike, and others have convinced us that the biographer is also the spokesman for Solimena in such passages. In any case De Dominici criticizes Preti's handling of women's physiognomy, which he characterizes as "rozza" and ignoble. Yet even here he attributes this opinion also to a third painter, Luca Giordano (De Dominici 1742–45, 3:348). And De Dominici himself finds fault with Preti for not having studied classical sculpture, especially during the time he lived in Rome. De Matteis shared De Dominici's views on this latter subject, though he put them somewhat differently. These views reappear in "lo scritto di Paolo de Matteis," which De Dominici cites in full (see biography of De Matteis by Evonne Levy below).

In short De Dominici establishes a dialogue between the two contemporaries, De Matteis and Solimena, often considered to be rivals, a dialogue that is about Preti, and then joins the dialogue himself. Such dialogues or discussions among real and imaginary characters who voiced set viewpoints, styles, and philosophies represented one of the established Renaissance literary modes. The form was employed by Vasari in the *Ragionamenti* and, closer to our period, by Ludovico Dolce, to name only two.

If De Dominici seems to convey Solimena's views without saying so, at certain times he makes direct reference to the ideas of his hero. For example De Dominici has Solimena say that Preti is a beacon for later painters, a notion we can be sure De Dominici shared. "How accurate is the sentiment of our famous Francesco Solimena," we read in De Dominici, "whom I heard several times say these words: 'he who follows in the footsteps of the Calabrese cannot lose his way, because he is guided to perfection by the secure path of truth'" (De Dominici 1742–45, 3:372).

Toward the end of the life of Preti, Solimena is brought in again. This time he is called upon to help resolve an inconsistency. If Preti was the forceful artist whose work could crush because of its terribilità and could overwhelm the spectator by its magnificence and intensity, he was also the painter who ignored the antique and whose figures consequently lacked correctness in drawing and physiognomical beauty. According to De Dominici, furthermore, Solimena was Preti's disciple. Thus the younger painter, more than other painters who were not his disciples, could speak of Preti's "bella maniera" and superb chiaroscuro, but also of the defects in Preti's art. Solimena, after all, was not called the "Cavalier Calabrese nobilitato," that is, an *ennobled* Preti, for nothing.

The dialogues in the *Vite* are full of these encomiastic rivalries. (An encomium, basically, is a hymn to a victor.) And these confrontations between artists emphasize the genealogies, the *nobiltà di sangue,* the master-to-pupil cohesion of a historic pageant that has its grand climax in Solimena. But well before his life of Solimena comes along De Dominici prepares us for it by describing another artist who venerates, yet outdoes, Preti. In the life of Luca Giordano we learn of Luca's attitude toward a whole range of earlier artists associated with Naples, among them Andrea Vaccaro, Beinaschi, and Francesco di Maria. However, Giordano has much more to say about Preti than he does about the others, and what he says is far more laudatory. "He [Luca] had a great deal of esteem for the Cavalier Calabrese," we read, "and was in the habit of saying that his compositions evoked Veronese, and his drawing made one think of Guercino, but now with 'perfettissimo chiaroscuro'" (De Dominici 1742–45, 3:437).

One example of De Dominici's praise-dialogues is the tale of San Pietro a Maiella told in George Hersey's essay on Preti in the present catalogue (De Dominici 1742–45, 3:437). In another such dialogue Luca comes upon his disciple Antonio di Simone copying a drawing by Preti and remarks that this was "the true method of drawing, because of its perfect contours and excellent chiaroscuro." Luca adds that if this disciple were still young enough and still needed it, only in this way — Mattia's way — would he have learned to draw (De Dominici 1742–45, 3:437). At the end of his life of Giordano, De Dominici has Preti return the compliment, so to speak. This was in a comment made to Bernardo De Dominici's father Raimondo, in Malta, by Preti at the very end of his life, about Raimondo's present master. Mattia, engaged in painting a cloud ("aria") in one of his canvases, announces to the elder De Dominici, "Your Luca Giordano painted these clouds and bursts of light excellently, having in this respect imitated the great Paolo Veronese and Pietro da Cortona." Thus does Preti's highest praise evoke Luca's own most significant heroes. Another example of praise-rivalry is Paolo de Matteis's self-portrait (cat. 30), which, as Carmen Bambach Cappel points out in her entry, praises Luca Giordano

*Bernardo
De Dominici*

67

praising Rubens. By acknowledging Preti's greatness, Luca's own greatness is enhanced. Bernardo De Dominici might have been exploring his father's career with the idea of building a case for Raimondo's pivotal role as well. Raimondo, we recall, was a pupil first of Mattia's on Malta and then of Luca's in Naples, and he was certainly in a unique position because of this double allegiance, a benefit which extended, of course, to his son.

Still another praise-dialogue occurs in Paolo de Matteis's account of Luca Giordano, which De Dominici quotes in the chapter on De Matteis and not in that on Giordano. The fact that De Matteis has written about Giordano, at one point his teacher, not only redounds to Luca's glory but to Paolo's own. The implication is that Paolo's exquisite judgment of Luca's work is as indicative of the former's talents as are his paintings. And, we know, Paolo's paintings indeed, *were* often tributes to Luca (cf. cat. 28). De Dominici's further, more subtle point is that if De Matteis was talented, he was not quite as talented as he himself liked to think. But he was gifted enough to recognize Luca Giordano's superior gifts, and this augmented Paolo's prestige. This of course is De Dominici's agenda for himself as well. As Bologna remarks, De Dominici is writing psychological allegories in the styles of the artists he describes. This has two meanings. It means that in De Dominici's dialogues each painter speaks, in the way that he paints, about how he or some other artist paints. And it also means that De Dominici has written his book as a whole in the style of its period — in the style, that is, of a belated Renaissance dialogue among real and imaginary artists who express their *nobiltà di sangue,* their encomia, in conformity with the moral patterns that De Dominici and his contemporaries derived from history. It was a contribution to what Vico called the *storia ideale delli nazioni,* a history of the highest rather than the lowest truths.

THE CRITICAL FORTUNES
OF NEAPOLITAN PAINTING:
NOTES ON AMERICAN COLLECTING

George Hersey

Neapolitan seicento and settecento artists played an auspicious role in the first tentative appearances of European art in North America. It is an irony that, for various reasons, we cannot include some of the finest of these pictures in our exhibition. But at least some of them can be illustrated and a word said about their place in the history of North American collecting. For instance in 1815 four works by Corrado Giaquinto, made for the Neapolitan church of San Luigi di Palazzo, were sold in Naples. Subsequently — just when we do not know — they entered the Curtis Collection in Boston, Massachusetts.[1] These depicted the *Marriage of the Virgin,* the *Visitation,* the *Purification,* and the *Rest on the Flight into Egypt.* They are still among the finest Giaquintos on this continent and are presently in public collections in Cambridge, Massachusetts, Pasadena, Montreal, and Detroit (Cioffi 1980 and in Detroit 1981, 1:109ff.). Since they have so recently been shown in a major American exhibition (Detroit 1981), it was supererogatory to display them again.

In 1820 another magnificent Neapolitan picture appeared on these shores, the Luca Giordano now at Georgetown University (fig. 32). This work, *The Calling of St. Matthew,* was acquired by Richard Meade, an American businessman who lived in Cádiz from 1804 to 1820 and who there brought together a "gallery" of pictures that was later on public display in Philadelphia.[2] The painting is without doubt the finest Giordano in North America, and it is a pity that it is too large to be moved. It would be a useful project for future research to trace the fate of the other pictures in Richard Meade's gallery. As far as I can tell (since we do not know precisely when the Curtis Giaquintos arrived) the Meade Giordano is the earliest identifiable Old Master painting in the United States.[3]

Other Italian and Neapolitan seicento and settecento pictures came to this country as royal or papal gifts to newly founded Roman Catholic parishes. Thus in 1827 Fr. Bertrand Martial traveled from Bardstown, Kentucky, to Naples seeking pictures from Francesco I, the Bourbon king of the Two Sicilies. He received six. Five of them, a *Coronation of the Virgin,* a *St. Bartholomew,* a *St. John the Baptist,* a *Winged St. Mark,* and a *St. Peter in Chains,* hang today in the Bardstown cathedral. The last three may be attributed to Mattia Preti's shop. The *St. Bartholomew,* though much repainted, could conceivably be from Preti's own hand.[4] Finally, four early nineteenth-century Italian or French neoclassical pictures were sent from Rome to the cathedral

in Bardstown by Pope Leo XII (Bardstown [ca. 1945]). Several paintings were also shipped to the new cathedral in St. Louis, one of them possibly by Charles-Antoine Coypel. These represent the first appearance on United States soil of European paintings on regular display in public buildings (Foucart-Walter in New York 1982, 382).

So far — we are now up to about 1830 — of the known Italian pictures publicly exhibited in the United States, a considerable number were Neapolitan and most were in liturgical use. This fact will have considerable importance in the future critical fortunes, in America, of Italian sei- and settecento art.[5] It is also reflected in the present exhibition, where religious subjects predominate.

After these sporadic events comes a long lull. It is easily explained: Richard Meade acquired his Luca Giordano at a time when that artist still enjoyed a high reputation. Francesco I sent paintings associated with Mattia Preti to Bardstown because Preti, too, was in the 1820s considered one of the great European masters. Throughout the eighteenth century and well into the nineteenth leading artists had considered these men their noble predecessors. Thus Sir Joshua Reynolds, president of the Royal Academy in London and the most important British art theorist of the eighteenth century, praised any number of major (and minor) Roman and Bolognese artists in his *Discourses,* especially Guido Reni, the three Carracci, Carlo Maratta, and Pompeo Batoni.[6]

In America those few who, in the early nineteenth century, were writing on European painting expressed the same esteem for the Italian painting of the previous two centuries. William Dunlap, author of *A History of the Rise and Progress of the Arts of Design in the United States* (1834), quotes with great approval Washington Allston's admiration for Ludovico Carracci: "I will mention here a picture . . . which then took great hold of me, by Ludovico Carracci. I do not remember the title, but the subject was the body of the Virgin borne for interment by four apostles. The figures are colossal; the tone dark, and of tremendous depth of color. It seemed as I looked at it as if the ground shook under their tread, and the air was darkened by their grief."[7] The picture Allston refers to is no doubt the *Funeral of the Virgin* now in the Galleria Nazionale, Parma.

But the prestige of Italian seicento figure painting was already doomed when Dunlap wrote. For decades a body of criticism had been building up that was deeply antithetical to seicento ideals: Neoclassicism. Its presiding genius for the figure arts was the great early archaeologist and connoisseur Johann Joachim Winckelmann. And Winckelmann had a long train of increasingly antibaroque followers lasting well into the nineteenth century. One was Giuseppe Nicola D'Azara, who wrote a biography of the painter Anton Raphael Mengs (D'Azara 1783). For D'Azara Neapolitan seventeenth and eighteenth-century painting is possessed of three great faults: 1) it has many unnecessary figures; 2) it has unreal flesh tones; 3) there is willful copiousness of incident and setting. Neoclassicism was to a considerable extent an attempt to root out these qualities, to "paint in a way coherent with [the subject's] assumptions, and provide only the necessary figures, with nothing otiose, nothing contorted, nothing carica-tured" (D'Azara 1783, 1:79; Volpi 1958a, 264ff.). If we compare Corrado Giaquinto's art to that of Mengs we see what these statements mean. Mengs was not really the Neoclassicist D'Azara makes him out to be, but he did more to obey D'Azara's conditions, certainly, than Giaquinto

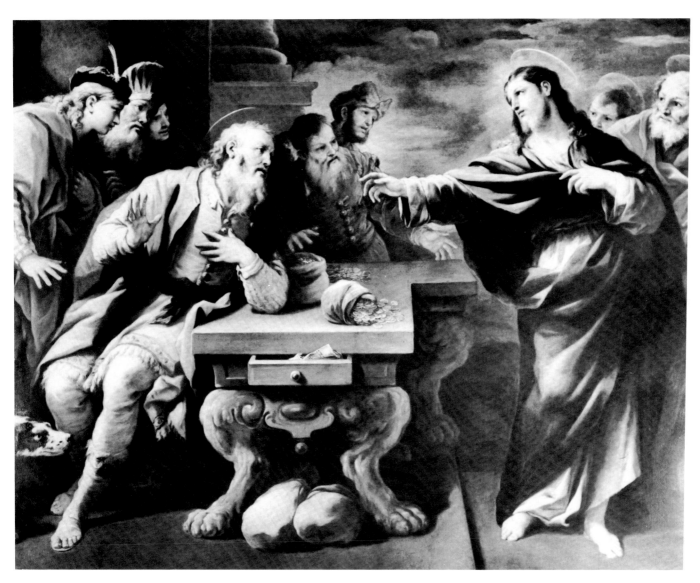

FIG. 32. Luca Giordano, *The Calling of St. Matthew*, Georgetown University Art Collection, Washington, DC

did. Thus in Mengs's *Apotheosis of Hercules* in the Antecámara de Gasparini in the Palacio Real, Madrid (after 1760), the Apollo strikes the pose of the Apollo Belvedere, a favorite model for Neoclassicists, and other figures come out of the classic phases of the High Renaissance. The mood is Raphaelesque; the drawing is very clear and there is no distortion in any pose. In Giaquinto's vault modello for Santa Croce in Gerusalemme (ca. 1744; cat. 42) the figure of St. Michael does not come from the antique, and the heretics he strides over are in wildly contorted poses. Figures constantly overlap and join, which often results in massings of limbs and heads; Giaquinto looks back more to Michelangelo than to Raphael, and the space, whether architectural or landscape, is extraterrestrial, a cosmos of pastel clouds supporting figures in dancing clusters.

But the downfall of Giaquinto and his predecessors was more than a matter of changing tastes. In the course of the nineteenth century Neoclassicism itself waned. A more fearsome enemy of the seicento and settecento was religion. Religion attacked, moreover, from both the Protestant and the Catholic sides. In the Catholic world the phenomenon can be ascribed to the liturgical revival, the nineteenth and twentieth-century renewal of interest in the Church's medieval customs and ceremonies (Koenker 1954; cf. his bibliography, 247ff.). Normally, in Catholic Europe, this revival is dated from the appearance in France of Dom Prosper Guéranger's *L'Année liturgique* in 1840. Guéranger's main achievement was to bring back medieval plainchant in churches. But along with this he and his followers and successors in France and other countries restructured the musical, ceremonial, and visual accoutrements of the mass. And ultimately they restructured the church buildings that contained the mass. They fought against the operatic service music inherited from Handel, Bach, Mozart, and Rossini, against seicento vestments, against the more extreme Counter-Reformation cults of tortured saints and, obviously, against the embodiments of all these things in religious pictures and statues. The preferred style was a mixture of neomedievalism and Neoclassicism. Oil paintings were frowned on. The liturgical revivalists wanted stained glass, not altarpieces, elaborate furniture, not sculpture, and Gothic architecture, not classic or Renaissance. In short, the so-called Catholic Revival, which eventually triumphed almost everywhere except in Italy and Austria, was an attack on seicento piety. The majority of the pictures in the present exhibition represent a kind of painting that was regularly excoriated by Catholic reformers from the 1840s onward.

In England the same thing happened, among both Catholics and Protestants. Thus the Catholic Augustus Welby Pugin, like Guéranger, denounced paintings and statues of saints and angels in "indecent costume" and the practice of exhibiting "the human figure after the manner of an opera dancer . . . half-naked in a distorted attitude." He caricatures Correggio's Parma *Assumption* to make the point (fig. 33; Pugin 1843, 24ff., 44ff.). This archaizing sensibility was taken over by the Protestant Ruskin and his innumerable followers. And they applied it not just to religious art but to all art.

John Ruskin was a unique figure. He was the first art historian — and he may well turn out to be the last — who was also a major literary influence, a best-selling author, and in the end a venerated seer of the stamp of Carlyle or Tolstoy. He had tens of thousands of readers and was an immensely popular lecturer. His decrees on taste are so absurd that today we can only laugh.

FIG. 33. A. W. N. Pugin,
Caricature of Correggio's Parma
Assumption. From Pugin, *An
Apology for the Revival of Christian
Architecture*, 1843

Yet he is still important: every year several books on him are published. Ruskin's decrees were obeyed not only by the art world, but by disciples who have ranged from Proust to Pater to Berenson to Mahatma Gandhi. They also, for that matter, included some of the founders of the Yale University Art Gallery. (Perhaps that explains why this is the first exhibition of Italian seicento or settecento art held at Yale.) Ruskin was among the first properly to appreciate the beauties of the trecento and quattrocento, and did much, for example, to reilluminate the works of Giotto and Fra Angelico. But at a price: for every promotion in rank these earlier painters received, their seicento successors were proportionately demoted. Indeed, Ruskin's books have one great theme above and beyond their praise of early art. That is the Jeremiah-like denunciation of the seicento; the revelation of what Ruskin considered its sick sensuosity, its melodrama, its falsity and superstition, its popery (Stein 1967, 141 ff.).

Ruskin began writing in the late 1830s. By the 1860s, it is not too much to say, Italian seicento art was despised far more in England and America than on the Continent. But the change is apparent everywhere. Let us look at prices. Solimena was considered a major painter in the eighteenth century. In 1757 a Solimena *Apollo and Daphne,* 29 x 24 inches, sold in France for 1,500 livres, in 1765 a *Nativity* by this artist for 1,000, and in 1773 an *Annunciation,* also by Solimena, 38 x 47 inches, went for 2,000 livres. But Mireur records no sale of a Solimena between 1800 and 1900 for more than 600 francs (the new currency, worth the same as the livre) except for a large scene from Roman history that sold in 1864 for 1,610 francs. Other seicento

artists fared similarly (Mireur, *Dictionnaire des ventes,* s.v.). Only the two unquestionable titans Rubens and Rembrandt survived the Ruskinian forces in the marketplace and in critical esteem (though not from lack of denouncing). This state of affairs lasted until 1940 or so.

How could this be so? The answer to that throws light on the phenomena this exhibition studies. Ruskin, as I have said elsewhere, was the first great negative critic in the history of art (Hersey 1982). And the way in which he goes to work on Italian seicento painting is a case in point, in a way *the* case in point. One way to destroy a reputation, of course, is to ignore it. Thus in all the thirty-nine volumes of the Cook and Wedderburn edition of Ruskin there is no mention of Preti or Solimena, let alone their followers. And Luca Giordano, the other Neapolitan giant, is mentioned just once (Ruskin 1903, 12:239; hereafter cited by volume and page number only), where his flesh-painting is described as seemingly spiritual but actually sensual: a trap for the unwary. Even more surprisingly, the Carracci, the Bolognese geniuses who created early seicento painting, are utterly omitted.

But some seicento artists could not be ignored. Guido Reni, for example, is actually praised, though only in the very earliest writing (1:271, 276). Later, in 1844, Sir Charles Eastlake is attacked for buying Renis for the National Gallery, an attack repeated several times (3:670; 4:xxxv, 394; 12:404). Yet Ruskin continued to see some virtue, some power, in Reni, albeit marred by the vices of his age and style. For Ruskin, Reni is a fallen angel.

But Ruskin saw something else, the face of pure evil, in the art that most conditions and immediately precedes the art we study in this exhibition: that of Caravaggio, Jusepe de Ribera, and Salvator Rosa. Ruskin's case against them explains a great deal about the obloquy that swallowed them and their successors. It also gives us a fascinating idea of how differently from us Ruskin's generation perceived visual reality.

Caravaggio, the first great seicento realist, creator of squalid tavern scenes, portrayer of the "street people" of the day — one can understand why Ruskin would not like Caravaggio. In the present exhibition we have Caravaggism in Preti — in the Sarasota *Herodias,* in the Currier Gallery picture, and in the San Francisco *St. John Preaching* (cats. 1, 3, 5). Such flickering shadows, spotlit features, realistic flesh distorted in agony or desire, in cruelty and squalor, were anathema to Ruskin. But the depth of his dislike is strange: Ruskin calls Caravaggio the "black slave" of painting (4:xxxv; 15:202). This means that he darkened his colors and created shadows with black rather than using layers or glazes of tone. But the blackness of Caravaggio's world is no mere technical shortcoming. Here and elsewhere Ruskin attaches a negative moral value to black. He plays with the word. Black paint delineates "blackguards by candlelight, and the reinforcement of villainy" (1:147). Ruskin also reviles Caravaggio's "morbid brutality" and his "perpetual seeking for, and feeding upon, horror and ugliness, and filthiness of sin" (4:213). The painter actually *delights* in evil. His pictures praise a destroyed Nature. He leaves no tree unblasted, no sky not rent by tempest, no human form not shattered in health and wandering in rags (10:223).

Such writing is too fierce to be called simply negative criticism. It is the denunciation not of incompetence but of radical evil. The language is that of the preacher, not the historian. Indeed Ruskin's larger aim was to reinterpret all of European art as a battlefield in which the forces of

the Good, the Real, and the Protestant combat the Armies of the Night. Ironically, Ruskin's prose takes on the violence of the painted flayings, beheadings, bloody sweats, and agonies he denounces. In this setting Caravaggio's satanic presence on the threshold of the seicento is no mere matter of taste, though Ruskin uses that word; or, better, for him taste is a, indeed *the* great moral and theological issue.

The same is true of the next two captains in Ruskin's seicento army of the damned. They get shorter shrift than Caravaggio, but not less brutal. Like Caravaggio, Ribera receives that dismal accolade "the black slave of painting" (15:202). And Domenichino, whose standing with Ruskin has been interestingly discussed by Spear (1982, 118ff.), is utterly base (13:336); his landscape, imitating Titian's, only turns the world into "vile scum" (5:400). And once again Ruskin sounds a warning to the viewer: Domenichino's art, indeed, offers "perfect, sufficient, incontrovertible proof that whatever appears good in any of the doings of such a painter must be deceptive, and that we may be assured that our taste is corrupted and false whenever we feel disposed to admire him" (quoted in Spear 1982, 118).

But the chief offender in the conspiracy of blackguards that is the art we study here was the Neapolitan Salvator Rosa. The index of the Cook and Wedderburn edition forms what amounts to a vituperative essay on Salvator simply by paraphrasing Ruskin's references to him. In his innocent youth he had liked Salvator (1:112, 421; 6:359; 12:369). But he soon saw the artist's true worth and, given Rosa's immense popularity in Britain at the time as the presiding genius of the picturesque landscape — gloomy, fascinating, and filled with menace — "he must be brought low so as to secure due appreciation for other painters" (3:84n.). Like Guido, Salvator was a fallen angel, a Lucifer of art. He had had imagination, power, and natural feeling for truth, and his works are even partly redeemed by a sense of infinity. There are indeed actual traces of the spiritual life in his paintings. And yet in the end he was conquered by evil (7:343). Ultimately he devoted himself solely to it (10:223), his powers now rendered nugatory by his baseness of thought (3:185; 5:400), his coarseness of feeling, his bluntness of sight (5:400), and his willful rejection of nature (4:243). Aiming at her effects, he misrepresents her objects (12:116–17; 15:116), caricatures them (12:373). He sees in her only the gross and the terrible (3:582; 7:308, 387). His works are degraded (12:458); their falseness cannot be sufficiently abused (3:475n.). Rosa has no rank but in the abyss (4:373; 5:56).

The inhabitants of Dante's *Inferno* are described more charitably than this. To Ruskin, Domenichino, Rosa, and *a fortiori* their ilk, were not just bad painters but a menace to civilization. "There is *no* entirely great or sincere art in the seventeenth century," he wrote (5:400), not even in Rembrandt, Bernini, or Rubens.

These words were read, marked, learned, and inwardly disgested in the United States. The earliest important art criticism and the earliest art history after Dunlap was in this Ruskinian mold. The first university teachers of art history were Daniel Cady Eaton at Yale, beginning in 1871, and, a few years later, Charles Eliot Norton at Harvard. While Eaton's Ruskinism was evanescent (as was his influence on the art-historical scene), Norton was Ruskin's chief American apostle and an important American tastemaker. In his lectures Norton made much of Ruskin's connection between the evils of Counter-Reform Catholicism and the corruption of

Italian art. He had a particular dislike of monks and cardinals. In 1856, he wrote to James Russell Lowell from Rome: "I think Bernini and Borromini may be taken as the exponents of Roman taste and Roman feeling . . . since Michael Angelo died. It is worse now than ever. I think I can roast a Franciscan with pleasure, and it would need only a tolerable opportunity to make me stab a Cardinal in the dark" (Norton 1913, 144). This is a jest but a grimly sincere one. Norton was the American apostle of Italian art, but of the sort of Italian pictures that were hanging in those citadels of popery, the cathedrals of Bardstown, Baltimore, and St. Louis.

The first important collection of Italian Old Masters in America (if we exclude, pending research, Richard Meade's gallery) was the Jarves Collection, housed from 1871 in the Yale University Art Gallery. Early Tuscan painters were in the majority (though there were pictures, now untraced, assigned to artists like Reni and Domenichino; Jarves 1860, nos. 130, 134, 140). This was the result of Jarves's Ruskinian taste (Steegmuller 1951, 135ff.). Jarves's description of that citadel of Neapolitan seicento, the now-destroyed abbey church of Montecassino, with its many pictures by Solimena, De Mura, and others and its magnificent polychrome marble architecture, is a good example. At first Jarves seems impressed:

That haughty Renaissant cathedral belonging to the Benedictine Convent at Montecassino, near San Germano, in the Kingdom of Naples, whose lavish wealth and profuse adornment of precious stones, sculptured marbles, frescos, and wood-carving, as it stands on its solitary eyry on that bleak mountain-peak, contrast so strongly with the desolation about it, — a church that sinks St. Peter's glory into dimness in comparison with its fulness and reality of ornament; for there is no cheating of the eye here, but all is solid wealth and marvellous magnificence.

And yet it is all false: "Each and all of these edifices [he refers to other sumptuous shrines in the poverty-stricken region] replete with attractions for the senses, are powerless to touch the heart" (Jarves 1960, 132ff.). The art of the seventeenth and eighteenth centuries is not only sensuous and Jesuitical but imperial and antidemocratic, he adds. It is the art of tyranny. It is part of the Counter-Reformation, and part, therefore, of an infinitely clever conspiracy "to engulf the earth." It must have no place in democratic, Protestant America.

Ruskin, Norton, and Jarves by and large created the taste of the moving spirits in America's golden age of art collecting. Virtually none of the great collectors of this period, 1880–1920 — Henry Clay Frick, Mrs. Jack Gardner, J. P. Morgan, and their many fellow collectors, bought Italian seventeenth or eighteenth-century pictures. The sole exceptions were Tiepolo and the Venetian view painters, whose subject matter was seldom recognizably papist. The two chief advisers to this generation, Duveen and Berenson, had different reasons to downplay this abundant art. Duveen noted its low prices (Duveen 1935, 274), no doubt fearing that if it became popular it would drive out the expensive Renaissance objects he sold. Berenson disliked seicento painting, perhaps because he was so close to Duveen, but also because he had made early Italian art so much his own preserve.

Duveen, of course, was right. To this day Italian seicento paintings are relatively inexpensive. Part of this inexpensiveness, in turn, derives from the fact that the artists and their assistants so copiously produced replicas and copies. Not only were there the preliminary

sketches in oil, the bozzetti, and the full-fledged modelli for large commissions, there were also ricordi, or mementos, usually not very large. These were often made for the walls of bourgeois rather than aristocratic houses. The demand for domestic (or "cabinet") paintings of grand church or mythological subjects ran throughout the eighteenth century. Good examples of such works in the present exhibition are cats. 32, 39, and 42. Indeed there were three levels of production, we are told, in the major studios: "gold brush, silver brush, and lead brush" (Ruotolo in Naples 1984, 1:41ff., paraphrasing De Dominici). John Spike thinks that these three categories refer respectively to autograph works, copies with heads by the master, and pure copies. This is on the basis of contemporaneous inventory language (Spike in De Vito 1985). Still today one of the pitfalls for the student of sei- and settecento painting is this plethora of more or less contemporaneous variants on each major composition. But even to put it this way distorts the truth, for it implies that there is a single great original and a flock of lesser copies and adaptations. And often in our period there is no such great original: the original will be inferior to the replica. The Baltimore *Abduction of Orithyia* (cat. 22), a copy of a picture by Solimena in the Galleria Spada, Rome, is an example. Or the copy may be the work of an artist of high merit. Luca Giordano was always making beautiful copies of the work of other artists, some of them, for example, Dürer, far removed from Luca in time and style (see Judith Colton's biography of Giordano, below).

Antiseicento sentiments continued to be the order of the day even after the influence of Berenson and Duveen began to wane. In her 1924 novel *False Dawn* Edith Wharton, looking back from a later peak of antiseicento sentiment toward the earlier one of the 1840s, created a Jarves-like character named Lewis Raycie. The son of a rich merchant, Raycie fell under Ruskin's enchantment — sketched the Alps, rapturously admired quattrocento frescoes. And, even more like Jarves, he bought early Italian paintings with the intention of giving them a permanent public home in the United States. His taste was rigidly antibaroque: "How insipid seemed to him all the sheep-faced Virgins draped in red and blue paint . . . and as for that fat naked Magdalen of Carlo Dolce's, lolling over the book she was not reading, and ogling the spectator in the good old way . . . faugh!" (Wharton 1924, 78).

Twenty years after Wharton's novel Berenson was still adjuring scholars to stay away from the seventeenth and eighteenth centuries. But his reasons had nothing to do with Catholic conspiracies or misplaced fleshliness. It was a question of a tradition, of a canon of artists and styles leading from Giotto onward across the terrain of European history to the triumph of modernism. For Berenson, that is, there is a particular way to get from Giotto to Cézanne; the student who does not follow it gets lost: "Art history must avoid what has not contributed to the main stream, no matter how interesting, how magnificent in itself. It should exclude, for instance, most German and even Spanish and Dutch art. It should dwell less and less on Italian art after Caravaggio, and end altogether by the middle of the eighteenth century with Solimena and Tiepolo" (Berenson 1948, 235). Artists who do not go to make up this stream are ahistoric, outside of time. Thus Berenson dismisses "the vapid ecstasies of Guido, Greuze, and their kind."[8] The fact that Guido was born in 1575 and Greuze in 1725 does not prevent them from being brothers, contemporaries even, in the timeless world of a-history.

These are the attitudes, the beliefs, the prejudices that, in the period 1840–1940, effectively prevented any revival of prestige for pictures like those in the present exhibition. And at first, at least in America, renewed interest occurred only at the fringes of the art scene. One of the earliest cultivators of the taste was A. Everett Austin, director of the Wadsworth Atheneum at Hartford (1927–44), and then of the Ringling museums at Sarasota (1946–57). An actor, painter, and scene designer as well as collector, Austin was a Diaghilev-like character. He acquired seicento and settecento pictures at an impressive rate. At Hartford, where he reaped the benefits of the recent (1927) Sumner bequest, these acquisitions occurred in an atmosphere of radical modernism. Hartford saw the first production of Gertrude Stein's *Four Saints in Three Acts,* with music by Virgil Thompson, and the first United States exhibitions of Picasso, Juan Gris, and Max Ernst (Hartford 1958). Austin's taste for Italian seicento was shaped by his close friend the painter and scene designer Eugene Berman, whose own art was inspired by the architectural fantasies of the Bibiena family, of Hubert Robert, and De Chirico. The Neapolitan seicento painter Domenico Gargiulo also seems akin. In the climate of his age, against the backdrop provided by Duveen's activities and by the acquisition policies of the Metropolitan Museum of Art, the Boston Museum of Fine Arts and, after 1930, the new National Gallery in Washington (presided over by John Walker, a Berenson protégé), Austin's admiration for seventeenth and eighteenth-century Italians must have seemed as aberrant as his taste for Picasso.

Another mover and shaker was John Ringling, who presided over the famous Ringling Brothers, Barnum and Bailey Circus and who, beginning in the mid-1920s, filled a new museum in Sarasota with baroque pictures. That collection, now known as the John and Mable Ringling Museum of Art, has as a pendant the Ringling Museum of the Circus — the circus whose style, in costume, ornament, vehicles, and even ballyhoo, is of course a long-running relic of the seicento life-style that managed to escape the Victorian wars of taste (Harlow 1958; Böhler MS 1948). Many a circus poster of leaping tigers has debts to Rubens.

Ringling bought more than six hundred Old Master paintings before the Museum of Art was founded in 1946 with Austin as the director. At first Ringling was more interested in the High Renaissance — Luini and Veronese; but then came his acquisition of a set of huge, magnificent Rubens cartoons that are still the glory of the collection. Thereafter, often with the advice of his friend the German art dealer Julius Böhler, Ringling bought Massimo Stanziones, a magnificent Andrea Vaccaro *St. John the Baptist* (for a risible amount), Rosas, Solimenas, and many Luca Giordanos (Tomory 1976, ixff.).

Another major public collection of Italian seicento art in this hemisphere is in Puerto Rico. There, in the ancient city of Ponce, Luis A. Ferré, abetted by Julius Held and René Taylor, began putting together a splendid collection that in the 1950s became the Museo de Arte. Austin and Ringling loved the theatricality of seicento and settecento painting, and undoubtedly also the idea that one was supposed to hate it. Ferré's attitude was different. For him Hispano–Italian culture and its source in the Mediterranean basin was what counted. The purpose of his collection was to emphasize the inheritance of the puertoriqueños (Julius S. Held in Ponce 1967). The museum in Ponce contains fine pictures by Luca Giordano, Francesco de Mura, Gaspare Traversi, and other Neapolitans. And it has published, in two successive catalogues of

1967 and 1984, all its pictures, and far more professionally than have most museums of its size — and, I am tempted to guess, than *any* museum so young.

A number of major private collectors, among them Robert L. and Bertina Suida Manning, Walter Chrysler, and the late Paul Ganz, have also been collecting in the field. This area of our subject has been well explored in an exhibition organized by John T. Spike, *Italian Baroque Paintings from New York Private Collections,* Princeton University Art Museum, 1980, which included notable Neapolitan works (Princeton 1980, Introduction; R. L. Manning in New York 1962). Many of the most beautiful sei- and settecento Chrysler pictures are now in the Chrysler Museum, Norfolk, Virginia (e.g., cats. 11, 28, 44).

Despite these recent enthusiasms the old curse of the sei- and settecento can still be mapped — even in books by scholars devoted to the field. The readers of Ellis Waterhouse's landmark study of Italian baroque painting, the first book in English on the subject (1962), are warned that they "may have some difficulty in finding their way through a period from which so many acres of dingy canvas or depressing fresco have survived" (Waterhouse 1962, Preface). A book on the Florentine quattrocento would not begin with those words. Even the major mid-twentieth-century scholar of baroque art in Italy, Rudolf Wittkower, expresses reservations about quality in his Pelican textbook — the book with which to this day every beginner in the field begins. Wittkower's Foreword tells us that Italian art in the seventeenth and early eighteenth centuries is very uneven, and that the sculpture and architecture are more important than the painting. For Wittkower, with the exception of Caravaggio, the Carracci, and Tiepolo, seventeenth and eighteenth-century Italian painting "often indeed has no more than strictly limited interest — an ideal hunting-ground for specialists and 'attributionists'" (Wittkower 1965, xxi).

It hardly needs to be said (the Bibliography of the present catalogue says it for us) that these specialists and attributionists have been hard at work in the twenty years since those words were written and that the object of their study, far from being of "strictly limited interest" has become a great feast.

About a third of the objects in the present exhibition illustrate, since they are recent acquisitions, the broader interest in south Italian art that has arisen since Wittkower's book appeared. Such interest has been brought about by the recent spate of major exhibitions. Two stand out because they visited America: *Painting in Naples from Caravaggio to Giordano,* National Gallery, London, 1982, and National Gallery of Art, Washington, 1983, and *The Golden Age of Naples: Art and Civilization under the Bourbons, 1734–1805,* Detroit Institute of Arts, 1981, and Art Institute of Chicago, 1982. The recent exhibition in 1985 at the Metropolitan Museum of Art devoted to the Age of Caravaggio and the two recent magnificent shows at Capodimonte about Naples in the eighteenth, and then Naples in the seventeenth century, have also added immensely to our knowledge. Further exhibitions in the field, especially at Capodimonte, are planned. The extent and richness of the objects displayed, the number of first-rate artists who have been rediscovered, and not least the new depth and power of the scholarship shown in the catalogues give to the field a much increased prestige.

These exhibitions, in turn, have inspired American public collections to acquire in the field.

The work of Solimena, Giordano, and the other major artists in our exhibition is now commonly to be found in American collections. And as more and more secondary artists are becoming known — Francesco Celebrano, Pietro Bardellino, Domenico Antonio Vaccaro, and Domenico Mondo are cases in point — American pictures once assigned to major figures like Solimena are now being correctly attributed. We are taking up where our predecessors left off 140 years ago when *Modern Painters* appeared.

1. At an unspecified date the sisters Harriet and Margaret Curtis gave the paintings to the Church of the Advent, Boston. In 1957 they were in the hands of a Boston dealer, Edward F. Cloran, who sold them as Solimenas (registrar's files, Fogg Art Museum).

2. Meade 1913, 1:1ff. No date is given but the implication is that the Philadelphia gallery was opened in the 1820s. In 1860 Margaret Meade, sister of the Civil War general George G. Meade, gave the picture to Georgetown (Georgetown 1962, 41, where the sister's name is incorrectly given as Martha).

3. In New York beginning in 1853, Thomas Jefferson Bryan showed a collection of mainly French, Flemish, and Dutch pictures, which before his death in 1870 he gave to the New-York Historical Society. (Saarinen 1958, xxi; Jeromack 1986).

4. Fredericksen and Zeri 1972, 169, and John T. Spike, personal communication in 1986 based on photographs. The *Coronation of the Virgin* is meanwhile closer to Giuseppe Bonito or Pacheco de Rosa. The sixth of the pictures sent by Francesco I is now in the Diocesan Museum, Louisville, and is a *San Carlo Borromeo in Prayer* of a common Lombard type, but possibly by a Neapolitan seventeenth-century hand.

5. Also to be looked into is the collection of pictures sent by Ludwig II of Bavaria to a Benedictine monastery in Latrobe, Pennsylvania, in the 1840s. Meanwhile Creighton Gilbert has called attention to a group of Old Masters collected by the monks of St. Meinrad's Archabbey, St. Meinrad, Indiana (Gilbert 1958, 356). "Their eventual source," he says, "is alleged to be a castle near Benevento." But there are not many South Italian pictures in the group — he illustrates an attribution to Conca (his fig. 11) and De Mura school (his fig. 12). The quality seems to be slightly better than that of the Bardstown pictures. (See also St. Meinrad 1968.)

6. It is true on the other hand that he idiosyncratically treats Luca Giordano as a feeble follower of Titian, and, worse (and more strangely) still, says that Titian led Italian painting astray into the realm of the "merely ornamental" (Reynolds 1975, 67).

7. Dunlap 1834, 310. For the corresponding prestige of Guido Reni in America see Stein 1967, 140ff.

8. Berenson 1948, 96. The same thing could happen in the history of architecture. Slightly earlier, Berenson's contemporary Banister Fletcher, in his *History of Architecture on the Comparative Method,* had grouped Indian, Chinese, Japanese, Meso-American and Saracenic architecture as "non-historic styles." Banister Fletcher, *A History of Architecture on the Comparative Method* [1896], New York, 1950, 888.

CATALOGUE

MATTIA PRETI, 1613-1699

George Hersey

The main source for Preti's life has traditionally been the account in Bernardo De Dominici's *Vite de' pittori, scultori ed architetti napoletani* (De Dominici 1742–45, 3:314ff.). Recent studies (Frangipane 1929; Refice Taschetta 1959) are largely based on De Dominici even as archival research (Capasso 1878; Longhi 1913; Carandente 1966; Nappi 1980, 32ff., 63ff.) has been revealing the many inaccuracies and even fictions in his tale. In 1979 John T. Spike, in a Harvard dissertation, chose to rewrite Preti's biography from the ground up, abandoning practically all dependence on De Dominici and making use only of the latter's verifiable claims (Spike 1979a, esp. 5ff.). Spike's monograph on Preti, currently in the works, will be a welcome *aggiornamento* of his dissertation and will constitute the definitive study. At the same time it is becoming evident, through the discoveries of Spike himself and of others, that not all of De Dominici's claims ought to be ignored. Even the fiction, as Judith Colton shows in the present volume, can be constructively interpreted.

Mattia Preti was born in the remote town of Taverna, near Catanzaro in Calabria. He seems to have arrived in Rome about 1630 at the age of seventeen. There his brother Gregorio was already established as a painter. The first influence on the young Mattia came from Caravaggio and his followers, especially Bartolommeo Manfredi. Particularly Caravaggesque were his views of gaudy card games with rakish youths (Galleria dell'Accademia Albertina, Turin; Galleria Doria-Pamphili, Rome; fragment, Jewett Art Center, Wellesley College). The Sarasota *Herodias*, cat. 1 in the present exhibition, is an excellent example of the application of this genre to a religious subject (*contra*, D'Argaville 1972). Indeed Preti's career as well as his style often mirrored Caravaggio's. Thus in 1641 or 1642 Urban VIII named him a *cavaliere d'obbedienza* of the Order of St. John of Malta. Caravaggio had been a member of that order and had painted pictures for it, as Preti was to do, and, also anticipating Preti, had lived on Malta itself (Hibbard 1983, 275ff.). Yet if Preti thus found himself following Caravaggio in various ways, his later work, though never oblivious of the older master's style, keeps that influence at bay.

These facts are ascertainable from sources other than De Dominici. Let us now cautiously look at De Dominici's rather different but not incompatible picture of Preti's youth. He says Guercino was Preti's master and describes trips that Preti took to Venice and Parma where the young artist supposedly studied Correggio's use of *da sotto in sù*, that difficult kind of fore-

shortening that gives the effect of looking up at something from below (e.g., cat. 2; De Dominici 1742–45, 3:318, 327). These trips seem to be fictional, as does any formal study with Guercino. Yet De Dominici could otherwise be telling us truths about Preti. Most scholars accept De Dominici's claim that he himself was the direct heir of Preti and his circle — that De Dominici's father and aunt had been Preti's pupils, and that after the artist's death, the De Dominicis, father and thirteen-year-old son, visited Malta (De Dominici 1742–45, 3:355ff.). If all this is true De Dominici had plenty of what might be called good secondhand information about his subject. Even some of the fiction — for example, the claim that the artist had aristocratic forebears (De Dominici 1742–45, 3:314ff.) — may well have come from Preti himself. Indeed Preti was required to accumulate evidence for noble blood when in the 1660s he sought appointment as a *cavaliere di giustizia* in the Knights of Malta (Spike 1979a, 123). In this same spirit one of De Dominici's debunkers, Bartolommeo Capasso, suggests that the tale of the gates of Naples, which I shall tell presently, may not be a false claim by De Dominici but rather a *fanfarronata del vanglorioso pittore,* a swaggering tale the artist himself habitually told (Capasso 1878, 605).

Furthermore De Dominici's claims of study of (if not with) Guercino are borne out in Preti's art. One of the hallmarks of this early style, apart from the early debts to Caravaggio, is the use of noble, three-quarter-length figures closely grouped, intensely interacting, bathed in gleaming twilight (cat. 3). This comes right out of Guercino (Pevsner 1968, 58). One particularly strong instance of Preti's Guercinism, recently discovered, is the 1649 standard for the abbey of San Martino al Cimino, near Viterbo. This has now been cleaned, revealing a strongly Guercinesque *Man of Sorrows* on one side of the banner.[1]

Similarly, whether or not Preti went to Venice at this time, his work rapidly developed away from his early Caravaggism toward the great Venetians of the High Renaissance, chiefly via their Roman imitators such as Pier Francesco Mola and Pietro Testa. To put it differently, if Preti turns Guercinesque he does so in a Venetian way. The Bob Jones *Christ Seats the Child* (cat. 6) has a Guercino composition but the color has broad, deep harmonies of red and blue and a tumultuous sky that go directly back to the Venetian High Renaissance and, in particular, the Bassanos. This neo-Venetianism resurfaces often in our period; we see it in Luca Giordano (cat. 9) and Solimena (cat. 26). Of course, if in fact — and it is *very* unlikely — Preti never went to Venice, there were Venetian pictures in Rome. And when he came to Naples he would have been able to see pictures by Jacopo Bassano, Titian, and Veronese in the collection of his patron, Ferdinand Vandeneynden (Ruotolo 1982, 28, 33).

Preti's earliest documented work is the *Martyrdom of St. Andrew* in the apse of Sant' Andrea della Valle (fig. 34; Spike 1979a, 61ff.).[2] Preti must have had high hopes for this prominent commission. But the frescoes were perceived both by Preti himself, apparently, and by De Dominici as a critical failure. De Dominici attributes the misfortune to Preti's following bad advice from Cortona, and making the figures colossal (De Dominici 1742–45, 3:330). Whatever Cortona's role, it must be admitted that the enormous head-on crucifixion, with the saint's figure grotesquely straddling its X-shaped cross, is strange, albeit unforgettable. (An impressive bozzetto or ricordo of the scene is in Goodstein 1983, 19 and was lot 10 in Sotheby's *Old Master Paintings,* London, December 10, 1986.) The comparison with Domenichino's frescoes

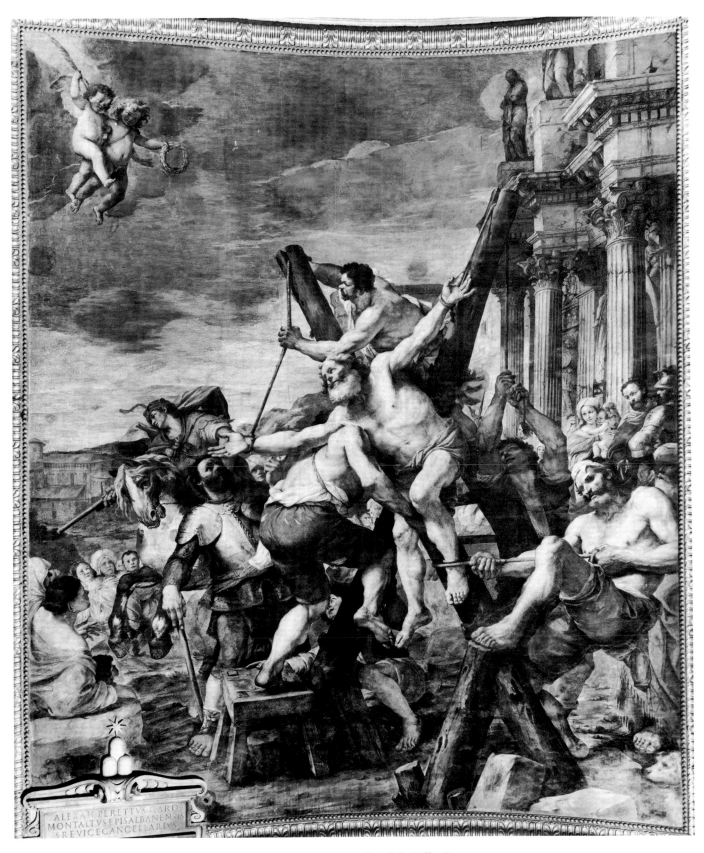

FIG. 34. Mattia Preti, *Martyrdom of St. Andrew*, fresco, apse of Sant' Andrea della Valle, Rome

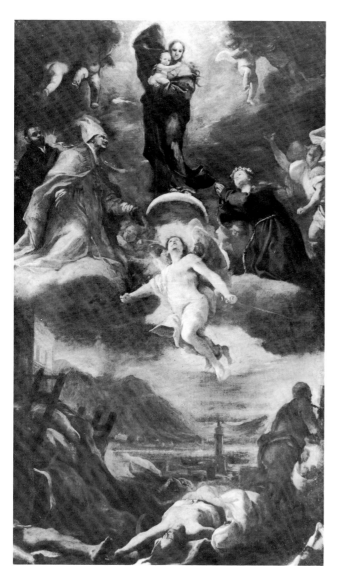

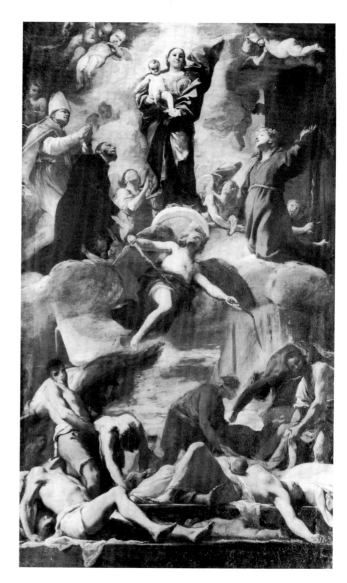

FIG. 35. Mattia Preti, bozzetto for plague fresco, Museo di Capodimonte, Naples

FIG. 36. Mattia Preti, bozzetto for plague fresco, Museo di Capodimonte, Naples

in the same church was held to be particularly damning. In later life, according to De Dominici, Preti even sought to repaint the work at his own expense (De Dominici 1742–45, 3:360), but this could be another myth. In any event Spike shows that the recorded contemporary reaction was by no means entirely hostile (Spike 1979a, 65ff.). Perhaps as a consequence of this failure, real or assumed, Preti left Rome and, after two years in Modena, where he frescoed the dome and apse of San Biagio, he proceeded to Naples, a city he seems to have resided in, at least at times, since 1653 (Spike-Clifton Forthcoming). There, in seven short years, 1653–60, he achieved great things.

Yet he did so against odds. There was a tradition of distinguished foreign artists coming to Naples, often to the fury of the local talent. Thus in the 1630s and 1640s Domenichino and Lanfranco were brought in to do the painted decorations in the Chapel of San Gennaro in the cathedral (Spear 1982, 19ff., 288ff.; Passeri 1772, 355). At that time the greatest artist in Naples was Jusepe de Ribera, certainly comparable in stature to Domenichino and Lanfranco. The failure to employ him resulted in years of turmoil (De Dominici 1742–45, 3:22). The same thing was to happen in the eighteenth century. (See the remodeling of the Duomo chancel described in the essay below on Giaquinto.) Another such event, at the end of the period studied by this exhibition, was Carlo di Borbone's decision to employ foreign architects for his building program and especially for two huge buildings, the Albergo dei Poveri, by Ferdinando Fuga, a Florentine, and Caserta, by the Roman Luigi Vanvitelli. Vanvitelli, the art-patronage czar of Naples throughout the 1750s, notoriously disliked the local school of painters, though by this time it had achieved Europe-wide fame (Hersey 1983, 64ff.).

As I have indicated these foreigners were given a difficult time by the local artists. Domenichino, it is said, suffered a persecution neurosis (Spear 1983, 19). But Domenichino's chief tormentor, Ribera, may also have suffered. At least De Dominici prints the tale (untrue) that he exiled himself and gave up painting (De Dominici 1742–45, 3:22). Vanvitelli meanwhile became something like a paranoid melancholic (Hersey 1983, 93ff.). We shall see that Preti got rough treatment too.

When Preti arrived in 1653 Naples was stricken by the plague (Nappi 1980). De Dominici has a famous tale about his arrest for killing a guard who tried to keep him from entering the quarantine city (another element, also apparently fictional, in his seeming attempt to provide Preti with a Caravaggesque lifestyle, for Caravaggio had also been accused of murder; Hibbard 1983, 206). According to De Dominici Preti's punishment was that he had to paint, free of charge, frescoes of Naples's protective saints over the city gates (De Dominici 1742–45, 3:332ff.). These were duly executed, but Capasso shows that Preti was employed by the *eletti,* or district leaders, of the city at regular rates with no hint that any punitive action was being carried out (Capasso 1878, 602ff.; Croce 1892).

Yet if we can dismiss the idea that Preti was personally engaging in a penitential act, the program itself was clearly an ex-voto on the part of the eletti themselves. A contemporary manuscript account in the Biblioteca Nazionale, Naples (MS 1647), describes these and other works of art undertaken during the plague summer as tools to protect the city from further infection. Here is the decree about the gate frescoes:

The most illustrious eletti *having considered that the defense and guardianship of the City and Kingdom depend on the omnipotent hand of God, and this most faithful city of Naples, under the special protection* (interxceptione) *of the Most Glorious Virgin, and of its protector-saints, having been preserved from infinite evils . . .* [it is decreed that] *there be painted over each gate of this city the image of the Immacolata holding her child in her arms, and, below, the glorious San Gennaro, with San Francesco Saverio on the right, and on the left Santa Rosalia; and over the said images in capital letters this versicle is to be read: "Praise to the Most Holy Sacrament; the Immaculate and pure Conception of the most holy Virgin conceived without stain of original sin."*

Preti is not mentioned in the decree. Instead it is stipulated that various artists be employed and paid at the regular rates.

By the time the frescoes were begun on the following October 30, the plague had receded (Capasso 1878, 602). They were completed on April 24, 1659, slightly less than three years after they were begun (Capasso 1878, 604). The idea of using various presumably local artists to do the work was abandoned, and Mattia Preti did all seven gates. This is fact; once again, that is, local artists were replaced by the foreigner. Further, De Dominici's (or Preti's) fancy, accompanying that fact, namely that Preti forced his way into the city, reinforces his status in the story as an outsider (even though, born in Taverna, he was a subject of the kingdom). Little is left today of this enormous and influential program except for two bozzetti in Capodimonte (figs. 35, 36).

Perhaps because the frescoes were in a sense temporary works and ex-votos, De Dominici does not record the sort of criticism that Neapolitan painters habitually directed at foreigners who received important commissions in their city. But there was plenty of criticism of Preti's other work. Thus De Dominici says that Luca Giordano criticized Preti as a matter of policy even though he admired him in secret. Indeed De Dominici records as much praise as blame when he writes about the impact on the local art scene of the artists in our exhibition. But that is part of his technique (see above, Judith Colton's essay "The Fall and Rise of Bernardo De Dominici"). The essence of that praise-blame technique is observable here. Luca belonged to an organization of local artists, the Corporazione dei pittori napoletani (Strazzullo 1962) who furthered their interests by criticizing the styles of their rivals. Preti's pictures were particular objects of dislike. They were found to portray ignoble human types — the women were considered especially vulgar — and to be too dark in tone. Especially, for Luca, Preti's Madonnas lacked the great beauty they should possess. He even managed to discredit the superb seated *St. Sebastian* now in Capodimonte on the grounds that the body was vulgar and lacking in the grace and nobility proper to such a personage (fig. 37). As a result of these criticisms, we read, the convent of the Dame Monache, which had commissioned the picture, refused to have it in its church (De Dominici 1742–45, 3:348). It is possible, since it is a male nude of great sensuousness, that the painting was not considered proper for nuns. But the very gloriousness of these nude saints was invoked by theologians: "What body is more splendid and admirable than yours, which shines all over with the glory, the brightness [of your wounds]?" (Bellarmino

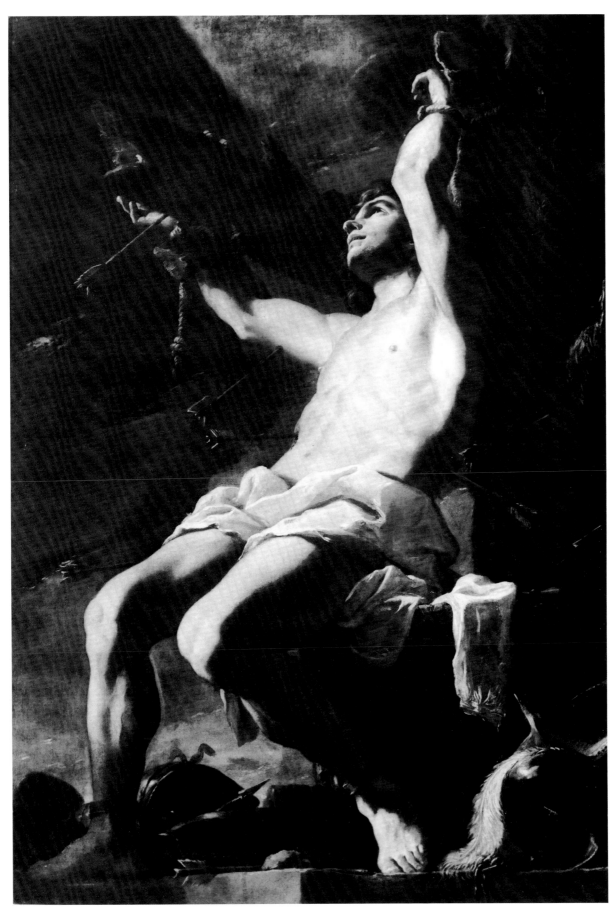

FIG. 37. Mattia Preti, *Martyrdom of St. Sebastian*, Santa Maria dei Sette Dolori, Naples (on deposit in Museo di Capodimonte)

1617, 6:228). This was written in the heyday of Caravaggio's early career, and its celebration of the beauties of nude, wounded bodies well accords with his art. What Giordano was objecting to in Preti's pictures was just this sort of Caravaggism.

Preti's most brilliant existing achievement in Naples is his ceiling (1657–59) for San Pietro a Maiella, a medieval church originally dedicated to St. Catherine of Alexandria and later rededicated to her and to Pope Celestine V (San Pietro Angeleri). Since Celestine was from a town in the region, Isernia, here was a chance for an interesting encounter between the issues of local vs. foreign artists. Preti created a set of panels for a gilded, flat ceiling in the Venetian manner (figs. 11, 12). As Spike points out, Veronese's pictures in San Sebastiano, Venice, and those by various masters in the Biblioteca Marciana are particularly relevant (De Conciliis-Lattuada 1979; Spike 1979a, 8). But one notes that the Duomo in Naples has the same sort of ceiling, though without the virtuoso figure foreshortenings we see in Preti and in the Venetian programs. The nave of San Pietro a Maiella is devoted to Preti's scenes from the life of Celestine and the transept to the career of St. Catherine (Celano 1692a, 845ff.). Preti's scenes are relatively small in scale for the immense medieval church and are constructed very much like some of the pictures in the present exhibition. Brilliant, dramatic personages tower upward. And if the picture spaces do not extend those of the church interior, the compositions themselves are mountainously architectural. The colors are dark, with the palette dominated by whites and blacks. Flesh is pale and studded with pearly highlights. The figures occasionally engage the viewer but mostly stare or move onward into cloud-streaked heavens. Always the saint is urged onward by angels. Light is a palpable substance, flooding each scene with a dominant tone. Luca Giordano will make this effect his own.

If local critics were stilled in regard to the plague frescoes that was not so, says De Dominici, in regard to this commission. One day the artist was painting one of the scenes of St. Catherine's life

when one of the monks, being acquainted with some painters who, with ignorant and denigrating tongues were censuring Mattia's works . . . spoke to Abbot Campana. And he, believing the false criticisms, and not having the slightest knowledge of the masterful art with which these pictures were being painted; and seeing that the paint was applied in powerful strokes and with large sweeps, and above all that the foreheads, eyes, noses and mouths were brought out with powerful highlights, as is proper with works that are to be seen from a great distance, convinced himself that the paintings were being thrown rather than painted [onto the canvas] (De Dominici 1742–45, 3:352).

So the abbot refused them for the monastery. Fortunately on this occasion some more informed local painters — Francesco di Maria, Luca Giordano, and Andrea Vaccaro — swallowed their jealousy and convinced the monks to accept Preti's work. Luca, says De Dominici, even suggested as an alternative that he himself supply the church with the scenes from the lives of Celestine and Catherine and that in exchange he would keep Preti's paintings of these subjects as examples for students. This tale, which is probably untrue but nonetheless seems *ben trovato* as a kind of explanatory myth, adds to the picture of Preti that formed in the minds of the younger generation: not only did he use ignoble types, not only was he Caravaggesque, his personages were too rudimentary in rendering, that is, not delicate enough. When De Dominici

praises Preti's *terribilità,* meaning something akin to the grand simplicity of Michelangelo, he may be defending him from this charge.

Despite the criticisms he received, Preti's Neapolitan work and the pictures he sent to Naples in later years from Malta were seminal for two generations of south Italian artists. Preti ennobled the earthy Caravaggism of such local painters as Battistello Caracciolo and even of the great Ribera by pointing the way to a more sublime concept of the body (see also De Dominici 1742–45, 3:379).

In short, as we can gather both from Preti's own criticisms of his predecessors and from Luca Giordano's criticisms of Preti, the figure ideal in Naples was gradually becoming more golden, more sensuous. The vivid gestures and abrupt actions of figures like the San Francisco *St. John the Baptist Preaching* (cat. 5) went out of fashion. Comparisons between early and late Preti, for example, the Sarasota *Herodias* (cat. 1), which probably dates from the 1630s, and the *Christ Seats the Child* at Bob Jones University (1680–85; cat. 6), make part of the point. The Bob Jones picture is softer, more powerful in drawing, and with fewer jagged contrasts of gesture and light. But then let us look at a picture of the 1660s by Giordano, namely the Ponce *Christ the Intercessor* (cat. 10). This goes much further than Preti in the exploitation of glowing nudity. The harsh, melodramatic flesh painting that had stemmed from Caravaggio and that we see in the Capodimonte *St. Sebastian* is replaced by this other nudity, this new, sweet crystallization of what is called Luca's *maniera dorata*. Yet it was Preti, with his personal mixture of ennobled Caravaggism and compositional ideas derived from Guercino, who most forcefully introduced all these possibilities to Naples. The criticisms of Luca Giordano and other young artists boil down to the charge that Preti had not gone far enough with his obviously welcome innovations.

De Dominici tells us that Preti was so upset by his quarrel with the Celestines that he abandoned work on their project (De Dominici 1742–45, 3:353). But apparently he completed the series before leaving the city (De Conciliis-Lattuada 1979). In any event we next find him outside Rome in 1661 painting frescoes (damaged) in the Palazzo Pamphili, Valmontone. In the same year he settled in Malta, which he had earlier briefly visited (De Dominici 1742–45, 3:323; Spike 1978; 1979a, 111ff.; 1979b). His most important work there was the decorative series in the convent church of St. John at La Valletta (1661–66). Preti worked industriously on Malta for the next forty years, far from the turmoil of Naples, shipping canvases abroad and filling local churches with his work.

Preti's influence continued to exert itself on Neapolitan art. In the seventeenth and eighteenth centuries the city was full of his somber scenes, his figures inhabiting his favorite Sansovinesque palaces and enlivened by flashes of crimson, azure, or saffron. There are major Pretis in the Palazzo Reale, Santa Maria del Carmine, San Lorenzo Maggiore, Santa Maria di Montevergine, the Museo Filangieri, and elsewhere. Capodimonte contains rooms full of them and has many of his drawings. The artist seems often to have executed large religious scenes for private patrons rather than for churches, and most of the important Neapolitan palaces — those of the dukes of San Severino, of the dukes of Maddaloni Carafa, of the Marchese di Genzano, Giacomo di Marino, of Gabriele Boragine — according to De Dominici had pictures by the famous cavaliere (De Dominici 1742–45, 3:372ff.). Less noble collectors like the merchant-financiers Gaspare Roomer and Ferdinand Vandeneynden possessed Pretis as well (De Dominici

1742–45, 3:343ff.; Ruotolo 1982, 6). Both these men were well-known connoisseurs, and perhaps it was of such patrons that De Dominici was thinking when he wrote of Preti, "He seems to have made [these pictures] rather to gratify the eyes of professionals in design, and those who understand the pictorial art, who are the true dilettanti, than for the common people" (De Dominici 1742–45, 3:359). In this same spirit Vandeneynden probably commissioned some of the Pretis he owned, of which he had a total of ten (Ruotolo 1982, 15).

But the works produced on Malta, though almost to the end of Preti's life as magnificent as his work of the 1660s, do not incorporate the shifts and changes in style that occurred in the traumatic artistic life of Rome and Naples. In any case Mattia Preti's ultimate affections seem to have been engaged not by Rome, Naples, or Malta, but by his birthplace. He sent a considerable number of altarpieces to the little town of Taverna, which is now a veritable museum of his work (Carandente 1966). One of his earliest paintings (ca. 1636–44) is a *Madonna della Purità with SS Gennaro and Nicola* over the high altar of the church of San Nicola. The altarpiece can be moved so as to reveal a niche containing a bust of the artist made the year of his death, 1699. From that same year dates Preti's last known painting, a *Madonna del Rosario* in San Domenico, Taverna (Carandente 1966, 27).

1. The standard was shown at the exhibition of the Laboratorio di Restauro, Rome, in January 1986 in the Palazzo Venezia. I owe this information to John Spike.

2. A 1642 fresco in San Carlo ai Catinari, Rome, *The Charity of San Carlo,* once thought to date from 1642, is now dated to 1652 (De Vito in De Vito 1985, 10).

I Herodias with the Head of John the Baptist

120 x 171 cm (47¼ x 67⅜ in)

PROVENANCE: Matthiesen Fine Art, Ltd., London, 1985

EXHIBITION: Sarasota 1986, 51ff.

LITERATURE: John and Mable Ringling Museum of Art, *Newsletter* 19(1), October 1985

John and Mable Ringling Museum of Art

With callous satisfaction Queen Herodias displays to Herod the cruel trophy of her revenge upon John the Baptist (Mark 6:17–28, Matthew 14:3–12). At her side her daughter Salome helps to hold the charger that bears the prophet's head. (Janson in Sarasota 1986 identifies the principal female figure as Salome, but it seems more likely that it is Herodias.) Although Herod had listened eagerly to John's teachings, the Baptist was imprisoned when he reproached Herod for marrying his brother's wife, Herodias. She took revenge (see also cat. 9). On the king's birthday her daughter (unnamed in the Bible but, according to tradition, Salome), entertained the company at the banquet with her dancing, and Herod rewarded her with any wish of her choice up to half his kingdom. It was Herodias who thereupon suggested she ask for the Baptist's head (Mark 6:24).

In his career Preti had frequent occasions to paint episodes from the ministry and life of John the Baptist, patron saint of the Sovereign Military Order of St. John of Jerusalem, Rhodes, and Malta. Indeed the Knights of Malta, as the order was known, were the sponsors of Preti's magnum opus, his majestic decoration on the vault of the Knights' conventual church of St. John, La Valletta (Malta), representing eighteen stories of the saint's life.

It is evident that Preti the artist, quite apart from Preti the Knight of Malta, was powerfully moved by the pathos and mystic intensity embodied in the Baptist's life. On the basis of style this painting would appear to be one of the artist's earliest known works, datable to the 1630s. It would therefore have been executed several years prior to his nomination by Urban VIII Barberini to the rolls of the Knights in 1641.

The picture accordingly dates from Preti's earliest period, during which he was influenced by Caravaggio. Preti's origins and extensive activity as a Caravaggesque painter were first outlined by Roberto Longhi (1943, 34n. 86). Longhi's account remains valid notwithstanding a recent attempt by Janson (drawing on an unpublished article by Brian D'Argaville) to see the Sarasota *Herodias* and Preti's Caravaggism in general as representative of a second phase of development that occurred in the 1640s. Janson and D'Argaville suppose that Preti "first adopted classicism before turning to Caravaggio's manner," without specifying, however, which are the classicizing works that Preti would have executed druing the 1630s.

There is ample room for confusion regarding the chronology of Preti's paintings in the 1630s and 1640s. Dates are lacking for all of his works prior to his single-figured *St. Andrew* in Lucerne of ca. 1642 and his altarpiece of *The Roman Empress Faustina Visiting St. Catherine of Alexandria in Prison* (Dayton Art Institute; fig. 38), which Spear has reasonably associated with a date close to Preti's knighthood in 1641 (Spear 1975, 145; De Dominici 1742–45, 3:321ff.;

93

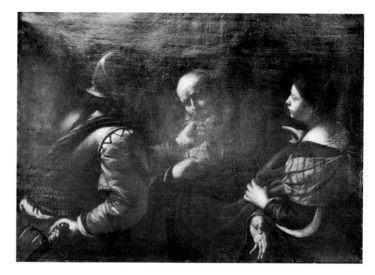

FIG. 38. Mattia Preti, *The Roman Empress Faustina Visiting St. Catherine of Alexandria in Prison,* Dayton Art Institute, Ohio

FIG. 39. Mattia Preti, *The Denial of St. Peter,* Musée des Beaux-Arts, Carcassonne

De Vito in De Vito 1985, 10). But even these dates must be approximations. Nonetheless the body of surviving works is extensive and revealing. Among Preti's numerous paintings in Caravaggesque style distinct differences in handling and in the measure of technical skill can be observed. In other words from the study of these works it is possible to observe Preti's hard-won progress from neophyte to master, which, we must assume, occurred over the course of the 1630s. It is inconceivable that the most tentative of these paintings — the present *Herodias,* for example, the *Denial of St. Peter* (Musée des Beaux-Arts, Carcassonne; fig. 39), and the three paintings of *Concerts* (Hermitage, Leningrad; Thyssen-Bornemisza Collection, Lugano; Municipio, Alba) — can be anything but juvenilia. The only logical assumption is that these works antedate not only the Dayton altarpiece but also the whole corpus of Preti's closely related paintings in Caravaggesque style including his two early altarpieces, the *Baptism of St. Augustine* (Museo Nazionale, L'Aquila) and the *Miracle of San Pantaleo* (Private Collection), as well as the large *Concert* and the *Tribute Money* in the Galleria Doria-Pamphili, Rome, and the paired *Tribute Money* and *Sinite Parvulos* (Brera, Milan), and so forth.

Toward the end of the 1630s Preti significantly broadened his stylistic repertory and began a period of experimentation. He continued to paint Caravaggesque compositions (e.g., the Dayton altarpiece) but was now also capable of bacchanales in the manner of Poussin (Musée

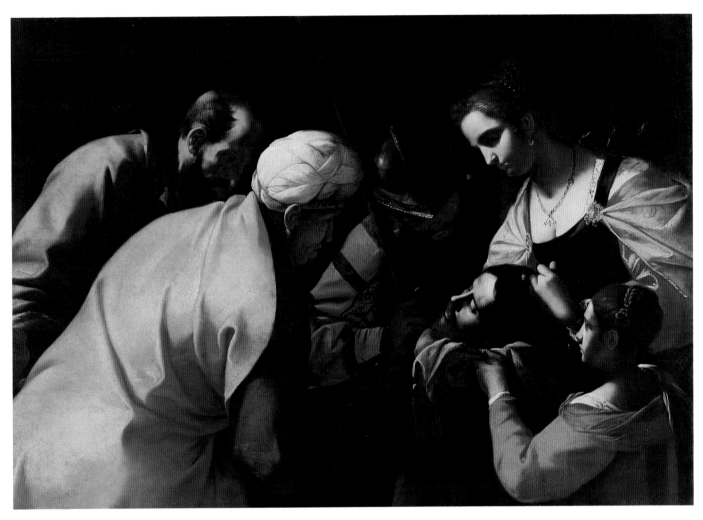

CAT. I

des Beaux-Arts, Tours) and even of classicizing works such as the *St. Andrew* in Lucerne, which he signed as an *eques* and which is therefore after 1642. Longhi (1943, 34n. 86) even suggests that Preti's stylistic fluctuations arose from his adherence to a theory of modes (see also Evonne Levy's biographical essay on Paolo de Matteis, below).

Preti's works, even at the outset of his career, are always distinguished by his irrepressible instinct for lifelike gesture and movement and his willingness to take risks for the sake of naturalness. For instance at the center of his *Herodias* Preti has positioned an anonymous soldier, his face obscured by his helmet. This supernumerary has the candor of real life. On the other hand Preti's process of self-instruction through trial and error had its lapses, and the many awkward passages in the *Herodias* reveal his inexperience. The figures are convincingly modeled as substantial volumes but the details lack crispness and the actors gesture mutely. In all these respects this *Herodias* is close in style to another work that I consider among Preti's earliest, his *Denial of St. Peter* in Carcassonne.

In the *Herodias,* furthermore, Preti is only partly successful in meeting the challenge of a five-figure composition. The principal focus falls appropriately on the charger bearing the Baptist's head. But the endless expanse of Herod's broad back, swathed in garish yellow, occupies altogether too much space, purposelessly distracting attention. Soon enough, as the later pictures in the exhibition make clear, Preti will master the skill of composing histories with figures at two-thirds length. JTS

2 *St. Paul the Hermit in the Wilderness*

233.7 x 180.7 cm (92 x 71½ in)

PROVENANCE: Colnaghi, London

EXHIBITION: Toronto 1981–82, no. 79

LITERATURE: *Burlington Magazine* 109 (June 1967), pl. xii; "La Chronique des Arts," *Gazette des Beaux-Arts* 71 (Feb. 1968): 38, no. 157, repr.; *Art Quarterly* 32 (1969): 216, repr.; Causa 1972, 338; Brown 1973, 56, fig. 28; *Art Gallery of Ontario Handbook* 1974, 53, repr.; McTavish in Toronto 1981–82, no. 79, repr.; Ann T. Lurie in Cleveland 1982, 392, fig. 173a

Collection Art Gallery of Ontario, Purchase, Frank P. Wood Endowment, 1968 67/36

St. Paul of Thebes is traditionally considered the first Christian hermit. During the Roman persecutions of the early fourth century Paul and other ascetics withdrew into the Egyptian desert where they passed their lives in prayer and self-discipline. St. Jerome wrote a biography of Paul the Hermit which abounds in miraculous apparitions and events, including the reminiscence that Paul, like Elijah, was sustained by gifts of bread brought to him by a raven. Towards the end of his long life word of Paul's holiness reached St. Anthony Abbot who sought him out in his isolation and eventually buried him (Attwater 1965, s.v.).

In Preti's painting the aged yet vigorous hermit is shown seated, interrupted at his meditations by the appearance of the raven from on high. On the lower right we glimpse another bearded head, which presumably belongs to Paul's holy visitor, St. Anthony. Paul's hoary

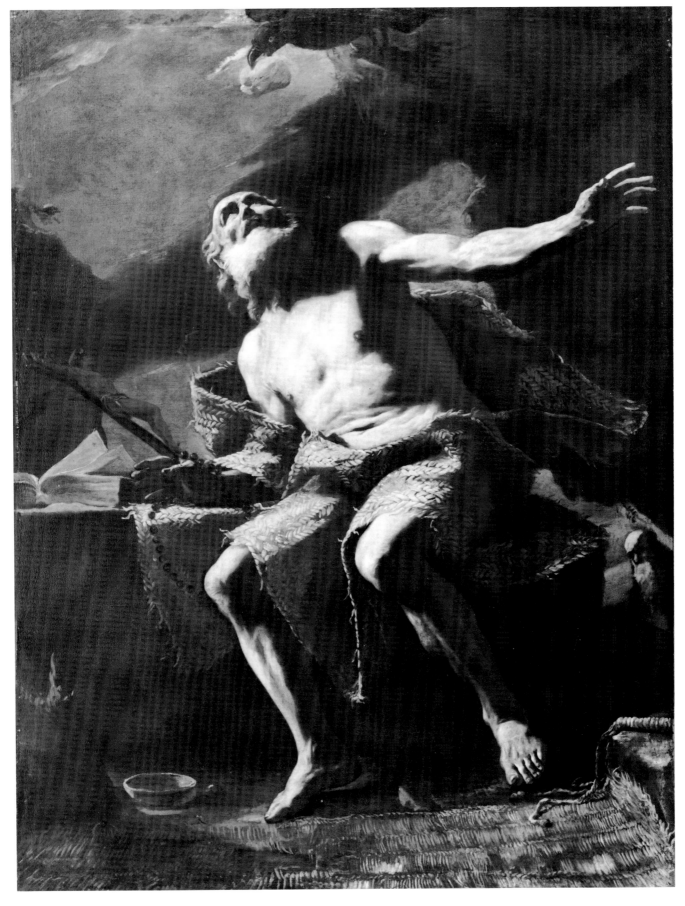

CAT. 2

FIG. 40. After Mattia Preti, *St. Paul the Hermit*, Museo de Bellas Artes de Cataluña, Barcelona

visage and his hermit's garb of woven palms depend ultimately on Guercino's portrayal of this saint in his 1637–38 altarpiece in the right transept of Sant'Agostino, Rome, and on related compositions by Guercino, including a picture in the Palazzo Colonna, Rome (Safarik 1981, no. 82) that Preti would also have known from his youth.

Apart from this family resemblance, however, this *St. Paul the Hermit* represents a striking and highly original departure from Guercino's well-known prototype. Most interpretations of the hermit saint and the miracle of the raven emphasize the humility, simplicity, and reticence of Paul as he receives his gift from heaven. Such meekness is evident in Preti's two other known treatments of the theme, both half-length figures: in the Cleveland Museum of Art (Lurie in Cleveland 1982, no. 173) and in the church of San Fermo Maggiore (Magagnato 1978, no. 21). The same holds true for a canvas in the Museo de Bellas Artes de Cataluña, Barcelona, which is apparently a copy after an untraced composition by Preti (fig. 40). It is not known which one of these pictures, if any, is to be identified with the *San Paolo primo eremita* cited in the collection of the Marchese Gagliano, Naples (De Dominici 1742–45, 3:342).

At any rate, in the present grand canvas Paul appears as a mystic enraptured by a celestial vision. The miraculous descent of the raven fills him with the kind of awe and terror that his namesake, the apostle, experienced when he was knocked off his horse while on the road to Damascus three centuries earlier. Preti has painted an icon of the high baroque that is electrified by an urgency of emotion, time, and place that can only have been inspired by Bernini. Five years earlier Preti had left Rome soon after the unveiling of the Four Rivers Fountain in the Piazza Navona, and he had adopted some of Bernini's sculptured figures for his frescoes in Modena of 1651–52 (Martinelli 1971, 193ff.). Evidently Preti's imagination was charged with

images observed from Bernini: when he came to paint the transcendent spirituality of the hermit Paul, he drew on other recollections from his youth, namely Bernini's *St. Longinus,* in St. Peter's (1630–39), the man of action, and *St. Teresa,* Santa Maria della Vittoria, Rome (ca. 1647), the mystic.

On the basis of style the *St. Paul the Hermit* is datable to the middle of Preti's Neapolitan period, ca. 1656. As in the *Martyrdom of St. Bartholomew* (cat. 3), the naturalistic treatment of the nude reveals some debt to Ribera; however the brushwork and the chiaroscuro are consciously Venetian in style and thus suggest that by now a few years had passed. The picture is probably best compared to Preti's well-known *St. Sebastian* (Capodimonte; fig. 37), although the latter work displays more of a grayish tonality observed from Lanfranco. JTS

3 *The Martyrdom of St. Bartholomew*

190.4 x 192.9 cm (74 x 76 in)

PROVENANCE: Ferdinand Vandeneynden, Naples, until 1688; Caterina Vandeneynden, Naples; Private Collection, Switzerland

EXHIBITION: Washington 1983, no. 105

LITERATURE: De Dominici 1742–45, 3:344; Sergi 1927, 89, 91, 98; Haskell 1963, 207–08; La Valletta 1970, 82–83; Rizzi 1970, 20–23; Carandente in London 1971a, no. 6; Pelaggi 1972, 68; Wright 1972, 3–10, no. 157, repr.; Spike in Princeton 1980, 94; Ruotolo 1982, 36

Currier Gallery of Art 1970.25

St. Bartholomew was one of the twelve apostles called by Christ; traditionally he is credited with carrying the gospel to India and Armenia. According to the *Golden Legend* he was flayed alive and died a martyr. These extremities of emotion and pain made his martyrdom a subject that baroque painters could not resist, especially in Naples, where Jusepe de Ribera painted it several times and etched a famous print. Byron undoubtedly had Ribera's paintings of Bartholomew's martyrdom foremost in his mind when he wrote, "Spagnoletto [Ribera's nickname] tainted/His brush with all the blood of the sainted."

In Ribera's wake Mattia Preti was similarly renowned as an uninhibited interpreter of Christian martyrdoms and Old Testament mayhem. Indeed it would appear that he was encouraged to work in this vein by Neapolitan collectors who had championed Ribera, only recently deceased (1652). Prior to his arrival in Naples in 1653 Preti had not treated violent themes with any more frequency or vehemence than any other painter associated with Caravagesque naturalism. During the 1640s, in fact, when Preti began his efforts to revive the style of Paolo Veronese, he mostly painted stately episodes from the life of Christ and other typical subjects of the Venetian Renaissance.

Preti, we now know, was present in Naples throughout 1656 and was personally witness to the ravages of the plague and famine that tortured the city during that time. He was commissioned by the *eletti* to paint ex-voto frescoes over the seven principal gates in recognition of the intercession of San Gennaro and other patron saints of Naples for the cessation of the plague

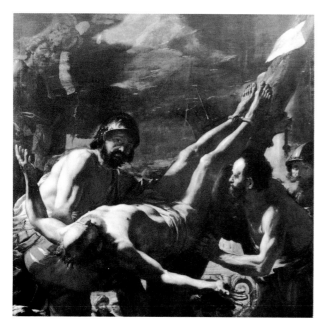 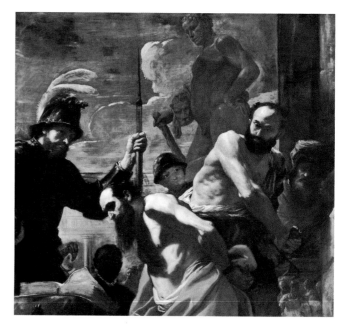

FIG. 41. Mattia Preti, *The Crucifixion of St. Peter*, Barber Institute of Fine Arts, Birmingham, England

FIG. 42. Mattia Preti, *The Decollation of St. Paul*, Museum of Fine Arts, Houston, Texas

(see Preti biography above). These poignant representations of a populace in distress (figs. 35, 36) greatly impressed his contemporaries.

According to De Dominici (writing many years after the fact), one of the first commissions that Preti received in Naples was for a large *Martyrdom of St. Bartholomew* executed for Antonio Caputo, president of the court of the Sommaria (De Dominici 1742–45, 3:341ff.). From De Dominici's description of a populous crowd and other particulars, the Caputo composition was apparently like — if it was not in fact identical to — the oblong canvas of the subject that was for many years in the Dragonetti-Cappelli Collection in L'Aquila (now on deposit in the Museo Nazionale, L'Aquila; a copy of this work was exhibited, incorrectly, as an original work and as identical to the Dragonetti-Cappelli canvas, in La Valletta 1970, no. 285).

De Dominici goes on to cite a *Martyrdom of St. Bartholomew,* of different composition from the Caputo picture, which the Flemish merchant Ferdinand Vandeneynden commissioned from Preti as one of a series of three paintings of martyrs (De Dominici 1742–45, 3:344ff.). In 1971, when a *Crucifixion of St. Peter* appeared on the London market, Giovanni Carandente proposed a reconstruction of the lost Vandeneynden series that has since been universally accepted by scholars. According to this the series consisted of the London *St. Peter* (now in the Barber Institute of Fine Arts, Birmingham; fig. 41), the Currier *Martyrdom of St. Bartholomew* exhibited here, and the *Decollation of St. Paul* in the Museum of Fine Arts, Houston (fig. 42). The series was dispersed as early as 1688 when the Vandeneynden collections were divided

100

CAT. 3

among the marchese's three daughters, and each received a Preti martyrdom (Ruotolo 1982, 12, 26, 31, and 35).

De Dominici's testimony that the Vandeneynden commission was accepted and completed during Preti's residence in Naples, and not afterwards, is fully confirmed by the style of these works. There are many points of comparison between the *Decollation of St. Paul* in Houston, particularly, and the fluid touch and brilliant chromatics of Preti's canvases for the ceiling of San Pietro a Maiella, 1657–59 (figs. 11, 12). The Vandeneynden series pays homage to Ribera in every respect, deliberately quoting the crowded arrangements and cumbersome physicality so typical of his compositions. It is evident, moreover, that Preti modeled the figures of St. Bartholomew and St. Peter with a tighter chiaroscuro that is more like Ribera's own technique. On the other hand in the Houston *Decollation of St. Paul* the shimmering passages of highlight and shadow seem to stream across the surfaces, collecting in pools and dissolving some of the massiveness of the forms. This pictorial quality accords with Preti's general development during the 1650s and presumably indicates that the *St. Paul* was the last completed of the Vandeneynden series, since we now see him beginning to lose interest in Ribera.

In addition to those just cited, two other paintings of the *Martyrdom of St. Bartholomew* by Preti are known, both of which were introduced into Preti scholarship early in our century in a pioneering article by Roberto Longhi (Longhi 1913, 41). In the Dresden gallery picture, the figures appear at two-thirds life-size, and their Riberesque conception suggests a date close in time to the *St. Bartholomew* exhibited here. A composition of two half-length figures currently on deposit in the Accademia dei Lincei, Rome, from the Galleria Nazionale d'Arte Antica, Palazzo Corsini, is a later work, difficult to judge through the surface grime, but seemingly datable to the early 1670s. Recently Spezzaferro, unaware of the existence of the Currier Gallery *St. Bartholomew,* published a copy of it, probably from the eighteenth century, that hangs in the Roman church of San Silvestro al Quirinale with a pendant *St. Sebastian* (Spezzaferro 1980, 91ff.). JTS

4 *Samuel Anointing David*

212.1 x 306.1 cm (83½ x 120½ in)

Private Collection

Shown in Kansas City only

1 Samuel 16 tells of Samuel's search for a successor to Saul, who had been rejected by God as king of the Israelites. The Lord sends Samuel to Bethlehem where he is told he will find a king among the sons of Jesse. It is only the youngest, David, called from the fields where he was tending the sheep, who receives God's blessing. He is anointed with oil by Samuel before his father and seven brothers.

Jesse solicitously holds back the edge of Samuel's rustic garment as the prophet pours oil from a horn onto the bowed head of the young shepherd, who "was ruddy and withal of a

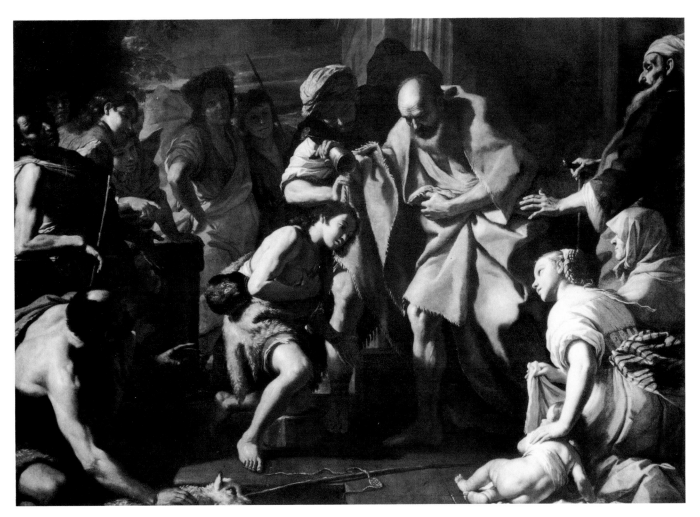

CAT. 4

beautiful countenance, and goodly to look to" (1 Samuel 16:12). The reaction of David's brothers is largely one of wonder, with the exception of the blue-and-red-draped man, his fist arrogantly on his hip, who may be Eliab, David's eldest brother. Eliab was the first to be passed over in favor of his sibling, and later he was angry at the would-be king (1 Samuel 17:28). As he does so often, Preti increases the momentousness of the event with the addition of four wondering figures on the right, not mentioned in the biblical text.

The painting can be compared to other works by Preti of similar size and subject-matter executed for private patrons in Naples. For example, De Dominici describes two large paintings in the collection of the duke of Sanseverino, *David Playing the Harp before Saul* and *The Feast of Absalom* — both subjects drawn from the book of Samuel (De Dominici 1742–45, 3:372). A painting currently with Stair Sainty Matthiesen is quite possibly the first of these. *The Feast of Absalom,* on the other hand, may be that in Capodimonte, dated by Spike to ca. 1668 (Washington 1983, 213–15). Another painting, probably dating from Preti's sojourn in Naples, i.e. from the 1650s, the Capodimonte *Return of the Prodigal Son* (fig. 8; Washington 1983, 207–09), resembles this *Saul Anointing David* in format, figure scale, and particularly in the group of the forgiving father and penitent son, who bear certain similarities to Samuel and David. Also similar are the addition of colorful, nontextual figures and the compositional arrangements across the picture plane with views into a background marked by grandiose architecture, views that derive ultimately from Veronese, to whom Preti was consistently attracted. Preti may even have seen Veronese's version of this unusual subject (Kunsthistorisches Museum, Vienna).

<div align="right">JDC</div>

5 *St. John the Baptist Preaching*

219 x 170 cm (85½ x 67 in)

PROVENANCE: Private Collection, Belgium; Galerie Heim, Paris, 1981

LITERATURE: *Triptych Calendar,* The Fine Arts Museums of San Francisco, 1981; "La Chronique des Arts," *Gazette des Beaux-Arts* 99 (Mar. 1982): 46, fig. 237

The Fine Arts Museums of San Francisco, Museum Purchase, Roscoe and Margaret Oakes Income Fund and Kathryn Bache Miller Fund 1981.32

"In those days came John the Baptist, preaching in the wilderness of Judaea, And saying, Repent ye: for the kingdom of heaven is at hand. For this is he that was spoken of by the prophet Isaiah, saying, The voice of one crying in the wilderness, Prepare ye the way of the Lord, make his paths straight. And the same John had his raiment of camel's hair, and a leathern girdle about his loins; and his meat was locusts and wild honey" (Matthew 3:1–4). St. John preaching is one of the most familiar subjects in Italian baroque painting. Its theme of charismatic evangelism was attuned to the missionary and Counter-Reformational impulses of the seventeenth century. Some painters, notably Francesco Albani and Pier Francesco Mola, favored the subject as an opportunity to set a sacred story in the midst of a pastoral landscape. Though Preti, himself a member of the order, was frequently called on to paint the Baptist as patron of the Knights of

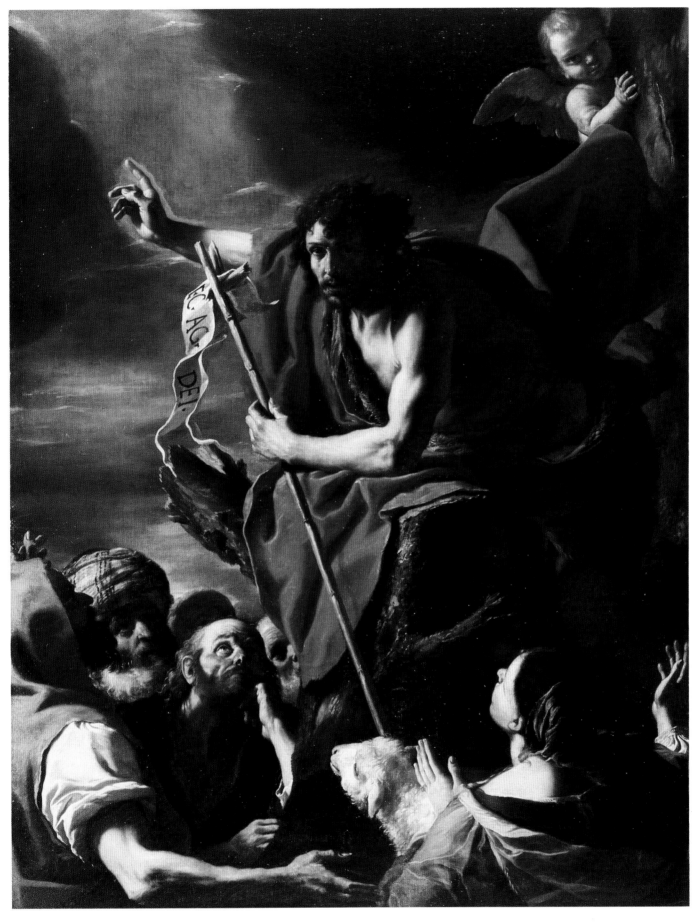

CAT. 5

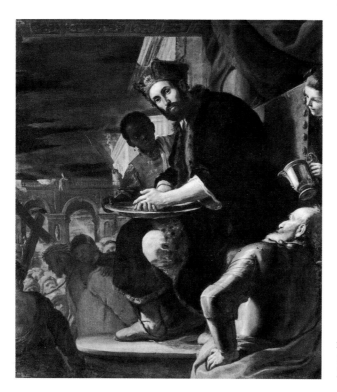

FIG. 43. Mattia Preti, *Pilate Washing His Hands*, Metropolitan Museum of Art, New York

Malta, his response to this saint never seems to have been perfunctory. He clearly felt an affinity to the Baptist's singular brand of visionary, rugged, and impassioned spirituality. An unforgettable interpretation in this vein is his *St. John* in Capodimonte. The early sources record portrayals by Preti of the Baptist preaching, but these cannot be identified with the San Francisco picture (De Dominici 1742–45, 3:346; Vandeneynden inventory in Ruotolo 1982, 29).

Although the chronology of Preti's paintings is more art than science, the present work can be dated with some confidence to the mid-1660s. Among several fixed points of reference during Preti's first decade of residence on Malta is his closely comparable canvas, *Pilate Washing His Hands* (Metropolitan Museum of Art, New York; fig. 43), which is securely dated to 1663. I infer this from a letter from Preti to Don Antonio Ruffo dated September 23, 1663 (Ruffo 1916, 318), which describes a picture of the proper size, 9 x 7 palmi, and of the same subject. One of the characteristic developments in Preti's style during the 1660s was his return to the relative stability of vertical compositions inspired by the Venetian Renaissance. In the two altarpieces of this period painted for the chapel of the grand master's palace in Boschetto and for the countryside Tal-Mirakli Church in Lija — both on the island of Malta — the artist's reference to Titian's *Pesaro Madonna* is explicit (noted by Carandente in La Valletta 1970, no. 408, pl. 81). The tendency to organize his compositions along a diagonal axis extending from lower left to upper right is also present in the San Francisco *St. John* and in Preti's *Judith Displaying the Head of Holofernes to the Bethulians* (Wallraf-Richartz Museum, Cologne), which depicts a similar company of half-length spectators in the foreground (Spike 1979b, 8). JTS

6 *Christ Seats the Child among the Disciples*

119.4 x 195.6 cm (47 x 77 in)

PROVENANCE: Julius Weitzner, New York and London, 1953

EXHIBITIONS: Oberlin 1952, no. 10; Sarasota 1961, no. 29; Raleigh 1984, no. 29

LITERATURE: *Artis* [Zurich], June 1961, 40, repr.; Bob Jones 1954, 76ff., repr.; Bob Jones 1962, 1:148ff., repr.; Bob Jones 1984, no. 96.1, repr.

Bob Jones University 53.41

*Preti
Paintings
Cats. 1–7*

The present picture, the first Preti to enter an American museum (1953) has been dated by Spike to ca. 1680–85 (Steel in Raleigh 1984, no. 29). He links it to "a group of altarpieces which the artist executed at this time for his native town of Taverna" (quoted by Pepper in Bob Jones 1984, no. 96.1). It thus would have been executed during the Malta period, about twelve years before the artist's death (Steel, in contrast, and on no cited ground, dates it "slightly earlier," and Gilbert [Sarasota 1961, no. 29] "about 1660").

The picture has stylistic and compositional affinities with Preti's *Christ and the Adultress* in the Galleria Spada, Rome (fig. 44). This latter picture, also from the early 1680s, possesses the characteristic low viewpoint, broad, powerful half- or three-quarter-length figures, friezelike composition, and air of pondered solemnity that are so pronounced in the Bob Jones picture. More specific to this decade, however, are the broad-brushed handling, less detailed than it would have been earlier, the simpler lighting effects, muted tonality, less elaborate modeling, and the somewhat flattened volumes.

One notes how much Preti does to emphasize the Saviour's divinity. His grand yet tender figure on the right, in a deep blue cloak, dominates the scene. His head shines out. The halo is sharp and brilliant, and the highlights on cheeks, forehead, and nose are dramatic emanations directly from it. Its brilliance also spills onto the back of Christ's gesturing hands.

Opposite Christ, on the left, a detached yet awed infant boy is seated on an invisible ledge or bench. The low viewpoint obscures the bench and thus dramatizes the presence of the child in the group. Behind him are the massed, heavily draped forms of the disciples. Their gravity mitigates the sense of shadowy menace that Preti had inherited from Caravaggio, that had haunted his youthful pictures, and that still appears here in this more majestic setting. That majesty comes from Guercino and the High Renaissance Venetians who were so much imitated in mid-seventeenth-century Rome.

The subject of the Bob Jones picture is taken from Matthew 18:1–6: the disciples come to Jesus and ask who is greatest in the kingdom of heaven. Christ calls forth a small child and sets him in their midst, saying that he who becomes like a little child shall be greatest in heaven. And whoever receives a child in Christ's name receives Christ; and woe to him who offends a believing child.

Yet Preti's episode is not completely distinct from the far more famous one reported by Matthew (19:13) and Mark (10:13), in which not one but several children are brought to Christ. In that scene the disciples rebuke those who have brought the children, but Christ says, "Suffer the little children to come unto me" and lays his hands on them in blessing. Mark adds Christ's

statement that "Whosoever shall not receive the kingdom of God as a little child, he shall not enter therein." This paraphrase of Christ's statement in Matthew 18:3 serves to unite the two episodes. And it is this repeated statement that Christ seems to be making in Preti's picture, for he points with his left hand to heaven and to the infant boy with his right. Meanwhile, one of the disciples, on the far right, as if to indicate adherence to this dictum, but also in fatherly protection before the overwhelmingness of Christ, grasps the boy's arm. So the frieze of hands across the front of the picture seems to say: be like this child, protect his presence among you, and you will be great in heaven.

Preti's emphasis on the protection and cherishing of children has theological dimensions. "Suffer the little children" and such variants on that theme as the present picture had become a common subject in seventeenth-century art. An early treatment by Preti is in the Brera. The episode was used by Catholics and conservative Protestants to press their belief in infant baptism as against more radical reformers who pointed out that there was no scriptural warrant for infant baptism. The orthodox Catholic view, of course, also held by most Protestants, is that babies, being prone to fatal disease yet incapable of bearing the responsibilies of the baptism that will erase original sin from their souls, should be baptized as soon as possible after they are born, with the moral and educational responsibilities of the sacrament being borne by the godparents (Bellarmino 1617, 6:190). GH

7 *The Decollation of San Gennaro*

153 x 200 cm (60½ x 78¾ in)

PROVENANCE: Marchese Gagliano; Angelo Cecconi, Florence

EXHIBITIONS: Florence 1922, no. 798; Princeton 1980, 94–95, no. 37

LITERATURE: Marangoni 1921, 367ff., repr.; Ojetti 1924, 235, repr.; Frangipane 1929, 81; Nugent 1930, 2:88–89, repr.; Refice Taschetta 1959, 65ff., fig. 44; Longhi 1961, 508; Spear 1980, 720

Private Collection, New York

San Gennaro (St. Januarius), chief patron saint of Naples, was bishop of Benevento in the fourth century (Tutini 1633). In 305 A.D., during Diocletian's persecution and after miraculously surviving various tortures, he was taken to Pozzuoli where he and his companions were beheaded on September 19. A pious woman (sometimes identified as his nurse Eusebia) collected part of his spilled blood and this was conserved in two ampules now in the Duomo of Naples. San Gennaro is perhaps best known for the miraculous liquefaction of his blood, which occurs several times each year when the ampules are brought into proximity with the saint's severed head (Caserta 1972). The first recorded instance of the miracle took place in 1389, and by the seventeenth century its occurrence was a regular part of the religious life of Naples. Failure of the blood to liquefy was interpreted as a bad civic omen. Conversely, if the miracle occurred during times of civic tragedy, it was seen as a sign of the saint's favor. Although San Gennaro was already in the fourth century proclaimed a patron saint of Naples, his relics were

CAT. 6

FIG. 44. Mattia Preti, *Christ and the Adultress*, Galleria Spada, Roma

moved several times during the Middle Ages, and their final transfer from Montevergine to Naples in 1497 contributed to the rise of his cult there. (Compare the painting by Corrado Giaquinto in the Duomo; see biography by George Hersey below.)

Two major decorative cycles were devoted to San Gennaro in Naples in the early 1630s. One, by Battistello Caracciolo, is in the Cappella San Gennaro in the Certosa di San Martino, and the other, by Domenichino and others, is in the Treasury or Cappella San Gennaro in the Duomo. But the seventeenth century in Naples is filled with images of the saint, including innumerable paintings of his martyrdom.

Unlike other representations which depict a crowd of people surrounding the seven martyrs in an open landscape (e.g., Athens 1984, 30; Naples 1984, 1:232, 254), in Preti's painting the crowd has been relegated to the background. Preti focuses instead on the single figure of the saint and on his two most important relics: his head, the darkened features of which are dramatically framed by the gold of his cope and mitre, and the blood which gushes and spurts from the gash in his neck, staining his white shirt. The saint's head is further emphasized by the cylindrical block on which it rests, by the cradling hand of the sympathetic youth behind him, and by its central position in the pyramidal grouping of the three dominant figures. One of the most salient aspects of Preti's art is just this forceful presentation of the gruesome aspects of the subject. Other examples are the Capodimonte *Judith and Holofernes* and the *Decapitated John the Baptist* in the Episcopal Palace, Seville.

The present painting essentially matches the description of a *Decollation of San Gennaro* seen by De Dominici in the house of the Marchese di Genzano (De Dominici 1742–45, 3:374). But both the attribution and the dating are problematic. While it had been accepted as autograph by all writers except the young Roberto Longhi (Longhi 1961, 508; Longhi's article was written in 1922), two other versions are now known to exist. One is in the church of Santa Maria dei Lanzati, Naples (Leonardo de Mauro in Galante 1985, 295n. 60). A good version was recently on the London art market (Christie's, July 11, 1980, lot 46, with repr.). This led Richard E. Spear, on the basis of a photograph, to reject the present work as a copy (Spear 1980, 720). However a number of Preti's compositions exist in alternative versions, and he often reworked subjects in similar ways, for example, the *Martyrdom of St. Catherine* in San Pietro a Maiella, Naples, that in Santa Caterina d'Italia, and that in the Palazzo Magistrale, La Valletta. Thus the existence of more than one autograph version of the *Decollation of San Gennaro* is very possible. Early writers assigned the present picture to the years ca. 1656–66. Spike, however, the only scholar who has studied Preti's Maltese years intensively, dates it to ca. 1685 (Princeton 1980, 94). JDC

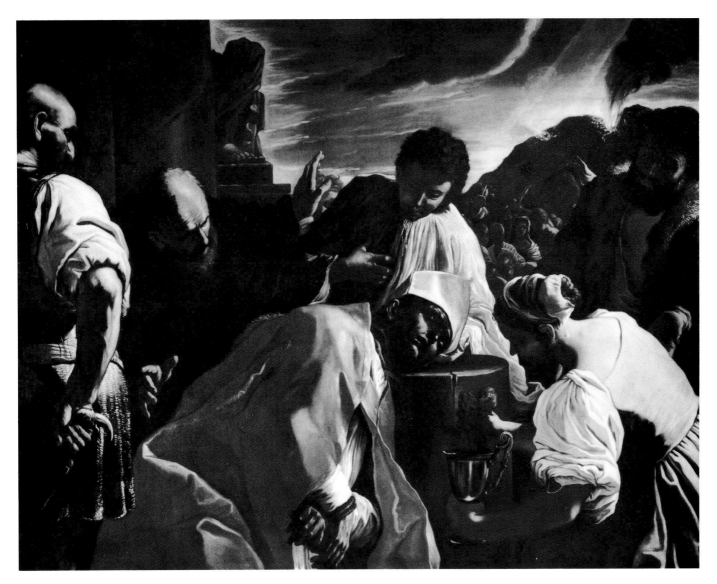

CAT. 7

LUCA GIORDANO, 1634-1705

Judith Colton

The Prior of the Escorial wrote to Charles II: *Today your Giordano has painted ten, eleven, twelve figures three times life-size, plus the Powers, Dominations, Angels, Seraphim and Cherubim that go with them and all the clouds that support them. The two theologians he has at his side to instruct him in the mysteries are less ready with their answers than he is with his questions, for their tongues are too slow for the speed of his brush* (Bottineau 1960, 252).

Luca Giordano was one of the most prolific painters who ever lived. Everyone knows that he was given the nickname "Luca fa presto," and it is said that this *fa prestismo* was displayed as never before in the Imperial Staircase and in the vaults of the church of the Escorial (see below, and Carr 1982, 44). From Lanzi we learn that he was called by two other names as well, the Thunderbolt, and the Proteus, of Painting (Lanzi 1834, 2:294) — which latter has to do with his legendary ability to imitate other artists — Dürer, Bassano, Titian, Rubens (see below). Still another legend has it that not only did Luca improvise entire frescoes while he was on the scaffolding but that he brought half-nude models up with him to make this possible (Millen 1976, 303, 312n. 33). No one faced with the task of writing a biography of Luca Giordano, be it ever so modest, can help joining the learned advisers at the Escorial in their wonder at the fecundity of his imagination. There is a social level to all this, too. De Dominici tells us that Luca claimed to have painted three classes of works, those done with brushes of gold, those with silver, and those with copper brushes, respectively for nobles, bourgeois, and plebeians, with prices to match (De Dominici 1742–45, 3:433; see also John Spike's essay above). From Pisanello's day onward those three metals had been used, along with bronze, to cast three corresponding grades of honorific medallions. In other words Giordano quite frankly executed some works that were below his top level and were intended to be. Like a modern manufacturer he went after a three-tiered market.

Luca Giordano's early years are embedded in mystery. Francesco Saverio Baldinucci and De Dominici are his chief early biographers (Ferrari 1966, 89ff., 129ff.; De Dominici 1742–45, 3:394–456). The two texts together produce the following picture: Giordano was born in Naples on October 18, 1634. His father, Antonio, a painter whom De Dominici characterizes as a mediocre copyist of Ribera, and his mother, Isabella Imparati, actually named the boy

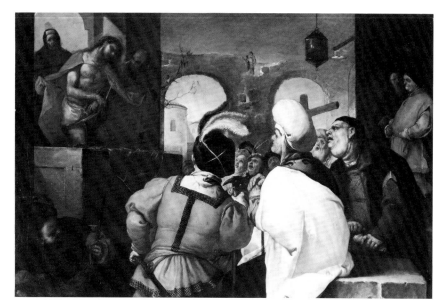

FIG. 45. Luca Giordano, *Ecce Homo*, panel, Walters Art Gallery, Baltimore, Maryland

Agostino. Only when they decided to have him trained as a painter did they rename him Luca. They may have assumed that their child, a disappointment in school, would need all the protection he could get from the patron saint of his future profession. But a few years later, when Luca was eight, Antonio and Isabella learned that their son's talent was in fact extraordinary. Both Baldinucci and De Dominici recount the same episode, which took place in the church of Santa Maria la Nova (Ferrari 1966, 90–91; De Dominici 1742–45, 3:395; see also Galante 1985, 82). The boy's father was commissioned to paint several angels in fresco in the chapel of Sant'Onofrio. Antonio was not a fresco painter himself. He rejected Luca's offer of help and instead left him in the chapel when he went to seek the aid of another artist. As soon as he was alone the child — as readers familiar with the topoi of artists' biographies might expect — climbed onto the scaffold, painted one of the angels, and sketched in the other. When the father returned and demanded to know who was the author of the "inaspettata novità," Luca admitted that it was he. He was then challenged to finish the second angel before his father's eyes. Antonio, upon seeing it completed, knelt down to thank God that he had been given a son of such talent (Ferrari 1966, 90–91). The next thing we know is that a viceroy of Naples (Baldinucci and De Dominici disagree as to which one [Ferrari 1966, 91; De Dominici 1742–45, 3:395]) heard about the young painter and introduced him to Ribera, who became his master.

There are other tales. We may not know with certainty whether Massimo Stanzione saw a drawing made by the five-year-old Luca and predicted that he would become the greatest artist of his time. But the story does illustrate the mood of childhood prodigy that fills the lore of Luca Giordano. Similarly, whether or not he was actually a pupil of Ribera's, it is certain that Luca was profoundly influenced by the older master and that he copied him not only in youth but throughout his life.

We can similarly exploit both fact and possible fiction in following Luca's early develop-ment. For example we read, and it may be true, that Luca and his father went to Rome when the boy was ten or eleven. We are told that the young artist made successful copies of works by Raphael, Michelangelo, Polidoro, and others, and that he continued to do this as well as to produce little paintings in imitation of various earlier masters when he returned to Naples (Ferrari 1966, 91, 92). However, no one today thinks all these pictures are childhood works. A case in point is the striking *Ecce Homo* (fig. 45) in the Walters Art Gallery, a fascinating commentary on Dürer. This once hung side by side with a mock Veronese, a *St. Lucy,* also by Luca, in the palace of Diomede Carafa in Naples (Celano 1692b, 1126). Luca's mimicry may have earned him a certain amount of criticism on the part of jealous fellow artists. Indeed, the characterization of him as Proteus was probably meant derogatorily (Millen 1976, 302).

Luca left Naples for Rome and for a visit to the north of Italy about 1652. The event may have coincided with Ribera's death in September of that year. De Dominici claims that the artist then spent three years in Rome, though more recent biographers say he was back in Naples early in 1653 (e.g., Ferrari in Naples 1984, 151). Whatever the length of his stay in Rome, it is certainly possible, as De Dominici claims, that Luca came into contact with Pietro da Cortona (De Dominici 1742–45, 3:396). And it is more than possible that in Rome he looked at the works of Correggio, Titian, Veronese, Tintoretto, and painters of the Lombard School. We also learn that Luca went on to Parma, perhaps to Bologna, and to Venice, and returned to Naples via Florence, Livorno, and Rome once again (De Dominici 1728, 309; De Dominici 1742–45, 3:397). In Venice the eighteen-year-old artist was invited to paint several altarpieces, a stunning accomplishment. These — the *Madonna delle Grazie* in San Pietro di Castello, probably the *Deposition* for Santa Maria del Pianto (today in the Accademia; a small replica is in the Worcester Museum of Art, Massachusetts), and the *Madonna and Child with St. Joseph and St. Anthony* painted for the Spirito Santo and today in the Brera — all illustrate Luca's early penchant for stylistic variety. He brought to Venice the robust naturalism of his native city derived from Ribera, of course, and from other artists at work in Naples such as Francesco Fracanzano. On his travels, however, Luca developed an interest in gold and silver tonalities. Great bursts of this light appear behind the otherwise retardataire groupings of figures that fill his Venetian works. In Venice he was also deeply drawn to the great painters of the cinquecento, especially Veronese. During much of the rest of his career Luca joined Venetian magnificence and tonality with what he learned about color from Cortona (De Dominici 1742–45, 3:397). Nor was he ever fully to reject what he had learned from Ribera.

The work Luca Giordano produced in Naples from ca. 1654 to ca. 1660 testifies to his willingness to experiment and, at times, to provoke. If we look at the *St. Michael* in the Ascensione a Chiaia of 1657 (fig.49), for which there is a sketch in the present exhibition (cat. 8), we are struck by the extreme foreshortening of the figures and by the suffusions of golden light (more pronounced in the full-scale work; see James Clifton's entry, below). Also from the 1650s are several pairs of altarpieces and a number of single paintings that established the artist's reputation. They are among his most powerful works. I am speaking, first, of the two pictures executed in 1658 for Sant'Agostino degli Scalzi, the *St. Thomas of Villanova Distributing Alms* and the *Ecstasy of St. Nicholas of Tolentino.* In the former (fig. 9) there is an obvious quotation from

FIG. 46. Luca Giordano, *San Gennaro Frees Naples from the Plague*, Santa Maria del Pianto, Naples (on deposit in Museo di Capodimonte)

Titian's *Martyrdom of St. Lawrence* in the Gesuiti, Venice, noted by most authors. And, too, Luca shows his fascination with Veronese in the architectural setting and placement of figures. He also begins to create a new kind of figure here, evoked only by the lightest and quickest of touches and enveloped in a golden light charged with grays, blues, and earth colors. All this is brought out magnificently in the details taken by the Neapolitan photographer Mimmo Jodice (Jodice 1985, 69, 71, 129, 149). As I see it, Cortona continues to play his part in this development. The semicircle of figures, lightly indicated and bathed in golden light, directly behind Divine Providence in the Barberini Palace, remains crucial to Luca Giordano. Even while in Venice focusing on Veronese, De Dominici claims, Luca does not forget Cortona's "bel colorito." It is this new manner that informs the great altarpieces of the late 1650s, works in which Giordano, following Preti, brought Neapolitan painting out of its fifty-year involvement with dark tonalities and with Caravaggism into the mainstream of the international late baroque.

Luca Giordano

One such altarpiece is the *San Gennaro Frees Naples from the Plague* (fig. 46), painted for Santa Maria del Pianto, Naples and in place by 1662. In it there are echoes of Ribera and perhaps of Fracanzano and Stanzione; but the work also reflects Luca's Venetian experiences, Cortona, and perhaps Rubens — or, as Spear temptingly suggests, Rubens's Venetianism (Spear 1983, 136). The painting has a pendant, *The Patron Saints of Naples Adoring the Crucifix* (Ferrari-Scavizzi, 1966, 3, pl. 94). Both were ex-votos from the plague of 1656 (Ferrari in Washington 1983, 175; see also Wethey 1967, 678–86). Here Giordano was competing with Andrea Vaccaro, also at work on a painting for this church. De Dominici claims that the bozzetti made by the two artists were sent to Rome and judged by Cortona, Sacchi, Giacinto Brandi, Gaulli, and Bernini, and that Vaccaro was declared the winner. Whether or not this is true the story shows that by about 1660 Luca Giordano was on a par with the best artists in Naples.

Another rivalry, more challenging, looms in the San Gennaro altarpiece. As several of our contributors point out, in 1656 Mattia Preti had been commissioned to fresco the city of Naples with ex-votos showing the Madonna and Child and the city's patron saints protecting the plague victims. From the two bozzetti for this latter program that have survived (figs. 35, 36) we know that Luca studied Mattia's frescoes carefully before painting his San Gennaro altarpiece. Yet for Mattia's livid-toned victims' bodies Luca substitutes golden light that nearly dissolves the forms and a palette of brilliant colors (Jodice 1985, 49). All this comes from the Venetians and perhaps from Cortona. In short, Luca's great picture involves a quintessentially Neapolitan subject — indeed an episode from the city's history — reinterpreted via Luca's own earlier work, with additions from Veronese, Cortona, possibly Rubens, and Preti — all formed into something new and fully personal to Luca.

Giordano's study of Veronese led him into another dialogue with Mattia Preti, since both artists in these same years were painting similar groups in resplendent architectural settings. Giordano's *Feast of Herod* (cat. 9) can be counted a small but striking example (see also figs. 51, 52). Though, as David Nolta points out in his entry, it clearly refers to Rubens's famous *Herod*, in Naples since 1640; it also echoes Preti's painting of the subject in the Toledo Museum of Art (fig. 7). But even while Luca draws near to Preti in some respects he moves away from him in his concentration on action as opposed to inner emotions. Luca will become more and more adept at rapid brushwork, eventually painting monumental frescoes which have the freshness

and rapidity of the modern watercolor. In works like the *Herod* we are struck by the play between the firm modeling and his own calligraphic leanings.

Luca's early penchant for mimicry was becoming one of the foundation stones of his achievement. By 1660 he was drawing contrasts — within a given work and between works made at the same time that were deliberately painted in different styles. His reputation had by now risen beyond that of all other Neapolitan painters (Ferrari 1970, 1252, 1254, 1256). Yet he was still involved with them, treating them as prisms through which to look at still other artists. As suggested, he was as interested in Preti's vision of Veronese as he was in Veronese himself. Preti indeed had made it possible for Giordano to see the "art of the present and the past as an open field . . . freely available for new experiences" (Ferrari 1970, 1246). Yet elsewhere Preti and Giordano remained separate. Preti's fusions of earlier styles employed a tragic mode. Ultimately he retained a powerful link with Caravaggism and with the seicento. Giordano, on the other hand, despite buried affinities with Ribera and Lanfranco, was the first Neapolitan to turn away from this tradition of solemn, violent, black-shadowed scenes.

During the 1660s and 1670s Luca was concerned with refining the styles he had appropriated from other artists in the 1650s. The old baroque exuberance calmed down. Yet Luca remained a true Proteus, consistent in his endless diversity. In the Philadelphia Museum of Art's *St. Sebastian Cured by St. Irene* (fig. 14), or in the vastly different *Christ the Intercessor* in Ponce (cat. 10), he reexamines Ribera and produces two paintings that are very different and powerful but that could never be mistaken for those of the older artist (see also fig. 13). As to another early "master," it would be difficult to find a time in Luca's life when Cortona is not reexamined. But in the period we are considering here Luca's interest extended to the artists Cortona had studied, to Annibale Carracci (e.g., Luca's *Assumption* of 1667 in Santa Maria della Salute, Venice), and to Annibale's Bolognese disciples. Then too, as Solimena was to do, Luca perfectly mimics his earlier self. One would not think it possible to mistake a work of the 1650s for one of thirty years later but this has indeed happened (for example, see Schleier in Washington 1983, 175–76).

The presence of Luca's pictures in a major Venetian church encourages one to consider his travels in 1660–80. Baldinucci is unique among Luca's biographers in mentioning a trip made in 1665 to Florence, where the artist painted a large and impressive *Triumph of Bacchus* for Cosimo III de'Medici and works for other Florentine patrons (Ferrari 1966, 94). This was apparently followed by a stop in Venice. Perhaps it was on this trip that he was commissioned to paint one or more pictures for the Salute for, two years later, in 1667, he sent the *Assumption,* already mentioned, from Naples (Pallucchini 1981, 240).

During the following decade, Luca painted two other pictures for the same Venetian church. Given his pictorial range it is not surprising that these are stylistically "Venetian" and have a clear relation to Titian, Tintoretto, and Veronese. But they are also closely related to Cortona and to Bolognese traditions of the period from about 1620 to 1650. For Solimena in the 1680s, Luca's reinterpretation of Cortona in these Salute pictures was all-important. Solimena's *Birth of the Virgin* (cat. 20) in the present exhibition bears this out.

In the 1670s Luca was involved in fresco commissions. The most important was for the ceiling of the nave of the Benedictine abbey church at Montecassino (see essay by Robert Enggass, above). Giordano's five major frescoes, contracted for in April 1677, are thought to

have been completed by the end of the same year (Ferrari-Scavizzi 1966, 1:75). Thus was the artist's legendary *fa prestismo* put to use for the first time in large-scale decoration. A contemporary cycle, much restored and in poor condition, is in Santa Brigida, Naples. Though we can see little of these works today, and though they were the result of Luca's collaboration with a large workshop, Luca now turned for inspiration to Lanfranco's dome fresco in the Cappella San Gennaro of the Duomo.

Luca's interest in Lanfranco's dome continued into the decade of the 1680s, as did his involvement with major decorative programs. As to the latter, in 1684 he painted a magnificent scene, the *Christ Expelling the Moneychangers from the Temple,* across the interior wall above the main entrances to the church of the Girolamini in Naples. Not only was it to have an effect on Solimena but prior developments in Solimena's own work may have led Luca to the great scenographic display we have here (see Carmen Bambach Cappel's biography, below). Today we await with eagerness the results of the current cleaning. A fresco of comparable importance was painted in these same years in Florence. Indeed, there are several Florentine works in this medium. First Luca undertook a dedicatory scene in the cupola of the Corsini chapel in Santa Maria del Carmine. A recently discovered letter of February 1682 by Andrea del Rosso tells us how quickly the frescoes were done (Detroit 1974, 258; Büttner 1972, 229; for the relationship between Del Rosso and the Corsini and Riccardi families, see Haskell 1980, 210–13; Ruotolo 1982, 9; Longhi 1956, 61–64). Recent scholars believe that Luca arrived in Florence early in 1682 and worked on the Carmine frescoes from February until about August of that year. Thus both the main Corsini chapel fresco and the four spandrel frescoes (Ferrari-Scavizzi 1966, 3, pls. 193–96), one of which contains the date 1682, were all executed in the same short period. In these months, Luca also began work on the Medici-Riccardi vault and is thought to have continued until about Christmas 1682 (see Millen 1976, 296).

New material has come to light on this latter project, often considered his masterpiece. The gallery was one of the additions to the famous fifteenth-century palace that were made in the 1670s by the Riccardi family, who had bought the building from the Medici in 1659 (Büttner 1970, 369, 402, 414; on the Riccardi, see Malanima 1976, 175ff.). Another addition was a library, also decorated with a fresco by Luca. The Marchese Francesco Riccardi, in commissioning these works from Luca Giordano in 1682, clearly wished to rival such earlier palace fresco programs as the Barberini and the Pamphili in Rome and the Medici and Corsini in Florence (see Millen 1976, 309). Francesco's gallery was originally destined to contain his collection of precious objects: crystal vases, agate, and jasper (Ferrari-Scavizzi 1966, 1:97–98).

Ronald Millen (1974, 1976) has shown that during his Florentine sojourn of 1682 Luca frescoed only the central portion of the gallery's vault. This was treated as a *sfondo,* or centerpiece, for which the artist painted an apotheosis of the gods on Olympus. It is not certain whether, at this first stage, the notion of including likenesses of the Medici family in the guise of the Olympian gods had yet been formulated. Figures of virtues were planned for the corners of the ceiling as well, and an elaborate stucco cornice was projected. But when the ceiling was completed several years later a more elaborate scheme was substituted, and the cornice was no longer needed (Ferrari in Naples 1984, 317; Millen 1974, 28–31).

The ceiling as we know it today resulted from a second campaign carried on from the spring

Luca Giordano

of 1685 through the spring of 1686. It is a rich array of figures in continuous narration all around the edges, with a complex iconography devised by the scholar Alessandro Segni representing an allegory of human progress (figs. 16, 17; see especially Büttner 1972, 32–73; also Ferrari in Naples 1984, 317–19; Chiarini in Detroit 1974, 260–61; Millen 1965, Introduction). Ten of the bozzetti and modelli for it are today in the Mahon Collection in London (see Briganti 1953, 9, 14, 16–17). An eleventh is in another private collection in London, and there may be still another on the art market (Ferrari in Naples 1984, 318–19). At least some of these works were made expressly for Francesco Riccardi in order to show him what his gallery would look like and are known to have decorated the walls of marchese's the private apartment (Ferrari in Naples 1984, 319; see also Millen 1976, 309). Today scholars do not agree about the original number of these preparatory works or whether they were bozzetti, modelli, or, in some cases, ricordi (see especially Millen 1976, 296ff.; Büttner 1972, 74–80).

Thus with Luca Giordano as with other artists in our exhibition we have the problem of sorting out bozzetti or modelli vs. ricordi. A case in point is the *Allegory of Prudence* at the Museum of Fine Arts, Houston (fig. 47). It depicts one of the Medici Palace allegories but comes from Spain (Ferrari in Naples 1984, 319). Ferrari calls it a ricordo, but Millen, on the basis of a photograph alone, thinks it may be the bozzetto itself (Millen 1976, 307). In the better-known but weaker version of this subject in the Mahon Collection, the figure in the upper left holds an olive branch. Here, however, as in the ceiling itself, she holds a caduceus. The Houston picture is thus probably a ricordo which Luca may have sent to Spain, where his work was popular, before he actually arrived there in 1692 (see Bottineau 1960, 252).

Another reason for our interest in the Medici-Riccardi frescoes and the spinoffs from them is the way in which they are linked to several paintings in the present exhibition that date from the years immediately following the ceiling. Indeed, by far the largest number of Giordanos in America are datable to the period from the late 1680s to the end of the following decade. The Norfolk *Bacchus and Ariadne* (cat. 11) is probably the earliest of our pictures from the 1680s. In mood, handling, and coloring it has strong affinities with the Riccardi modelli and with such contemporary works as the *Latona* today in the Palazzo di Montecitorio, Rome (Ferrari-Scavizzi 1966, 3, pl. 315). It also has affinities with the Hartford *Rape of Europa* (cat. 12).

There are three or four pictures in our exhibition which may have been painted in the period between Luca's return to Naples from Florence and his departure for Spain — that is, between the spring of 1686 and May 1692. I am speaking of the Austin *Presentation of the Virgin* (cat. 13), *The Hymn of Miriam* at Bob Jones University (cat. 14), and the New Orleans *Baptism of Christ* (cat. 15). Though there are important differences among all these works, taken together they give us a picture of Luca at the height of his powers. His figures move easily and rhythmically, often in a dancelike way. Some compositions, such as the *Europa,* the *Presentation,* and the *Baptism,* are contained within the confines of the canvas; others, the *Bacchus and Ariadne* and the *Miriam,* imply horizontal continuation beyond the frame. In this respect the two latter works reflect the Medici-Riccardi ceiling with its friezelike arrangement. Luca returns to this idea often in the two remaining decades of his career. It can be seen once again in the two bozzetti for the Cappella del Tesoro of the Certosa di San Martino (cats. 17, 18). Other aspects of Luca Giordano's work of the 1680s also carry forward into the last fifteen years of his career. For

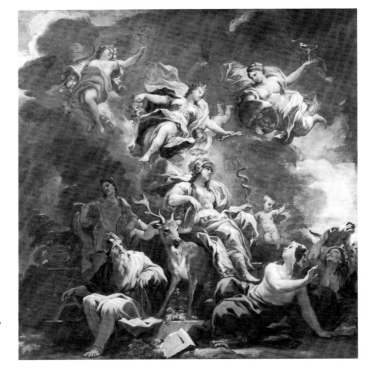

FIG. 47. Luca Giordano, *Allegory
of Prudence*, Museum of Fine
Arts, Houston, Texas

example, the balletic poses of the 1680s recur in the spectacular *Calling of St. Matthew* (fig. 32), in Georgetown University, with its monumental figures whose gestures sweep across the picture plane.

With this picture we open up the subject of Giordano in Spain. Unfortunately Luca's frescoes in the Escorial now suffer from a certain amount of ugly, black outlining by modern restorers. But if they could be properly cleaned it would be possible to follow Luca's pursuit of a new freedom and openness. An early work in his Spanish career, the imperial staircase vault, shows his strong ties to the Roman baroque, especially to Gaulli and through him to Bernini. The space is filled with a great mass of surging figures, those of the Trinity in the center being adored by Charles V and Philip II, the founders of the House of Austria in Spain (see Carr 1982, 44; Griseri 1956, 33–39), and, below, behind a balustrade, the reigning royal family. As Luca proceeded to decorate the vaults of the Escorial church, first those of the side aisles and later the main vaults, there comes however a great freedom in rhythm and in the density of the groupings. Yet in the sacristy of Toledo Cathedral, begun in the spring of 1698, he returns to the Roman plasticity of the imperial staircase. Also, surprisingly, in the bozzetti for the lost cupola frescoes of the royal chapel at the Alcázar, the artist once again draws closer to Mattia Preti. He will do this yet again in San Antonio de los Alemanes, of ca. 1690, and, back in Naples, in some of the dramatic paintings of the last three or four years of his life. Yet in the very last of these Spanish ensembles, the ceiling fresco for the Casón del Buen Retiro with its representation of the Foundation of the Order of the Golden Fleece, the rhythm is entirely different from that

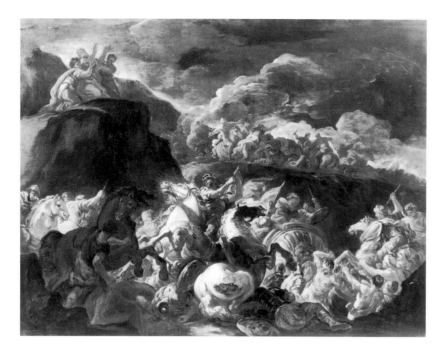

FIG. 48. Luca Giordano, *Battle of the Amalekites and the Israelites*, Sarah Campbell Blaffer Foundation, Houston, Texas

of the Escorial staircase and of Gaulli in the Gesù. Figures are dispersed through the ample, spacious vault. The whole is reminiscent of Preti's precocious fresco at Valmontone, of ca. 1660, but in Luca's case is imbued with the flow and brilliant lighting we have come to associate with him.

If we turn briefly to the easel paintings Luca made in Spain we find a wide spectrum of possibilities. One work in an American collection but not in the present exhibition is the *Battle of the Amalekites and the Israelites* (fig. 48), formerly in the Manning Collection in New York and today in the Blaffer Foundation, Houston. While it was thought some years ago that this was a painting of the 1680s, scholars have recently linked it, to my mind convincingly, with a vault in the right transept of the Escorial church (Pignatti 1985, 158). The Blaffer painting is probably not a proper bozzetto but a sketch relating to different parts of the fresco — a working out, directly on canvas, of certain relationships that the artist then developed in the final work. It has the immediacy of preparatory work and anticipates in many ways our two studies from St. Louis for the Cappella del Tesoro at San Martino (cats. 17, 18).

In 1702 (Palomino 1715, 1113; Bologna Forthcoming; Chiarini in Detroit 1974, 254 exceptionally gives the date as 1703), Luca Giordano returned home via Livorno, where he was employed briefly by the Medici. During his ten-year absence from Naples much had occurred. Preti, who had lived until 1699, had continued to send canvases back to Naples from Malta, and others were probably sent after his death. Solimena, in the meantime, had shifted from the Giordanesque style of the San Paolo Maggiore frescoes to the Arcadian mode that characterizes much of his production from ca. 1695 to ca. 1730. In a sense De Matteis was caught between

these two alternatives, the Giordanesque and the Arcadian. Yet De Matteis, the closest disciple Giordano had left behind, was not even in Naples, but in France, when Luca returned. Meanwhile with both Giordano and De Matteis gone, Solimena was clearly moving up in fame, though in 1702 he may not yet have achieved his fullest eminence (Rabiner 1978a, 8ff.).

In this setting Luca retains the painterly freedom he had exercised in Spain. But his work gains in intensity. In the frescoes of the Cappella del Tesoro of San Martino, which De Matteis thought were Luca's best works (De Dominici 1742–45, 3:541ff.), though there is a range of color accents (predicting Sebastiano Ricci and Giaquinto), the pictures are dominated by silver-gold tonalities that produce an effect of monochrome (cats. 17, 18). In his old age Preti had done the same thing, though his tonalities were much darker and more "tragic" than Luca's. Indeed the frescoes in the Certosa look steadily forward to the lightness of atmosphere and balletic buoyancy of the later settecento.

Yet Preti is not permanently forgotten. Some of the paintings of ca. 1704–05 point to a renewed study both of Preti's and of Solimena's most recent work. This comes out most fully in the Girolamini paintings (Ferrari-Scavizzi 1966, 3, pls. 520–24), where Giordano reintroduces monumental figures, usually grouped in pairs with subsidiary personages. They combine the monumentality of Preti with Solimena's powerful shadow-calligraphy (see Ferrari-Scavizzi 1966, 1:179). In two other series, one for Santa Maria Egiziaca done soon after Luca's return and, at the very end of his life, in the Donnaregina series, the artist combines his Spanish freedom with a new, or renewed, penchant for violence. This too may come from Solimena.

Luca Giordano remained, in a sense, the inspired mimic, the daredevil, that the childhood lore portrays. His career maps his climb to European eminence. But that eminence only made him a kind of titanic protean. Celano perhaps best summed him up: "What was not possible to that ferocious but broadly imitative imagination of Luca's?" (Celano 1692b, 2030).

Luca Giordano

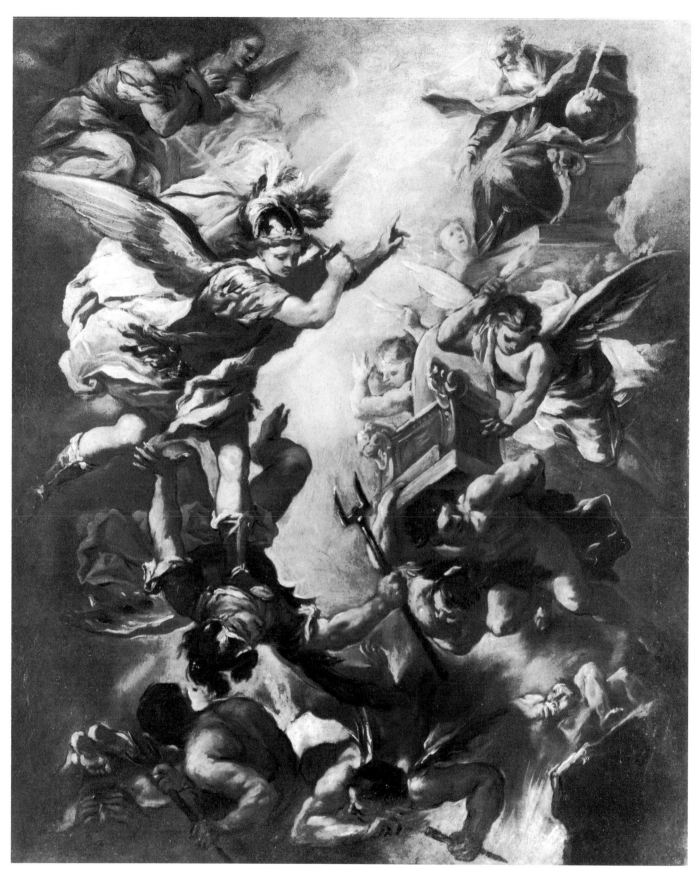

CAT. 8

8 The Archangel Michael

76.2 x 63.1 cm (30 x 24⅞ in)

Didier Aaron, Inc., New York

The painting illustrates a passage in Revelation 12:7–9. Angels who had been created good, led by Satan (later identified with Lucifer), turned against God. St. Michael cast them out of heaven. His greatest victory was over Lucifer, who in the battle assumed the form of a dragon (Schleier 1971, 510).

The present work is a preparatory sketch for Giordano's painting above the high altar of the Chiesa dell'Ascensione a Chiaia, Naples (Galante 1872, 386ff.), signed and dated 1657 (fig. 49). Giordano painted a second altarpiece for the church, a *St. Anne and the Virgin,* also signed and dated 1657 (Ferrari-Scavizzi 1966, 3, pl. 57).

Giordano's conception of St. Michael's battle with Lucifer and the other rebel angels differs radically from earlier ones. To be sure the angel's precarious leap harks back to Raphael's prototype from 1504, now in the Louvre; nor is the complexity and tumultuousness of the battle itself unprecedented. But where other representations of the theme center on a struggle between St. Michael and Lucifer, Giordano has shifted this confrontation to the left side of the canvas and creates a swirling, o-shaped composition out of other angelic and demonic figures. It is a fuller realization of the famous phrase from Revelation: "There was war in heaven."

There is another novelty. In the upper right-hand corner is the enthroned figure of God the Father who gestures downward on a diagonal matching St. Michael's own gesture toward him. God the Father only rarely appears in depictions of St. Michael, and Giordano's inclusion of, and even emphasis on, God's throne seems new. This is in turn exploits the most unusual of the iconographic elements Giordano introduces into this composition: the other throne, Lucifer's, which is carried to the fiery pit by one of his demon allies. In support of these thrones Giordano adduces (in the final version only) an additional biblical passage which he has inscribed on Lucifer's throne — *similis ero altissimo* (I will be like the Most High) — based on Isaiah 14:12–15: "How art thou fallen from heaven, O Lucifer, who didst rise in the morning? . . . And thou saidst in thy heart: I will ascend into heaven, I will exalt my throne above the stars of God, I will sit in the mountains of the covenant, in the sides of the north. I will ascend above the height of the clouds, I will be like the Most High. But yet thou shalt be brought down to hell, into the depth of the pit" (Douay-Rheims version).

Giordano treated the theme of St. Michael about a dozen times during his long career (Ferrari-Scavizzi 1966, 2:35, 55, 62, 175–76, 191, 281, 283, 304, 335, 352, 353, 359, 365, 376; Schleier 1971, 510ff.). The throne of Lucifer appears two more times in Giordano, though with somewhat less emphasis: in an altarpiece now in Vienna and in a painting now in the collection of the Duque de Almazán (Madrid), executed during Giordano's sojourn in Spain (Ferrari-Scavizzi, 1966, 3, pl. 349). There was also a major version of the subject, now destroyed, at Montecassino (see above, essay by Enggass). The motif of the two thrones seems to have been picked up only by artists active in and around Naples. It appears in altarpieces by Angelo Solimena (Sarno, Duomo; Spinosa 1984, pl. 737 and Pavone 1980, fig. 81). Francesco Solimena

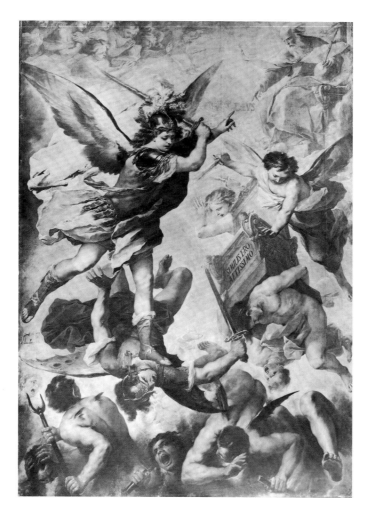

FIG. 49. Luca Giordano, *The Archangel Michael*, Chiesa dell'Ascensione a Chiaia, Naples

also used it (Chiesa di San Giorgio, Salerno; Bologna 1958, 74, and fig. 87). These artists were probably most directly influenced by Luca's Vienna picture (fig. 50), in which Lucifer is still more or less seated on the throne rather than being cast from heaven as in the Ascensione composition. Giaquinto's St. Michael in Santa Croce in Gerusalemme (cat. 42), on the other hand, is more like the Ascensione figure.

The present sketch well illustrates how a bozzetto relates to the final altarpiece. It is thinly painted in rather dull colors (compare, for example, the transformation of gray to light blue in the robe of God the Father); the brick-red underpainting provides shadow tones, particularly on the figure of St. Michael; many of the forms, especially along the left edge of the canvas, are lightly sketched in with a brown outline or are left incomplete. Lucifer's two-pronged pitchfork and the thunderbolts of the angel at the right side of the bozzetto are both replaced in the altarpiece with swords, so that these two angels are armed as St. Michael is. At the upper left a chorus of bright golden angels is substituted for the more darkly painted pair in the sketch. This

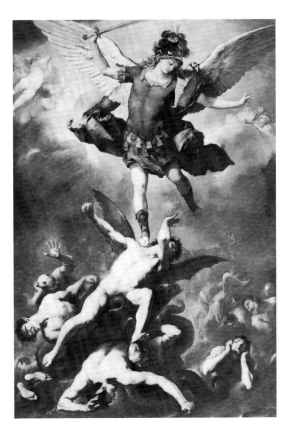

FIG. 50. Luca Giordano, *The Archangel Michael*, Kunsthistorisches Museum, Vienna

may echo Revelation 12:10: the triumph of the good angels after St. Michael's victory. Significant changes also occur in the lowest register of the composition, where the relative positions of the main figures are shifted slightly, other figures are removed, and new ones added. One element that was eliminated in the final version is the pair of feet in the lower left-hand corner. These also appear in Giordano's Vienna *St. Michael* (fig. 50), suggesting that the two works may be close in time.

A final point about the Didier Aaron composition involves Luca's relationship to his master, Jusepe de Ribera. The demon in the lower right-hand corner of the Didier Aaron canvas who raises one hand to his mouth and looks upward in fear recalls a similarly placed figure in the Vienna picture who, however, holds his hands to the sides of his head as he screams. This figure appears elsewhere in Giordano's oeuvre, in two versions of *Apollo and Marsyas* (Museo Bardini, Florence, and in the Museo di San Martino, Naples; Ferrari-Scavizzi 1966, 3, pls. 12, 13). It derives directly from a Ribera prototype (Felton 1971, 125).

Thus the removal of this figure in the Ascensione version of the scene means that one debt to Ribera has been eliminated. Yet other such debts remain. Aside from the demon at the lower right the figures are firmly modeled with taut, sinewy muscles and leathery skin, effects derived from the older artist. But this influence is not equally felt in all parts of the bozzetto, and in the

127

altarpiece itself that influence diminishes further still. Thus in the Ascensione altarpiece the forms are newly abundant and flaccid, the colors newly clear and bright. As Baldinucci notes this shows the impact of Veronese (Baldinucci 1975, 344). De Dominici also discerns links between Luca and Veronese (De Dominici 1742–45, 3:400). Meanwhile Ferrari and Scavizzi suggest that the final altarpiece's more baroque elements are the results of Rubens's influence (Ferrari-Scavizzi 1966, 2:35). One thinks particularly of the o-shaped composition.

While Giordano's style during the 1650s and early 1660s does not seem to conform to an identifiably linear development — due largely to his inconsistent use of Riberesque modes of painting — the Didier Aaron *St. Michael* does show him in the process of rejecting Ribera and developing a mature style based more on non-Neapolitan sources. JDC

9 *The Feast of Herod*

70 x 72 cm (27½ x 28⅓ in)

PROVENANCE: Edoardo Almagià, Rome

LITERATURE: Spear 1983, 136

Richard and Athena Spear

Were it not for the severed head on the silver platter this scene might be mistaken for the depiction of a privileged family at table. The story of the feast of Herod is found in the Gospels of Mark and Matthew (see also cat. 1). It is the climactic moment in a series of sordid if aristocratic squabbles and intrigues; but here, suddenly, all the trivial domestic disturbances end with the arrival of the holy man's head. In Giordano's deft theatrical rendition of the theme the four primary characters are grouped about a small round table covered with a white cloth. On the left, in the throes of intense but mixed emotions, sits Herod Antipas (referred to in the Gospels as King Herod though he was actually tetrarch — governor — of Galilee and Perea). He is dressed luxuriously in a rich red tunic with a gold chain around his waist and an ermine robe fastened around his shoulders. On his head he wears a spiked golden crown. Behind Herod and to his left is his second wife, Herodias, former wife of his own brother. She leans forward in her white dress lavishly trimmed in gold, with a pearl collar around her throat and another strand of pearls binding her dark hair. The opulence of her clothes is exceeded only by that of her daughter's (by her first marriage), who has just entered the scene on the right. This is Salome, whose legendary dance caused her stepfather to grant her whatever she desired, even up to half his kingdom. Here she is portrayed as a pretty blond, festively arrayed and jeweled. Her dress is of the deepest blue-black with an elaborate gold edging and heavily-impastoed, puffy white sleeves against which the smooth pearl tones of her exposed left arm vividly stand out. Among her many accoutrements is a yellow-gold scarf dropping off her back and a gold hair ornament set with a large blue stone and crested with a stiff white feather. She seems oblivious of the tragedy she has expedited; her air is entirely that of a young girl participating in a pantomime for which she has taken on the role of a favorite maid bringing to her rich

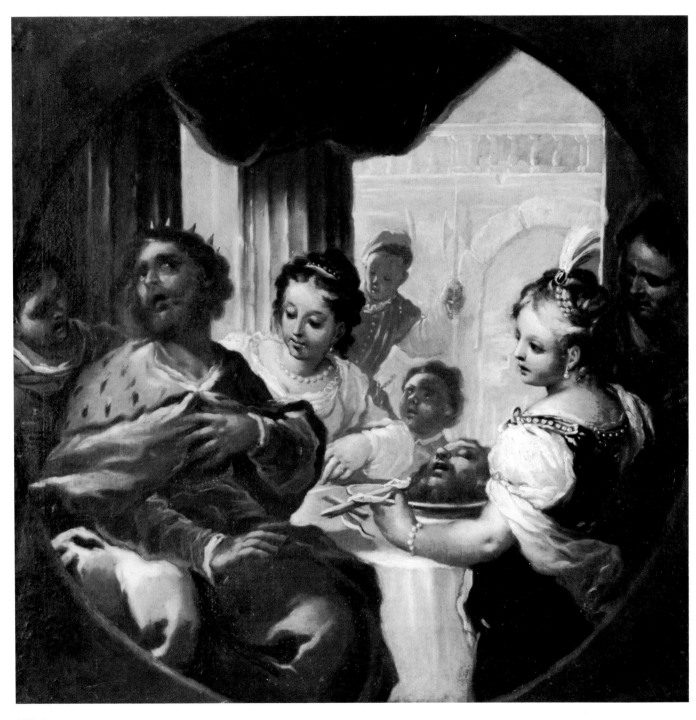

CAT. 9

padrone the calling card of a distinguished visitor on a silver salver. And this brings us to the last of the important personages attending the banquet, John the Baptist himself, whose physical presence is grisly, perhaps, but whose spiritual presence electrifies the scene. The head is face up, the mouth open as though still denouncing the sinfulness of Herod's house, with a waxen, gray-green pallor and soft yellow-brown hair. It lies in the dish beside a cross of reeds denoting John's mission as Christ's precursor. Having criticized Herod for marrying his brother's wife, John had been imprisoned by the ruler, who nevertheless recognized and feared him as a prophet and man of God. Herodias, however, stung by the saint's just condemnation of her character, longed for the Baptist's death and persuaded Salome to request his head as payment for her celebrated dance (Mark 6:17–28; Matthew 14:3–12). With regret, the king complies (although according to the *Golden Legend* [1948, 502–03], his reluctance was only a pose, part of a complex plot that included even the dance and the granting of the wish).

Giordano's skill in describing the scene is so subtle, his touch so light, that the true power of the picture might easily be overlooked. He has captured the exotic luxury of Herod's court, loading the small space with rich stuffs and accessories, all in colors that are equally rich and that shimmer with light. Surrounding the brilliant central scene are two attendants, a boy on the left and an elderly female on the right, who are wrapped in shadow and serve as dim parentheses to the feast. Directly behind Herod's family are two more boys in muted tones of peach and pale blue, the more distant clinging to one of the fluted pillars that seal off the foreground at the rear. Beyond this rather ambiguous and perfunctory middle ground a great space opens outward, with a grandiose architectural backdrop bathed in a golden haze, the entire expanse literally awash with light. Giordano has created a pictorial continuum that recedes infinitely away from the viewer and at the same time seems capable of spilling over the round frame into the viewer's world. This simple brown frame is of particular interest; painted in trompe l'oeil, the lower edge illuminated and the upper edge in shadow, it has the effect of a window or the lens of a telescope through which something private can be observed at close range. It might also be seen as an analogy for, or the pictorial equivalent of, a flashback, since in both Gospels where it is found the story of the execution of the Baptist is recalled and reported to Christ. The handling of the paint is light throughout, with staccato brushstrokes built up to thick white highlights in the hands and fingers and the jewels of the figures. As splendid as the treatment of light and space is that of the characters themselves, and the psychology of their different reactions. Not one of the three banqueters looks at the severed head; Salome, as we have noted, remains naively aloof, Herodias exudes unflinching calm, and Herod has become a breast-clutching, eye-rolling caricature of grief, which is a perceptive achievement on Giordano's part, considering the questionable sincerity of the ruler's regret.

This *Feast of Herod* bears obvious affinities with another version of the subject by Giordano, a large work executed, along with a pendant of *The Marriage at Cana,* for the Certosa di San Martino, and today at Capodimonte (figs. 51, 52). A date of around 1659 has been proposed and repeatedly accepted for this pair of works (Ferrari-Scavizzi 1966, 2:45). The similarities between the Certosa *Feast* and our picture are numerous and easily recognized; though the compositions are reversed, the same figure types appear in both, the same poses have been used for the figure of Salome, the same device of surrounding the scene with shadowy onlookers and suspending

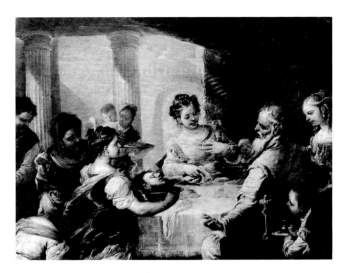

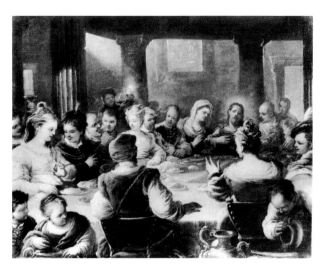

FIG. 51. Luca Giordano, *The Feast of Herod*, Museo di Capodimonte, Naples

FIG. 52. Luca Giordano, *The Marriage at Cana*, Museo di Capodimonte, Naples

a dark cloth from above has been employed, and the architectural backgrounds are identical. It seems sound, then, as has been suggested, to date the picture to ca. 1659, always keeping in mind that paintings by Giordano which seem identical in terms of style or content can nevertheless be separated by decades (see above, biography of Luca Giordano). De Dominici's assertion that the Certosa paintings were often mistaken by foreigners for Veronese (De Dominici 1742–45, 3:400) reinforces a date in the 1650s, after the artist's return to Naples from Venice (Pallucchini 1981, 239ff.). The influence of Veronese is obvious above all in the monumental arch surmounted by a balustrade that melts into a cream, rose, and gold illusion in the background of the picture and is reminiscent of the architectural settings in the feast scenes produced by the Venetian master over a century before. The brilliant coloring and the lightness of touch are also traits more commonly associated with sixteenth-century Venetian painting than with the early seventeenth-century Neapolitan tradition in which Giordano was trained.

Interesting parallels may be drawn, however, between this picture and a wide range of works also accessible to Giordano in Naples and elsewhere. For example, around 1640 the well-known Rubens *Feast of Herod* entered the collection of Gaspare Roomer in Naples (Washington 1983, 239–40). This remarkable picture seems to have received a great deal of attention among native artists and is inevitably the progenitor of innumerable banquet scenes throughout the decades following its arrival in the southern capital. One of the greatest Neapolitan descendants of this work is Mattia Preti's version of the subject now in the Toledo Museum (fig. 7). The diminutive Giordano before us, like Preti's several Neapolitan banquet scenes, follows the Flemish example in its sumptuous interpretation of the unadorned Gospel narrative, evoking the light and the atmosphere, and reviving the sparkling palette of Venice, to create an image overflowing with rich details. But whereas Rubens and Preti, in their feast scenes, have employed different but equally dynamic techniques in order to project the exquisitely static hush of a horrifying

revelation — a paralyzed moment — Giordano's handling reflects the mood of his picture, every aspect of which seems ecstatically alive and in motion.

To list all the other pictures upon which Giordano's *Feast of Herod* may draw iconographically or stylistically would be an interminable task. Among the possible prototypes for specific passages in the work one can mention the iconic depictions of *The Head of St. John the Baptist* painted by Giordano's teacher, Ribera, in the 1640s (Craig Felton in Fort Worth 1982, 214–17). For the somewhat contorted figure of Herod, a link with Venetian art has been suggested (Spear 1983, 136). It is interesting that fifty years after the proposed date of this picture Giordano painted a series of royal saints for the church of San Antonio de los Alemanes in Madrid, several of whom bear a striking resemblance to this Herod.

Another version of the present picture, in a private collection in Palma de Mallorca, has been published (cf. Spear 1983, 136n. 20). DN

10 *Christ the Intercessor*

187.5 x 97.5 cm (73¾ x 38⅓ in)

PROVENANCE: Marquess of Ormonde, Kilkenny Castle, Co. Leinster, Ireland

EXHIBITION: Museo de la Universidad de Puerto Rico, *Diecisiete pinturas de grandes maestros,* 1960, no. 3

LITERATURE: Ponce 1967, 76; Ferrari-Scavizzi 1966, 1:61; Ponce 1984, 130

Museo de Arte de Ponce (Fundación Luis A. Ferré) 59.0086

This may be a fragment of a large altarpiece; but, more likely, it is a pendant to one or more other paintings depicting God the Father (in the center) and the Virgin or St. John on the right in a pose balancing Christ's here. Ferrari and Scavizzi (1966, 2:70–72) suggest that the right-hand pendant may be an *Adoring Virgin Mary* that in 1966 was with Newhouse Galleries, New York and was in the Christie's, New York, auction of January 13, 1987, lot 134. Their hypothesis is that the different shapes of the two canvases result from the Ponce picture's having been cut down. Stylistically the present work belongs to the artist's first *maniera dorata* of the 1660s.

The sky teems with seraphim (baby angels consisting only of heads and wings) lightly brushed in ochre. The three lower putti meanwhile adore Christ and help carry his cross. Except for his loincloth he is nude, striding in glory among the clouds, showing his wounds, eyes half-closed in ecstasy. He appears as intercessor, as the Saviour who mediates between God and Man (Bellarmino 1617, 1:289ff.). Typical of Giordano is the picture's golden, indeed solar, atmosphere. This too has a theological bearing in the present picture. Christ is often compared to the sun. Roberto Bellarmino, one of the architects of Counter-Reformation theology whose treatises were considered classics in our period, takes up the idea. He says that, as Christ has been the Sun of Heaven, when the bodies of the blessed are resurrected on the last day they too will become suns, for they will be figures of Christ. And the image of the sun, applied to the human body, makes it beautiful. "What joy [to see] innumerable suns, not merely shining with

CAT. 10

light but most beautiful in the variety and attractiveness of their limbs?" Even the wounds on these bodies will be beautiful. "As to Christ, king of martyrs, who wished to keep the marks of lance and swords, to his glory and our salvation, no tongue can tell what light shines forth from these holy wounds" (Bellarmino 1617, 6:305). Such thinking foretells the bodily splendor of Giordano's Christ.

One of the most prominent yet least-noticed aspects of seventeenth and eighteenth-century religious art is precisely this nudity. Personages such as Christ and St. Sebastian are provided with draperies, but they often wear them so loosely and revealingly that their nakedness is actually emphasized. I would instance St. Bartholomew and the Baptist in Preti's paintings (respectively, cats. 3, 5) and the Giaquintos from Rochester, Minneapolis, and St. Louis (cats. 39, 40, 42) as well as the present picture. These works celebrate human flesh in a way hardly demanded by the texts they illustrate.

The theology of the time tells us why they did so. For one thing since God fashioned the human body in his own image, that body was ipso facto the most beautiful of all forms. On earth, of course, this divinely shaped flesh rebels against the spirit and must be controlled, even hidden, by postlapsarian humanity. But that is not true of Christ, born without sin. He and the other innocent spirits who inhabit heaven may, indeed must, take joy in nudity. After the Resurrection of the Dead all humanity will be clothed in the bodies they had in life, but idealized and perfected, each "enjoying the prize of their proper virtue [i.e., the perfection of their physical characteristics] that they had exercised in their sex" (Bellarmino 1617, 6:172). Nudity is exalting to the spirit. Bellarmino claims that the [nonprurient] sight of beautiful bodies is the greatest joy of the senses. When the soul finally gains the kingdoms of the blest "it will joy first in the celestial country in the splendor and pulchritude of its proper body" and later in the sight of the bodies of the martyrs.

But the great reason for Christ's nudity is that it expresses the Incarnation, the central dogma of Christianity. The Incarnation encompasses the mysteries of the Trinity, of the Virgin Birth, and of Christ's nature as being fully God yet also fully human, yet also without sin. "And the Word was made flesh, and dwelt among us, full of grace and truth; we beheld his glory, the glory of the only-begotten of the Father" (John 1:14). That is the classic definition. *Incarnatio,* furthermore, means to make something of, or into, flesh. So does the Greek equivalent, *sarcosis.* Bellarmino makes belief in the Incarnation the main division between heresy and orthodoxy (Bellarmino 1617, 1:236ff.). And here is a trope that would escape no Christian painter, for in our period incarnation was also the common term for flesh-painting. GH

11 *Bacchus and Ariadne*

122 x 175 cm (48 x 69 in); signed l. l.: "Jordanus F."

PROVENANCE: A. Schindler, Germany, 1956; Acquavella Galleries, New York, 1957

EXHIBITIONS: Provincetown 1958, 14, and pl. 22; Fort Worth 1962, 38; Norfolk 1967b, no. 44; New York 1978, no. 6

LITERATURE: Memphis 1964, 38; Ferrari-Scavizzi 1966, 2:366, and 3, pl. 611, as whereabouts unknown; Zafran 1978, 247, pl. IV; Norfolk 1982, 31, repr.

The Chrysler Museum, Norfolk, Virginia, Gift of Walter P. Chrysler, Jr. 71.650

Shown in New Haven and Sarasota only

Ariadne was a Cretan princess, daughter of of Minos and Pasiphaë. Her lover Theseus abandoned her on the island of Naxos, where Bacchus consoled her and, after a voyage of conquest to India, returned to marry her. After the wedding he set her bridal crown among the stars, where it became a constellation. One of their children, Oenopion, was the first mortal to make wine, having been taught by his father. Like many artists before him Luca conflates Bacchus's first arrival on Naxos, when he finds Ariadne asleep on the shore, and his second, when he returns in triumph to find her once again. It is on this second occasion, after she becomes immortal, that the jewels of her crown are transformed into a constellation (Panofsky 1969, 142). In Luca's picture the crown is clearly visible above Bacchus's head.

In my discussion of Luca Giordano's career I referred briefly to the affinities between the Norfolk *Bacchus and Ariadne* and Luca's frescoes in the Palazzo Medici-Riccardi, Florence (figs. 16, 17; see also Giordano biography above). Although we do not know for whom the Norfolk painting was intended we can assume that it was commissioned and probably also made when the artist was at work on that great fresco ensemble. In particular, the Bacchus scene on the Medici Palace ceiling is similar to ours (Millen 1965, pl. 13). There the god in his leopard-drawn chariot has some of his traditional companions, such as satyrs and maenads, with him. But he is also accompanied by several figures not in the Norfolk painting, namely, three wind gods, Atlas, Hercules, and two philosophers. Büttner, rejecting other candidates, identifies these latter as Momus and Harpocrates, who are mentioned in early descriptions of the ceiling (Büttner 1972, 43, with bibliography). Momus, the son of Night and Somnus, holds a whip and a trumpet with which he reprimands the gods for their bad behavior. Harpocrates calls for silence, indicating in turn his own disapproval of these unruly divinities (Büttner 1972, 43). Presumably because wine grows from the soil, the scene signifies the element Earth (Millen 1976, 303ff.).

The original oil sketch for the Medici Bacchus has apparently not survived. Millen suggests that it would have portrayed the joint triumph of Bacchus and Neptune and he illustrates an engraving of 1822 by Giovanni Paolo Lasinio made after this sketch (Riccardi Vernaccia 1822, 17–20, and pl. IV). An oil sketch of the subject formerly in the Fogg Art Museum, Cambridge, is thought not to be autograph. However the latter work, whether "dashed off in haste" by Luca himself or a copy — these are alternatives Millen puts forward — is the closest in composition

of all the Medici *Nachlass* to the Norfolk picture (Millen 1976). In short our picture should be seen as a free variation of the Medici *Triumph of Bacchus* in which Luca has shifted his subject from the triumph itself to the god's return to Ariadne.

Whatever the problems of its purpose the Norfolk picture is a lyrical symphony of blues offset by pinks, browns, and beiges that is certainly as beautiful as the best of the Medici-Riccardi bozzetti and modelli (see those in the Mahon Collection, London: Naples 1984, 1:317–19, nos. 125a, 125b; and Detroit 1974, 260–73, nos. 151–61). As in some of these latter, there is a dominant silver tonality. One is struck especially by the range of blues all through the Norfolk picture. There is the deep royal blue garment of the female figure who flies in from the right to uncover the sleeping Ariadne. This intense color accent is picked up at various points in the landscape; but in the distance, off to the right, Luca's blue is so dark as to be nearly black. All of the fresh, clear, silver tones, meanwhile, are offset by the range of contrasting warm tones of the central figures and their draperies. The cooler flesh tones of the woman at the upper right become warmer in the reclining nude body of Ariadne. The pink of Bacchus's magnificent, flowing garment joins his darker flesh and the mauve drapery lifted above Ariadne. The warm tones deepen even further into the hot browns and pinks of the elongated body of Bacchus's companion with the pointed ear in the foreground and in that of the little satyr to his right. The dark flesh tones of the former companion counterpoint the cool flesh and the deep blue garment of the typically Giordanesque woman in the upper right. Giordano's painting is virtuosic throughout — see, for example, the almost transparent wings of the two putti who surround Ariadne. As in the bozzetti and modelli for the Medici-Riccardi ceiling, Luca here applies thick impasto with liveliness and immediacy. The sketchy maenads and putti surrounding the leopards in the left middle distance are a case in point.

Like Titian in the *Bacchus and Ariadne* made for the studio of Alfonso d'Este and now in London, Luca fuses, and even deliberately confuses, several visual sources. Aside from the evocation of Titian's other *favole* and of Poussin's early, Titianesque pictures, he comments in a number of specific ways on Titian's Este picture. Both artists use a similar range of colors, emphasizing bright reds and pinks. Luca has closely studied Titian's bounding god with his billowing mantle. Panofsky has shown that Titian, in turn, was referring here to Ovid's evocation of "the swift bound of Bacchus from his chariot" in the *Ars amatoria* 1.525–64 (Panofsky 1969, 143). Luca relaxes that leap into a graceful balletic pose and eliminates the chariot.

If Luca's Bacchus comments on Titian's his Ariadne has more to do with other works. In a general way she refers, as do most Ariadnes of Renaissance and post-Renaissance times, to the ancient statue dubbed *Ariadne* in the Vatican Museum. But Luca does not simply transpose this famous work onto the canvas. Instead, he makes a simultaneous and more direct reference to another famous statue, Michelangelo's *Notte* from the tomb of Giuliano de'Medici, who now appears relaxed and softened into perfect harmony with the rest of the scene. Quotations like this from Michelangelo sculptures are rather rare in Neapolitan art of this period. Another example is Giaquinto's use of the St. Peter's *Pietà* (cats. 39, 40).

Besides having ties with Titian, Luca's Norfolk picture is part of a whole family of mythological works. To take only several examples, there is a general resemblance between our

CAT. II

painting and some of Tintoretto's late mythologies — more his *Hercules and Omphale* and *Parnassus* than his *Ariadne* (Bernari 1970, pl. XLIII, and figs. 255b and 256). Works such as an *Amore Leteo* in the Kunsthistorisches Museum, Vienna, given to Agostino Carracci (Bologna 1956, pl. 38), and the much better known *Venus and Adonis* of Annibale, also in Vienna (Bologna 1956, pl. 81), are part of this extended family of paintings. So, of course, is an entire body of works by Pietro da Cortona, especially his Pitti Palace frescoes. More than this general resemblance, there may be a deeper connection between the ceiling of the Pitti Sala di Venere and our *Bacchus and Ariadne*. Luca's canvas has figures clearly inspired by Cortona; but the way in which his composition is disposed suggests that although he carefully studied Cortona's rhythms he slowed them down. I am thinking of the charged female figure who surges out of the lower right corner of Cortona's fresco and of Luca's blue-clad woman in the upper right. And, too, there is the Hercules at the upper left of the Venus ceiling who is transformed into a winged Cupid in the Norfolk picture.

Then there are several pictures by or close to Poussin that have been recently exhibited as among that artist's earliest works. The most relevant of these is a *Meeting of Bacchus and Ariadne* in the Prado (Rosenberg in Rome 1977, 110–11, no. 1; Thuillier 1974, B8, 113; Rosenberg mentions a copy of this Prado picture in the Chrysler Museum in Norfolk on page 110). This and other early Poussin mythologies have a striking resemblance, in tone and lyrical quality, to Luca's Norfolk picture — and even gesturally, in the Bacchus and some of his companions.

We know of three other renditions of the subject by Luca Giordano, of which two are extant. The earlier, dating probably from the 1670s, is in the Museo di Castelvecchio, Verona (Ferrari-Scavizzi 1966, 2:87, and 3, pl. 138; it has as its pendant a *Diana and Endymion,* also in Verona, which bears a strong resemblance to the signed Luca Giordano of the same subject now on loan to the Yale Art Gallery; cf. Ferrari-Scavizzi 1966, 3, pl. 137). Luca returns to this picture for his Bacchus figure, and he does so once again in the more ambitious Dresden composition that is closer to ours in date. But in other respects the Verona picture is awkward and poorly resolved, especially if one compares it with the lovely painting we exhibit here.

Of the two Dresden *Bacchus and Ariadnes* one was destroyed during the Second World War. It was signed "Jordanus F.," in a manner identical to that of the Norfolk picture and many others (Dresden 1929, 210, no. 475; Ferrari-Scavizzi 1966, 2:272). The second has been thought by some scholars to be a modello for a ceiling decoration, but Luca's recent biographers argue against that hypothesis (Dresden 1929, 221, 212, no. 484; Ferrari-Scavizzi 1966, 2:111, and 3, pl. 191). In any case, this is a vast upright composition with some similarities to the present work; the figure of Bacchus, seen in reverse, is the most significant. Ferrari-Scavizzi give the painting a date of 1682–83, to link it with the Medici-Riccardi ceiling frescoes. Hence Luca may well have worked on this more complex, more ambitious picture at about the same time he painted ours.

A painting of *Bacchus and Ariadne* by Luca Giordano is included in a catalogue of pictures belonging to Prince Lucien Bonaparte which were on private view in 1814 at William Buchanan's London gallery (Buchanan 1824, 2:289, no. 38). It is suggested in the files of the Chrysler Museum in Norfolk that this may be the work exhibited here. JC

12 The Rape of Europa

193.6 x 227 cm (76¼ x 89⅝ in); pendant *Rape of Helen* (fig. 53), also Hartford, signed lower right corner: "L. Jordanus f. 1686"

PROVENANCE: Purchased from Durlacher Bros., New York, 1930

EXHIBITIONS: Hartford 1930; Dayton 1953, no. 55; Hartford 1958, no. 34; Memphis 1964, no. 38

LITERATURE: Wadsworth 1930, 2ff.; McComb 1934, 124; Ferrari-Scavizzi 1966, 2:145

Wadsworth Atheneum, Hartford. The Ella Gallup Sumner and Mary Catlin Sumner Collection 1930.3

The scene is a rocky coast, the sky filled with turbulent blue-gray clouds shot with tawny flashes. Europa reclines perilously on the back of a white-faced bull who lies in a circle of gracefully plump young women who garland him with vines and bright red hibiscus flowers. Europa is dressed more simply than her companion in a white garment revealing her right breast. Above her head her saffron mantle snaps in the wind. Beside the foreground woman whose back is to us, on the left, we see the glint of a golden tambourine, a horn, and a bit of pink, blue, and white striped cloth. These are the playthings Europa's companions have brought with them. On the left, high in the deep sky, a putto frolics with a mask.

The figure of Europa is a variant of Titian's famous *Europas* in the Gardner Museum, Boston, and in the Prado. But Titian, like most other artists, shows the girl riding on the bull's back as he swims through the sea. Normally, also, she is hanging on for dear life as she tries to steer the animal back to the shore. Luca's Europa, on the other hand, seems quite comfortable. She even converses, for she seems to be making some point with her nearby handmaiden. Behind, on the left, is a rocky landscape with a single tree. There we see the distant silhouette of one of the bulls in the herd that normally grazes near this spot.

The whole picture is suffused with rich tones of blue and gold culminating in the generous beauty of the princess. Overall the fleshtones are pale but here and there deeply ruddy, an effect that Luca would have learned from his master Ribera. As a foil for this overall warmth of tone the woman with her back turned to us is all in blue. Though the brighter colors in the picture are now sunk with time one can tell that the palette was intended to climax in the brilliant red flowers decorating the bull's horns, in Europa's glistening skin and wisp of dress, and in the bull's shaggy white breast and snout.

The quotation from Titian is not the only invocation of Venice in Luca's picture. The style of the whole is a tribute to Veronese whose art was so consistently invoked by the Italian baroque masters. The picture's effects of brilliant sunlight flashing on gold and blue, of draperies in sea breezes, and of opulent, pearly nudity are all cases in point. Particularly relevant is Veronese's *Rape of Europa* in the Sala dell'Anticollegio, Ducal Palace, Venice (fig. 54).

The tale of Europa was the object of endless reflections in classical literature. Her abduction by Jupiter in the form of a bull is told three times by Ovid (*Metamorphoses* 2.835–77, 6.103–07; *Fasti* 5.605–16). But Homer, Hesiod, Apollodorus, Euripides, and many others also tell it:

Jupiter, traveling through the skies, spots Europa picking flowers with her companions on the shore of what is now Lebanon. The god falls in love with her and, to obtain her, transforms

CAT. 12

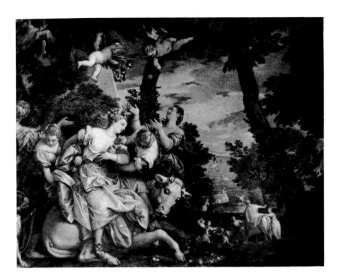

FIG. 54. Paolo Veronese, *Rape of Europa*, Sala dell'Anticollegio, Ducal Palace, Venice

FIG. 53. Luca Giordano, *Rape of Helen*, Wadsworth Atheneum, Hartford, Connecticut

himself into a beautiful bull. Europa, we are told, is equally *éprise* when she sees this splendid animal. As she approaches him the bull lies down at her feet and gazes up at her with soft longing eyes; then he kisses her hand and frolics in the grass. Next, Europa seats herself on his back, inviting her companions to do the same. This is probably the moment Luca depicts. Ovid says Europa is particularly charmed by the animal's crescent horns and it is about these that she seems to be speaking to her companion. The juxtaposition of hand and horn in the painting could in fact illustrate Ovid's subsequent aside to the reader (2.855ff.): "But what [horn] could possibly contend with hands so made, pure as the most brilliant gem?"

However, no sooner is Europa seated on the bull than he betakes himself and his passenger to the billows of the sea. There, tritons and nereids, as on the right in the painting, welcome the bull-god. Despite Europa's protests he swims with her to Crete. There Jupiter returns to human shape and fathers her child.

Europa's name is appropriate. It means "beautiful gift" and also tropes the Greek words *euros, europos,* and *euroos,* which, respectively, mean "west wind," "lying down," and "free flowing," all of which well describe Europa's escapade and Luca's portrayal of it. We recall how Ovid emphasizes that Europa lies on the bull's back (as he lies down before her), while her name also suggests the flowing of the waves and winds during their voyage to Crete. The young woman's reclining position and flying mantle seem to be part of the same phenomenon.

I called Jupiter a bull-god on purpose. In Homer (*Iliad* 14.321), Europa's child is Minos, kingpin of the Cretan bull-cult. In *Met.* 8.115ff. Ovid makes this Cretan connection explicit, linking Europa to her daughter-in-law Pasiphaë, who also loved a bull (see also cat. 11 above). Beneath the surface grotesqueness of the story there no doubt lies the repressed race-memory of an animal-god who demanded the periodic sacrifice of a virgin. (That gives a new twist to the meaning of Europa's name, for sacrifices were perceived as gifts, *europai,* to the gods.) It was also common to perceive these victims as being eager to expire so that they would become one with the divinity (Burkert 1985, 56). Europa's otherwise inexplicable passion for the bull is a variant on this idea.

As Ovid remarks, in the end Europa profited from her abduction. One-third of the (then known) world came to bear her name. Jupiter's bull-form, meanwhile, migrated to the heavens, where it became a constellation.

Europa and the bull was a favorite subject for ancient artists, who like their Renaissance successors normally chose a later moment in the story than Luca's — namely when, as he charges over the sea, Europa grasps the bull's horns and seeks to guide him back to shore. As to Luca's own period, aside from the Titian and Veronese pictures already mentioned, there are *Europas,* almost all of this more orthodox sort, by Annibale Carracci (Palazzo Fava, Bologna), Francesco Albani (Galleria Colonna, Rome, and elsewhere), Preti (Galleria Pallavicini, Rome), and Bernardo Cavallino (Walker Art Gallery, Liverpool). Luca himself essayed the subject many times if we are to accept the attributions listed in Pigler 1974, s.v. But none of these is given in Ferrari-Scavizzi. Pigler lists Luca Giordano *Europas* in the Palazzo Borromeo, Isola Bella; Galerie, Schleissheim; Pinacoteca Manfrin, Venice; Musée Abbatiale, Douai; and two in private collections. Another noncanonical Luca *Europa* is said to be at Hickleton Hall, Yorkshire (registrar's files, Wadsworth Atheneum). GH

13 *The Presentation of the Virgin*

105.5 x 135.9 cm (41½ x 53½ in)

PROVENANCE: At Althorp by 1750. Presumably bought by the Hon. John Spencer (1708–1746), thence to his only son, 1st Earl Spencer (1734–1783), and thence by descent to the 8th and present Earl Spencer, Althorp. Purchased from David Carritt, Ltd., London, 1984

LITERATURE: Dibdin 1822, 279; Garlick 1974–76, 33, no. 239; *Newsletter,* Archer M. Huntington Art Gallery, Fall 1984, 2

Archer M. Huntington Art Gallery, The University of Texas at Austin, Archer M. Huntington Museum Fund 1984.50

This is one of at least five versions of the subject that Luca Giordano made. Although artists have depicted it in many ways, Luca basically settled on this statement early on and made few major changes. His first *Presentation* was executed in ca. 1672–73 for the Venetian church of Santa Maria della Salute (Ferrari-Scavizzi 1966, 2:73, 80–81, and 3, pl. 128; for this dating cf. Pallucchini 1981, 240, with further bibliography). There was a pendant altarpiece, the *Birth of*

CAT. 13

FIG. 55. Luca Giordano,
*Presentation of the Virgin in the
Temple*, drawing, graphite,
Prado, Madrid

the Virgin (Ferrari-Scavizzi 1966, 3, pl. 127). All other versions seem to date from at least fifteen years later. They were made either in the 1680s, right before Luca's stay in Spain, 1692–1702, or during that stay. Probably the earliest of this later group, at least according to Ferrari-Scavizzi, is the painting presently in the Palazzo Durazzo-Pallavicini in Genoa (Ferrari-Scavizzi 1966, 2:156, and 3, pl. 305; there dated ca. 1688). The Genoa picture has many affinities with ours. The key figures move from right to left, as is not the case in the other versions. The high priest, the young Mary ascending the temple stairs, and Anna behind, who guides her, are linked in the two paintings by gesture and position. Yet the figures in the Genoa picture are more dynamic; they lack the calm, the distance, the balance of the Austin figures. In the Genoa scene they diminish in weight and presence as they wind up the stairs toward the priest. And one must move beyond the onlookers in order to locate the main action. In the present work Luca seeks to create more of a balance between these additional figures and the protagonists.

Of the other versions of the Austin picture, one is in the Kunsthistorisches Museum, Vienna (Ferrari-Scavizzi 1966, 3, pl. 397), a second is in a private collection in Naples (Ferrari-Scavizzi 1966, 3, pl. 400), and a third in the monastery at Guadalupe, Spain (Ferrari-Scavizzi 1966, 3, pl. 428). These have simpler architectural settings than the Austin picture.

An interesting addition to this corpus of *Presentations* is a drawing in the Prado (fig. 55). Though Pérez Sánchez (1978, no. 53) speaks of it as being directly related to the Vienna picture, it is just as close to the others mentioned. Indeed, a drawing like this may help explain the ease

FIG. 56. Attributed to Valerio Castello, *Presentation of the Virgin in the Temple*, drawing, pen and brown ink, brown wash, Metropolitan Museum of Art, New York

with which Luca moves from one rendition of the subject to another. Two or three other versions of the subject are known today, but these have little to do with the Austin picture (cf. London 1975, no. 12, with further bibliography; see also Ferrari-Scavizzi 1966, 2:156). But in general Luca Giordano *Presentations* are like different performances of a given scenario by itinerant players. Each time, the Virgin or Anna or the high priest plays the role with slight variations. But it is clearly the same actor, the same role, and the same setting.

Because of its subtlety in color and handling, because it is both spontaneous and careful without being *figé,* the present picture is to me an autograph work, built around exquisite color harmonies. The most prevalent is that of golden yellow suffused with white and gray. This can be seen in the garments of the high priest with his gold headgear and robe and in Anna's similar gold cloak, this time with a mauve undergarment. This dominant golden tonality is echoed in the clothing of other figures — for example, in the turban of the man standing directly behind the high priest and in the dresses of the woman in the left foreground and of the two women at the right. Quiet blues, also suffused with white and gray, form a counterpoint to the golden tones. The blue, gold, and white garment under the high priest's cope is echoed by the undergarment of the kneeling figure on the stairs with his back to us and also by the blues and grays of the stormy sky. There are accents of strong color dotted throughout: the deep blue of the young Virgin's cloak; the even stronger blue worn by the balding man with the basket on the left. Similarly there is the red skirt of the child in the foreground holding the turtledoves (the

offerings made on such occasions; see cat. 44) and the even brighter red of the cloak of the young man looking back at the extreme left. In parts of the painting Luca seems not to be using any color at all. This is true of those figures, barely visible, which he sketches in so lightly in the central space between Zachariah and the Virgin and of the turbaned man with his white beard and greenish robe peering out from behind the high priest. These wraithlike figures are a hallmark. They appear also in the altarpieces of the late 1650s (see biography of Luca Giordano, above), and they still appear almost fifty years later in the Cappella del Tesoro frescoes in San Martino. Even large-scale figures, and here I refer to the two women in the right foreground, seem to be painted almost in a monochrome — gold barely suffused with white, blue, and green strokes of paint that from a distance turn into flesh-and-blood figures.

Hence the Austin *Presentation* is a later, looser, less clear, more painterly work than, say, the Norfolk *Bacchus and Ariadne* (cat. 11). Like the latter, and unlike the heroic *Rape of Europa* in Hartford (cat. 12), it is predominantly lyrical, even intimate. I have mentioned elsewhere (see biography above) that it is difficult to date Luca's works of the late 1680s and early 1690s. But it seems reasonable in this case to go along with the date of ca. 1688 proposed by Andrea Norris, chief curator at the Archer M. Huntington Art Gallery.

The story of the Presentation of the Virgin was told first in certain apocryphal Greek gospels and later disseminated in the thirteenth-century *Golden Legend* of Jacobus de Voragine. When Mary was about three years old, her parents Joachim and Anna brought her with gifts to the temple at Jerusalem. In the verbal accounts of the story the child mounted all fifteen steps of the temple without the aid of her parents. There she was welcomed by the high priest (*Golden Legend* 1948, 523).

Although the history and literature of the Feast of the Presentation have been extensively studied in a Ph.D. dissertation (Kishpaugh 1941), its appearance in works of art has come in for less thorough treatment. There is a short chapter by Adolfo Venturi (1900, 105ff.) and, much more recently, a rewarding chapter by David Rosand on Titian's *Presentation* in the Scuola della Carità, Venice (Rosand 1982, 85–144, with extensive bibliography, 263–82). In the visual renditions of the theme as well as in the texts, there is at first an emphasis on the young Mary as a courageous and specially endowed young girl mounting the stairs on her own, without looking back, as her parents and others watch with pride. This is true of the great renditions of the Presentation, those of Titian and Tintoretto, and it was true as well in works of two important predecessors, Carpaccio and Cima da Conegliano, to mention only those. There the solemn isolation of the young girl is the theme.

Yet even as early as Giotto's Arena Chapel *Presentation,* another current had been established that reinforced the more human aspects of the story. In these works Anna lovingly guides her child up the steps and protects her from falling, while the others — priests, women in prayer, women and children with offerings — display a range of reactions.

Needless to say Luca Giordano knew, or knew of, the great earlier renditions of his theme. But more than to Titian's monumentality and Tintoretto's dramatic spiral up that extraordinary curving staircase in the Madonna dell'Orto, Luca seems to have looked to more recent precedents. A drawing attributed to Valerio Castello and today in the Metropolitan Museum of Art seems remarkably close to our painting (fig. 56; cf. Bean 1979, 83–84, no. 112). In the

drawing the setting is more complex than in the other scenes mentioned. And the figures seem to rush up the stairs to converge on the priest at the apex. Yet in one crucial way Luca has fully absorbed the lesson of Titian: the young Virgin is enveloped in a halo of light. True, it is not the mandorla that surrounds Titian's figure, but it conveys the same message (Rosand 1982, 105–07; Grabar 1955, 310–11).

Still another version of the Austin painting, thought to be from Luca Giordano's studio, was auctioned at Christie's, London, on February 20, 1986, lot 263. JC

14 *The Hymn of Miriam*

152.7 x 231.5 cm (60⅛ x 91⅛ in)

PROVENANCE: Probably Alcázar de Toledo by 1700

EXHIBITIONS: Houston 1960; Memphis 1964, no. 22; Detroit 1965, no. 164; Washington County Museum of Fine Arts, Hagerstown, Maryland, Feb.-Mar. 1969; Raleigh 1984, 70ff., no. 19

LITERATURE: De Dominici 1742–45, 3:409; Ceán Bermúdez 1800, 2:344; "Acquisitions," *Art Quarterly* 18 (1959):352ff.; Bob Jones 1962, 1:152ff.; Haskell 1963, 223; Hibbard and Lewine, "Review: Art in Italy," *Burlington Magazine* 107 (1965):370, 372ff.; Ferrari-Scavizzi 1966, 1:118ff., 132n. 11; idem 2:153, 188, 281–82; idem 3, pl. 308; Posner 1967, 147, fig. 8; Bob Jones 1984, 62

Bob Jones University 59.2

Certainly one of the most glorious Luca Giordanos in North America, the *Hymn of Miriam* nonetheless presents problems of dating and patronage. Although it has been proposed that it was intended for the ceiling frescoes in the church of San Lorenzo del Escorial, and thus that it dates from Luca's Spanish period (1692–1702; Denis Mahon's suggestions in Detroit 1965, 148), I feel that the Bob Jones picture should be connected with the cycle of eight paintings executed in 1687 for the transept walls of the Annunziata in Naples (see also Ferrari-Scavizzi 1966, 2:281–82). The figure of Miriam indeed appears in Luca's Escorial frescoes as one of many figures in both *The Triumph of Virginal Purity* and *The Story of Moses* (Ferrari-Scavizzi 1966, 3, pls. 355, 358). But the allegorical mode of the frescoes would not permit the inclusion of a complete narrative as depicted in the Bob Jones modello. Painting a modello that depicts a vast horizontal narrative full of genre touches would seem redundant if this were for only a portion of a fresco. Furthermore, the near-eye-level composition of the Bob Jones canvas makes it less likely that it served as a modello for the Spanish ceiling frescoes, which are designed in *da sotto in sù* perspective. On the other hand the Annunziata pictures were hung on the walls of the transept. Unfortunately these paintings, which depicted famous men and women from the Old Testament, perished when the church was destroyed by fire in 1757 (Gleijeses 1978, 301). But De Dominici describes the composition of one of them in a manner reminiscent of the Bob Jones modello: "Mary [i.e., Miriam], sister of Moses, with holy joy sounds the drum and sings praises to the Lord, while in the distance the Pharaoh's army is seen in the Red Sea" (De Dominici 1742–45, 3:409).

Luca Giordano painted a number of versions of this subject, though none has quite the vivacity of handling or the poetry of light found in the Bob Jones canvas. The most famous of these other versions is in the Prado. Ferrari and Scavizzi (1966, 3, pl. 369) call it a bozzetto for the larger versions in San Lorenzo del Escorial. There is also a copy of the Prado picture in the Pinacoteca Provinciale, Bari, while possible copies of the Bob Jones canvas are recorded in the Brass Collection in Venice and in the Museo Cerralbo, Madrid. Finally, a small study depicting the central figures of the scene was on the art market during the 1950s. Nonetheless, following De Dominici's text and the visual evidence in the picture, it would seem clear that this modello dates to the 1680s rather than after 1692, when Luca went to Spain and when presumably most of these other versions of the scene were painted. The present picture is therefore roughly coeval with the New Orleans *Baptism* (cat. 15). The great freedom in the handling, the generally subdued palette, the almost liquid application of paint to the canvas, and the soft plasticity of the forms in the Bob Jones canvas are traits befitting its function as a modello, this being the final preparatory study before the actual execution of the work. In these ways the Bob Jones picture is also comparable to the bozzetti for the Palazzo Medici-Riccardi ceiling now in London in the collection of Denis Mahon (Ferrari-Scavizzi 1966, 3, pls. 198–216). The muted hues and the gentle chiaroscuro in the *Miriam* also recall Lanfranco's *maniera dolce,* which, as De Dominici says, Luca tried to imitate — and this particularly in the Annunziata series (De Dominici 1742–45, 3:409, e.g., the two paintings of the dreams of St. Joseph he mentions as being in the lateral arches of the Annunziata's high altar). Elements such as the warm, almost golden light that divorces the foreground plane from the cool, darkish background, the monumentality of the composition, the touch of saturated color here and there, and the soft chiaroscuro seem like a logical development in Luca's manner after his great 1684 fresco in Naples in the Girolamini church, *Christ Expelling the Moneychangers from the Temple* (Ferrari-Scavizzi 1966, 3, pl. 247). This Lanfranchesque character weighs too heavily on Luca's forms for the *Miriam* to fit in comfortably with his grander and more fantastic manner of the 1690s.

Depictions with the subject of the *Hymn of Miriam* seem almost nonexistent. Most frequently Miriam is portrayed in *The Finding of Moses* or in *The Crossing of the Red Sea.* Therefore the subject of the Bob Jones picture is relatively unusual. It comes just after Moses' parting of the waters of the Red Sea which is the salvation of the Jewish people: "Then, Miriam, the prophetess, the sister of Aaron, took a timbrel in her hand; and all the women went out after her with timbrels and dancing. And Miriam sang to them: 'Sing to the Lord, for he has triumphed gloriously; the horse and his rider he has thrown into the sea'" (Exodus 15:20–22). Touched by streaming light, Miriam commands the center of the stage. The enemy's disaster is in the background, and Moses himself is barely discernible in the dusky distance to Miriam's left. The grateful Jewish people gather around the prophetess to hear and accompany her song with musical instruments and dances.

Although not as predictable as a Judith or a Deborah, Miriam is a common choice for cycles of famous men and woman from the Old Testament. She was the sister of Moses and Aaron (Numbers 12:1). When the pharaoh's daughter found the infant Moses in the reeds of the Nile, Miriam, who had been watching, offered to find a wetnurse for the baby and brought their mother to the palace (Exodus 2:1–11). Not always properly reverential, she and Aaron dared

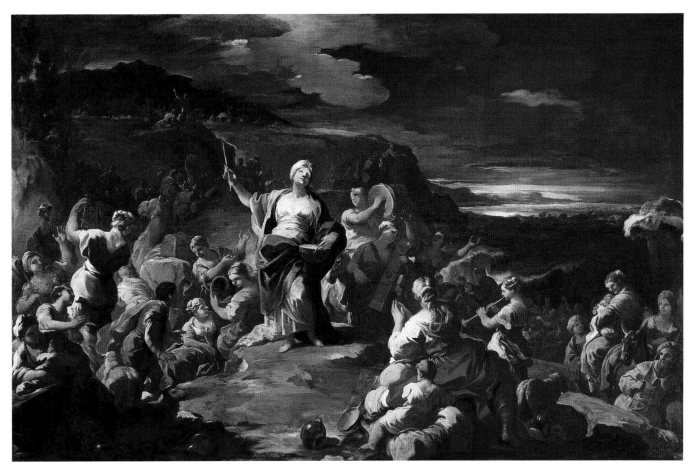

CAT. 14

rebuke Moses for marrying an Ethiopian woman and also for his claim that he was God's exclusive prophet. God punished Miriam for this by making her leprous. But her brother interceded, and God let Miriam be healed, though not until she had done a seven-day penance (Numbers 12:1–16). Miriam's hymn and dance after the crossing of the Red Sea (Exodus 15:20, 21), then, mark her reinstatement in God's favor. Her fame was not forgotten by succeeding generations. The prophet Micah (6:4) put her on the same footing as Moses and Aaron: "For I brought you up from the land of Egypt, and redeemed you from the house of bondage; and I sent before you Moses, Aaron, and Miriam." Theologians have thought Miriam prefigured the Virgin Mary, not only because of the similarity of their names — "Miriam" is one of the many Hebrew versions for "Mary" — but also because Miriam's hymn and dance foreshadowed the Virgin's hymn, the *Magnificat* (Réau 1956, 2:195). The Annunziata was a Servite church, that is, it was operated by an order known as the Servants of Mary. CBC

15 *The Baptism of Christ*

237.5 x 193 cm (92 x 76 in)

PROVENANCE: Julius Weitzner, London, 1969; Herner Wengraf, London, 1971; Jacques Seligmann, New York, 1974; said to have come from a church in Buckinghamshire, England, which we have not been able to trace

EXHIBITION: Herner Wengraf Old Master Galleries, London, Spring 1971, as "hitherto unrecorded"

LITERATURE: *Burlington Magazine* 113 (Apr. 1971):228, fig. 73; *Apollo* 93 (Apr. 1971): 325ff., and fig. 5; "La Chronique des Arts," *Gazette des Beaux-Arts* 85 (1975):37

New Orleans Museum of Art: General Membership Fund and Women's Volunteer Committee Funds 74.43

This painting came to light only in 1974. One can plot its position in Luca's oeuvre, first by comparing it with the very early roundel of the same subject in Santa Maria la Nova, Naples (Ferrari-Scavizzi 1966, 2:40ff.), dating from the artist's youth, and then with a later version of the same scene in the cathedral, Toledo (Ferrari-Scavizzi, 2:139). Milkovich dates the New Orleans picture just before 1684–85 on the basis of a *Flight into Egypt* in the Santa Marca Collection, Madrid (letter, registrar's files, New Orleans Museum of Art). However we feel the painting belongs with the works painted just before he left for Spain or just after his arrival there — in the early 1690s.

The scene is a rocky wilderness river. The picture is dominated by the figure of St. John, who, on the right facing inward, half kneels on a tree stump as he leans forward to pour baptismal water from a shell on the figure of Christ below him. Much of the symbolism is obvious: John is clad in deep red, no doubt as a foretaste of Christ's Passion — or for that matter of his own death at the insistence of Salome. The stump meanwhile reflects the Old Testament, the incomplete revelation now interrupted. And its roots, which have blossomed with fresh dark green leaves, reflect the revelation to come in the New Testament. Blue-black

150

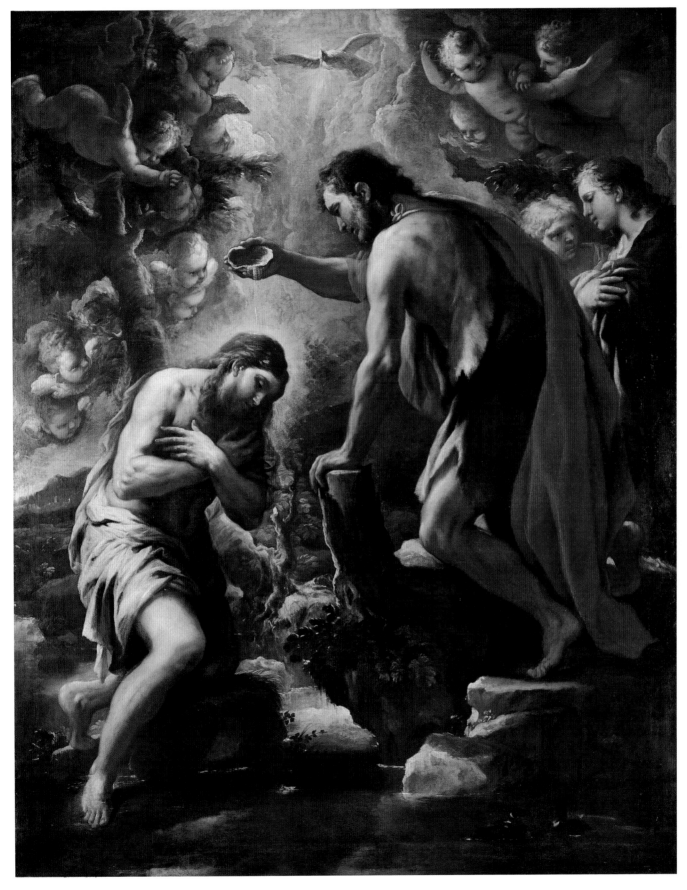

CAT. 15

ducks swim below the stone on which St. John rests his foot: even that may predict the rock upon which the Church is to be founded (Matthew 16:18; Bellarmino 1617, 1:334) though the ducks, as symbols, have evaded our investigations.

According to Emile Mâle (Mâle 1932, 26off.) Counter-Reformation *Baptisms* forsook the earlier tradition in which Christ stood nobly erect and frontal in the center with St. John as a kind of acolyte to one side and substituted the new formula we see here. Christ's *manus exsertae* pose, with his hands lightly crossed over his breast, symbolizes humility — in this case voluntary abasement, the pose of the sinner even though he is without sin. Mâle quotes Santa Maria Maddalena dei Pazzi on the subject: "O incarnate word! You wished to bow and humble yourself before St. John as if you were a sinner, as if you had need to be purified!"

Christ is opposite John, standing in the stream flowing down the picture's center. He kneels on his left knee, his hands folded across his chest, his head bent into the soft shadow of his brown hair. He is nude except for a very pale purple loincloth set off with heavily brushed, pale gold highlights. At a later date the purple drapery was extended over Christ's left arm, though most of the overpainting has been removed so as to reveal the original. The same thing has happened to St. John's right arm.

Behind St. John two witnesses regard each other in awed silence, one dark-haired, the other light-haired, both wearing heavy cloaks. A frond over their heads unites them. They are recensions of the famous Leonardo angels in Verrocchio's Uffizi *Baptism,* which Luca would have seen on his trips to Florence, the first of which was in 1652–53 and the second in 1665. Above, rosy-cheeked, gold-bodied putti fly upward. The omnipresent angels of seicento and settecento art have an artistic as well as a theological meaning. According to Bellarmino angels are God's own works of art, greater even than human beings as works of God's art. For example, the painter or sculptor can create the human form only with much difficulty and labor, but God assembles angels instantly out of the elements and gives them bodies, clothes, and speech in the twinkling of an eye (Bellarmino 1617, 6:240). So, as here in Luca's case, a painter who paints an angel enriches the concetto still further. On the other side of the scene, behind Christ, a sapling breaks off into a dark cloud populated by putti and seraphim. Other angels of the same type float like tufts of cloud below its branches, trailing into the sky's vividly brushed in gold-gray clouds.

The picture is in essence a burst of gold that fades into warm, clear shadows at the edges. Luca's *maniera dorata* is put to good purpose. The stream becomes a river of gold; and one recalls that it is the Jordan, a trope of the artist's name. The water's brilliance climaxes vertically in the highlight behind the dove of the Holy Ghost at the top of the scene. Luca models the figures outward from this central axis in a powerful impasto of flesh tones. Sinewy highlights shimmer across the darks. The upper highlight behind the dove is almost white-gold, the lesser highlights behind Christ's head a paler orange-gold. There is an entire minidrama of highlights in the water, whose rocks, between the figures, are suffused with brilliant foam. GH / SO

16 *St. John the Baptist Preaching*

64.1 x 79.4 cm (25¼ x 31¼ in); oil on copper

PROVENANCE: Dr. E. I. Shapiro, London

EXHIBITIONS: London 1950, no. 350; New York 1984, no. 21

LITERATURE: Longhi 1954, 31; Ferrari-Scavizzi 1966, 2:339 (wrongly stating that the picture is on canvas); *Important Old Master Pictures,* Christie's, London, March 30, 1979, lot 16

Piero Corsini, Inc., New York

This painting, relatively large for a copper, cannot be identified with a specific event in the Gospels but does illustrate the prophet's preparation of the Jewish people for the coming of the Messiah (Réau 1956, 2:432ff.). Though he wears the legendary camel's hair garment, Luca's saint does not fit the familiar image of St. John as an anchorite. This St. John, rather, is the last of the Old Testament prophets, "the voice of one crying in the wilderness" (Isaiah 40:3, Matthew 3:3, Mark 1:3, Luke 3:4, John 1:23). He is a response, in short, to Mattia Preti's magnificent *St. John* in the present exhibition (cat. 5). Luca Giordano and other artists who have thus depicted what might be called St. John's glorious aspect (Pigler 1956, 2:273) may have been aware of the Byzantine tradition of venerating the saint as an angel (Réau 1956, 2:439).

The saint appears in Luca's picture, certainly, with all an angel's resplendent power. The crowd of listeners young and old gathers on the rocks around the Baptist's cave, captivated by the Word and its otherworldly utterer. The saint is silhouetted against a powerful aura of golden light that emanates from his person independently of the picture's other lightsources. His heavy-set nude body is in contrast to the popular costumes of his audience. The muscular torso and the deep reddish pink mantle hovering about his right arm and left hand have parallels in Luca's treatment of St. Michael the Archangel (cat. 8).

It is fitting that Luca Giordano should have painted this glorification of St. John at a moment when Counter-Reformation theologians were advocating that dogma be promulgated by means of charismatic pulpit orators (De Maio in *Storia di Napoli* 1970, 6:609ff.). And the technique of preaching is a factor in Luca's use of sources: if we look at Bernini's frontispiece to volume 2 of Giovanni Paolo Oliva's *Prediche* (Oliva 1659; Lavin 1981, 254ff.), we find an apt prototype for Giordano's preacher (fig. 57). Engraved by François Spierre, Bernini's design depicting *St. John the Baptist Preaching* was well enough known for G. B. Gaulli to recreate it almost identically in his painting now at the Louvre. Surely, at the very least, the print after Bernini's design was known to Luca Giordano and to the patron of the Corsini picture. Though reversed, there are many points of similarity between the Giordano and the Bernini: partly unclad, both figures stand in the three-quarter view on a rock. In both scenes, too, the listening crowds constitute veritable genre episodes. The two portrayals also emphasize the triumphalist aspect of the Baptist's preaching, the notion of glorification mentioned earlier, though the Bernini more so than the Giordano.

A drawing depicting this same subject now in the collection of Gloria Porcella, Rome (Porcella 1967), and most likely, a copy by someone else after Luca Giordano, is oriented like

FIG. 57. After Gianlorenzo
Bernini, frontispiece to volume
2 of Giovanni Paolo Oliva's
Prediche, 1659

Bernini's engraved design and testifies, perhaps, to the fact that Luca made a drawing of the Bernini engraving.

Though the patron of the Corsini painting is unknown, judging from its medium and size it was probably made for a private patron. The copper support excludes the possibility that it could be a bozzetto; and the frequent pentimenti such as the profile of St. John the Baptist, the turban of the young nursing mother, the horse's head, and the head of the old man in a turban below the saint's arm — these, together with the firm handling throughout, argue for this picture's being completely autograph. The paint is applied quite thickly on the copper surface, the impasto being greatest in the highlights. In areas of shadow Luca allowed the dark copper itself to show through. While the foreground with its monumental main characters is detailed and careful the figures in the background are rendered with Luca's proverbial rough bravura. The pentimenti bear witness to his preference for unraveling compositional problems more or less directly on the painted surface rather than through preparatory drawings.

Longhi was the first to date the Corsini picture to some time during Giordano's stay in Spain, singling out the "modernist" handling that seems to prefigure Goya (Longhi 1954, 31). Following Longhi, Ferrari and Scavizzi, who were apparently judging from a photograph, date the work to 1696. Yet it is worth noting that many of the features of this painting were present in Luca's work a decade before his Spanish sojourn. The saturated coloring in the Corsini

CAT. 16

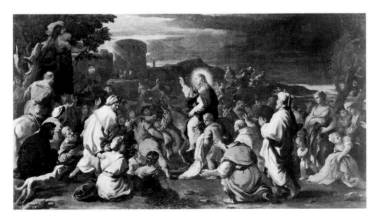

FIG. 58. Luca Giordano, *Christ's Entrance to Jerusalem*, Galleria Nazionale d'Arte Antica, Palazzo Corsini, Rome

copper — the yellows, reds, greens, the silvery whites — was part of Luca's vocabulary by the 1680s as was this type of composition, which seems less grandiloquent and at the same time less ethereal than the Spanish commissions (e.g., the *Calling of St. Matthew* at Georgetown University, fig. 32). The genrelike characters in the Corsini painting find analogues in the *Hymn of Miriam* now at Bob Jones University (cat. 14) and in the pendant canvases in the museum at the University of Würzburg: *The Raising of the Cross* and *The Multiplication of the Loaves and Fishes,* signed and dated 1686 (Ferrari-Scavizzi 1966, 3, pls. 284, 285). Above all the similarities between our painting and *Christ's Entrance to Jerusalem* now in Rome at the Galleria Nazionale d'Arte Antica, Palazzo Corsini (fig. 58; Ferrari-Scavizzi 1966, 3, pl. 286) are striking. Many of the figures share identical poses. The St. John and the Christ are nearly clones. Despite the slightly different hues that paintings on copper have, the palette in our *St. John* is very close to that in the Roman picture, though the latter clearly needs a good cleaning. Curiously, Ferrari-Scavizzi group these two paintings together in their discussion though they placed them ten years apart. Some information kindly provided by Dawson S. Carr might explain this discrepancy. He suggests that before Luca's tenure as court painter in Madrid, he rarely painted on copper. Hence it is tempting to date this painting to the 1690s and to reaffirm here that Luca's style does not change appreciably when he goes to Spain.

A *St. John the Baptist Preaching* now in the collection of Eric Young in London (London 1975, no. 14) is usually linked stylistically to the picture under discussion. Although there are compositional similarities, the Young picture is more roughly executed and has little of the plastic *stile dolce* found in the Corsini *St. John*. CBC

17 *Judith with the Head of Holofernes*
18 *The Discovery of Holofernes' Body*

Each 76.4 x 102.2 cm (30 x 40¼ in)

PROVENANCE: Private Collection, Paris; Wildenstein and Co., New York, 1958

EXHIBITIONS: New York 1958; Sarasota 1961, nos. 35, 36; Detroit 1981, no. 26

LITERATURE: Co. Durham 1962 (Addenda); Memphis 1964, nos. 28–29; Ferrari-Scavizzi 1966, 2:231–32, and 3, pls. 518–19; Naples 1979, 2:368

The Saint Louis Art Museum, Museum Purchase 60.65 and 61.65

In April of 1704, when Luca Giordano had completed his fresco in the cupola or vault of the Cappella del Tesoro, San Martino, Naples, the monks proclaimed that the "painting not only was to our complete satisfaction, but is admired by everyone for the particular sentiment and devotion that Don Luca carried and carries for our monastery" (Archivio 1972, 141). The fresco became one of Giordano's most famous works (figs. 59, 60, 61), admired by Solimena and De Matteis and by most writers since the eighteenth century (De Dominici 1742–45, 3:429ff., 542; Ferrari-Scavizzi 1966, 2:231). Giordano executed a number of bozzetti for this important

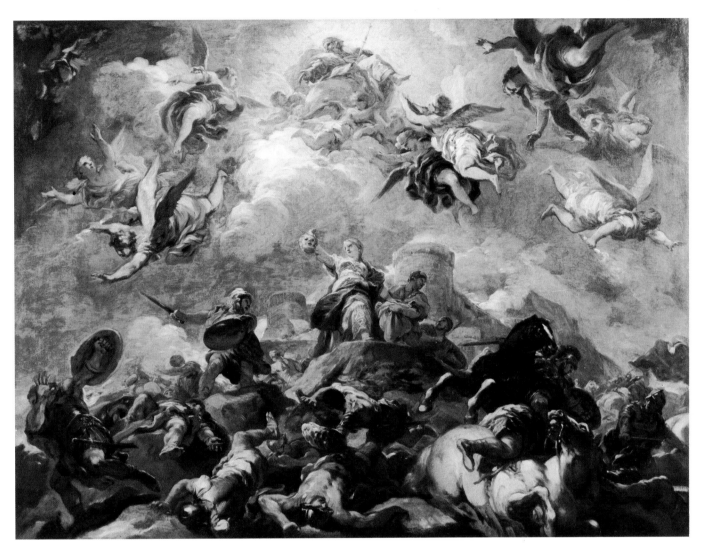

CAT. 17

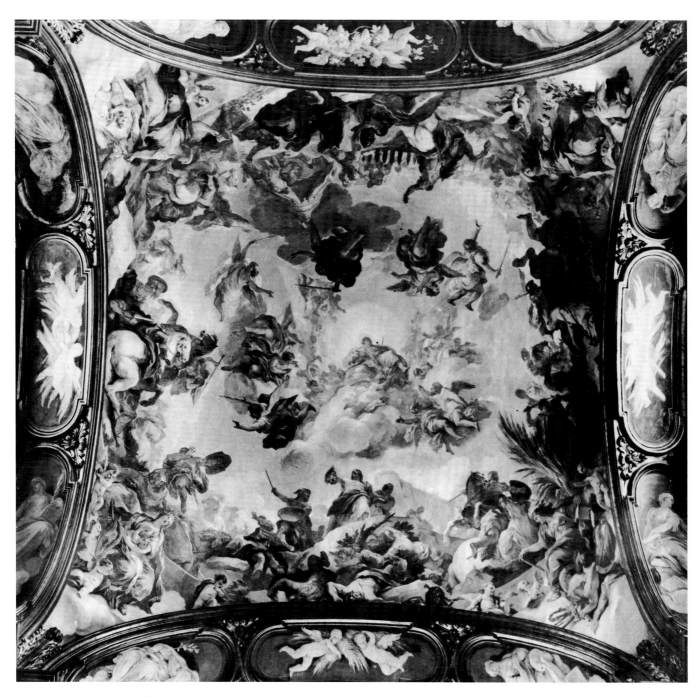

FIG. 59. Luca Giordano, *The Triumph of Judith*, Cappella del Tesoro, Certosa di San Martino, Naples

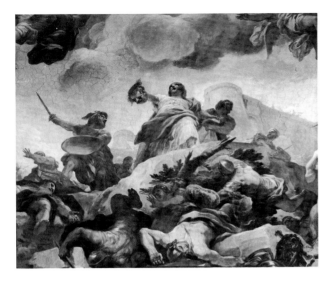 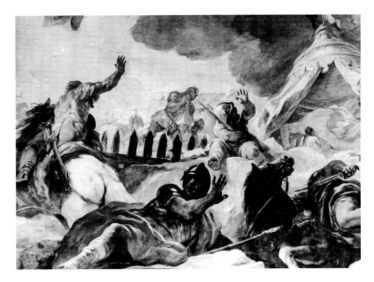

FIG. 60. Detail of fig. 59 FIG. 61. Detail of fig. 59

composition, two of which are now in St. Louis. A sketch for the figure of Judith is in the Cuomo Collection, Naples (Naples-Paris 1983, no. 41). The paintings represent two scenes from the story of Judith which are arranged on opposite sides of the vault but are integrated into a unified scheme. (See also the bozzetto in the Museo di San Martino, Naples, for the *Worship of the Bronze Serpent,* another scene in the treasury vault.)

According to the apocryphal Book of Judith, the Hebrew town of Bethulia was under siege by the forces of the Assyrian king Nebuchadnezzar, led by the general Holofernes. In order to save her people a beautiful and pious widow named Judith exchanged her mourning for her most seductive finery and descended into the camp of the Assyrians. After a banquet with Holofernes she was left alone with him in his tent, where he had fallen into a drunken slumber. With his own sword she severed his head, placed it in a sack carried by her maid, and surreptitiously returned to her people, to whom she displayed her grisly prize. The next day the Israelites attacked the Assyrians who, deprived of their leader, were easily routed.

In one of the St. Louis pictures Giordano has depicted Judith standing outside the walls of Bethulia, her maid by her side, holding aloft Holofernes' severed head. The other painting features the discovery of the general's headless body by his horrified soldiers. Giordano has departed somewhat from the textual account, and from traditional representations, in that Judith displays the head not to her own people within the city walls, but above the scene of battle. She thus encourages the Hebrew forces and causes the enemy to panic at the sight. The Assyrians are scattered, also, by a number of angels, some of them armed with thunderbolts, commanded by God the Father.

Depictions of Judith and Holofernes, generally in compositions of two or three figures, had been popular since the late fifteenth century. Often they signified the triumph of the Church

over heresy. The subject is also, however, an example of women's power over men — a theme often treated from the Middle Ages on. In connection with this there are four Old Testament heroines not in the bozzetti but which appear at the corners of the vault: Jael, who killed the Canaanite captain Sisera in an episode analogous to that of Judith; Deborah the prophetess; the daughter of pharaoh, who saved the infant Moses; and (perhaps) the daughter of Jephthah. (See also the discussion of the *Miriam,* cat. 14.) Precedents for these heroines are in Luca's *Apotheosis of Santa Brigida,* of 1678, in the cupola of the church of Santa Brigida, Naples.

Other paintings related to the fresco are an oil sketch in the Bowes Museum, Barnard Castle, Co. Durham, England, probably representing an early idea for the composition we see in the St. Louis *Judith with the Head of Holofernes,* which is substantially that of the finished fresco; two paintings in the Treccani Collection, Milan, studio copies after the St. Louis pictures, which they follow very closely (Ferrari in Washington 1983, 179, and in Paris 1983, 128); and two drawings in the Società Napoletana di Storia Patria, probably representing early ideas for the figure of Judith (Causa Picone 1970, 47, and 1974, 101, and in Naples 1979, 1:368; Ferrari in Paris 1983, 128). A third preparatory drawing was formerly in the Lemmermann Collection, Rome (Ferrari in Paris 1983, 128). An oil sketch in the Royal Museum of Fine Arts, Copenhagen, once thought to be a study for the San Martino ceiling, is now believed to be a bozzetto by Paolo de Matteis for his painting formerly on the ceiling of the church of Santo Spirito di Palazzo, Naples (Olsen 1961, 76ff. and pl. LIXa). This painting follows Giordano's lead in that Judith holds the head of Holofernes outside the gates of Bethulia, inciting her countrymen to battle and towering over panic-stricken Assyrian soldiers. Its existence is confirmation of the prestige enjoyed by Giordano's last masterpiece.

It is interesting to compare the St. Louis bozzetti to Giordano's *St. Michael* sketch of nearly a half century before (cat. 8). While the Riberesque qualities of the earlier work have now long been left behind, the colors in all three paintings remain relatively subdued owing to the reddish-brown ground which Giordano continued to use and which is even more evident in later work. The tonality of the St. Louis bozzetti hardly prepares the viewer for the bright, airy appearance of the fresco, which has often been seen as a herald of the rococo style (but see, *contra,* Enggass 1981, 341). In the intervening years between the *St. Michael* and the St. Louis paintings *Luca fa presto* seems only to have gained in speed and dexterity. Now a few deft strokes define the forms. The speed and accuracy of Giordano's late work is perhaps best expressed by Solimena, who is reported to have said of the San Martino fresco that "no great painter could imitate the fury, the fire, and the knowledge with which he painted that battle, because it seems to have been painted all in one breath, and with a single turn of the brush" (De Dominici 1742–45, 3:430). JDC

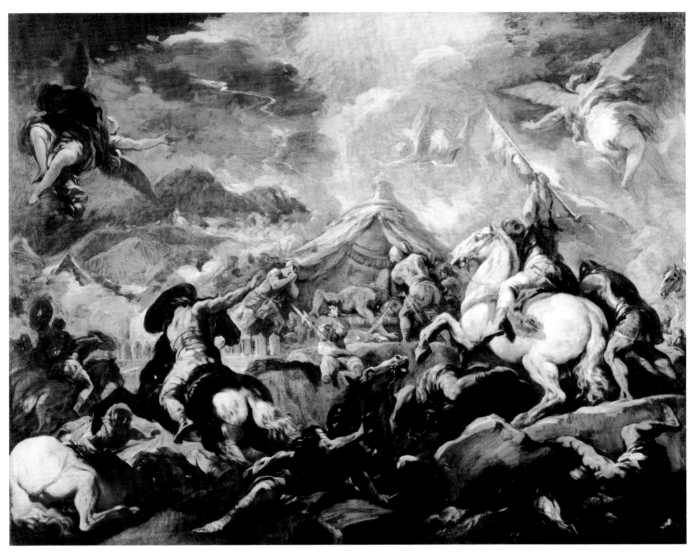

CAT. 18

FRANCESCO SOLIMENA, 1657-1747

Carmen Bambach Cappel

Francesco Solimena brought Neapolitan art to its greatest glory. After the death of Carlo
Maratta in 1713, he was unarguably the most famous painter in Europe. He was also one of the
most popular painters of his day; as one admirer claimed in 1733, "Everyone has wished, and
wishes, to have his works" (Orlandi 1733, Dedication; for early sources see Bologna 1958,
223ff.). And Pierleone Ghezzi's inscription on a caricature of 1735 says: "He is the best master
we have in this century" (Bologna 1958, 211). No subsequent Neapolitan artist has ever
matched Solimena's international reputation.

In the present essay I shall attempt a critical reading of the rich contemporary source
material, chiefly De Dominici's biography. Some of these texts are biased in the artist's favor.
Indeed some even claim that Solimena, old and covered with glory, may have dictated his life
to De Dominici, feat by feat, as Michelangelo is said to have done two centuries before with
Vasari and Condivi. But biased or not, De Dominici's eye was extraordinarily sensitive to
Solimena's complex development. De Dominici's insights have often appeared, thinly dis-
guised and unacknowledged, in twentieth-century criticism.

Francesco Solimena was born to Angelo Solimena and Marta Grisignano of Nocera on
October 4, 1657 (Pavone 1980, 135ff.). He was baptized in the parish church of San Lorenzo in
Canale di Serino on October 11, 1657 (Bologna 1958, 177ff.). Despite De Dominici's claim that
the Solimena family was of noble Salernitan lineage it was actually of humble origins (De
Dominici 1742–45, 3:579; Giannone quoted in Ceci 1908, 631). Orlandi and De Dominici both
claim that the boy awed his elders with his prodigious ability from very early in life (compare
with Luca Giordano's boyhood angels above, in Judith Colton's biography). As De Dominici
has it, Angelo Solimena, himself a painter and a poet of some note, at first intended his son to
study law (De Dominici 1742–45, 3:579ff.). Young Francesco was thus forced into a rigorous
program of grammar, oratory, and philosophy. But he preferred to paint. He did so, we are
told, at night, hiding the fact from his father, while during the day he applied himself to his
academic subjects (De Dominici 1742–45, 3:585). In view of the fact that later in his life
Solimena seems to have taken minor clerical orders (contemporary biographers call him the
"abbate Ciccio"), and since he depicted himself in clerical dress in his self-portrait (fig. 62),
Angelo possibly had destined him for canon law. In any case, as De Dominici tells it, Cardinal

FIG. 62. Francesco Solimena, *Self-Portrait*, Museo di San Martino, Naples

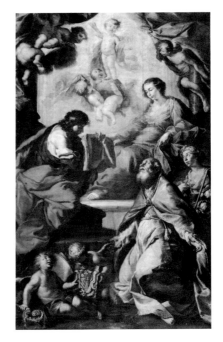

FIG. 63. Angelo and Francesco
Solimena, *Vision of St. Cyril
of Alexandria*, San Domenico,
Solofra

Vincenzo Orsini, later Pope Benedict XIII, on seeing Francesco's drawings, admonished the
father that such talent should be encouraged on the grounds that a single great artist was better
than many *dottori* (De Dominici 1742–45, 3:580ff.; see also Bologna 1958, 15ff.; Bologna 1962;
Pavone 1980, 61, 66).

As a painter Angelo Solimena was one of the last exponents of seicento naturalism. He had
been trained by Francesco Guarino (Pavone 1980, 43ff.), and works such as the *Deposition* for
San Matteo, Nocera Inferiore (1664) and the *Madonna and Saints* for the Chiesa del Purgatorio
in Serino (1667), though they display a certain dignity, are unimaginative (Pavone 1980 figs. 4,
5). The ambitious fresco program for the church of San Giorgio, Salerno (1674–75), is more
successful (Pavone 1980, figs. 16–53). But Angelo remained faithful to the formulas of the great
naturalistic artist of the earliest age, Francesco Guarino, who had died in 1654. Only later, in the
1670s, did his son lead him to the manner of Luca Giordano. The number of paintings that
Angelo and Francesco painted together signals Francesco's rapid rise from pupil to collaborator.
This collaboration is, indeed, the main new discovery about Francesco's early career (Pavone
1980). Soon, furthermore, the roles were reversed and the father found his inspiration in the
son's work.

When the seventeen-year-old Francesco Solimena arrived in Naples in 1674 no single school
dominated. There were the followers of Francesco di Maria, who espoused careful drawing and
construction, and the Giordanisti who preferred the charms of color and the inspiration of the
moment: *fa prestismo*. Solimena decided to study in Di Maria's studio. But, says De Dominici
acidly, he did not stay long. He rejected the incessant study of the nude and preferred to paint
finished pictures. He supposedly explained to his teacher that it was paintings, not drawings,

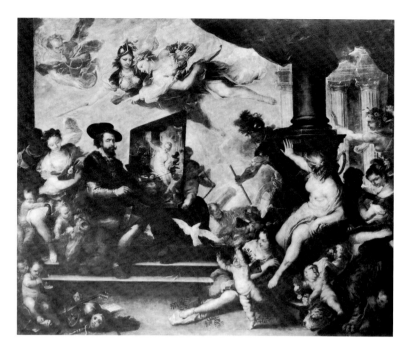

FIG. 64. Luca Giordano,
*Rubens Depicting the Allegory
of Peace and War*, Prado,
Madrid

that hung in churches and public places. After this Solimena seems to have had no further formal training (De Dominici 1742–45, 3:581; Orlandi 1733, Dedication). But he did become an assiduous if unofficial follower of Giordano.

A good example of Solimena's first brush with Giordanism is also the finest collaborative effort between Solimena and his father: the altarpiece for the church of San Domenico, Solofra, depicting the *Vision of St. Cyril of Alexandria* (ca. 1675–77; Pavone 1980, 82; fig. 63). With its golden but somewhat artificial light the painting is reminiscent of Giordano's work in the Neapolitan church of Sant' Agostino degli Scalzi and of his *Rubens Depicting the Allegory of Peace and War* at the Prado (fig. 64). The composition is artfully complex and the spatial arrangement, for the first time in Angelo Solimena's oeuvre, is believable. Despite the soft golden light that seems to dissolve them, the forms are made sculptural by the chiaroscuro. Through Luca Giordano's style, both painters integrated a Neo-Venetian chromaticism and warm light into their pictorial vocabulary. This luxurious, painterly manner is also evident in Francesco's *Lot and His Daughters* in Ponce (cat. 19), which is particularly reminiscent of Luca Giordano's *Finding of Moses* (ca. 1672) at the Harrach Gallery outside Vienna (Ferrari-Scavizzi 1966, 3, pl. 140). Similar effects of light, and of Venetian chromaticism, characterize much of Giordano's own early work. They pervade Solimena's art through the 1670s and the early 1680s. By 1689–90, however, when Solimena was painting the sacristy of San Paolo Maggiore, Naples (fig. 5) and the *Birth of the Virgin* now in the Metropolitan Museum (cat. 20), he had begun to move toward the mature Giordano. It was a change seen primarily in the new solidity of forms and increased scale as well as in sharper contrasts of golden light and shadow and more vivid colors. Furthermore, as would become increasingly apparent in the late 1670s and 1680s,

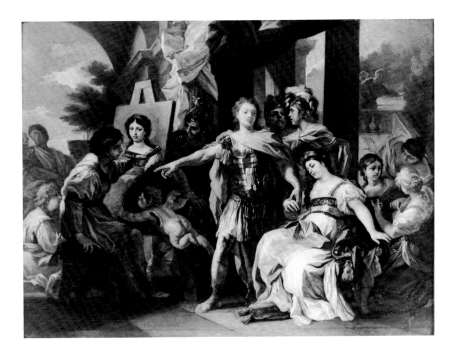

FIG. 65. Francesco Solimena,
Apelles, Campaspe, and Alexander,
oil on copper, Private Collection

FIG. 66. Francesco Solimena, Virtues, fresco, sacristy, San Paolo Maggiore, Naples

Solimena also now began to absorb something of the manner of Pietro da Cortona. Pietro's *Death of Sant'Alessio* had hung in the Neapolitan church of the Girolamini since 1634 and was an important precedent for many of Giordano's innovations. De Dominici also records that two famous Solimena compositions, exemplified by the little coppers of *Apelles, Campaspe, and Alexander* and *Zeuxis Painting the Maidens of Croton* (ca. 1689; in a private collection, on loan to the Detroit Institute of Arts), "were also painted in Cortona's manner for his own study in his youth" (De Dominici 1742–45, 3:612; Bologna 1968a; fig. 65). Solimena's illustrations for Giannettasio's *Piscatoria et Nautica* of 1685 also owe much to Cortona (Bologna 1958, figs. 68, 69). In time, too, Solimena's paintings, like Giordano's, would display typically Cortonesque figure types: broad, generous, imposingly draped women with delicately pointed faces, their hair knotted in artful disarray. Such types abound in paintings like the Donnaregina cycle, the Virtues on the ceiling and spandrels of the sacristy in San Paolo Maggiore (1689; fig. 66; Bologna 1958, figs. 46–61, 74, 78–83), and in the present exhibition, the Metropolitan Museum *Birth of the Virgin* (cat. 20), and the *Death of St. Joseph* (cat. 21).

Although De Dominici thinks Solimena learned very little from Francesco di Maria, this artist in his limited way was Domenichino's heir in Naples. His Accademia del Nudo was an important predecessor of the Accademia Reale founded in 1752 (Ceci 1899, 8ff.; Pevsner 1940, 141). Despite his early flight from Di Maria's tutelage and his subsequent Giordanism, Solimena developed into a stern advocate of accurate figure drawing, of disegno. His own studio — another predecessor of the Accademia Reale — was paradoxically to be much like Francesco di Maria's. The influence of the latter's own rather academic Domenichinesque style would become apparent in the first decade of the eighteenth century.

After a start at fresco in San Giorgio ai Mannesi, Naples (no longer extant), came an important achievement: the 1677 ceiling for the Cappella dei Martiri (or of Sant'Anna) at the Gesù Nuovo (De Dominici 1742–45, 3:583). These frescoes, afterward totally repainted and still only partly restored, show a surprisingly mature assimilation both of Luca Giordano and of Emilian art (Bologna 1958, 49, and figs. 14–19). The manner is still very much in keeping with Solimena's most youthful works such as the *Vision of St. Cyril* in Solofra (fig. 63). But the anatomy of the seraphim, the tectonic quality of their draperies, and a sophisticated disegno that integrates these elegant heavenly figures into a trompe l'oeil framework of moldings, volutes, and swags is astonishing for a painter barely twenty years old. As a result of this commission, says De Dominici, Francesco became famous. Students turned eagerly to "this rising sun that would with his light illuminate the minds of students of painting, indicating to them, with the guidance of nature, the true path in which whoever wants to pursue this most noble profession must follow" (1742–45, 3:583).

Sometime between 1678 and 1680 Francesco and Angelo frescoed the small dome of the cathedral of Nocera Inferiore with a great *Paradise* seen from below, *da sotto in sù* (Pavone 1980, figs. 58–63).[1] The contrast of the palpably sculptural bodies tightly encircling the dome of heaven and the fantastic effects of light emanating from them is similar to that in the Solofra *Vision of St. Cyril.* The composition however is Correggesque. (Correggesque formulae would have been visible in Naples in Lanfranco's frescoes for the dome in the Cappella di San Gennaro in the cathedral and in the *Paradise* in the Gesù Nuovo.)

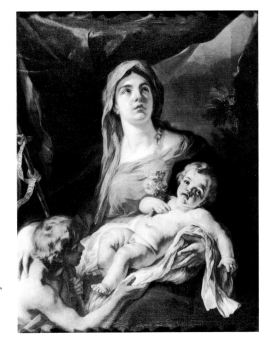

Francesco Solimena

FIG. 67. Francesco Solimena, *Madonna and Child*, Spencer Museum of Art, Lawrence, Kansas

The great fresco cycle of 1680 dedicated to the martyrdoms of SS Tecla, Archelaa, and Susanna for the monastery of San Giorgio in Salerno was Solimena's first independent large-scale commission (Bologna 1958, figs. 22–29). It is in a predictable Giordano–Cortona manner with saturated tones and a flickering light that touches the profiles of the kneeling saints, recalling Barocci. But it has a pathos and majesty that foreshadow Solimena's masterpiece, *The Conversion of St. Paul* (1689) in the sacristy of San Paolo Maggiore, Naples (fig. 5).

The beginnings of Solimena's long association with the Abbey of Montecassino can be placed around 1681. This is the date inscribed on the altarpiece depicting SS Jerome, Francis of Assisi, and Anthony of Padua (Bologna 1958, 180ff., 285). Judging from photographs — the painting was destroyed in the tragic bombing of 1943 — the altarpiece was a superb product of Solimena's early years (see also the essay by Robert Enggass, above pp. 41ff.) The self-confident light is Giordanesque, the tender, strong chiaroscuro reminiscent of Lanfranco. There is even a touch of Ribera in the nude St. Jerome. It suggests that Solimena has wrought a new personal manner from the study of his masters.

Perhaps the most glorious canvases from this period are two altarpieces for San Nicola alla Carità (Bologna 1959, figs. 38, 64). One, depicting SS Francis of Sales, Francis of Assisi, and Anthony of Padua, ca. 1681 (fig. 15; cf. also De Dominici 1742–45, 3:584), is composed in elegant curves and molds itself to the dramatic contrasts of light and shadow. The light, ever more golden, sweeps diagonally upwards from the lower left corner, imbuing the forms with a supernatural aura. Also dating from between 1680 and 1682 and closely related to the Salernitan frescoes and the San Nicola altarpieces are the *Madonna of the Rosary,* now in Berlin, and the *Madonna and Child* at the Spencer Museum in Lawrence, Kansas, a recent attribution

(fig. 67). Although the Berlin painting is compositionally more ambitious, both paintings glow with similarly vibrant harmonies of primary colors set against a background suffused with golden light. A soft chiaroscuro caresses the picture sufaces. The figure types, for example the sweet auburn-haired Madonnas and the red-faced cherubim, seem identical.

Solimena's monumental frescoes for the choir of the church of Santa Maria Donnaregina (1681–84), depicting episodes from the life of St. Francis of Assisi, show the painter's visionary imagination at its best (Bologna 1958, figs. 46–61). He is still fruitfully infatuated with Luca Giordano's vigorous fantastic style. As De Dominici says of this politically delicate commission, a work by Luca himself was placed not far from Solimena's in the church (De Dominici 1742–45, 3:585). Indeed, some have thought that with these frescoes young Solimena caught up with Luca and began to influence him. Since this grand fresco cycle was detached from its original location to make way for a dubious restoration of the church's Gothic architecture, here as with Montecassino we must rely on old photographs for the original effect. *The Glory of St. Francis* betrays its compositional kinship with the *SS Francis of Sales, Francis of Assisi, and Anthony of Padua* altarpiece in San Nicola (fig. 15), but now the main thrust tilts upward in a diagonal, increasing the depth of the picture plane. The *da sotto in sù* foreshortening meanwhile endows the figures with unexpected monumentality. The scenes of *St. Francis Refusing the Priesthood* and *The Vision of St. Francis* recall Luca Giordano's altarpiece for SS Giuseppe e Teresa a Pontecorvo, *The Holy Family with the Symbols of the Passion* (1660; Ferrari-Scavizzi 1966, 3, pl. 93), and his *Apparition of the Virgin to St. Francis,* now in the Cleveland Museum of Art. Solimena, like Luca Giordano, played down the saint to emphasize the vision. Influence from Veronese and Cortona, via Giordano, permeates the paintings. Bologna has proposed that in the great scene of the *Miracle of the Rose* (1684), now illegible, Solimena went beyond Giordano's previous achievements. He also claims that after Giordano's return to Naples from Florence, the older painter was inspired by these Solimena frescoes to produce the *Christ Expelling the Moneychangers from the Temple* at the church of the Girolamini (1684; Ferrari-Scavizzi 1966, 3, pl. 247). Both compositions are scenographic, and Arcangelo Guglielmelli, a specialist, may have executed the complicated quadratura (architectural perspectives) for both (Bologna 1958, 68). Furthermore, Solimena's "naturalism," evident in the various still-life touches throughout the Donnaregina series, may have drawn Giordano from his renewed Cortonism, which he had acquired during his Florentine sojourn, into this more "naturalistic" mode. Certainly, until the Girolamini fresco, Luca Giordano had rarely used such architectural settings.

The frescoes for the sacristy of San Paolo Maggiore (1689–90) represent the peak of Solimena's early career (figs. 5, 66; Bologna 1958, figs. 74–83). Like cool glowing gems embedded in gilded stucco the frescoes foreshadow the last feat of Luca Giordano's career, the 1705 ceiling fresco for the treasury of San Martino, *The Triumph of Judith* (fig. 59). Because the room is entirely by Solimena there is complete unity. Seated virtues in *quadri riportati* populate the elaborately stuccoed ceiling, spandrels, and lunettes, while at either end are the spectacular scenes of the *Conversion of St. Paul* and *The Fall of Simon Magus*. As De Dominici says of the *St. Paul,* "It is admirable how the fury of the running horses is depicted, spurred by the terror of the soldiers and by the sudden light that has thrown the holy apostle from the saddle, who can be seen fallen on the ground." And he adds later: "A similar perfection in fresco painting one has

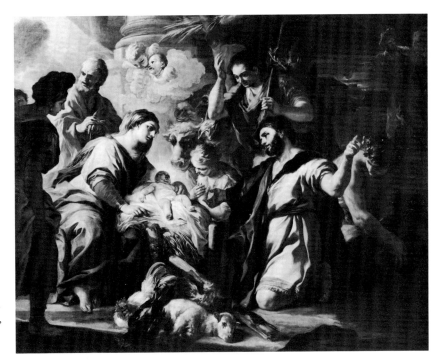

FIG. 68. Francesco Solimena,
The Adoration of the Shepherds,
Elvehjem Museum of Art,
Madison, Wisconsin

never seen, neither in painters of the past nor in modern ones." His description of the *Fall of Simon Magus,* the last of the frescoes to be painted, constitutes a veritable ecphrasis: "The present multitude [is] well posed around the throne of the Emperor Nero, which is ascended by a few steps, and there are situated many beautiful figures, and amongst whom a young lady stands out who holds a spirited girl by the hand, and further forward there is a seated nude male and he, being blind, concentrates on what he can hear about what is happening" (De Dominici 1742–45, 3:586). The *Conversion of St. Paul* was surely inspired by Luca Giordano's two great canvases now in Rome at the Galleria Pallavicini, one of them itself a *Conversion of St. Paul* and the other the *Death of Julian the Apostate* (ca. 1683; Ferrari-Scavizzi 1966, 3, pls. 232–33). But the monumental figure-architecture of the San Paolo Maggiore compositions goes well beyond any work of Luca's. Solimena's frescoes became famous; Fragonard drew after them in the 1770s (Bologna 1958, 73).

The much-damaged frescoes for the nave vault of San Nicola alla Carità, depicting scenes from the life of St. Nicholas of Bari, probably date from around this time (De Dominici 1742–45, 3:586; Bologna 1958, 182, 263). A number of easel pictures, meanwhile, can also be dated to this period. Their relation to the San Paolo Maggiore frescoes is unmistakable. The monumental seated female figures reappear in works such as the *Hagar in the Desert,* now on permanent loan to Capodimonte (Bologna 1958, figs. 84–85), and the Metropolitan Museum *Birth of the Virgin* (cat. 20).

Luca Giordano's departure for Spain in 1692 marked another change in style for Solimena. He now began to distance himself from the exuberant chromatic luminosity of the older artist.

FIG. 69. Francesco Solimena,
*The Madonna and Child in Glory
with SS Angelo and Chiara da
Montefalco*, Santa Maria
Egiziaca a Forcella, Naples

In spite of the rivalries that seem to have clouded Solimena's interaction with Paolo de Matteis, the latter, who in Rome had come into contact with Carlo Maratta and with Roman seicento classicists, has been credited with inspiring the new classicism apparent in Solimena's work of the late 1680s and early 1690s (London 1971a, nos 11, 12; see also Evonne Levy's essay, below). *Joseph and Potiphar's Wife* (1689–90) illustrates the new mode. While it conserves Giordanesque figure types and lighting, it has vibrant primary colors and a refined disegno. Other works dating to ca. 1692 mark Solimena's parting fling with Giordanism: *The Adoration of the Shepherds* now in the Elvehjem Museum of Art, Madison, Wisconsin (though that museum dates the picture to ca. 1688; fig. 68), the *Annunciation* now at the Mauritshuis in The Hague (Bologna 1958, fig. 92), and the Gesù Vecchio *Triumph of St. Ignatius of Loyola,* which Bologna dates to the late 1690s (Bologna 1958, 108). These paintings show similar figure types, feathery brushwork, and flickering chiaroscuro. They are still imbued with Luca's golden haze; yet through that haze they now look back to Preti's darker, more tragic style.

We have, then, followed De Dominici in seeing a development in Solimena from his father's naturalism, through a Cortona phase, to this third, composite style "of admirable study, and beauty of drapery, of exquisite grace in the gestures, and wonderful, even marvelous, in the variations of physiognomy in the great compositions" (De Dominici 1742–45, 3:613). Solimena's second version of *St. Francis Refusing the Priesthood,* in Santa Maria Donnaregina, dated 1693

(Bologna 1958, 79, 182ff., 262), again displays this new mode. Now too, probably led by the example of Paolo de Matteis, Solimena's figures and compositions became more classicizing, even Marattesque, as in the altarpiece for Santa Maria Egiziaca a Forcella of *The Madonna and Child in Glory with SS Angelo and Chiara da Montefalco* (ca. 1696; fig. 69; Bologna 1958, fig. 103), and in some of the canvases for Santa Maria Donnalbina.

De Dominici seems to have had a special admiration for Solimena's work in the latter church (Bologna 1958, 84ff., 99, 184, 262; Bologna 1968, 56): he calls it a "heroic poem" (De Dominici 1742–45, 3:587). Unfortunately the frescoes (ca. 1698) are in such dismal condition as to render confirmation impossible. The series of canvases for the transept of the church (1699–1701), however, a Marian cycle that De Dominici hardly describes, truly do embody Solimena's newfound manner at its most monumental (Bologna 1958, figs. 114, 115, 120–123). They have been restored and are exhibited now in the picture gallery of the church of San Lorenzo Maggiore. The influence in these magnificent pictures of Paolo de Matteis, as in his *Madonna and Child,* San Giovanni dei Fiorentini (1690), or his *Madonna and Child with Saints* for San Liborio (late 1690s), has been pointed out (Pavone 1980, 33). The scenes also seem refreshingly Arcadian. For instance, the Virgin in the *Annunciation* (Bologna 1958, fig. 120) is remarkably reminiscent of Orithyia's attendant in the *Abduction of Orithyia,* not only in type but also in stance (cf. cat. 22). Even the *Adoration of the Shepherds* (fig. 68), usually handled like a *presepio,* or panoramic folk Nativity, has slender aristocratic figures gesturing loftily. Belonging to this same period, and of related subject matter, is the elegant but powerful *Death of St. Joseph* discussed in the entry for cat. 21.

Solimena, still involved in the programs at Montecassino, now also visited Rome, apparently for the first time. The trip is usually dated to 1700 but more probably took place in 1702 (based on a careful reading of De Dominici 1742–45, 3:588; Bologna 1958, 185, *contra,* dates the trip to 1700). The trip would have taught him much more about the art of such admired masters as Maratta, Reni, Domenichino, and Guercino, whose work he had first come to know via their influence on Paolo de Matteis and through prints. As a result Solimena turned further still from Giordano and from his vigorous reinterpretations of Preti's tenebrism; or, rather, he classicized these earlier elements of his style. His great interest in Maratta shaped his development through the first decade of the eighteenth century, so much so that Giannone was to claim, erroneously, that Solimena gave up all other influences in favor of the Roman painter (Giannone in Ceci 1908, 631). Solimena, who may have met Maratta personally on this trip, is said to have loved to praise the painter's *Death of San Francesco Saverio* in the Gesù in Rome (De Dominici 1742–45, 3:588).

Solimena's new Roman classicism seems also closely related to the Arcadian movement. Roman in origin, a Neapolitan branch was begun ca. 1690 (Bologna 1958, 94; Giannantonio 1962; De Dominici 1742–45, 3:605, 623). Many of Solimena's Neapolitan patrons were members of this literary movement and he executed the *Abduction of Orithyia* (1702; Bologna 1958, fig. 117) for the Spada family in Rome, which also had Arcadian connections. Another Roman Arcadian commission was the *Naming of St. John the Baptist,* now at the Walker Art Gallery in Liverpool (ca. 1717; Bologna 1958, fig. 154), along with some other paintings mentioned by De Dominici, for Cardinal Ottoboni (De Dominici 1742–45, 3:592; Bologna 1958, 105, 112).

Solimena also illustrated the first edition of *Piscatoria et Nautica* (1685) by N. P. Giannettasio, as noted, and in 1729, *Tragedie Cristiane* by Annibale Marchese (fig. 70). Both authors were Arcadians (Bologna 1958, 105ff.). Giambattista Vico was another, and Solimena painted Vico's portrait, which later, in engraved form, would serve as the frontispiece for the *Scienza Nuova* of 1744.

Around 1702, probably as a result of influence from this movement, which cultivated pagan mythology and Petrarchan ideals, Solimena painted a number of subjects from Greek and Roman poetry. One such is the *Abduction of Orithyia,* just mentioned, in the Galleria Spada, Rome. A copy of this work in the Walters Art Gallery, Baltimore, is in the present exhibition (cat. 22). In these same years Solimena moved on to what might be called heroic allegory: the *Allegory of Louis XIV,* now at the Hermitage (Bologna 1958, 85ff., 185, 225; Bologna 1968, 35ff.). De Dominici describes the picture (Bologna 1958, fig. 119): "Pallas in the act of ordering History to narrate the deeds of the glorious monarch, whose portrait in a bronze medal is being yearned for by many kingly Virtues, with Time lying on the ground, subordinate to History, while in the distance one sees Heresy fleeing with a Hydra, oppressed by ruin, and other beautiful episodes" (De Dominici 1742–45, 3:593; the portrait in the medallion was later transformed from Louis to Catherine the Great.) The figural types and general composition of the Leningrad canvas owe much to Paolo de Matteis's own paintings of allegories and even to such an early example as the *Allegory of the Arts,* now at the J. Paul Getty Museum in Malibu (mid-1680s; fig. 18). But the Leningrad picture in turn could have inspired De Matteis's own *Self-Portrait with an Allegory of the Peace of Rastatt* (cat. 30). The fresco depicting the *Triumph of a Prince,* discovered in a double ceiling in a Neapolitan palace, now the Scuola Media Vittorio Emmanuele II (Spinosa 1979, figs. 10–13), is another specimen of this newfound interest. The fresco is stylistically related to the *Orithyia* and the Hermitage *Allegory* — the figures reflecting, particularly, Maratta's types, while the composition is close to Paolo de Matteis.

But Solimena was not abandoning religious art. Also dating to the first decade of the eighteenth century is the altarpiece for the church of San Pietro Martire depicting the *Madonna dei Martiri* (ca. 1705; Cosenza 1900, 117; Bologna 1958, fig. 138). There is a preparatory drawing at the Albertina in Vienna (inv. 630; Bologna 1958, 91, 93, 187, 264) and a bozzetto at the Minneapolis Institute of Arts (fig. 71). The influence of Preti, ennobled and classicized, is apparent throughout this altarpiece, a fact even more obvious in the Minneapolis bozzetto because of its free handling. Also, the tenebrist qualities of the picture tie it to Solimena's more unabashedly Pretian altarpiece for the cathedral of Sarzana: a *SS Clement, Philip Neri, Lawrence, and Lazarus* that must date also to the middle of the first decade of the eighteenth century (Bologna 1958, fig. 131). In its compressed and copious composition, dramatic chiaroscuro, finished disegno, and figure types the *Madonna dei Martiri* is also related to the Villa Bombrini pendants, *Judith Showing the Head of Holofernes to the Bethulians* and *Deborah and Barach,* compositions which, though often replicated in later years, originally date to ca. 1705 (Bologna 1958, figs. 132–35).

The commission for what turned out to be Solimena's most influential fresco, *The Triumph of the Dominican Order* in the sacristy of San Domenico Maggiore (figs. 72, 73), came in 1709.[2] From the first the fresco was regarded as a major feat, a Neapolitan response to Andrea Pozzo's

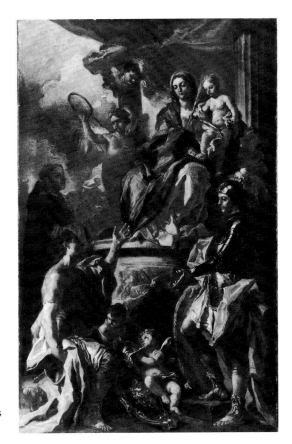

FIG. 70. Francesco Solimena, frontispiece to Annibale Marchese's *Tragedie Cristiane*, Naples, 1729

FIG. 71. Francesco Solimena, bozzetto for the *Madonna dei Martiri* altarpiece, San Pietro Martire, Naples. Minneapolis Institute of Arts, Minnesota

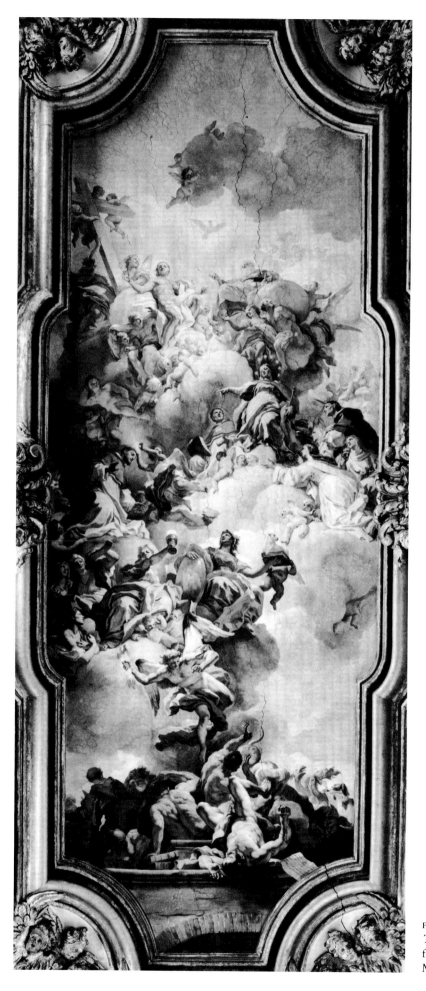

FIG. 72. Francesco Solimena,
Triumph of the Dominican Order,
fresco, San Domenico
Maggiore, Naples

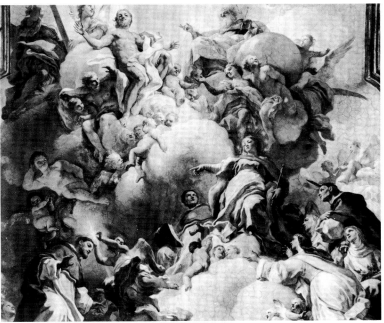

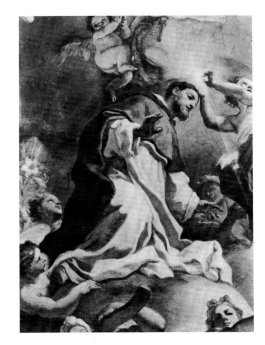

FIG. 73. Detail of fig. 72 FIG. 74. Detail of fig. 72

illusionistic ceilings in Rome: "And the whole of the composition is judiciously divided, so that, sweetly deceiving the eye, the disproportionate length is not noticeable" (De Dominici 1742–45, 3:590). The narrowness of many of these ceilings was a generic problem. Most previous solutions, such as that by Giordano in the Palazzo Medici-Riccardi, tended to construct the perimeter out of figures around an isolated central group. Not only is the composition in the sacristy ceiling thus visually shortened, the *da sotto in sù* effect is so conceived that the figures are for the most part small, giving the impression of great distance. In Solimena's fresco the Madonna introduces St. Dominic (fig. 74) to the Holy Trinity, while the Virtues and angels drive out heretics who literally fall towards the viewer. By means of these effects the scale is magnified. Full of triumphalism, eloquent gestures, and trompe l'oeil effects, the scene echoes Paolo de Matteis's fresco on the ceiling of the pharmacy in the Certosa di San Martino (1699; fig. 19). Many years later it was to influence Giaquinto (see entry for cat. 42).

Related to this monumental manner is the great, much-replicated altarpiece for the cathedral of Aversa, *St. Bonaventure Receiving the Banner of the Holy Sepulcher from the Madonna,* signed and dated 1710 (Spinosa in Naples, 174; Spinosa in Detroit 1981, 1, no. 43). Clearly the Aversa altarpiece looks back to Solimena's earlier *Madonna dei Martiri* in San Pietro Martire. But now it is composed in purely classical terms. The angle of vision has been rotated to reveal mostly profile views, and the pictorial field is less compressed. The *da sotto in sù* perspective has been increased. The figures achieve a serene monumentality. The strong diagonal formed by the linking gestures between the kneeling observers, the erect St. Bonaventure holding the standard with one hand, and the Madonna seated on a throne above a high pedestal as she reaches out to

the saint lend the composition a solidity that is unexpected, given the sweet elegance of everything else. Meanwhile the vibrant coloring and daring chiaroscuro define volumes cleanly. The detail verges on the precious, and the handling of the draperies, such as St. Paul's inflated robe and the filmy habit on St. Bonaventure, reminds one that Solimena sought to master Maratta's drapery style. The Cleveland *Risen Christ Appearing to His Mother,* ca. 1708, also comes at this point in Solimena's career (see cat. 25) and exhibits many of these tendencies.

After establishing these strong relationships with Roman art Solimena characteristically now turned back to Luca Giordano. But this time he and his predecessor are clearly peers, not master and pupil. De Dominici presents this involvement as a "rivalry of praise" similar to those described in Judith Colton's essay on De Dominici. Writing of a commission supposedly of the 1680s (1687?), the frescoes of four Virtues in the Cappella di San Carlo in the Gesù Nuovo, De Dominici says: "These were painted at the same time that the famous Luca Giordano was painting the neighboring Cappella del Reggente Merlino, and each saw the other at work, with much satisfaction on the part of both, Solimena venerating Luca Giordano as a great master and Giordano finding Solimena singular in painting, for which thing both came mutually to love each other" (De Dominici 1742–45, 3:587). Not surprisingly these frescoes have occasioned acrobatic bouts of connoisseurship, their attribution having swung back and forth between the two artists (Bologna 1958, 68; Bologna 1968, 44f, 60). Solimena is even credited with being able to out-Giordano Giordano (De Dominici 1742–45, 3:613ff.). Palomino in his *Museo Pictorico* of 1715 writes, "[Francesco Solimena] imitates everything that Giordano did best, and in that which he did not do, [Solimena] surpasses him with his study, so that he is the greatest that can be found in Europe" (quoted in Bologna 1958, 191). Even Giannone, who disliked Solimena, admitted that "he has no competitors that equal him in Naples" (quoted by Ceci 1908, 633).

But the question does not end here. Not only are there the Cappella di San Carlo frescoes, there is a considerable corpus of easel paintings that have been attributed at one time or another to both (e.g., the Metropolitan Museum *Birth of the Virgin*). And then in 1706 Solimena was asked to complete twelve canvases for the chapel in the Royal Palace, Madrid, depicting subjects from the Old Testament. These had been left unfinished in Naples at Luca Giordano's death. De Dominici makes the event a rite of passage in which the son pays homage to the dead father: "But our modest painter did not want to touch with his hand the work of Giordano, whom he venerated as he did the great masters, but, ordering similar canvases, he painted them anew with the same stories and the figures as by Luca himself, only varying one" (De Dominici 1742–45, 3:595). Similar involvements between Solimena and Paolo de Matteis are described by Evonne Levy in her essay on the latter artist. Also dating from this period — in fact to 1704–08 — are the two Getty mythologies (cats. 23, 24).

Beginning in the second decade of the eighteenth century Solimena embarked on a phase of even more erudite eclecticism. Quotations from other artists abound. Fairly often he was accused of plagiarism (De Dominici 1742–45, 3:579, 633). Yet, fascinated as he was by the art of his contemporaries and immediate predecessors, he always refrained from quoting ancient sculpture. De Dominici explains: "Poetic furor, which comes from nature, cools off in the study of the antique." Only by studying from the living model, he adds, does one discover how to sweeten nature and to make it stylish, noble, and choice (De Dominici 1742–45, 3:630, 632).

FIG. 75. Francesco Solimena, Preparatory drawing for *The Landing of Christopher Columbus in the New World,* pen and brown ink, brush and gray wash over black chalk underdrawing. Cooper-Hewitt Museum, New York

Between roughly 1715 and 1725 Solimena also developed his penchant, perhaps inspired by collaborations with Guglielmelli, for glorious architectural backgrounds. As early as 1708 the Genoese Republic had asked Solimena to paint three enormous canvases for the Sala del Consiglio of the Senate Palace (Bologna 1958, 111, 189ff., 285; Wunder 1961). The project did not begin to materialize until 1714. The pictures illustrated events in the history of Genoa: *The Martyrdom of the Giustiniani, The Arrival of the Ashes of St. John the Baptist in Genoa,* and *The Landing of Christopher Columbus in the New World* (see figs. 23, 75). *The Martyrdom of the Giustiniani* probably decorated the ceiling and probably dates from 1715–17. In the latter year the second picture, the *St. John,* also arrived from Naples (Wunder 1961, 152). The third was not sent until 1728 according to De Dominici. From Montesquieu's *Voyages* it is to be deduced that the entire program was installed by 1728–29. In 1777 all the paintings perished in a fire that gutted the senatorial palace. De Dominici notes of the *St. John* that "in this painting he has caused to reappear everything he had studied and absorbed from the work of the Cavalier Calabrese; thus he placed a boat with nude sailors in front, depicted with awesome disegno and powerful chiaroscuro, imitating that great man" (De Dominici 1742–45, 3:591; Bologna 1958, 191). Similarly the central section of the *Martyrdom of the Giustiniani* seems inspired by Preti's *Martyrdom of St. Catherine* in San Pietro a Maiella.

Indeed, what has captivated De Dominici and later writers about Solimena's use of Preti is how he imitated Preti's chiaroscuro without losing himself in Pretian tenebrism. It was this ability to transfigure the older master that earned him the sobriquet "il Cavalier Calabrese nobilitato," coined by De Dominici in reference to the Genoa commission (De Dominici 1742–45, 3:591, 626ff.).

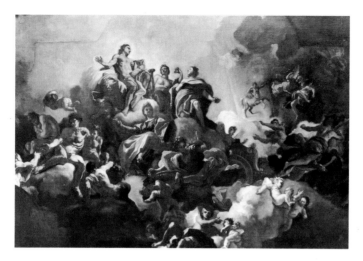

FIG. 76. Francesco Solimena, *Helios and Phaethon*, bozzetto, Crocker Art Museum, Sacramento, California

But Solimena's sublimity sometimes tumbled into the realm of the ridiculous. For example there is the bozzetto of ca. 1715 of the fable of Phaethon now at the Crocker Art Museum in Sacramento (fig. 76). The subject was intended for the ceiling of a gallery, no longer extant, in a palace belonging to Count Daun, then viceroy of Naples (Spinosa 1979, 218ff.). Cloud-borne deities gesticulate in operatic abandon as the disobedient Phaethon meets his ignoble end in a corner, unbeknownst to the divine crowd. The scene is more appropriate to the Teatro San Carlo, complete with reckless singers and creaky machines, than to the majesty of Olympus. The famous fresco of 1725 in the Gesù Nuovo, Naples, *The Expulsion of Heliodorus from the Temple,* discussed in the entry under cat. 26 (fig. 87), was also criticized on the grounds of decorum. A third vast enterprise of these years is the *Assumption* on the high altar of the cathedral of Capua (1725; fig. 77).

But let us turn to a more intimate genre. Solimena's self-portrait, commissioned by the grand duke of Tuscany, is the most powerful document of the artist's personality that we have (cf. fig. 62; see also Spinosa in Detroit 1981, 1, no. 45). There are four versions, of varying quality, one in the Uffizi, one in the Prado, one in a Spanish private collection, and one — the best — in the museum of San Martino, Naples. The paintings are usually dated 1729–30. The painter's eyes gaze almost angrily past the viewer. Though he depicts himself at work, leaning forward to dip his brush as he turns away from the dainty canvas depicting Flora and Zephyr, he is dressed in his full clerical habit. Over this he wears a flowing green mantle, which identifies him as an artist (Ripa 1611, 20; compare Paolo de Matteis in his own self-portrait, cat. 30).

Dido Receiving Aeneas and Cupid Disguised as Ascanius, now at the National Gallery in London (Levey 1973, 386), and the *Aurora* of 1720, now at the castle of Pommersfelden (Bologna 1958, 192), are further keys to Solimena's development in the 1720s. The handling in the *Dido* with its clear, friezelike composition and classicizing chiaroscuro is similar to larger, more complex compositions such as the Genoa *Arrival of the Ashes of St. John the Baptist* and also to the *Christ and the Woman of Samaria* now in the Pisani Collection, Naples, dating to the early 1720s (fig. 121; Bologna 1958, 117).

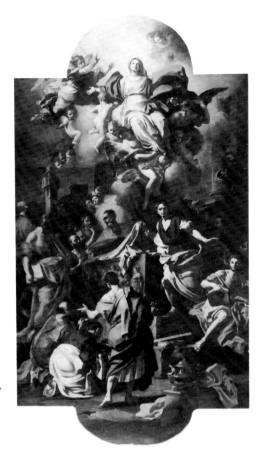

FIG. 77. Francesco
Solimena, *Assumption,*
cathedral, Capua

Two other bozzetti, now in Opočno, near Prague, are related to both the *Aurora* and the
Flora and Zephyr in the self-portraits. The first is the *Dido and Aeneas,* which Ferrari dates to
1713 or 1714 (Ferrari 1979, 17), but which I think should be dated to the 1720s on stylistic
grounds. It was painted for the Galleria dell'Eneide of the Palazzo Bonaccorsi, Macerata. A
version of this composition is now at the Getty Museum in Malibu. The Juno in the *Dido and
Aeneas* pictures is especially reminiscent of the Flora in the Uffizi self-portrait. A similar
arrangement is found in the *Rape of Cephalus* (also a story about Aurora; Spinosa 1979, fig. 19)
which Solimena painted for Eugene of Savoy in ca. 1725.[3]

Solimena's late style is problematic. By the late mid-1730s the master had once more
changed course. Bologna perceives the change as a reversion to a "baroque manner," the result
of a supposed rift between Solimena and his most gifted follower, De Mura. Bologna thinks
that, on confronting the younger man's interpretation of his own formulas, Solimena became
aware of the dangerous frigidity, the exhausted perfection, that now burdened their joint style.
Whether or not this is so, Solimena did now embrace a simpler, more powerful, less colorful
manner, returning once more to Preti and the Venetians — though now it is late Titian and
Tintoretto, not Veronese, who are most closely studied. Paintings, such as the *Bathsheba at Her
Bath* (versions in the Palacio Real, Aranjuez, and the Virginia Museum of Fine Arts, Richmond),
and *The Death of Messalina* (at the J. Paul Getty Museum in Malibu; fig. 78), exemplify the

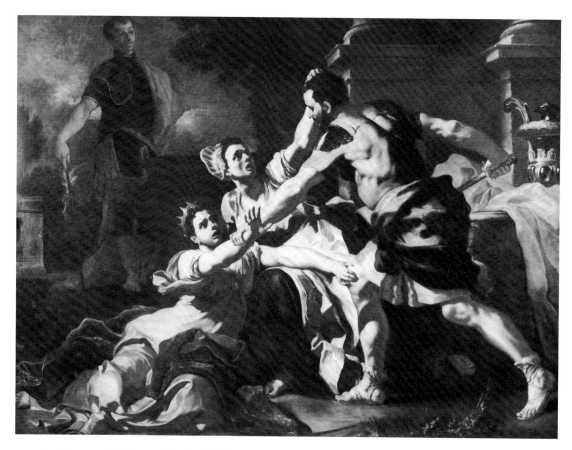

FIG. 78. Francesco Solimena, *The Death of Messalina*, J. Paul Getty Museum, Malibu, California

tenebrist and disegno-oriented manner of Solimena by the mid-1730s. Rabiner, investigating notices in the *Gazzetta di Napoli,* has even claimed that Solimena's supremacy on the Neapolitan scene begins only now, in ca. 1730, and not with Giordano's death a quarter-century earlier as De Dominici always held (Rabiner 1978a, 14). Bologna sees this new manner as a mark of new freedom, as a sign of a *providenza vichiana* that became possible with the arrival of the Bourbons in Naples in 1734 (Bologna 1958, 122ff.; Spinosa in Detroit 1981, 1:140). But the vigorous new freedom is also a mark of age and failing eyesight (De Dominici 1742–45, 3:610ff.). Solimena was after all now in his eighties. His paintings of the 1720s had still possessed the structural cogency of his Marattesque years; those of the late 1730s and early 1740s are conceived in terms of surface and textural patterns. Sometimes the results are unhappy. In the bozzetto for the *Holy Trinity with Saints,* Santa Maria di Piedigrotta, the chiaroscuro is thick and heavy, there is no studied relationship among the figures, and the composition is calligraphic (see De Dominici 1742–45, 3:611 on the reception of this painting in the Spanish court; Spinosa in Detroit 1981, 1, no. 48). It is a period of uniform maroon shadows and ever more impastoed surfaces. In the more ambitious works the disegno, no longer elegant or precise, decays into a *horror vacui.* On

the other hand the little *Leda* in the Harris Collection (cat. 27) is also from this late period (ca. 1730s) and here all the old magic prevails.

Throughout his life Solimena's versatility was noteworthy: he painted still life and landscape (De Dominici 1742–45, 3:619). His portraits were famous (De Dominici 1742–45, 3:588). He was a learned and inventive man, reputedly a sculptor (De Dominici 1742–45, 3:620), a lover of music, a good friend of Alessandro Scarlatti (De Dominici 1742–45, 3:624), a writer of sonnets (Orlandi 1733, Dedication). He was also an architect (De Dominici 1742–45, 3:619).

We have conflicting reports concerning Solimena's role as teacher. Although De Dominici exalted his patience and selflessness, Giannone could remember only Solimena's jealousy of his own pupils and exploitation of their talents. Yet the evidence is overwhelming that Solimena maintained a studio-academy of considerable size (De Dominici 1742–45, 3:612); this indeed is a subject unto itself. For both financial and pedagogical reasons, moreover (and to the dismay of modern connoisseurs), Solimena lovingly retouched the works of his pupils (De Dominici 1742–45, 3:616). The world is full of the results. Sometimes they are good pictures (e.g., cat. 22). And they document the forty-odd years during which Solimena trained emerging generations of Neapolitan painters, sculptors, and architects. Francesco de Mura, the greatest of the Solimenisti, began in his studio in 1708 and Corrado Giaquinto in 1719; Nicola Maria Rossi, Ferdinando Sanfelice, Domenico Antonio Vaccaro, Alfonso di Spigna, Filippo Raguzzini, and Giuseppe Bonito were other pupils who achieved fame. Still others came from farther afield (De Dominici 1742–45, 3:600), among them the Scottish painter Allan Ramsay.

Francesco Solimena remained a noteworthy personality in European art until his death on April 3, 1747, at his Villa San Potito in the suburban village of Barra. After this, interest in his work declined. He had lived ninety years, surviving all the Neapolitan painters of his own generation and many of the next: by the time of his death his art was old-fashioned. His many changes of style, his replications, his penchant for quotation and mimicry, were all based on the ideas of the seicento, even of the Counter-Reformation. His work embodied the goals of recognizability, decorum, and communication.

But Solimena's achievement was unquestionably immense. He translated Luca Giordano's grand but loose compositions of broad golden figures into more articulated, more stylish form. In some of his most characteristic work sumptuous architectural settings worthy of Veronese were added. Solimena received the achievements of Giordano the individual and made them those of a great school.

1. Bologna 1958, 48 dates the work to 1675–77. But for me it comes after the Santa Brigida dome fresco of 1678.

2. A sketch in a private collection in Florence, a preliminary drawing now at the University of Colorado, and a possible earlier design at Windsor document the gestation of the composition (Chicago 1970, 238).

3. Ferrari 1979, 16. Although the iconography, like that of Solimena's oeuvre in general, has not been studied, the motif of the seated pair might shed light both on the self-portraits and on these related paintings. Bologna 1958, fig. 209, lists this picture in a private collection in Hamburg and wrongly dates it to 1740.

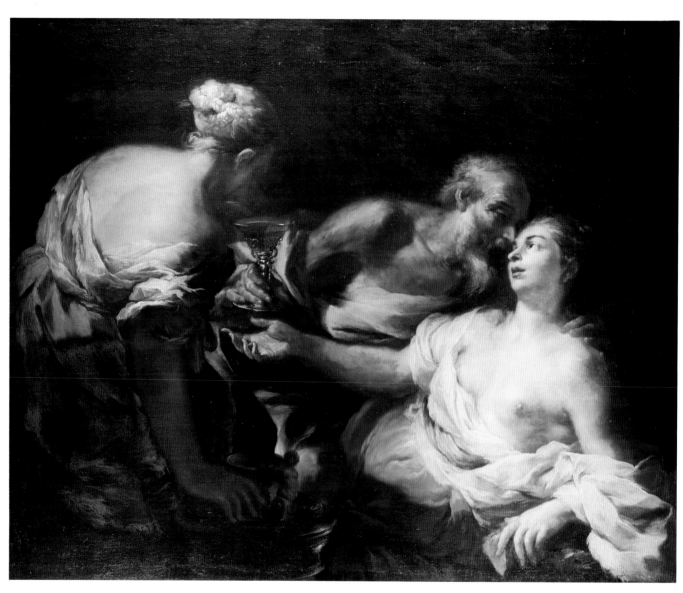

CAT. 19

19 *Lot and His Daughters*

126.2 x 152.5 cm (49⅝ x 60 in)

PROVENANCE: Unidentified Neapolitan collection ca. 1674; Duke of Castello Airola until ca. 1742

LITERATURE: De Dominici 1742–45, 3:582; Bologna 1958, 44ff., 179, fig. 11, as whereabouts unknown; Bologna 1962, 1; Ponce 1967, 163ff.; Pavone 1980, 87–88; Ponce 1984, 284

Museo de Arte de Ponce (Fundación Luis A. Ferré) 57.0027

This picture is probably the one mentioned by De Dominici as belonging to a group of four, each about six palmi wide (one palmo equals about 25 cm or 10 in), which were the earliest commissioned pictures Solimena ever did (De Dominici 1742–45, 3:582). The three other paintings, according to De Dominici, were a *Judith with the Head of Holofernes,* a *Conversion of Saul,* and an *Abraham and Isaac.* De Dominici describes them as being in the artist's earlier style, derived from Preti and Giordano but also from Reni, Maratta, and Cortona. Thus with this earliest masterpiece by Solimena in the exhibition we see the artist taking leave of the Guarinesque style he had learned from his father (Pavone 1980, 87–88). The loose, magnificent golden brushwork, the powerful refulgence of the flesh tones, the liquid color, and the secure but relaxed positioning of the figures in this painting recall Giordano more than the other models De Dominici names. Nonetheless the picture was at one time attributed to Giovanni Antonio Pellegrini, a Venetian follower of Sebastiano Ricci and Giordano; not until 1958 did it receive its proper attribution, from Bologna (Bologna 1958, 44ff., and 1962, 1ff.). A comparison with Angelo Solimena's version of the subject, now in the archbishop's palace, Salerno (Pavone 1980, fig. 94), shows how fluent and painterly his son's style had become under Giordano's influence. Solimena probably found a useful prototype in Massimo Stanzione's *Lot and His Daughters* (Palazzo Reale, Naples; Musée des Beaux-Arts, Besançon; London 1971a, no. 1), where naturalistic and classicizing tendencies are felicitously reconciled.

The story of Lot and his daughters comes from Genesis 19:29–38. Having escaped the total destruction decreed by God for the inhabitants of Sodom and Gomorrah, the father and his two daughters take refuge in a cave. The older daughter remarks to the younger that no man except their own father remains on earth for them. "Come, let us make our father drink wine," says the older, "and we will lie with him, that we may preserve the seed of our father." On successive nights they sleep with the old man, he being on both occasions insensible to what was going on. As a result both daughters conceive. The older becomes the mother of Moab, ancestor of the Moabites. The younger daughter bears Ammon, father of the Ammonites.

Solimena shows the elder daughter on the right, reclining in considerable deshabille, her white undergarments and pale blue gown down around her waist and over her right shoulder, while a saffron mantle fills her lap. She gestures toward her sister and toward the cup the old man lifts as he bends his face to hers. Her face is filled with a sad urgency. The father, in a waking dream, is swathed in bedclothes as he reaches around his daughter's pale body. The ruby-red wine in its glass, almost at the picture's center, symbolizes the event. The daughter on the left, who will share her father's bed on the succeeding night, has a hand on the large wine jug in the foreground, ready to pour another draught. Back to the viewer, majestic in her blue draperies,

her powerful shoulders shining in the nighttime light, her blond hair coiled in intricate braids to contrast with the elder daughter's hair cascading over her shoulders, the younger woman is paralleled in many other Solimenas. CBC / GH

20 *The Birth of the Virgin*

201.5 x 168.7 cm (80 x 67 in)

PROVENANCE: Cocks Collection, London

EXHIBITION: Huntington 1968, no. 15

LITERATURE: Metropolitan 1906, 72 (as by Luca Giordano, and as a *Presentation in the Temple*); Bologna 1958, pl. 76, 131n. 65, fig. 90; Spinosa 1984, pl. 757

The Metropolitan Museum of Art, Rogers Fund, 1906 07.66

On the right a buxom, black-haired young servant, in a gray-white dress with a massive red mantle over her knees, sits holding the infant. She displays its little body, still partly swaddled and in close contact with her own bosom, to the other kneeling white-clad woman attending on the left. The latter meanwhile, her back to us, points to an upper, inner tableau on the left that takes place behind a balustrade. Here rejoicing servants surround Anna propped up in bed.

In the center of this foreground scene is the ruddy, haloed figure of Joachim clad in a brown mantle and white-sleeved undergarment. With infinite tenderness he takes his little daughter's hand. On the far right is another servant, balancing Joachim, to complete the canopy of adults over the brightly lighted child. At the corner, prominently displayed, stand the brass ewer and basin that evoke the Byzantine motif of the Infant's first bath. Behind it all, bathed in the golden clouds of incense that proclaim the presence of saints, palatial walls are visible.

The picture is in Luca Giordano's manner and has ever been even been attributed to him, for example by A. McComb in 1935 (registrar's files, Metropolitan Museum). It was first given to Solimena by Hermann Voss (Wehle 1940, 266ff.). Comparison of Solimena's *Birth of the Virgin* with Giordano's own depictions of the subject, e.g., in SS Apostoli, Naples (ca. 1690–92; see also Ferrari-Scavizzi 1966, 2:167–68) and in the Norton Simon Museum of Art in Pasadena, (surely earlier than its assigned date of 1696–98; fig. 79) reveals how closely both artists followed each other's styles in the late eighties to early nineties. Luca's preparatory sketch in black chalk for the Pasadena version of his picture is in the British Museum, no. 1950-11-11-11 (fig. 80). This further abridges the narrow gap between the compositions by the two artists. As in Solimena's painting, in the drawing by Giordano the forms seem enveloped in fantastic contrasts of light and shadow and the figure types Cortonesque. But the composition in Luca Giordano's *Birth of the Virgin* is spacious and horizontal, whereas Solimena's is compressed and vertical in format. Both artists build their compositions in two general planes. The female attendants, the holy babe, and Joachim occupy the front, whereas Anna and her helpers are placed on slightly elevated terrain in the back to the left. Even the swarm of cherubim hovers above the newborn in nearly identical positions in both paintings. (See also Luca's paintings of

CAT. 20

FIG. 79. Luca Giordano, *The Birth of the Virgin*, Norton Simon Museum, Pasadena, California

FIG. 80. Luca Giordano, preparatory sketch for fig 79, black chalk, British Museum, London

the subject that in 1964 was in the Ganz Collection, New York [Memphis 1964, no. 24].) The broad, active forms and palpable golden light are also characteristic borrowings from the older artist.

As to Solimena's own oeuvre, *The Birth of the Virgin* probably dates from ca. 1690, during the period immediately following his first great masterpiece in fresco, the sacristy of San Paolo Maggiore (fig. 66). Also to be mentioned are a contemporaneous *Annunciation* and *Sposalizio* in the Gesù delle Monache, Naples (Bologna 1958, figs. 98, 99), which are close in sensibility to the Metropolitan picture: the *Sposalizio* in fact quotes, reversed, the kneeling woman in the foreground of the present work. We can also insert, as being parallel in style and date, the *Annunciation* now in the Mauritshuis, The Hague, and the *St. Francis Refusing the Priesthood* of 1693, in Santa Maria Donnaregina, Naples (Bologna 1958, 79, figs. 92, 93). As he took Giordano's place during the older painter's absence from Naples, Solimena began to move away from Giordano's style. Thus there are hints of Solimena's approaching classicism in the Metropolitan picture despite its coexisting role as a homage to Giordano. For one thing it lacks the soaring groups of interlocked angels we see in comparable earlier pictures (*Adoration of the Shepherds,* Annunziata, Aversa; Bologna 1958, fig. 72). Instead, the presence of angels, which the subject calls for (this is one way of distinguishing the scene from the *Birth of St. John the Baptist*), is subtly rendered in the form of clouds representing cherub heads. Our painting is

fresher, more serene in palette, and more pastoral in feeling than Solimena's earlier work. The forms are solidly defined in terms of light and shadow despite the generally golden tinge of the light which reminds one of Giordano. The composition is disciplined. It omits many of the excesses in genre that are usually connected with pictures of this subject, such as pets and overly descriptive domestic architecture. And the artist has cropped the composition precisely to avoid distraction from the drama of the scene, a lesson surely learned from Mattia Preti.

Veneration of the Virgin's Mary's birth, which is not described in the New Testament, is an old tradition. The event appears in various early apocryphal writings, for example, the *Liber de infantia Mariae et Christi salvatoris* and the *Evangelium de nativitate Mariae*. It was a frequent subject of sermons and meditations during the Counter-Reformation and well into the eighteenth century (Feroni 1728). Both Anna and Joachim were the objects of special devotion (note Joachim's halo).

Though the belief that the Virgin, like Christ, had been immaculately conceived and was without Original Sin had been a doctrine in the Catholic church since its approval by Pope Sixtus IV in 1477, and was championed by Counter-Reformation theologians, it did not become dogma until 1854. Yet the Virgin could not have been conceived by the Holy Ghost as Christ had been. It was therefore necessary to show — let us say in a painting — that despite her immaculate conception the Blessed Virgin had had a purely human father. It is tempting to interpret the brightly lighted central figure of Joachim as an affirmation of this. Note that he is a far cry from the shadowy figure who usually embodies his antitype, St. Joseph, in scenes of Christ's Nativity. For example, the Joseph in the Norfolk Giaquinto (cat. 44) stands far on the left, is in deep shadow, and gestures up to heaven with both arms, acknowledging the true father of the child his wife holds. GH / CBC

21 *The Death of St. Joseph*

219.7 x 169.5 cm (86½ x 66¾ in)

PROVENANCE: Arthur Wolfe, Viscount Kilwarden (1739–1803), Newlands House, Clondalkin, Co. Dublin, Ireland; Mullins Family, Dublin, 1803–1918 by inheritance; sale, Dublin, 1918 (as a *Raising of Lazarus* by Ribera); Patrick A. O'Connor, New York, 1918; St. Joseph's Church in Greenwich Village, New York City, Parish purchase, 1949 (as Murillo)

LITERATURE: Hoffman 1952; Spinosa in Gaeta 1981, 76, fig. 3; Spinosa 1986, 104–06, no. 14, fig. 17

Private Collection, New York

Despite the exceptional quality of this work it hung for the past forty years in relative obscurity in a church in Greenwich Village. Recent conservation has returned it to its pristine glory.

The tale of St. Joseph's death or "transit" to heaven is found in various apocryphal sources. In the best known, the so-called Infancy Gospels, Christ watches over Joseph's death and prays for him. When his prayer is ended SS Michael and Gabriel and a choir of angels descend (Apocrypha 1926, 86). The many images of this scene made in the seventeenth and eighteenth centuries reflect the idea that Joseph's was the model of the "good death," of the "art of holy

dying" (Réau 1955–59, 3, pt. 2:759; Mâle 1932, 314ff., 324). St. Teresa of Avila was a devout practitioner of the cult, and it was also taken up by the Jesuits. The painting probably served at one time as an altarpiece (evidence of candle smoke was found at the bottom of the canvas), and as such it offers the traditional associations of altars with death and resurrection.

The aged saint lies on his deathbed. Michael stands to the left, his sword resting on his left shoulder, with another angel, possibly Gabriel, beside him. He is subdued and pitying as he steps from a misty background, his face and hair almost Leonardesque in their sfumato. In the story, though less clearly here, the two angels arrive to wrap the saint in a precious silken robe in which they will carry him to heaven. A third, saffron-clad angel bearing a censer genuflects magnificently at Joseph's feet as three pairs of putti hover above the scene. A strong diagonal shaft of light from the upper left falls across the back of this kneeling angel, defining Joseph's tense, shriveled chest and arms, brilliantly illuminating a blue drapery beside the bed, and then also the figure of Christ in his robe of dusty rose. The lighting invites us to consider Jesus, Mary, and Joseph grouped as a Holy Family united on earth for the last time. The vigil of Mary and Jesus at Joseph's death, in fact, is the climax of the text Solimena illustrates. Meanwhile Christ blesses Joseph as day breaks and the moment of departure comes (Apocrypha 1926, 86). Indeed the old man's lips seem to be speaking: it is possible that he is making his last confession, that Christ's gesture is one of absolution. The pose of the Virgin appropriately bespeaks resignation and release.

The general dominance of shadow and the warm tonalities increase the tranquil ambience. But there are moments of drama: the Virgin's magnificent orange dress, green mantle (now darkened with time), and the mustard-brown veil haloing her face and neck; Michael's armor shining with rich, golden light; the deathbed, a sea of supernatural brilliance.

Although the composition of the present picture is complicated in comparison to the simpler, Giordanesque compositions Solimena had earlier favored (for example, cat. 19), the *St. Joseph* does echo a version of the subject by Giordano now in the Pinacoteca at Ascoli Piceno. In palette, and in its eloquent chiaroscuro, Solimena's picture also harks back to his and his father's even earlier collaborations when they worked under Guarino's influence. Guarino, indeed, is known to have executed two canvases of this subject, one for the Collegiata at Solofra, based on a work by Stanzione, and the other in the church of the Sacro Corpo di Christo at San Sossio di Serino (Bologna 1955, 68), a church not far from Solimena's birthplace. There are several correspondences of composition, figure, and dress between the San Sossio canvas and the present painting. Also present in the picture's background, probably, is Francesco Fracanzano's treatment of the same theme in the Trinità dei Pellegrini, Naples (Pane 1984, 220).

The most important prototype, however, is Carlo Maratta's *Death of St. Joseph* (1676) now in the Kunsthistorisches Museum, Vienna. This is the most likely source for the central part — the Madonna, her hands clasped before her as she gazes at her husband, and the memorable Joseph. Solimena greatly admired Maratta (see biographical essay above) and insisted that his students work from Maratta prints (De Dominici 1742–45, 3:631). He almost certainly would have been aware of this composition — probably through the print by Nicolas Dorigny (fig. 81). A drawing in the British Museum (1946-7-13-909; fig. 82), which is surely

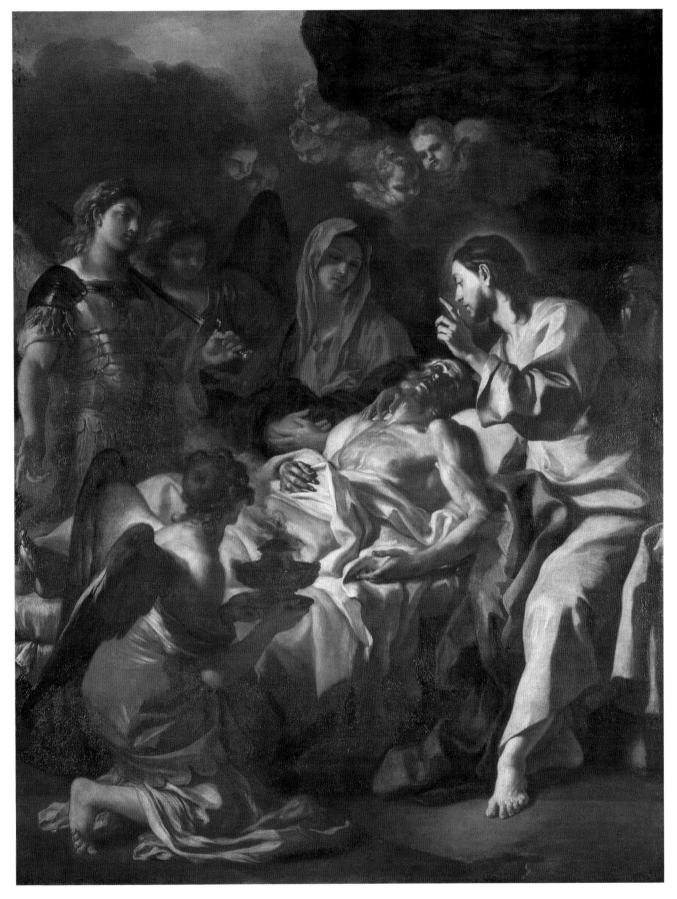

CAT. 21

FIG. 82. Francesco Solimena, *The Death of St. Joseph*, drawing, black chalk, British Museum, London

FIG. 81. Nicolas Dorigny, engraving after Carlo Maratta, *The Death of St. Joseph*, British Museum, London

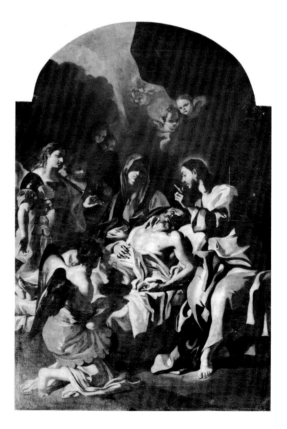

FIG. 83. Francesco Solimena, *The Death of St. Joseph*, Santa Maria di Caravaggio, Naples

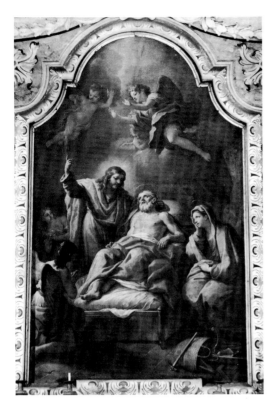

FIG. 84. Paolo de Matteis, *The Death of St. Joseph*, Chiesa della Concezione (Le Crocelle), Naples

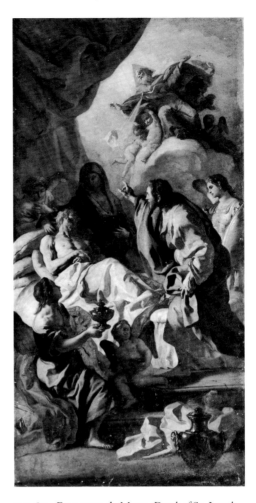

FIG. 85. Francesco de Mura, *Death of St. Joseph*, Museo del Duca di Martina, Naples

preparatory for this painting, provides a conceptual link between it and Maratta's composition. When Bologna published this drawing he did not know our painting, and dated the drawing to ca. 1730 on the basis of its relationship to an inferior, late version of the subject in the church of Santa Maria di Caravaggio (fig. 83). Such a date for the overall composition now seems too late: the present painting in all probability dates from 1698–1700.

Besides the version of the painting in Santa Maria di Caravaggio, Naples, already mentioned and probably by the artist himself, there is an old copy of the New York *St. Joseph* in the church of the Madre di Buon Consiglio, Naples, and another one in another in the Tweed Museum of Art, Duluth, Minnesota (for the latter, cf. Duluth 1986, no. 11). Later treatments of the theme were obviously influenced by the present work: one by De Matteis in Le Crocelle (fig. 84) and another by De Mura (De Dominici 1742–45, 3:683) in the Museo del Duca di Martina, Naples (fig. 85). One should also mention the *Death of St. Joseph* by Francesco Trevisani in Sant'Ignazio, Rome. JJI / CBC

22 *The Abduction of Orithyia*

98.8 x 135.2 cm (38⅞ x 53¼ in)

PROVENANCE: As Francesco Solimena, Marcello Massarenti, Rome, Catalogue 1881, no. 230; as Solimena, with the title *Time Abducting Youth* (Massarenti 1897, no. 454); acquired with the Massarenti Collection by the Walters Art Gallery in 1902

EXHIBITION: Dayton 1953, no. 59

LITERATURE: Zeri 1976, 2:543, no. 431

Courtesy The Walters Art Gallery 37.1695

The original of this replica is in the Galleria Spada, Rome, and has been dated to just after 1700 (Bologna 1958, 85 and fig. 117; Zeri 1954, 127, no. 119, pl. 172). The Spada picture was painted during Solimena's brief stay in Rome for the well-known collector Fabrizio Spada Veralli. A copy of it is in the Hermitage, Leningrad (Bologna 1958, 274; Dimier 1909, probably that formerly in the Rauchfuss Collection [St. Petersburg 1910, 107]). An oil sketch, a study of the servant on the left, is at the Ashmolean (Parker 1954, 2:480ff.: B.1657). Much later the artist executed a different version of the scene which is now in the Kunsthistorisches Museum, Vienna (Bologna 1958, 282, fig. 173). This puts the scene into a vertical format but reuses many of the Spada figures. The Vienna picture, originally at the Belvedere, was engraved in 1735. Bologna presumes that it was made for Prince Eugene of Savoy, for whom Solimena painted a *Deposition* now also in the Kunsthistorisches Museum (Bologna 1958, 117). According to Zeri (1976, 2:543), in 1952 there was still another variant in the Franz Mayer Collection, Mexico City.

The date of the Vienna *Orithyia* is probably around 1730. At this period Solimena was making replicas of his earlier works for another Viennese client, the former viceroy of Naples Alois von Harrach. On the basis of a photograph Bologna calls the Walters picture "a good copy" of the Spada work and attributes it to a south Italian artist working in Rome in the circle of Carlo Maratta — possibly Conca or Onofrio Avellino (letter, registrar's files, Walters Art Gallery; see also Zeri 1954, 127, and 1976, 2:543, who agrees with Bologna).

It is more than a good copy and is too refined for Conca. If my attribution of it to Solimena himself turns out to be wrong I would vote for Francesco de Mura. In any event it is an example of the many first-rate replicas and *ricordi* made in these years by the masters and their assistants, often in collaboration. These were highly prized. We have just seen that no less a personage than Count Harrach had no qualms about ordering such autograph copies. In short the Walters painting is a Romanized version of a popular composition, "Romanized," that is, via a strong crystalline surface treatment and solid drawing. It also has Roman classicism's transparency. All of this is an improvement over the dowdy and dirty original (though cleaning would probably bring back lost beauty).

In any event, two possible dates can be suggested for the Walters picture: just after 1702, when the original was painted, or around 1730 when, as we saw, the artist was making replicas for Viennese clients of pictures he had painted thirty years before. The present state of our knowledge does not allow us to go much further than this, either as to dating or hand.

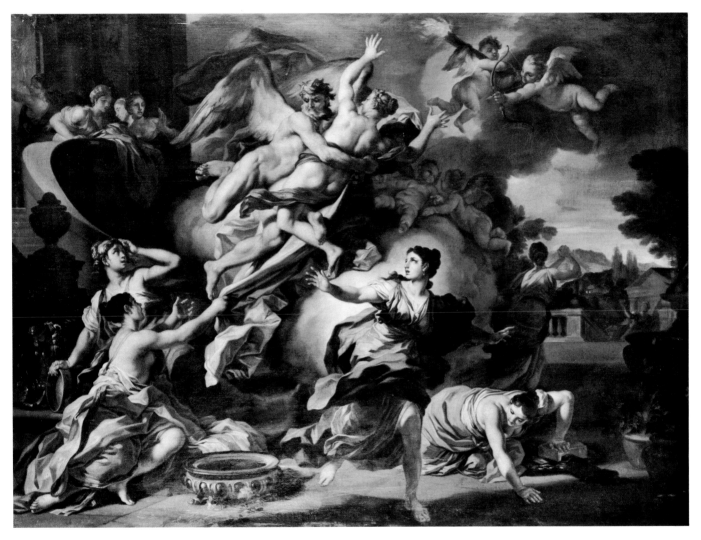

CAT. 22

In any case, even the original has its Roman aspects. As Bologna notes, Solimena had chosen a disegno-oriented classical mode, in particular paying his respects to Carlo Maratta. Gone, therefore, is the powerful, inky chiaroscuro of Solimena's more or less contemporaneous works for Neapolitan clients such as the *St. Christopher* of Sant'Anna dei Lombardi (Bologna 1958, fig. 112) and the *Dream of St. Joseph* in Santa Maria Donnalbina (Bologna 1958, fig. 114). And he has also moved well beyond the fresh, serene Giordanism we see in the Metropolitan Museum *Birth of the Virgin* of ca. 1690 (cat. 20). The logical outgrowth of the classical tendencies whose beginnings we saw in the latter painting would bear fruit in just such a work as the *Orithyia*. This in turn allows us to see how completely Solimena could now embrace the classical-pastoral ideals of the Arcadians (Bologna 1958, 94, 96ff., 103; Giannantonio 1962; see above, biography of Solimena). Bologna makes the case that Solimena painted the *Orithyia* in an intellectual climate created by them, *as* a Roman picture for a Roman collector, on a Roman or at least Latin subject, to be seen by Roman artists.

The literary source is probably Ovid's *Metamorphoses* (6.692–721). Boreas, the North Wind, a deity of legendary power and cunning, was often portrayed in ancient art. He has particular powers over the cold, the sea, storms, and the like. He is possessed of huge wings whose wind blows all before them. One day, Ovid says, he was looking down at the earth and saw the beautiful Orithyia, who paled at the sight of him. He took her up and flew off with her, "the fire of his love floating forth on the mighty wind [of his wings]." He takes her to Ciconia in Thrace. There she bears him two "chilly sons" who inherit their father's wings. As a tale in which the lover spots his quarry from the air, adopts animal shapes in order to bear off his prize, and provides her with children, the picture may be compared to Giordano's *Rape of Europa* (cat. 12).

The scene is constructed around the explosive apparition of Boreas in the midst of Orithyia's group. Her maids and companions, outside the palace in a calm landscape, burst into an array of highly charged reactions to this wild naked god whose wings sweep across the upper sky. Taking her up in a kicking erotic embrace, her clothes slipping from her in the turmoil, Boreas soars off with her into the heavens. Putti bearing Cupid's symbols assist him in his deed. Behind them are the sumptuous clouds of incense that betoken divine events in pictures.

But in large part the picture is also about Orithyia's companions. One of them, her blue and gold draperies flung round her body, rushes from the scene toward us with a look of fearful wonder. Another, on the right, also dressed in gold, flattens herself to avoid the dreadful presence; a third, on the left, vainly attempts to drag Orithyia back by her white mantle but only suceeds in denuding her as she struggles with the wind god. Wondering inhabitants of the palace look on from a distant balcony.

Many other artists have painted Boreas and Orithyia, including Federigo Zuccaro on commission from the poet Giovanni Battista Marino (Marino 1647, 20), Annibale Carracci (a grisaille in the Farnese Gallery), G. F. Romanelli (Palazzo Spada, Rome), and Rubens (Academy of Fine Arts, Vienna). GH

23 *Venus at the Forge of Vulcan*

202.5 x 153 cm (80⅞ x 60½ in); inscribed on back: "ANNO 1704."; in corner, at l.r. a monogrammed FS visible under infrared light (Department of Paintings files, Getty Museum)

24 *Tithonus Dazzled by Aurora*

202 x 151.2 cm (79½ x 59½ in); in corner, at l.l. same monogram FS visible under infrared light

PROVENANCE: Canale Collection, Venice, 1704-08; Pezzana Collection, San Polo, Venice, 1773; a European noble family; possibly in the collection of the Duchesse de Berry (d. 1870); inherited by Adinolfo Lucchese-Palli, Duca della Grazia, of Brunsee, Switzerland; Christie's, London, sale of old master pictures, April 6, 1984, lots 63 and 64; Matthiesen Fine Art, Ltd., London, April 1984

LITERATURE: Getty 1985, 206, nos. 128a, b; Spinosa 1986, 107, no. 26, and figs. 29, 30

The J. Paul Getty Museum 84.PA.64 and 84.PA.65

De Dominici (1742–45, 3:594ff.) mentions a *Venus at the Forge of Vulcan* in a group of five pictures painted by Solimena for the Procurator Canale in Venice but does not include an *Aurora* on the list. Two of these pictures, a *Sophonisba Taking Poison* and a *Juno Delivering Io to Argus,* are now in the Dresden gallery and are dated by Bologna to ca. 1705 (Bologna 1958, 252ff.). The present pair also seems to belong to this group, though, if so, one has to assume that De Dominici omitted the *Aurora* from his list, which could have happened if it was a later addition. And in fact a later addition was made: in a letter of August 30, 1708, Solimena writes to a correspondent in Montecassino: "I am working on a large picture . . . for the Procurator Canale, similar to one I sent him a while ago" (Bologna 1958, 189). One notes, too, that another picture in Canale's group is a *Messalina* (listed as lost by Bologna 1958, 290). A *Messalina* by Solimena is now in the J. Paul Getty Museum (fig. 78; 167 x 226 cm, 72.PA.24).

The following hypothesis suggests itself: that originally a group of five pictures was painted for Canale in ca. 1704, namely:

1. the *Sophonisba* and
2. the *Juno* now both at Dresden
3. the J. Paul Getty *Venus* of 1704 (copy, Museum of Fine Arts, Budapest, 51.2821; Pigler 1974, 2:292)
4. a *Messalina* which may be the Getty picture
5. an *Apollo and Daphne* still to be located — perhaps still in the Lucchese-Palli Collection

Then, in 1708, the procurator ordered the additional large picture that Solimena mentions. This would logically be the Getty *Aurora,* to complete a total group of six mythologies for the Casa Canale. There is another slightly smaller but more elaborate *Aurora* of 1720 now at the castle of Pommersfelden (Bologna 1958, 192), probably identifiable with the *Aurora and Tithonus* mentioned by De Dominici 1742–45, 3:595 as having been painted for the elector of Mainz.

And there is one more bit of evidence to consider: in 1773 Giacomo Leonardis made etchings of the *Venus* and the *Aurora* (Correr 1983, 243; Le Blond 11, 12). By this time, according to the

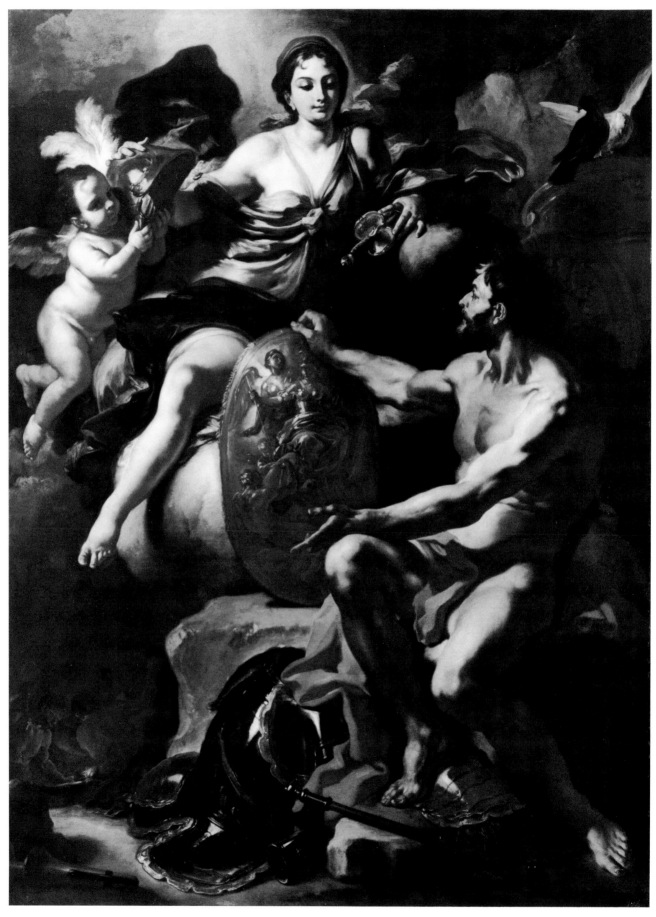

CAT. 23

inscription on the *Aurora* print, that picture was in the collection of the Pezzana family, San Polo, Venice. One has to assume that at least one, and probably two, of the Canale pictures were acquired some time before 1773 by the Pezzanas. Thereafter the pair seems to have remained together as a subgroup independent of the other Canale pictures.

The two paintings do go well together. The tone of both is established by the warm, gray-brown underpaint, with the brushwork varying from tight to free. Especially visible are the strokes that form the drapery. The flesh has drybrushed highlights and middle tones over the shadows. In the *Venus* the flesh-painting is appropriately luscious, and in both pictures the women function as sources of light, illuminating their companions and settings. Like the *Abduction of Orithyia* (cat. 22), these two works develop our knowledge of Solimena's turn to classicism in the first decade of the eighteenth century. But, as always with the artists in this exhibition, the change is a mixture of many different impulses: not only do we see a comparative classicism in these pictures when we compare them with slightly earlier paintings such as the Metropolitan *Birth of the Virgin,* we also see a new interest in Solimena's great precursor, Preti — the Preti who worked in Naples from 1653 on before his permanent move to Malta.

The scene is Troy. Aurora is dressed in blue, in a paler blue fabric shot with pink, and in white. A gold belt encircles her waist and a cloud enthrones her. Her white arms are spread out and raised, her right hand holding a lighted torch and her left a small bouquet; from the left a winged genius crowns her with a wreath of red and white flowers. On her other side, at the picture's far right margin, a putto flies forth with a gilded dish of more flowers. Behind her is the night that as goddess of the dawn she will now dispel. She gazes solemnly down on her husband Tithonus. He, his body partly covered with a saffron sheet, rises from sleep, shielding his aged eyes from his young wife's brightness. In contrast to her splendor the other figures in the scene are brownish gold and ruddy, as if with the reflection of her radiance.

Aurora, who loved all that was young and beautiful, had seduced a number of handsome youths — Orion, Kleitos, Cephalus, and finally Tithonus. In the Fifth Homeric Hymn, to Aphrodite, 218ff., when she carries off this latter prize she asks Zeus to grant him immortality. But she forgets to ask for eternal youth as well. Every morning, therefore, Aurora, who being a goddess has both immortality and eternal youth, must bid goodbye to an increasingly older husband. The description of this event, in which she rises from her saffron-colored marriage-bed and takes up torch and dew-flowers, is a Homeric formula for starting off a day's events (for example, *Odyssey* 12.3, 22.197; *Iliad* 11.1, 19.1).

Solimena's version of the scene is rather different from the norm established in the early 1620s by Guercino's far-famed fresco on the ceiling of the Villa Ludovisi. There Aurora flies through the sky in her chariot drawn by airborne horses. Tithonus is simply an aged shadow in the night on the far left. Other versions by Guercino (Mahon Collection, London), by Pietro da Cortona (Poitiers), and by Artemisia Gentileschi (Casa Arrighetti, Florence) follow the same pattern. Solimena's composition on the other hand creates a confrontation between the couple. Interestingly, Roscher (*Lexikon,* s.v. "Tithonus") publishes a sketch based on the design on an amphora from Nola which similarly has the young Aurora face to face with her aged husband, who supports himself with a staff.

The Pommersfelden *Aurora,* mentioned above, dating from 1720, a dozen years or more after the Getty pictures, is an instructive contrast. It elaborates Aurora's functions. De Dominici describes it:

First must be mentioned the fine picture of Aurora painted for the Most Serene Elector of Mainz. [Solimena] shows her in the act of being dressed by her companions, the Hours. In the meantime various amorini prepare her chariot, which one sees in the distance among clouds, surrounded by Hours and Minutes in the form of youths with butterfly wings; and below you see the bed with the figure of the elderly Tithonus, in beautiful foreshortening who, rising, turns to his wife, warding off her light with his left hand and at the same time with his right hand braced on the bed he manages to raise himself from it. On the left is Effort (Fatiga), a standing nude with musical instruments showing herself ready for her daily labors. In the center you see Sleep falling from bed and the nocturnal hours fleeing at the appearance of Aurora (De Dominici 1742–45, 3:595; Bologna 1958, 192ff.; Doria 1962, pl. 17).

Francesco de Mura, Solimena's pupil, adapted the composition of the Getty *Aurora* for a painting on the same theme of about 1750, now in the Museum of Fine Arts, Houston (85.430). He did two further versions, one of them closer to that in the Villa Ludovisi, now in the Pio Monte della Misericordia, Naples (Causa 1970, xxxv).

Solimena's version of the event is a foil for his pendant picture, whose title is given by De Dominici (1742–45, 3:594) as *Venus Approving the Armor Vulcan Has Made for Aeneas.* Here we have a similar but reversed composition. The upper white, "bright," nearly nude body of the woman, the lower, semireclining, warm-toned, nearly nude man, and the dispositions of putti and implements also correspond. Vulcan has just completed a shield emblazoned with a winged aegis and image of Athena. Seated on a stone, a red cloth mantling his thighs and falling in thick folds among gold-rimmed steel armor and weapons on the floor, Vulcan turns to his wife. The contrast between the two compares with that in the *Aurora.* Venus, clad in deep blue and gray-green, grasps a sword as her attendant putto, possibly Eros, hands her the new gilded helmet. Two doves, black and white, perch on the rim of her chariot on the far left. In the lower left hand corner we see the freely painted red-brown forms of the Cyclopes who have made the armor under Vulcan's direction.

The scene upon which Solimena has drawn takes place in the bowels of Sicily's Mt. Etna. It is inspired by Virgil's *Aeneid* 8.370–85 and 8.439–40. Venus goes to her husband Vulcan's forge to ask him to make arms for her son Aeneas (the offspring of her earlier marriage to Anchises). The goddess shows no reticence about the earlier relationship. She invokes it, indeed, as an argument for her cause (and she also brings in Aurora, paralleling her own request for armor to the request Aurora had made to Vulcan for arms for *her* son, Memnon [8.383–84]). Indeed Venus insists on the parallel between herself and Vulcan on the one hand and Aurora and Tithonus on the other, thus furnishing the inspiration for the concetto embodied in the pair of pictures.

Yet we have said that Solimena has drawn on Virgil, not that he has illustrated him. For in fact the poet does not mention the event Solimena paints. Vulcan does not, in the *Aeneid,* present Aeneas's arms to Venus for her approval. In the only Venus-Vulcan scene, Venus *asks*

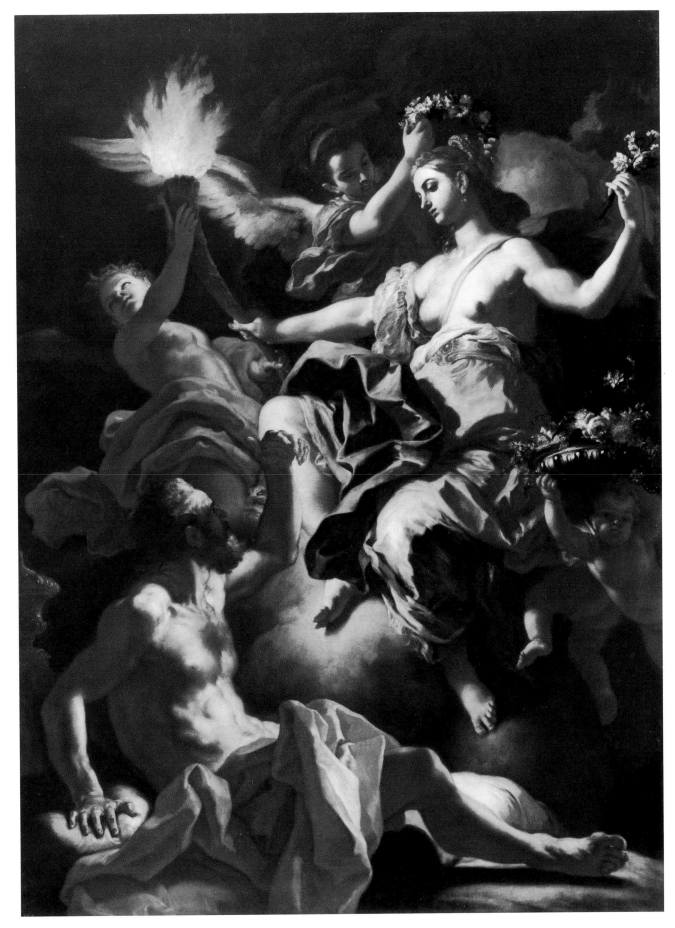

CAT. 24

Vulcan to make the armor; this is followed by another scene, without Vulcan, in which she presents that armor to Aeneas. Most Venus-Vulcan scenes show Venus requesting the armor, or else they portray some other incident in the lives of the couple, for example, Ludovico Carracci (Braunschweig, attr.); Francesco Albani (Musée de Moulins); Pietro da Cortona (Palazzo Doria-Pamphili, Rome); Giacinto Brandi (Palazzo Taverna, Rome). Pigler (1974, 2:292) lists further versions of the scene by Giacomo del Po, Paolo de Matteis, and Corrado Giaquinto (D'Orsi 1958, fig. 22). There is a *Venus Asking Vulcan for Arms* by Giaquinto's quondam assistant Antonio González Velázquez now in the Museum of Art, Rhode Island School of Design.

So, as with the *Aurora,* Solimena has set the normative iconography aside, probably in the interests of the overall program. Given the other subjects in the Canale Collection — Apollo pursuing Daphne, who eludes him by turning into a tree; Sophonisba taking the poison sent her by her husband; Messalina being put to death at her husband's command; Juno delivering Io, in the form of a cow, to Argus who will guard the disguised girl from Jupiter's advances — the general theme of the Procurator Canale's collection appears to have been the problematics of love and marriage. GH / SO / CBC

25 *The Risen Christ Appearing to His Mother*

222.2 x 169.5 cm (87⅝ x 66¾ in)

PROVENANCE: Private Collection, France; Heim Gallery, London

LITERATURE: Lurie 1972; Cleveland 1982, 417ff., no. 183

The Cleveland Museum of Art, Mr. and Mrs. William H. Marlatt Fund 71.63

Shown in New Haven only

Despite its size and excellent quality this picture remained unrecorded and virtually unknown until a few years ago. It is now recognized as an outstanding work of Solimena's maturity. It is datable, on the basis of its affinities with documented works such as the Dresden *Juno Delivering Io, in the Form of a Cow, to Argus* (Bologna in London 1971a, no. 9), to the period immediately following Luca Giordano's death in 1705. It is thus coeval with the two Getty mythologies in the present exhibition.

During his early years Solimena had imitated the older master's brilliant painterly manner, but by the 1690s that influence had begun to wane. A brief visit to Rome in 1700 confirmed Solimena's longstanding inclinations toward classicism. Yet the artist maintained the technical and emotional vivacity of Luca and his other Neapolitan forebears. Indeed *The Risen Christ Appearing to His Mother* synthesizes stylistic and iconographical concerns from a wide range of baroque painters from Reni to Domenichino to Preti. The result is a work of physical grace and spiritual grandeur.

Just how far Solimena has progressed toward a personal style that differs dramatically from the early Giordanesque manner is shown, in this exhibition, by Solimena's *Lot and His Daughters* (cat. 19) and *The Birth of the Virgin* (cat. 20). There is a newfound interest in sculptural form,

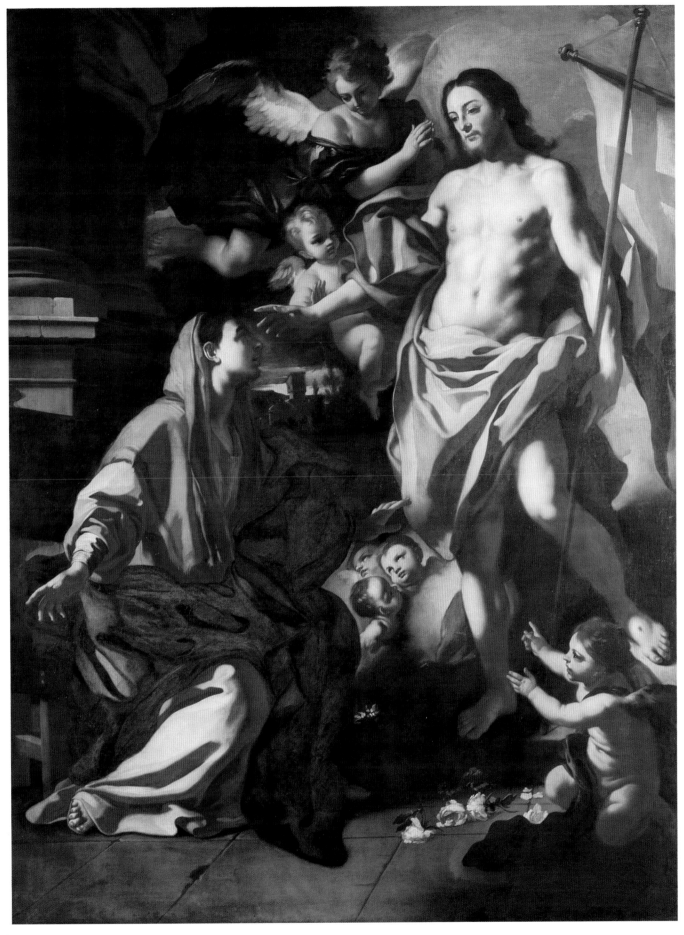

CAT. 25

reflected in the two primary figures that fill the canvas and overwhelm its shallow space. They dwarf all other elements, including the gray stone bases of the columns on the left. In front of these columns, and close to the viewer, is the Virgin. Clad in a rich pink garment half hidden beneath a voluminous blue mantle, she has her head draped in a rust-colored scarf or veil mottled with glowing patches of olive green. She slips from her chair to her knees before the radiant, erect figure of Christ on the right, who steps down from a glory of soft gray clouds. Against this billowing nimbus the pale flesh tones of his upper torso and limbs stand out vividly. His loins and right arm are loosely swathed in ample light silvery green, falling in smooth folds that range in hue from yellow in the highlights to black in the deepest shadows. In his left hand he bears the fluttering banner of the Resurrection emblazoned with a red cross. A golden halo crowns him, and scattered at his feet are lavender, pink, and blue roses.

Aside from the two main figures the most important feature is the animated retinue of angelic attendants between Christ and the Virgin. According to De Dominici (1742–45, 3:621, 632ff.), the artist took particular delight in the depiction of angels — his beloved father was named Angelo — and six are shown here, representing three distinct types of divine creatures. Flanking the trio of winged cherubs floating in the lower center are two fully developed putti, one a ruddy Lanfranchesque child with blond hair romping in midair near the Saviour's right elbow, the other a slightly older, darker-haired *angiolino* with a deep green scarf draped over his left shoulder. The pose of this angel, who kneels in the right foreground and points toward Christ, recalls figures of the young St. John in paintings of the Holy Family. Finally, at the top of the canvas, an adolescent angel is shown looking down at the Virgin. Dressed in a black tunic with silver highlights, his gray and white wings spread wide, this may be Gabriel (Lurie 1972), the angel of the Annunciation, who now worships the resurrected Christ.

The glimpse of landscape in the center shows us that it is dawn. Yet Christ's body is illuminated by a dazzling, unearthly light reminiscent of Preti, whose works Solimena, we are told, never tired of praising (De Dominici 1742–45, 3:626, 629). These intense visual contrasts, with their psychological implications, extend into the faces of the primary figures. The Virgin's face is uplifted in profile, her startled features almost completely enveloped in shade, while Christ's face shines powerfully, his dark eyes and pale, impassive lips filled with calm divinity. This is a moment of encounter, of intimacy. As such, it is also a moment of suspense ripe for physical contact, and more than anything else this is what the artist has succeeded in expressing — not only here but in the Virgin's white fingers just overlapping the bright green garment that wraps her son's loins, in the fingers of Christ almost touching his mother's face, and even in the attitude of the blond cherub whose hand timorously guards Christ's extended arm. So as not to interfere with the suspense that here just precedes physical interaction, the paint has been applied smoothly and evenly except for a small area of heavier impasto along the Virgin's right sleeve. By no means does technical virtuosity detract from the human drama, as is occasionally the case with Luca Giordano.

Given the sense of imminent physical touch that the picture conveys, it is not surprising that it was at first mistakenly identified as a *Noli me tangere* (Bologna in London 1971a, no. 9). Though no meeting between the Risen Christ and his mother is found in the Gospels there is a tradition, going back to the second century, that Christ visited her on the morning of the

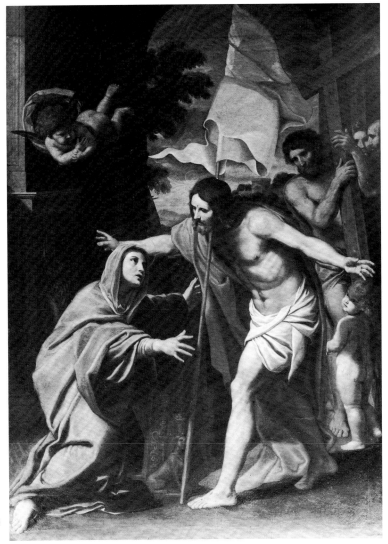

FIG. 86. Domenichino, *Christ
Appearing to His Mother*, Palazzo
Durazzo-Pallavicini, Genoa

Resurrection before appearing to anyone else. Pseudo-Bonaventure's thirteenth-century ac-
count of the episode became standard (Breckinridge 1957). A very early instance of the scene,
datable to the 1320s, is in the Donnaregina, Naples. Solimena no doubt knew it since he worked
there himself in the 1680s (Breckinridge 1957, 19ff.; see above). Both the literary and artistic
recensions of this event borrow from the *Noli me tangere* encounter. Baroque artists developed
the idea in several versions, in one of which Christ presents the newly rescued souls of Adam
and his worthy descendants to the Virgin. In ca. 1634–36 Domenichino had painted such a scene
(fig. 86), and this is a possible prototype for Solimena's. The settings are nearly identical,
and certain details, such as the prominent angels to the right and overhead and the drapery on
Christ's loins and arm, are similar. The poses of the main figures, on the other hand, are quite
different: yet it is not difficult to imagine the moment in Solimena as just preceding that shown

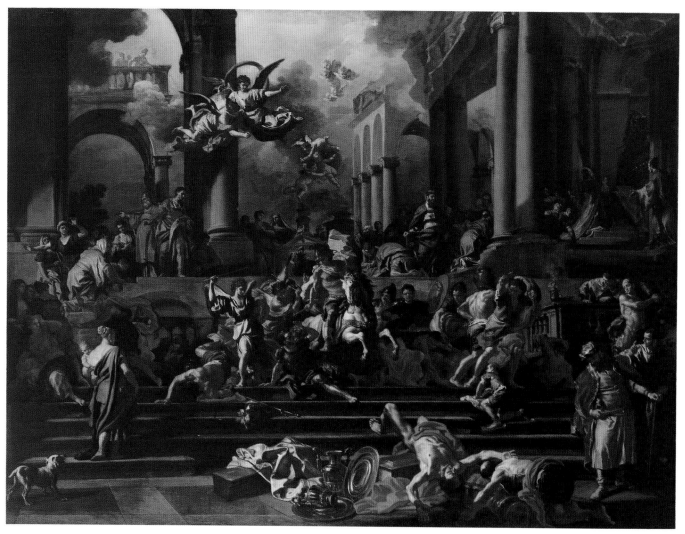

CAT. 26

FIG. 87. Francesco Solimena,
*The Expulsion of Heliodorus
from the Temple*, fresco, nave
overdoor, Gesù Nuovo, Naples

by Domenichino. Solimena might have seen the picture, which is now in the Palazzo Durazzo-Pallavicini, Genoa, but was probably painted in Rome (Spear 1982, 306) during Domenichino's visit in 1602. It is closely related to altarpieces such as the *Madonna dei Martiri* (see bozzetto, fig. 71) and the *St. Bonaventure* in the cathedral at Aversa. Even earlier works such as the Donnalbina *Adoration of the Magi* (1701) are in the same refined style, but there the composition is still comparatively untidy and the figures still earthy. DN

26 *The Expulsion of Heliodorus from the Temple*

152.4 x 203.8 cm (60 x 80¼ in)

PROVENANCE: England, late 1720s (?); Hotel Drouot, Paris, sale July 17, 1877; Galerie Heim, Paris; Heim Gallery, London, 1973

EXHIBITIONS: Naples 1979, 1:176, no. 75; Detroit 1981, 1:142ff., no. 44

LITERATURE: Cybo 1725, 45; De Dominici 1742–45, 3:591; London 1973, no. 10; Toledo 1976, 154ff. and pl. 24; *Gazette des Beaux-Arts* 89 (1977):91; *Art News* 76 (1977):67; Bologna 1979, 64n.; Stoughton 1982; Spinosa 1986, 114, no. 42, and fig. 48, pls. 7, 8

The Toledo Museum of Art; Gift of Edward Drummond Libbey 73.44

This is an autograph version of one of the most famous of Solimena's paintings, *The Expulsion of Heliodorus from the Temple* (1725; fig. 87), a fresco on the overdoor of the Gesù Nuovo, Naples. Solimena received the commission between 1722 and 1723, but it was not finished until 1725. Despite the fiery excellence of this Toledo version, the unveiling of the fresco itself marked Solimena's closest brush with critical disaster. Even De Dominici wrote that

one cannot deny that this work lacks unity in the depiction of the story, which [fault] *was denounced by the clique of literati; and that the greatest part of the figures lack the expression necessary for the action, which occurred in the temple venerated by all the Hebrew people; for many figures (they say) seem to do nothing, and do not seem to see anything of what is happening in the temple, which has been robbed of the holy vessels, and of many other rich furnishings. This action should fill the spectators with horror and fear of the soldiers who have entered the sanctuary. Not only did the literati want to see all this expression, which is the soul of the subject represented, but* [so did] *the great majority of those who admire the picture* (De Dominici 1742–45, 3:591ff.).

Despite such criticism Solimena's great mural influenced artists working in Naples almost immediately. One example is the large fresco on the overdoor of San Paolo Maggiore by Santolo Cirillo, *Solomon Inaugurating His Temple* (1737).

As in most of Solimena's more ambitious paintings of this period the composition is scenographic. One thinks of *The Arrival of the Ashes of St. John the Baptist in Genoa* or the later *Landing of Christopher Columbus in the New World* painted for the Sala del Consiglio of the Senate Palace, Genoa (see biography above and fig. 75). The action takes place in the foreground in an almost friezelike composition, as is also the case in the *Dido Receiving Aeneas and Cupid in the Guise of Ascanius* in the National Gallery, London (ca. 1725), while once again a majestic

architectural setting serves as a complex background — in the present case full of clouds and flying angels. Just as in Solimena's Venetian models Veronese and Tintoretto, here subsidiary onlookers ascend and descend the stairs connecting foreground to background. Actions and rhetorical gestures are frozen into brilliant colors alternating with abrupt hard-edged chiaroscuro. The angel in the center, commandingly astride his rearing horse, seems more an equestrian portrait than an agent of the Lord. This is sacred theater; and it is appropriate to recall both that the Jesuits who commissioned the work specialized in such theater and that in 1706 the legendary scenographers Ferdinando and Francesco Bibiena and that master of theatrical palaces and churches Filippo Juvarra all visited Naples, having come to supervise theatrical projects (London 1971a, no. 12). Their stage sets, which presumably were reused in succeeding decades, may have inspired Solimena as he undertook this great drama on the stage of the Gesù.

But despite this, and despite the ur-source of the scene of Raphael's version of the subject in the Stanza d'Eliodoro in the Vatican, the most obvious prototype for the composition is Luca Giordano's *Christ Expelling the Moneychangers from the Temple* on the overdoor of the Girolamini. Both show an exclusive concern with the panoramic organization of figures within a rectangular stagelike opening. But here again Solimena is more theatrical: the curtains in his scene wrap the corner of the foreground as a theater curtain would cover the corner of a proscenium arch, whereas in Giordano's fresco the twirling cloth wraps around columns in the background. The horseman who expels the fallen Heliodorus, meanwhile, is an almost exact recreation of Rubens's *St. George* in the Prado.

The story of Heliodorus comes from the Old Testament, 2 Maccabees 3: Heliodorus (fl. ca. 175 B.C.) was the treasurer of Seleucus IV Philopator, Ptolemaic king of various realms in the Near East. At the time the temple of Solomon was at the height of its architectural glory. In the king's name Heliodorus wished to tax it of some of its wealth. We see him enter with his retinue; the priests in their richest robes prostrate themselves at the altar. The crowd of worshipers is thrown into turmoil. The high priest Onias (extreme right background, praying at the altar) calls upon God to justify the law by which the temple's riches had been acquired and to expel those who would rob the great building of its treasure. In response to Onias's prayer a horseman on a white steed miraculously appears, angels assisting him, and they drive the tax collector and his men from the place, trampling upon them. The text fully justifies the elaboration, the violence, and the sumptuous ceremoniousness of Solimena's scene.

There is a relatively large corpus of paintings and drawings associated with Solimena's Gesù Nuovo fresco, not all of them preparatory. Herein lies the controversy. These works, however, help us to appreciate Solimena's invention, since the fresco is today nearly illegible. The rather finished drawing at the Louvre (pen and brown ink, brown and gray washes over black chalk with white heightening, no. 9819) seems to be a copy, heavily retouched by Natoire, after the fresco; it can be ruled out of the preparatory corpus (Naples-Paris 1983, 165). The compositional study at Chatsworth (pen and gray wash over black chalk, no. 626) is certainly autograph. It shows the composition for the fresco in an early form (Chatsworth 1969, no. 63). The section occupied by the door in the actual fresco, at the bottom center, is already a dominant feature.

Of the four known painted versions of the subject, too, those at the Galleria Nazionale d'Arte Antica, Palazzo Corsini, in Rome and at the Galleria Sabauda in Turin, which are nearly

FIG. 88. Francesco Solimena, detail of *The Expulsion of Heliodorus*, Toledo Museum of Art, Ohio

FIG. 89. Francesco Solimena, detail of *The Expulsion of Heliodorus*, Louvre

identical, can be ruled out as bozzetti, mainly on the grounds of quality and because they seem directly derivative of a third painting of the scene in the Louvre. Before the Toledo canvas appeared on the art market, Bologna held that the Louvre painting was the autograph bozzetto (Bologna 1958, 114ff., 194, 272ff., 276).

When the Toledo canvas surfaced, however, Bologna identified it with a work mentioned in the diary of a Monsignor Cybo recording the 1725 sale of the bozzetto for the *Heliodorus* to an Englishman (Bologna 1979, 64). According to Bologna this is the Toledo painting. He now relegates the Louvre painting to the status of a very good autograph ricordo that in turn inspired the Turin and Rome ricordi.

There is another piece of evidence. In all the clearcut ricordi the lower part of the scene, where in the fresco the top of the church door protrudes into the temple steps, has been filled with a shimmering still-life of overturned vessels and the nude bodies of two slaughtered

porters (fig. 88). This is critical, as it turns out, for in the Louvre version, and only in the Louvre version, one can still see the steps of the temple through the right foot of the man sprawled near the center foreground of the painting (fig. 89). This means that the Louvre painting must be the work mentioned by Monsignor Cybo: the bozzetto reworked by the artist so that it could be sold as a cabinet picture, minus the intruding door.

The Toledo picture, then, is not the bozzetto. But if it is a ricordo it is certainly by Solimena's hand. In quality it is far superior to the replicas in Rome and Turin. Its relative independence from the fresco composition, the more panoramic feeling (the conception of space relative to the figures seems vast), the superimposition of the various compositional elements, and the emphasis on silhouette, make the Toledo version look later than 1725. Since Solimena frequently made autograph replicas of works he had painted years and even decades earlier, it is likely that the Toledo painting is one such — possibly the one he is said to have painted for the king of Sardinia (De Dominici 1742–45, 3:602). CBC

27 Leda and the Swan

24 x 35.5 cm (9½ x 14 in)

PROVENANCE: Ettore Viancini, Venice, 1976

LITERATURE: Spinosa in De Seta 1982, 227–28n. 29, and fig. 9

Mr. and Mrs. Morton B. Harris, New York

This small and elegant picture illustrates Solimena's return to Arcadian classicism in the 1730s. At the same time the artist was pursuing the interest in Venetian art that marked the *Heliodorus* fresco, painted about five years before the *Leda*. It is a moment in Solimena's career not otherwise represented in the present exhibition, a moment of renewed classical balance before the turbulent paintings of the last decades (see biography by Carmen Bambach Cappel above). In this sense it is interesting to consider the *Leda* alongside such lyrical mythologies as the *Bacchus and Ariadne* of Giordano (cat. 11) and De Mura's *Bacchus and Ceres* (cat. 38).

Leda is presented frontally, with her torso parallel to the picture plane. Her head is turned as she gazes at the swan beside her and embraces him tenderly. Leda's body is formed from heavily shaded modeling of the shoulders, breasts, torso, and legs. The left side of her face and part of the right are in deep shadow, as is most of the swan's body. The swan's torso meanwhile follows the curve of Leda's body, his left wing jutting out into our space, the top of his head confronting Leda's at close range as his webbed foot perches on her thigh.

In organizing his picture the artist has turned to a well-known Venetian pattern in which figures, bed, and curtain on the left side of the canvas are juxtaposed with an open vista into a distant landscape on the right. However, Solimena seems to have made use of an actual prototype by Titian, or, more probably, of an engraving after Titian. The subject of Titian's drawing, in the Musée Bonnat in Bayonne, and of Cornelis Cort's 1565 engraving after it (fig. 90; Bierens de Haan 1948, 8, 205ff.), is not *Leda* but *Roger Delivering Angelica*. Yet the disposition

CAT. 27

FIG. 90. Cornelis Cort, *Roger Delivering Angelica*, engraving after drawing by Titian in the Musée Bonnat, Bayonne

FIG. 91. Francesco Solimena, *Venus and Cupid*, Museo del Duca di Martina, Naples

of the nude female figures is so close as to suggest that Solimena knew the Titian. Perhaps under Titan's inspiration, too, he endowed his nude with an unusual (for him) degree of sensuality. And there is another near-quotation: behind the protagonists is a charming Amor who, as assistant, recalls his counterpart in the Endymion scene from Annibale Carracci's Farnese Gallery.

The main line of Renaissance and baroque Ledas celebrated the episode as a moment of ecstasy, a tradition that proceeds from Michelangelo's famous lost drawing, so often replicated and varied (Knauer 1969, 3–35; for a recent thorough treatment of the ancient literary references, see Wise 1971, 3–23). Our picture stands outside this tradition. If Solimena's Leda has an earlier sister it is Correggio's in Berlin. That Leda, like Solimena's, is characterized by restraint rather than excess, gentleness rather than passion.

With its careful attention to placement of figures and composition nothing appears to be left to chance in this little work. Surely it is not a bozzetto. But is it a cabinet picture instead? Nicola Spinosa has related it to a series of pictures that may have been for a royal carriage (Spinosa in De Seta 1982, 227n. 29). One of these is the *Venus and Cupid* (fig. 91), now in the Duca di Martina Museum, Naples.

The painting is very much of the late twenties and thirties. The London *Dido Receiving Aeneas,* although somewhat earlier than our picture, is comparable stylistically. The figures of Flora and Zephyr in the self-portrait (see discussion of this painting in Solimena biography,

212

above) are even more similar. Other comparisons can be made between the putto and the angel in Solimena's *Madonna addolorata* in Cremona (Bologna 1958, fig. 182) and between the Leda and the angel in the Scuola di San Rocco *Annunciation* (Bologna 1958, fig. 205). But by far the closest is the *Venus and Cupid* mentioned above. These works, and others, comprise Solimena's reinterpretation, late in life, of the Arcadian pictures he had painted in the first years of the century. If the Baltimore *Orithyia* (cat. 22) represents those earlier works, the *Leda* represents the later retrospection: one that bathes the brilliant classicism of ca. 1700 in a darker, sadder, but still sweetly sensuous mood. JC

PAOLO DE MATTEIS, 1662-1728

Evonne Levy

Paolo de Matteis was a leading international figure in Neapolitan painting in the late seventeenth and early eighteenth centuries. An extremely rich yet critical biography by De Dominici has unfortunately cast his work into disrepute and obscured his personality from the mid-eighteenth century onward. Recent work on De Matteis by the last two generations of scholars, mostly Italians, has concentrated on resurrecting his reputation and outlining his considerable oeuvre. He is generally regarded as an eclectic, poised between the stylistic polarities of Giordanism and Roman classicism. In America only a dozen or so works are known in public and private collections; but he is increasingly coming to our attention, and many of his paintings are appearing on the art market.[1]

Born on the Piano del Cilento on February 9, 1662, Paolo de Matteis was supposedly brought to Naples to study painting at a young age. The story of his early education recounted by De Dominici is consistent with one of several biographical topoi used repeatedly in lives of the artists since Vasari (De Dominici 1742–45, 3:518ff.). De Matteis was inclined toward painting from childhood, De Dominici says, and his parents supported his instincts, sending him to a minor master for elementary instruction. However, wishing to put his natural intelligence to use in a career of greater prestige than painting, his father redirected him toward the liberal arts. De Dominici mentions his study of grammar and later of geometry and philosophy with members of the Neapolitan intellectual elite: Lionardo di Capoa, Tommaso di Cornelio, Luca Tozzi, and Tommaso Donzello. In spite of this enviable training Paolo's natural inclination for painting convinced his father to allow him to return to it, this time under a definitive master.

Through the regent of Gaeta, who favored De Matteis's father, Paolo was introduced into Luca Giordano's studio. If De Dominici is correct Paolo copied Giordano's numerous drawings after the Roman masters (De Dominici 1742–45, 3:396, 519). Thus inspired, when the opportunity arose to travel with Don Filippo Macedonia, he went along and there copied the originals themselves. In Rome he caught the attention of a more prestigious patron, the Marchese del Carpio, who paid him for drawings after paintings in St. Peter's, took him into his household, and sent him to study in the shop of Giovanni Maria Morandi (1622–1717), a Florentine in the

FIG. 92. Paolo de Matteis, figure Study, drawing, red chalk. Gabinetto Disegni e Stampe, Museo di Capodimonte

FIG. 93. Paolo de Matteis, *Alexander the Great in India*, competition drawing, black chalk. Accademia Nazionale di San Luca, Rome

circle of Rome's leading painter, Carlo Maratta.[2] Known primarily as a portrait painter, Morandi practiced a moderate and varied classicism.

Morandi's election as *principe* of the Accademia di San Luca in 1680 supports De Dominici's assertion, until now the only evidence, that De Matteis also attended the Roman academy. De Dominici writes: "With that master [Morandi], Paolo thus carried on his studies and, by attending the Accademia di San Luca, tried to master the nude as well as draw the beautiful statues of antiquity" (De Dominici 1742–45, 3:519). Two surviving drawings from De Matteis's Roman sojourn now document specific elements of this training; they also reveal a relatively unknown side of his graphic work, the academic graphite drawings and red chalk figure studies praised more than once by De Dominici. An example of the latter, a surprisingly robust, firmly drawn nude preserved at Capodimonte (fig. 92), is now securely attributable to De Matteis, and faint sketches of ruins and buildings of the skyline on the verso point to its execution in Rome.[3] Moreover, the drawing was adapted later for an engraved plate in a drawing book De Matteis produced between 1698 and 1707 for the instruction of his pupils.[4] A black chalk drawing (fig. 93) executed for the biannual drawing competition at the Accademia in October of 1682 and recorded as a third prize winner in the academy notes constitutes the earliest known dated work by the young artist.[5] Although it is difficult to determine the exact pedagogical role the Accademia played in this period, these drawings present unequivocal evidence that, whether acquired in Morandi's shop or in the academy itself,[6] De Matteis's training was formalized and classical: he was instructed in drawing the nude and in composing a history painting, and most likely attended the academy's lectures on theory, held on Sundays. De Matteis was still in Rome for the competition in October of 1682, the same month the Marchese del Carpio left Rome to

Paolo de Matteis

assume the viceroyship of Naples. On his return to Naples De Matteis was introduced into Giordano's studio in accordance with Del Carpio's desire (De Dominici 1742–45, 3:520).

While Giordano has always been considered De Matteis's primary model, the first decade of work by the young artist offers both an affirmation and a challenge to the master. This is apparent in an iconographically complex work of the 1680s, the *Allegory of the Arts* (fig. 18), the artist's first known dated painting, now in the J. Paul Getty Museum (Fredericksen 1972, 54ff.). Science appears at the apex of the composition surrounded by figures representing Painting and Architecture and by a putto with a drawing. Virtue appears to the left of the central figure of Painting, who is depicting Time revealing Truth. While the figure of Science is Giordanesque, the smooth, clear contours and idealized beauty of Virtue and Painting, and the balanced, choreographed design, are more typical of De Matteis's Roman masters.

A similar measured equilibrium and tender idealization hold forth in his next dated painting, a *Madonna and Child* of 1690 now in the Neapolitan church of San Giovanni dei Fiorentini, a work inspired by Maratta's multiple versions of the composition. Up until this point, seven years after he entered Giordano's studio, Paolo's Roman training rather than the loose painterly manner of Giordano has predominated in his known work.

The 1690s, however, were the years of De Matteis's most intense Giordanism. After the master's departure for Spain in 1692 at least one large commission was passed on to the younger artist.[7] Filling the older artist's shoes may have encouraged open emulation; it might even have been required to satisfy the patron's taste. Imitation of Giordano is apparent first in the *Galatea* of 1692 in the Brera, subsequently in a pair of canvases in the Gesù delle Monache in Naples, and nowhere more blatantly than in the *Olindo and Sofronia* exhibited here (cat. 28). However, in contrast to the scene from Tasso, in *Santa Chiara Driving the Saracens Out of the Temple* (fig. 94) De Matteis's personality shows through.[8] From Giordano he takes a lightened palette of

violets, light blues, and yellow for the exotic costumes, and the loose handling of the tumbling Saracens. Yet the slightly awkward, elongated Saracen in front, typical round-faced nuns, and hallmark hands — thin, wavy fingers with ascending tips — locked into a controlled, semicircular composition are all idiosyncratic elements of De Matteis's style.

A painting by De Matteis has recently come to light (Falanga Gallery, Naples) that exemplifies the artist's synthesis of two diverse styles into his own idiom. *Marcus Curtius Throwing Himself into the Chasm* (fig. 95) is quite obviously modeled on a much-copied composition by Giordano, one version of which, from the Burghley House Collection, is illustrated here (fig. 96).[9] De Matteis has retained the basic organization of the composition and made significant changes. First, while maintaining the dramatic proximity of the soldiers watching their heroic compatriot sacrifice himself to spare their lives (Livy 7.6), he transposes them into a neat pyramidal grouping with solid, visible foundations. Second, with some hesitation he turns the furious, lunging horse placed by Giordano on the diagonal into an almost perfect profile. This alteration may have been suggested to him, if he knew it, by Giordano's tamer version of the horse and rider in the *Marcus Curtius* in Spain. Last, he makes the wall parallel to the picture plane more important, thus emphasizing the measured layering of space. In this work, whose unusually saturated tones and firm modeling are reminiscent of his 1712 *Triumph of San Rocco* (Chiesa di San Rocco, Guardia Sanframondi), he achieves a high degree of plasticity and stability while conveying movement and excitement. In employing the compositional techniques of classicism, De Matteis has brought high baroque drama into a more controlled and, in terms of the narrative, understandable image.

From the time of Giordano's departure for Spain in 1692 to the end of the century De Matteis received commissions for at least five major fresco cycles in important Neapolitan churches. From 1693 to 1697 he was at work on the decoration of San Francesco Saverio, a church rededicated to San Ferdinando in the late eighteenth century, and on frescoes in the convent of San Sebastiano, now the Istituto Vittorio Emanuele II (Galante 1985, 218; De Martini 1975, 224n. 13). In 1698 and 1699, respectively, De Matteis signed and dated vault frescoes in the Gesù Nuovo and the pharmacy ceiling in the Certosa of San Martino (fig. 19).[10]

In San Ferdinando, a church whose decoration awaits a thorough documentary and iconographic study, De Matteis frescoed the vault, the nave and transept lunettes, the transept vaults, and the apse. The masterpiece of the cycle is undoubtedly the nave panel depicting the *Saints in Glory*. Here the figures are interspersed with dense clouds at balanced and regular intervals. The result is a rich, undulating surface which appears also in two important canvases of the 1690s, the *Annunciation* executed for the church of the Annunziata in Guardia Sanframondi in 1693 and the enormous *Santa Teresa and St. Simon Stock* of 1696 in Santa Teresa agli Studi in Naples, as well as in the subsequent Gesù frescoes. Striking in the Gesù and San Ferdinando paintings is De Matteis's extensive use of strong white highlights that accentuate the volume of the figures against the highly active surrounding surface.

In the pharmacy at San Martino, with a significantly lighter, unified palette, Paolo also considerably alters his figure style. Here a graceful angel mounted on a cloud aims an arrow at a soul tumbling upside down, part of a controlled choreography of figures. The latter are slimmer and more elegant than in the two previous frescoes, and the scene is composed

FIG. 95. Paolo de Matteis, *Marcus Curtius Throwing Himself into the Chasm*, Falanga Gallery, Naples

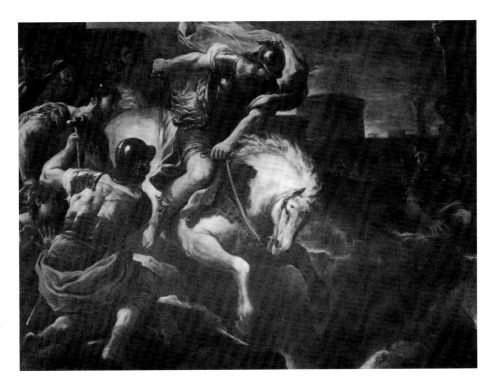

FIG. 96. Luca Giordano, *Marcus Curtius Throwing Himself into the Chasm*, Burghley House, England

Paolo de Matteis

similarly to the Getty Museum picture of the 1680s, in an oval. This work points the way toward Paolo's continued development in the 1710s and 1720s of a classicism moderated by a lightened palette.

After the turn of the century De Matteis received his only known invitation to a foreign court. According to De Dominici and an anonymous French source, De Matteis traveled to Paris in 1702 at the invitation of the vice admiral d'Estrées, who met the artist while in Naples with Philip V in 1702.[11] De Dominici notes that the invitation was confirmed "per volontà del Delfino," although five years after his departure only one work by De Matteis was catalogued in the royal collection.[12]

Among works recorded from the sojourn in France are painted decorations for the galleries of the Compagnie des Indes, and of the palaces of Antoine Crozat and the Marquis de Clérembaut, and a *Salmacis and Hermaphrodite* for the Duc d'Orléans, the latter recorded in an engraving as the only painting by De Matteis in the duke's collection.[13] For the Augustinian royal convent formerly in the Place des Petits-Pères, De Matteis executed a large fresco representing *Religion and Truth Confronting Error* along with a vault, painted afterward, in August 1703. Executed in eighteen hours and at his own insistence for no fee, the convent fresco earned him the honor, extended to his wife and eight children, of affiliation with the order.

An anonymous French manuscript addition to the affiliation document reports that De Matteis "tried to imitate the color of the old painters with his bold manner. In two or three strokes he traced the outlines of the faces of those whose portraits he did, and earned at least eighty *écus* for each. He made all the capable painters in that city jealous" (*Nouvelles Archives* 1880, 2:377). After his return to Italy Paolo composed short biographies of the Neapolitan painters at the request of a Frenchman who intended to use them for a publication on the lives of the European painters. According to De Dominici, who reprinted the eighteen lives completed by De Matteis, the project never went to press (De Dominici 1742–45, 2:50).

Works subsequent to the years 1702–05 show not the influence of his French sojourn but rather De Matteis's strong assertion of the Italian tradition in Naples. Vega de Martini has noted a "reconfirmation of certain academicizing positions, above all in the light of the great Italian and Bolognese classics" (De Martini 1975, 217). It is, however, impossible to find real consistency in Paolo's use of the great masters immediately after 1705. For instance, the *Crucifixion* of 1706 in Santa Restituta in Naples is characterized by a decisive use of light and dark and by a robust figure and drapery style. On the other hand in the Montecassino *Adoration of the Shepherds,* also dated to 1706, De Matteis draws on the sweetness and the luminous, unsaturated tones of late Reni and Giordano. In the *Death of St. Nicholas of Bari* (1707) in San Nicola alla Carità and the *Rape of Persephone* (1709; Christie's, London, March 11, 1983, lot 11), a palette of warm and saturated reds, yellows, and blues bathed in a luscious *sfumatura* is unmistakably Lanfranchesque in character. Similarly, in the San Giovanni Battista pendants of 1708 in the homonymous chapel in the Certosa of San Martino, he operates with a rich, saturated color scheme and a dramatic light recalling the Neapolitan realists of two generations before him who dominate the decoration of the Certosa.

De Dominici recognized the change in De Matteis's post-Parisian works as an improvement over his Giordanism of the 1690s. He describes the new manner as more forceful in its chiar-

FIG. 97. Paolo de Matteis, *Annunciation*, Saint Louis Art Museum, Missouri

oscuro "but with softness and tenderness in the colors" (De Dominici 1742–45, 3:539). Nowhere are these qualities more apparent than in the *Adoration of the Shepherds* (cat. 31) exhibited here, and the *Annunciation* (fig. 97), now in the Saint Louis Art Museum, a pair executed in 1712 for Aurora Sanseverino, duchess of Laurenzano.

The coincidence in 1712 of De Matteis's relationship with two important patrons and his election as prefect of the Corporazione dei pittori napoletani marks a second apogee in his career after his invitation to the dauphin's court.[14] The duchess of Laurenzano, who was involved in founding the Neapolitan Arcadian Academy, was an important patron of art and literature. De Matteis's circle definitely overlapped with that of the Sanseverinos. For example, the artist was a friend of Matteo Egizio, poet, archeologist, and adviser to De Dominici on the *Vite,* and the teachers of De Matteis's youth were also those of the duke (Willette 1986b, 259, 262). While De Matteis has, through Sanseverino, been linked to the Arcadian movement, the ramifications for painting and for De Matteis in particular have yet to be explored in depth. It is due to the high level of interest and sophistication of the patrons, though, that the *Adoration* and *Annunciation* along with the *Choice of Hercules* (fig. 22), commissioned by De Matteis's second patron of 1712, the third earl of Shaftesbury, were subject to unusually scrupulous planning. Shaftesbury, a British Platonist who came to Naples for reasons of health, directed the composition of the painting and published his instructions in 1713 as *A Notion of the Historical Draught or Tablature of the Judgement of Hercules.*[15] His concerns were with the moral nature of the subject and its expression through emblematic devices with no purely ornamental additions. A portrait of Shaftesbury by De Matteis was in the planning stages at the time of the earl's death in 1713.

The years following 1712 brought a continuous flow of commissions, now marking the growing dominance of De Matteis's style beyond Naples in Apulia (Mongelli 1978–79; Ferrara 1982). Before his first known trip to the region, probably in 1713, he had already sent works to Lecce and Grottaglie and thereafter received numerous commissions through the end of the decade. In 1713 Paolo executed three works for the church of San Giacomo in Bari, and he is generally believed to have frescoed subsequently the oval dome of the *cappellone* of San Cataldo in the Duomo of Taranto (Marciano 1985, 31). It is the only extant dome executed by De Matteis, who reputedly transformed the cupola in Santa Caterina a Formiello in Naples earlier in the same year.[16]

In the Apulian paintings he consistently works his synthesis of Giordanism and Marattesque classicism, sometimes tending toward bold brushwork and movement, at other times toward finish and distilled effects. For example, the *Madonna and Child with San Benedetto and Santa Scolastica* in Santa Maria delle Vergini in Bitonto is a combination of compositions by Giordano and Maratta, but the influence of Giordano predominates in the fluid brushwork and sense of immateriality.[17] On the other hand his *Virgin and Child with Sant'Ignazio and San Francesco Saverio,* dated to 1715, while still demonstrating a marked interest in the softness of Giordano's brush, is stiffly vertical.[18] In this work, the diminution of the figures in relation to the surrounding picture space isolates and fixes them in their restrained poses.

By the end of the 1710s, De Matteis's most advanced stylistic tendencies — the lightened palette and refined figures that appeared in the pharmacy of San Martino — were being reasserted after more than a dozen years. Returning to the Certosa in 1718–19, he and Domenico

FIG. 98. Paolo de Matteis, *St.
Joseph in Glory*, Monastery
Church, Certosa di San Martino,
Naples

Antonio Vaccaro collaborated on the decoration of the chapel of St. Joseph, producing an ornate ensemble of white and gold patterns and highly ornamented frames and altar. De Matteis executed five canvases, including the *St. Joseph in Glory* (fig. 98) and the ceiling frescoes, all rendered in lightened tones dominated by ochre and light blue. There is a new refinement and elegance in the figure types and gestures.

According to De Dominici, De Matteis traveled to Rome for another extended period to work for Cardinal Polignac, the French ambassador (De Dominici 1742–45, 3:533). His stay is documented in the only known letter from his hand, written to his friend Matteo Egizio in Naples on January 1, 1724, seven months after his arrival in Rome (Borzelli 1924). He explained that he was enjoying great success among the cardinals and nobles, who were amazed by the speed and finish of his method. Paolo also gives another reason for leaving Naples — to escape from his second wife.

De Dominici also tells us that De Matteis stayed in Rome for approximately three years. In that time he served, in addition to numerous cardinals and nobles, two popes, Innocent XIII Conti (1721–24) and Benedict XIII Orsini (1724–30). Innocent commissioned at least one work, identifiable with the *Miracle of the Blessed Andrea di Conti* now in a private collection in Paris.[19] Although only two works by De Matteis are known to have been commissioned by

Pope Benedict XIII, the context surrounding the artist and patron is more complex and worthy of further research. Before his election to the papacy Orsini served for almost four decades in the archiepiscopal see of Benevento. It is likely that during that time he would have come into contact with De Matteis, who worked on three occasions in nearby Guardia Sanframondi.[20] De Matteis was responsible for the inventory, of ca. 1710, of over two hundred works of art owned by the Gravina branch of the Orsini family. The artist, who was known as a connoisseur, would have been a logical choice for the task.[21] Benedict's well-known tendency to favor Beneventan artists may have extended to De Matteis, from whom he commissioned a portrait of himself, now lost, and a painting for the main altar of the chapel of San Domenico in Santa Maria sopra Minerva, where he was later buried. The painting, which still hangs in its original location, represents the *Miracle at Soriano* in which the Madonna of the Rosary appears with Santa Caterina and Santa Maria Maddalena, with putti holding a gold-ground painting of San Domenico.[22] The painting probably dates from the year of the chapel's dedication, which took place in August of 1725 (Scatassa 1913, 113).

Upon his return from Rome De Matteis undertook the decoration of Le Crocelle, the church in which he desired to be buried. He and his workshop executed altarpieces for the apse, transepts, and most of the eight chapels (Galante 1985, 253; Pagano in Galante 1985, 262nn. 74ff.). There is a great deal of continuity between these and the paintings in the chapel of St. Joseph in San Martino of 1718–19. For instance in the *Death of St. Joseph* (fig. 84) the light falling between the angel's wings, the point of view, and the cadence of the figures descending from left to right in a pyramidal formation are fundamentally the same. Most of the images for this church were culled from a familiar repertory of saints and subjects — the *Immacolata,* the *Addolorata, St. Nicholas, St. Michael* — and are composed in stable symmetrical compositions modeled firmly with clear contours and in a lightened palette. The artist's last known works include four ovals of Old Testament scenes sent to Bergamo and one or two large canvases for Messina in 1728, the year he died (Dreoni 1979; Barbera 1980, 43–44).

The impact of De Matteis's moderate classicism (or moderated Giordanism) on painting in southern Italy, though not inconsiderable, is slight compared to the virtual domination of Neapolitan painting by Solimena who, after all, outlived De Matteis by almost twenty years. De Matteis's reputation also suffered from misfortune: several of his most talented students died young, and his biographer, De Dominici, had both a personal grudge as well as an artistic bias that makes his praise of Paolo more than faint. On the other hand, De Dominici, who almost twenty years after the artist's death perceived a crisis in the training of young painters, had high praise for De Matteis as a teacher. Perhaps through his teaching, using imported Roman methods now better known to us through his two Roman drawings (figs. 92 and 93), and his drawing book, De Matteis may have influenced Neapolitan painting at the instructional level. More important, his Roman training may provide the conceptual framework for the frustrating multiplicity of stylistic tendencies his work exhibits.

The importance of De Matteis's early sojourn in Rome was first suggested by Ferdinando Bologna, who noted that De Matteis contributed to Solimena's shift in the 1690s to a more classicizing idiom (Bologna 1958, 143–44). De Matteis's clarity, stability, and compositional techniques may have served to counter the frenetic, splintered tendencies Solimena was exhib-

iting in his very advanced early work. Solimena may also have looked to De Matteis for a legitimate academic method supported by disegno.

A second reason for underscoring the importance of De Matteis's Roman training is that from an educational point of view Giordanism represented a dead end for Neapolitan painting. De Dominici recognized that disegno was a fundamental precept without which Giordano's students simply copied his inventions, fantasy, and color with no profound knowledge of the master they were imitating (De Dominici 1742–45, 3:520). He acknowledged Giordano's genius but revealed the failure of his "inimitable" method for future generations.[23] The importance of De Matteis's Roman drawings and of the drawing book as evidence of his academic training should not be underestimated. It is probably because of this traditional grounding in disegno, best obtained in Rome, that De Dominici favorably distinguished De Matteis from the rest of Giordano's pupils and upheld him as an important teacher. De Matteis was the only artist who, having learned in Rome to draw *i belli contorni* , which De Dominici so admired, had the potential to succeed almost in spite of Giordano's teaching.

Though De Dominici considers De Matteis a student of Giordano's, De Matteis may have perceived himself equally a product of the Roman school. De Matteis's own account of the life of Giordano states, "He did not have the good fortune of having important students, because of which I believe he did not waste his time instructing them, having been throughout the course of his life full of things to do" (De Dominici 1742–45, 3:542). Evidently Paolo did not count himself among these students. When he returned to Naples in 1682–83 he must not have considered himself a student and therefore held his Roman training to be primary. De Dominici views De Matteis as trying to emulate Giordano, especially in the rapidity of his execution. However, in his letter from Rome to Matteo Egizio, De Matteis wrote, "But here I distinguish myself from everyone, attentive not only to the easy and bold way of painting but [to] what appears to the eyes of all as the completed and finished method of operating, and they compare [me], for example, [to] Raphael of Urbino, who in 37 years of life left more finished works [than anyone], a certain argument for the sureness and certainty of the technique" (Borzelli 1924, 9). Here speed is more a technical accomplishment than it is the pictorial value that was the foundation of Giordano's *prestezza*. And the final effect is not speed but finish. It is also significant that De Matteis compares his "finito modo di operare" to that of Raphael, the great-grandfather of Roman classicism.

More important, De Matteis's Roman training may have provided an ideological foundation for his work which, somewhat justifiably, has been considered eclectic. Even though a broad development by decade has here been traced, Paolo's stylistic incongruities cannot be stretched into a neat linear development. Rather, it seems possible that he used style flexibly as a function of subject matter or, as I have suggested in more than one case, taste. In other words, positive value can be found in the much-maligned label of eclecticism by looking to specific issues within his work and in late seventeenth-century Roman painting and teaching (Mahon 1971, 193ff.).

In contrast to workshop training under a single master, classical pedagogy tends to teach not a style but a method. De Matteis's *Marcus Curtius* (fig. 95), discussed above, employed such a method with formulaic precision. Moreover his competition drawing (fig. 93) of the *Alexander*

the Great in India is similar to other academy drawings of the period and shows that, with some variations, an almost generic style was taught from the 1660s on. Carl Goldstein suggests that academic training in Rome at the end of the seventeenth century tended to suppress personal style: "The basic orientation that artists in Rome had been receiving from the individual masters in whose studios they were trained came increasingly to be provided by the Accademia. Once the individual ceased to be the custodian of style, style ceased to be an individual thing: the Accademia, like the Académie Royale . . . identified and taught a supra-individual style that all young artists were expected to adopt" (Goldstein 1978, 14). Once style has ceased to be an individual thing, stylistic multiplicity can hold a positive value.

The notion of the positive value of multiplicity for De Matteis receives support when one considers other aspects of the problem — aspects still in the beginning stages of investigation — of Roman classicism at the end of the seventeenth century. Maratta's classicism, generally a point of reference taken for granted in literature on De Matteis, is actually quite moderate and changeable. Morandi, De Matteis's teacher in Rome, whose style is even more changeable, was referred to by Goethe as "a plagiarist of plagiarists" (Waterhouse 1967, 117). Dwight Miller has suggested that in the late seventeenth century classicism provided a foundation for style, alterable according to its appropriateness or to the congeniality to subject (Miller 1982, 491).

These attitudes toward style may have informed the multiplicity of De Matteis's expression. For example, his Giordanesque *Olindo and Sofronia* (cat. 28) is among the least naturalistic, the least material, of his works; the fictive presentation may have been considered most appropriate for the literary subject. The *Marcus Curtius* (fig. 95), a dramatic historical scene, is uniquely tangible, painted with his most naturalistic palette to evoke the veracity of the subject. Last, both the *Adoration of the Shepherds* (cat. 31) and the *St. Joseph in Glory* (fig. 98) retain their sense of materiality. Yet, through a lightened palette, softness, and idealization, they are among his most moving representations of the border between the human and the divine.

Unlike Giordano, whose blatant feats of mimesis were intended to fool his patrons, De Matteis consciously and proudly likened his work to that of others. He possessed a view of imitation that recognized the efficacy of given stylistic means to fulfill the expressive potential of diverse subjects. The negative connotations of eclecticism have masked an approach to painting which, for Paolo de Matteis, may have been programmatic. By understanding this, we can provide a positive framework for the future study of this important painter.

1. I would like to thank several individuals for their assistance on this project. Research in Italy was facilitated by a grant from the Italian Studies Committee of Princeton Universtiy. In Naples Professor Nicola Spinosa was instrumental in providing access to works and sources. Most of all, my thanks go to Professor Irving Lavin, whose numerous comments and suggestions have been incorporated into this essay.

2. Pascoli, writing before De Dominici, records that Morandi had many students. He mentions De Matteis as the most inventive and famous of the four named (Pascoli 1736, 2:135).

3. The drawing's verso bears a signature written with a brush in brown ink. There are two parallel bands of sketches running across the width of the sheet on the upper and lower halves of the page. The building on the right end of one band is repeated at the left of the second band as the continuation of the skyline.

4. This book is documented in an appendix to De Dominici's life of De Matteis containing a description of engravings after his works by others, and by the artist himself (De Dominici 1742–45, 3:551). The drawing book, which continues a tradition championed by the great Bolognese artist-teachers such as the Carracci and Guercino, consists of sixteen plates, twelve of which are full-length academic studies of male nudes. Engraved by Francesco Aquila in Rome, it can be dated 1698–1703 or 1705–07, from the periods in which the dedicatee, Adriano Ulloa, served as regent of Naples. I am grateful to Thomas Willette for having brought to my attention the copy in the Biblioteca Hertziana, Rome, and to Nicola Spinosa for mentioning that in the collection of Aldo de Juliis, Naples.

5. The drawing is in the collection of the Accademia di San Luca. An inscription on the bottom reads: "Paolo di Mattheo Nap.o 2.do Pr." The inscription was added later. The competition was recorded on October 4, 1682. In contrast to the drawing inscription noting a second prize, in the records he is said to have shared the third prize with another pupil. "Libro delle congregazioni, 1674–1699." Archivio dell'Accademia di San Luca 45, fol. 105 v. The drawing was originally published in Salerno 1974, 341, 345, pl. 17.

6. According to Professor Angela Cipriani (oral communication), who has been studying the academy's existing seventeenth-century records and statutes, drawing classes may only have been held on a casual basis for the beginning students.

7. De Dominici 1742–45, 3:537 records works for the Jesuit College in Madrid. Another large series of paintings documented to the 1690s was still in the church of the Clarisas del Milagro in Cocentaina in the 1960s. See Pérez Sánchez 1965, 406ff.

8. The Gesù delle Monache pendant depicts the *Initiation of Santa Chiara*. Nappi reports the dating of the canvases to 1696 as suggested by De Martini's stylistic comparison of the pair to the large canvas in the apse of Santa Teresa agli Studi (De Martini 1975, 224n. 13; Spinosa 1984, pl. 259). The date is more or less accurate since the paintings were in place by 1700. See Nappi in Galante 1985, 60n. 35.

9. The Burghley House picture, and another version in the Bowes Museum, Barnard Castle, Co. Durham, England, are dated to Giordano's Florentine period (Ferrari-Scavizzi 1966, 2:120–21). Still another version of the composition possibly painted for the church of San Pablo in Córdoba is now in the University of Barcelona. See Ferrari-Scavizzi 1966, 2:136, 195, 324; 3, pl. 260. Although the horse and rider in the Barcelona work are far closer to De Matteis's version than are those in the Burghley House version, the Spanish picture lacks the essential features of the prominent soldiers in the left foreground and the figures approaching on the right against the cityscape. These elements make the Burghley House compositional type a much more likely primary source for De Matteis.

10. The fifth commission, for which a partial payment was made in December of 1699, was for decorations in the church of Santo Spirito di Palazzo. These were dispersed when the church was destroyed.

11. De Dominici 1742–45, 3:523. A manuscript note by an unnamed member of the Augustinian convent on a "letter of affiliation" gives a more detailed and anecdotal account of De Matteis's invitation and sojourn. See *Nouvelles Archives* 1880, 2:373, 377.

12. The painting was the *Rape of Europa*. See Bailly 1899, 638.

13. The first is recorded by De Dominici; the second and third are summarized in *Nouvelles Archives* 1880, 2:374. The fourth was brought to my attention by Nicola Spinosa. Unfortunately, Arnauld Brejon de Lavergnée's article on De Matteis's work in France had not appeared by the time of writing. I am grateful to M. Brejon, however, for having communicated to me some of his findings on this subject.

14. For De Matteis's extensive participation in the Corporazione, see Strazzullo 1962.

15. I am grateful to Sheila O'Connell for sharing her research on Shaftesbury and De Matteis, which will appear in the publication of the Walpole Society. On Shaftesbury, see Sweetman 1956 and Wind 1938.

16. De Matteis's dome at Santa Caterina is all but gone; his replacement, in 1717, of Lanfranco's at the Gesù Nuovo after the collapse of the cupola in 1688 was also destroyed. See Rabiner 1978b, 327–28, and Baer 1972.

17. Illustrated in Ferrara 1982, 48, fig. 9. See Maratta's SS Carlo Borromeo and Ignazio of Loyola at the Feet of the Virgin in Santa Maria in Vallicella in Rome and Giordano's Madonna of the Rosary (1664–65) in San Potito, Naples.

18. Now in the left transept of the Gesù Nuovo, it was originally in Taranto at the Chiesa di Monteoliveto.

19. Illustrated in Brejon 1981, 64, fig. 3. A work which could have been a pendant was recorded shortly thereafter in the Roman church of Santa Maria d'Aracoeli: "Veggonsi dalla parte dell'epistola due quadri coloriti a olio, uno esprimente il martirio del beato Giovanni de Prado, l'altro il beato Andrea Conti in atto di esorcizzare una indemoniata, dipinto da Paolo Mattei in congiuntura della dilui beatifica-zione." See Casimiro 1736, 63. Innocent, who was responsible for the beatification of Andrea Conti (November 12, 1724) evidently distributed engravings of the Aracoeli image to the devout (De Dominici 1742–45, 3:534, 552).

20. In 1693 he painted the Annunciation (misdated ca. 1712 by De Martini prior to restoration), in 1712 the Triumph of San Rocco and two other altarpieces for San Rocco, and the entire fresco decoration of San Sebastiano, which according to an inscription in the church was consecrated in 1721.

21. The inventory is transcribed in Rubsamen 1980, 68ff. No works by De Matteis are listed.

22. According to De Dominici, whose description of the work is inaccurate, elements that Benedict considered scandalous were overpainted after the artist's departure (De Dominici 1742–45, 3:533).

23. De Dominici writes that it was actually Solimena who called Giordano's unity, his "intelligenza del tutto," inimitable (De Dominici 1742–45, 3:430).

28 *Olindo and Sofronia Rescued by Clorinda*

176.5 x 229.2 cm (69½ x 90¼ in); signed and dated (indistinctly): "1692" or "1695"

PROVENANCE: Talbot Collection, Margam, Glamorganshire, Wales; Messrs. Thos. Agnew and Sons, Ltd., London, 1959; Leger Gallery, London, 1962; Central Picture Galleries, New York, 1969; Walter P. Chrysler, Jr.

LITERATURE: De Dominici 1742–45, 3:541; Ferrari 1970, 6:1312; Chrysler 1978; Chrysler 1982; Spinosa 1984, pl. 253; Spinosa 1986, 132, no. 115, and fig. 136

The Chrysler Museum, Norfolk, Virginia; Gift of Walter P. Chrysler, Jr. 71.540

Shown in New Haven and Sarasota only

> *Aladine will kill the Christians in his ire:*
> *Sophronia and Olindo would be slain*
> *To save the rest, the king grants their desire;*
> *Clorinda hears their fact, and fortune's plain,*
> *Their pardon gets, and keeps them from the fire.*
>
> Trans. Edward Fairfax

Torquato Tasso's *Gerusalemme Liberata,* first published in Venice in 1581, was a favorite source of subject matter for secular decoration among artists during the two succeeding centuries (Rouchès 1920), from Annibale Carracci (*Rinaldo and Armida,* Capodimonte, Naples) to Giovanni Battista Tiepolo whose magnificent group of four paintings is now in the Art Institute of Chicago. Tasso's lengthy poem deals with the crusade of Godfrey of Boulogne which captured Jerusalem in 1099. It combines chivalric romance with Christian themes and provided a new iconography that could be both erotic and inspirational as well as exotic, fantastic, and supernatural. The tale might readily be given a Counter-Reformation interpretation alluding to the longed-for conquest by Roman Catholicism of the heretics of northern Europe, but romantic episodes intersperse the main narrative and it is these, perhaps inevitably, which appealed to artists and patrons — the stories of Tancred and Erminia, Rinaldo and Armida, and Olindo and Sofronia.

Paolo de Matteis knew the poem well — De Dominici tells us that he could quote it from memory — and he painted a number of Tasso subjects. His frescoes in the Palazzo Pignatelli, Naples, painted in 1721, have been destroyed, but the present picture and its pair, *Tancred and Erminia* (the provenance of this picture, now in a Swiss private collection, is the same as that of the Chrysler *Olindo and Sofronia;* "Notable Works of Art Now on the Market," *Burlington Magazine* 101 [1959], pl. xi, as *Rinaldo and Armida*), may have been part of another decorative scheme. Nicola Spinosa has published two other scenes from *Gerusalemme Liberata:* a battle (Neapolitan private collection; see Spinosa 1984, pl. 254), and *Rinaldo and Armida* (formerly Galerie Pardo, Paris; see Spinosa 1984, pl. 263). Further Tasso subjects have been attributed, more or less convincingly, to De Matteis: *Erminia and the Shepherds* (Kunsthistorisches Museum, Vienna, inv. 1659; Wolfgang Prohaska has kindly communicated to me Manuela Mena's oral attribution of this painting to Andrea Procaccini); a variant of the present composition apparent-

CAT. 28

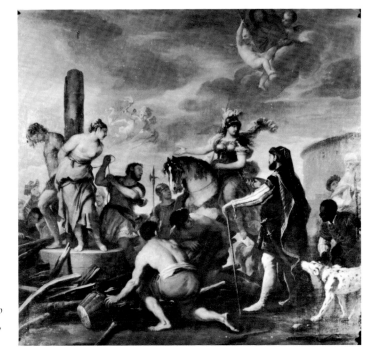

FIG. 99. Luca Giordano, *Olindo and Sofronia Rescued by Clorinda*, Palazzo Reale, Genoa

ly to be viewed from below (Sotheby's, London, July 2, 1986, lot 116); a pair of *Rinaldo and Armida* and *Tancred and Erminia* (Sotheby's, London, April 15, 1981, lot 101); a pair of *Erminia and the Shepherds* and *Tancred and Erminia* (Christie's, London, October 26, 1976, lot 22; with Chaucer Fine Art, 1978; according to Spinosa's annotation on photographs in the Witt Library, London, these are probably the work of G. B. Lama); and a group of *Carlo and Ubaldo Resisting the Enchantment of Armida's Nymphs, Carlo and Ubaldo Departing for Armida's Island, Erminia and the Shepherds,* and *Rinaldo and Armida* (with Messrs. Thos. Agnew and Sons, London, in 1968; see "Notable Works of Art Now on the Market," *Burlington Magazine* 110 [December 1968], pls. li–liv. Spinosa has attributed these also to G. B. Lama [annotations on photographs in the Witt Library, London]).

The lines from the introductory stanza to canto 2 illustrated in the present picture tell how Sofronia and Olindo were rescued from martyrdom by the Persian warrior-maiden Clorinda. Aladine, the king of Jerusalem, had removed an image of the Virgin from a hidden altar and placed it in his own chapel. When the image disappeared he threatened to massacre the Christians of the city. Sofronia, to save the others, took responsibility on herself, but her admirer Olindo, when he learned that she was to be burned, claimed that it was he who had stolen the image. Aladine condemned them both to death. As they await the fire Clorinda arrives (on horseback, upper right), takes pity on them, and offers to fight in Aladine's army in return for their release.

De Matteis has drawn closely on Luca Giordano's painting of the subject in the Palazzo Reale, Genoa (fig. 99) for both iconography and composition. Giordano himself seems to have

231

FIG. 100. Mattia Preti, *Olindo and Sofronia Rescued by Clorinda*, J. Paul Getty Museum, Malibu, California

owed something to a painting of the subject by Valerio Castello in a Genoese private collection which appears, in turn, to be related to Bernardo Castello's illustration of the scene in the 1612 edition of Tasso (Manzitti 1972, 77). At this early stage in Paolo's career his debt to Giordano was still obvious and is apparent even in the handling of paint which retains something of his master's bravura. In later paintings, for instance the Richmond *Adoration of the Shepherds* (cat. 31), the picture surface is characteristically smooth and highly finished. A comparison of the spatial organization of Giordano's *Olindo and Sofronia* and De Matteis's version is telling. The younger artist's concern with clarity and structure, reflecting the influence of Carlo Maratta in Rome (see biography, above), is here applied to a typically Giordanesque free-ranging composition. De Matteis has brought the figures closer together, grouping them securely around the platform on which the fire is being built. Sofronia, the focus of the narrative, also acts as the pivot around which the composition is resolved both in three dimensions and on the picture surface. As in the Richmond *Adoration of the Shepherds* De Matteis has organized the scene around a central female figure who glows with a pearly luminosity. In both pictures the eye is led from the lower left-hand corner, in the present example along the back of the man (taken from Giordano) who lays sticks from his basket at Sofronia's feet, and in the *Adoration* along the back of the cow. There is a stronger diagonal movement from the lower right back into the picture towards the group of figures beyond and to the left of the stake. The repoussoir figures on either side have the additional function of forming the lower corners of a triangle, stabilizing the composition, of which Sofronia's head is the apex.

Perhaps because he was concentrating on creating a coherent illusion of space through careful modulation of light and shade De Matteis restricted his palette almost entirely to a warm gray-brown. There are, however, patches of color — the costume of the man on the right in rich yellow with touches of pink which are echoed in the pink of Clorinda's plume and in the turban of the man on the left. These relieve the overall monochromy and act as a further

unifying factor within the composition, serving to reinforce the pattern on the picture surface. At the same time richer fabrics differentiate wealthy spectators from the executioners.

While in terms of form and space De Matteis's picture is clearer than Giordano's, the relationship of the principals is less compelling. This may have a textual explanation. As a student of Tasso, De Matteis may have chosen to abandon his master's tense triangular depiction of the moment at which Aladine decides to free the couple. In the poem such a moment does not exist, for Aladine is not present at the execution. Perhaps this is why De Matteis has made Giordano's king, the man in yellow, into a mere onlooker, ignored by Clorinda. De Matteis has expressed other aspects of the text with similar exactitude. Tasso describes Sofronia as a beatific virgin martyr concentrating on heaven with no thought of rescue, in contrast to Olindo, relegated to shadow by De Matteis, who desists from moaning only when Sofronia reproves him. It is Sofronia's heroism which impresses Clorinda and results in the release of the pair.

De Matteis Paintings Cats. 28–32

The scene had been depicted by Mattia Preti in at least two versions, one in the Palazzo Rosso, Genoa, and another now at the J. Paul Getty Museum, Malibu (fig. 100). Composition, atmosphere, and interpretation of the text differ entirely from those of Giordano and De Matteis. Preti, characteristically, organized his space in a series of planes with the main action taking place between boldly silhouetted foreground figures further emphasized by dramatic chiaroscuro. Sofronia is naked, following Tasso, and she appears not as a heroic virgin but bound and passively awaiting death or rescue.

Preti's interpretation is haunting but it is far removed from Tasso's epic. To De Matteis's ordered intellect a faithful rendering of the text must have seemed as essential as the clear construction of his composition and the careful balancing of tone and color. In the present picture he achieved these aims and, perhaps because of his fascination with the subject, or because the liberating influence of Giordano was still strong, he did so without allowing formal considerations to overwhelm expressiveness. so

29 *The Miracle of St. Catherine of Alexandria*

45.2 x 36.3 cm (17¾ x 14¼ in); signed verso, before relining: "Paulus de Matthei F. 1708 Neapoli"

EXHIBITION: Chicago 1970, 232, no. 98

LITERATURE: De Martini 1975, 226n. 44; Spinosa 1986, 132, no. 120, and fig. 159

Private Collection, New York

St. Catherine of Alexandria was a pagan queen who, as a converted Christian, was ordered killed by the Emperor Maxentius. The scene represented here is the saint's deliverance from Maxentius's attempt to cause her death by fixing her to spiked wheels. But the angel above, to whom Catherine looks, has already broken the deadly vise that had fastened her to the wheel, sending fragments flying and spectators fleeing. Though Catherine was eventually beheaded, this episode is often called her martyrdom and it is the wheel that is her most common attribute.

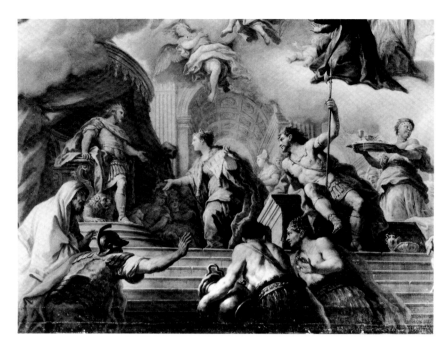

FIG. 101. Paolo de Matteis,
Encounter of Solomon and Sheba,
Gesù Nuovo, Naples

Painted thinly on canvas, this work is not immediately identifiable as a bozzetto, a ricordo, or a cabinet picture. Although its size would make one suspect it to be a bozzetto, it is not in fact consistent with the two bozzetti by De Matteis exhibited here, the *Self-Portrait with an Allegory of the Peace of Rastatt* (cat. 30), and the *St. Nicholas of Bari Felling a Tree* (cat. 32). In contrast to the fluent brushwork and rather provisional character of the latter works, the *Miracle of St. Catherine* is a fully resolved composition. It is, however, similar in execution to another important bozzetto, the finished sketch that has been connected with his fresco in the cupola of the Gesù Nuovo (Baer 1972). The date of the Gesù sketch is not known although Baer dates it to the end of the 1690s and hence about a decade before this work, which is dated 1708. Regardless of the chronology, comparison of the two works reveals the maturity of this small composition, suggesting that it was indeed a study for or a ricordo after a larger unknown work.

In De Matteis's *Encounter of Solomon and Sheba* for the Gesù (fig. 101), the supporting relationship between the figures above and those converging below — Sheba being depicted with a full round face and voluminous regal attire — carry over into the *Miracle of St. Catherine*. The similarity of the types and the full, dynamic composition held together firmly by Catherine's weighty pose show the artist arriving at similar solutions to diverse problems: on the one hand an earthly encounter paralleled by a heavenly host generates a centrifugal composition; on the other a single figure saved by divine intervention generates a centripetal force. Yet despite this divergence the compositional technique is fundamentally the same in both scenes.

Baer has shown that De Matteis's involvement with the Solomon and Sheba portion of the Gesù composition begins with a drawing dated 1693; Baer also suggests convincingly that De Matteis's source for the composition was Rubens's version of the same subject for the ceiling of

234

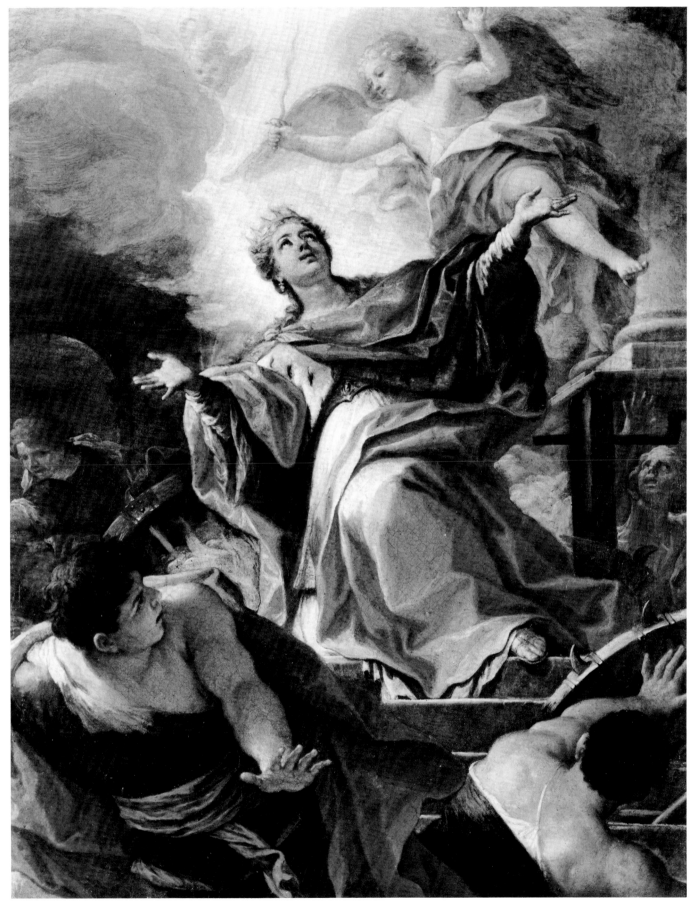

CAT. 29

the Jesuit church in Antwerp, which was well known through engraved copies. The *Miracle of St. Catherine* reflects that composition although the placement of the saint on top of a stepped platform is so prevalent in De Matteis's work, and in that of other Neapolitan painters such as Preti and Giordano, that no direct connection between the first drawing and this canvas is necessary.

De Matteis's other works depicting St. Catherine, and his works for churches of which she was patron, help us further to circumscribe the origins of this canvas, although at this stage no conclusions can be drawn. De Matteis received two major and several minor commissions from the church and convent of Santa Caterina a Formiello in Naples (Ceci 1901, 180). In 1712 he frescoed the dome depicting SS Catherine of Alexandria and Siena with other patrons and saints of Naples invoking the Virgin and Holy Trinity. Highly praised at its unveiling, the surface of the picture deteriorated almost immediately, leaving only faint traces today (Rabiner 1978b, 327). Paolo also decorated the convent's renowned pharmacy, but we know neither the date nor the subject of the commission (De Dominici 1742–45, 3:523).

It has been pointed out that De Matteis's work in this church was preceded by the frescoes of the Roman artist Luigi Garzi which date from 1695–97. In fact De Martini believes that Garzi was an enduring influence on De Matteis from the time of his early study in Rome (De Martini 1975, 210ff.). While this assessment is too extreme, De Matteis's work does carry on a dialogue with Garzi's overdoor of the same subject in Santa Caterina a Formiello. De Matteis's canvas is a distillation of Garzi's large and dispersive treatment of the event. However, where Garzi dwarfs his Catherine with the enormous supernatural machinery, De Matteis emphasizes the saint on a scale similar to that of the Rubens Antwerp ceiling or Mattia Preti's *Martyrdom of St. Catherine* in San Pietro a Maiella. Both De Matteis and Garzi depict one figure running outward on the left and one running in on the right. In contrast to Garzi, however, De Matteis here as in other works packs the corners, creating a striking diagonal surface design. Typical too is the figure on the left trying to run from the scene but held in check by his glance back to the saint.

The crucial and characteristic treatment of the corners in this canvas seems to preclude an earlier suggestion that the compositions might be related to two tondi cited by De Dominici as being in the "Casa del Cardinale Polignac" in France (Chicago 1970, 232; De Dominici 1742–45, 3:541). It is known that De Matteis worked for Cardinal Polignac in Rome in the 1720s but it has not been established — as De Dominici's words might imply — that patron and painter met while De Matteis was in Paris ca. 1702–05, that is, several years before this work was executed. And the half-length *Marriage of St. Catherine* cited by De Dominici as possessing a pendant would more probably have been accompanied by another half-length composition rather than this full-length *Miracle*. EL

30 *Self-Portrait with an Allegory of the Peace of Rastatt*

77.2 x 106.6 cm (30⅓ x 42 in)

PROVENANCE: Colnaghi, London, 1979

EXHIBITIONS: Naples 1979, 1:154, no. 61; Detroit 1981, 1:123–24, no. 30

LITERATURE: De Dominici 1742–45, 3:538, 540; De Martini 1975, 209ff.; Ferrari 1979, 26; Ferrari in Detroit 1981, 1:54; Spinosa 1986, 138, no. 139, and pl. 21

Sarah Campbell Blaffer Foundation, Houston, Texas

The picture celebrates the 1714 agreement by which the Kingdom of the Two Sicilies ceased to be a Spanish vice-kingdom and became an Austrian one. And yet of course it is also a self-portrait. Seated left center, his body turned slightly away from us but with his face looking over his shoulder with a wry gaze, the artist works on a good-sized canvas depicting allegorical figures of Spain and Austria. These are two women, crowned and dressed in robes of state, who are seated and shaking hands. The artist wears rather old-fashioned hose and culottes, and over them a saffron *robe de chambre.* He also wears a white turban or cap. These latter may be work clothes, which would imply that the artist is putting the finishing touches on a canvas he is about to present at court. In any event, behind the rock on which the artist sits is a monkey. He undoubtedly signifies *ars simia naturae* (art, the ape of nature), but one recalls that De Dominici had described De Matteis himself as looking like a monkey and that he connected this trait with the present work (De Dominici 1742–45, 3:538).

Most strikingly the scene takes place outdoors. Pleinairisme, the making of finished oil pictures with an easel set up in the landscape one was painting, was unknown in the early eighteenth century. Here it has a purpose different from that it was to have for the French Impressionists who exploited the practice. Paolo is shown painting what was called at the time a *quadro riportato,* a fictive easel painting that seems to hang, or to be supported by putti and other divinities, in a frescoed ceiling. Normally such ceilings were painted to resemble skies filled with flying figures. But in this case, as Ferrari (Detroit 1981, 1:54) notes, the frescoed ceiling is a real sky filled with real presences. Paolo's *quadro* is even *riportato* by a "real" Atlas seated on the ground. Putti flutter about and help keep the picture upright. Behind, on high on the right, is the figure of the Catholic Church in pontifical robes carrying cross and chalice. Attendant allegories, Hope and Charity seemingly, flank the Church, all three washed in golden light. This motif no doubt refers to Clement XI's negotiations that had helped achieve the peace. On the far right Mars is chased from the scene by Peace and Fame, while the lion lies down with the lamb. On the left we see war's victims, some of them still able to greet the peace messenger floating above. Figures of Peace and Plenty in brilliant red and pale green are seated on clouds above to the left. In the lower background Vesuvius erupts — presumably as a form of salute — and on the near shore Parthenope, mythical siren queen of Naples, makes music.

The picture probably dates from shortly after 1714 when the treaties were signed. Spinosa has maintained that the Houston canvas is a bozzetto for the larger version of the same subject whose central fragment is at Capodimonte (fig. 102; Spinosa in Detroit 1981, 1:123). Ferrari, in

FIG. 102. Paolo de Matteis,
*Self-Portrait Painting the Peace
of Rastatt*, fragment, Museo
di Capodimonte, Naples

contrast, thinks our painting is an autograph copy of the final version (Ferrari 1979, 26n. 72).
There is also a studio copy in the Jedding Collection in Hamburg (Spinosa in Detroit 1981,
1:123). But compared to our picture the Capodimonte self-portrait is labored and stiff and
substantially different in some details. The handling of the paint in the Houston canvas, on the
other hand, is marvelously fluent and free. One must agree with Spinosa that our picture is a
spirited bozzetto.

Paolo de Matteis's style is usually described, rather too simply, as classicizing Giordanism.
Such a view ignores the complex evolution that led from the full-blown Giordanesque baroque
of his early works to the subtler style of his later years (see above, biography of Paolo de
Matteis). The latter is exemplified by the Detroit *Danaë* (fig. 103) to which the Houston
self-portrait already points. The Richmond *Adoration of the Shepherds* (cat. 31), which dates to

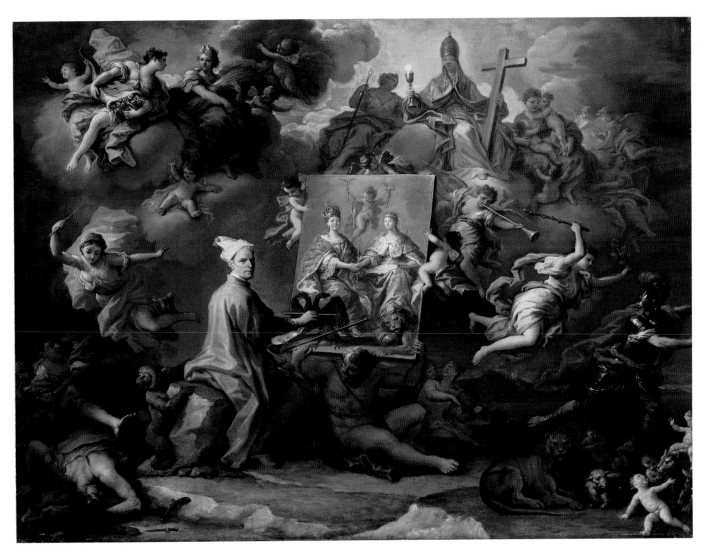

CAT. 30

FIG. 103. Paolo de Matteis,
Danaë, Detroit Institute of Arts,
Michigan

ca. 1712, does the same. Still other works by De Matteis, for example, his *Allegory of a Peace Treaty* (Mittelrheinisches Landesmuseum, Mainz) and *Venus Offering Arms to Aeneas* (Palazzo Bonaccorsi, Macerata), which Ferrari has dated to ca. 1714 (Ferrari 1979, 26), can be understood as dress rehearsals for the project represented here. All these works bespeak Paolo's draughtsmanship and suggest his assimilation of the Roman classicizing taste during his education in that city. At the same time he absorbed a kindred taste for porcelain flesh and clear outlines from French artists whose work was visible in Rome, for example, Simon Vouet. We also recall that Paolo went to France in 1702 (De Dominici 1742–45, 3:523). The composition in the *Allegory of a Peace Treaty* and *Venus Offering Arms to Aeneas,* however, has a certain compression, a certain lack of pictorial space, in contrast to the Houston painting. These two pictures really belong with his earlier work, of which the masterpiece is the ceiling fresco in the pharmacy of the Certosa di San Martino of 1699, *St. Bruno Interceding with the Madonna for the Suffering* (fig. 19).

In his earlier period the creation of plastic effects had been Paolo's aim. In the Houston canvas, on the other hand, he tempers this disegno–oriented style with a painterly freedom not simply due to the picture's being a bozzetto. Long after his apprenticeship to Luca Giordano, and after a period of experimental classicism, he now turns back to his master's manner. He reinvestigates Luca's airy sweep of the brush and reflects his command of space, atmosphere, and light. Details such as the white monochrome group of putti to the right of the Virtues exemplify the shift. The passages of golden light, the dreamy atmosphere, the figure types, even some of the poses such as those of the messengers of peace, and above all the fa presto handling of the paint inevitably remind one of Luca's last great fresco, *The Triumph of Judith* in the Certosa di San Martino (see cats. 17, 18). In all these ways the Houston self-portrait is Paolo's homage to his master.

De Matteis Paintings Cats. 28–32

The idea of fusing three different genres — the political allegory, the self-portrait, and the scene of an artist at work — was not so strange in 1714 as it may seem to us. One of the most famous is Luca Giordano's *Rubens Depicting the Allegory of Peace and War* (Prado; Ferrari-Scavizzi 1966, 2:37; see fig. 64). This homage by Giordano to Rubens was for a number of years iconographically unique. Levey (1982, 39ff.) has noted that Giordano's painting may be the first picture of its kind. In any event Rubens was soon to become a familiar subject for painted tributes, notably French ones. Another relevant predecessor, also by Giordano, is his *Homage to Velázquez,* now at the National Gallery, London, usually dated to the beginning of Luca's stay in Spain, that is, the early 1690s (Ferrari in Detroit 1981, 1:179). This second *omaggio* also shows the artist at work. Another relevant aspect of this particularly Giordanesque tradition is Luca's *St. Luke Painting the Virgin,* Museo de Arte de Ponce, Puerto Rico (fig. 104), where, once again, the artist shown is actually Luca Giordano (but also Luke — note his name; Réau 1955–59, 3:831ff.; Ponce 1984, 130). Furthermore Paolo was surely aware of another type of concetto as seen in G. B. Castiglione's etching *The Genius of G. B. Castiglione* (1647–48, Bartsch 21.23) and Salvator Rosa's *The Genius of Salvator Rosa* (Bartsch 20.24). Both prints illustrate artistic inspiration via allegorical figures such as those in the Houston picture.

De Dominici rather unjustly calls the De Matteis self-portrait a "concetto basso" and says it was criticized for this when first exhibited (De Dominici 1742–45, 3:540). But, in the

perspective provided above, Paolo is simply relating himself to Luca Giordano as Luca had related himself to Rubens, Velázquez, and St. Luke. How can that be "low"? Quite the contrary, it caps the climax of this genre of artists' tributes to each other. It is much like the verbal praise-competitions that Judith Colton discusses above in her essay. Such a reading provides even a meaning for the monkey. The concetto would run as follows: Paolo, who physically resembles a monkey (De Dominici 1742–45, 3:538), makes himself the ape of Giordano who is literally equated, in the larger scene, with the landscape; for example, when Paolo copies a Luca Giordano landscape it is like copying Nature itself. Or one could say that Paolo shows himself painting in an allegorical landscape, a world created by Luca Giordano.

CBC / GH

31 *Adoration of the Shepherds*

202 x 178 cm (79½ x 70¹⁄₁₆ in); signed and dated l.r.: "Paulus de Mattei F. 1712"

PROVENANCE: Duchess of Laurenzano, Naples; H. R. H. Prince Henry of Bourbon-Parma, Count of Bardi; sale, E. Hirschler, Vienna, April 2, 1906, lot 69; Burián-Fejérváry; sale, A. Kende, Vienna, April 12–14, 1932, lot 32; Heim Gallery, London, 1973

EXHIBITION: London 1973, no. 16

LITERATURE: De Dominici 1742–45, 3:535–36; Neilson 1974, 21–22; De Martini 1975, 222; London 1978, no. 26; Ferrari 1979, 26–27, fig. 27; Naples 1979, 1:152; Near 1985, 445–46, fig. 10; Spinosa 1986, 133, no. 127, and fig. 147

Virginia Museum of Fine Arts, The Williams Fund 79.102

The Virginia Museum of Fine Arts *Adoration of the Shepherds,* together with its original pendant, the *Annunciation* (fig. 97), now in the Saint Louis Art Museum, represents perhaps one of the highest expressions of De Matteis's classicizing idiom and his most advanced technical achievement. Commissioned by Aurora Sanseverino, duchess of Laurenzano, in 1712, the two pictures were obviously the object of meticulous planning and execution.

Aurora Sanseverino was a prominent figure in Neapolitan intellectual and artistic circles. A poet, she was a member of the Neapolitan Arcadian Academy founded in 1703 and a strong supporter of Solimena; under her protection De Dominici began his *Lives* of the Neapolitan artists. The duke and duchess's involvement with De Matteis is less well documented, although their circles undoubtedly overlapped. According to De Dominici they commissioned from him only two other works, a lost pair of ovals representing *Pan and Syrinx* and *Apollo and Daphne* (De Dominici 1742–45, 3:535). The duchess's interest in art and in the literary and philosophical questions of the day undoubtedly influenced the attention with which this commission was executed.

The *Adoration* is composed around the central pyramidal grouping of the Virgin and Child in loosely knit circles which function both on the surface and in depth. Movement of the eye around the canvas is reinforced by gesture, the use of local color, and the light radiating from the child illuminating faces as points on a circle. The subtlety of the composition is revealed in

CAT. 31

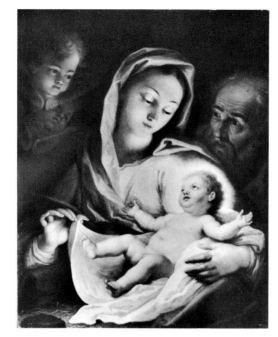

FIG. 105. Paolo de Matteis, *Holy Family*, Crocker Art Museum, Sacramento, California

details such as the shadowed drapery of the flying putto crowning Joseph's and the Virgin's heads, and the cow whose curved haunch draws us into the scene as his horns enframe the Virgin and Child.

In contrast to the high saturation and full range of his palette on the *St. Nicholas* bozzetto (cat. 32), here Paolo works with a limited palette. Painting on a ground of almond brown he brings the animals, shepherds, and setting into a unity of color broken only by the Virgin's electric blue mantle and the rich green garment worn by the adoring child. He subtly unites the figure of Joseph, the putto, and the girl with the basket of doves through the use of color, a veil of light gray-blue activated by the neutral ground.

The *Annunciation* and the *Adoration,* both signed and dated 1712, are documented by De Dominici. The latter, having lived for a time in the Laurenzano palace, would have known the pair and comments favorably on them in a list of De Matteis's finest works: "As were also so praised the two paintings which he painted for the duchess of Laurenzano of glorious memory: in one of them he represented the Annunciate, and in the other the Birth of Christ, both painted with amenity, and with noble colors; and especially the Nativity in which he sought to imitate in some of the shepherdesses and angels, and even more in the Holy Virgin, the noble type of faces of the most excellent Guido Reni" (De Dominici 1742–45, 3:535–36).

While De Dominici is correct in pointing to Reni as a source for the smooth perfectionism evidenced in this painting, Reni is not De Matteis's only source, and the originality of the image cannot be explained through reference to Reni. The Raphaelesque motif of the Virgin gingerly pulling away the swaddling clothes to reveal the child who lights the scene belongs to a tradition which grew up around Correggio's *Notte.* Perpetuated by Annibale Carracci in his lost version

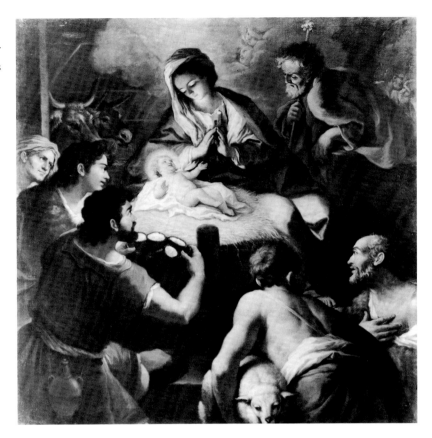

FIG. 106. Paolo de Matteis, *Adoration of the Shepherds*, Cappella dell'Idria, convent of San Gregorio Armeno, Naples

of the Correggio, by Domenichino in his copy of the latter, by Badalocchio, and by Lanfranco, the motif retained remarkable consistency down through Maratta's isolation of the Madonna and Child in numerous half-length versions (Schleier 1962). De Matteis also produced numerous popular half-length versions in the manner of Maratta. In fact, an exact copy by the artist in half-length of the Richmond Madonna and Child is in the Crocker Art Museum in Sacramento (fig. 105). It is more to Maratta than to Reni, in fact, that De Matteis owes the inspiration for his Virgin.

While the spirit of the shepherds is most derivative of Domenichino, De Matteis has transformed the subject according to the vision of his time. In the Bolognese versions the Virgin is depicted close to the ground, protectively enveloped by figures who stand to the sides and tower above the newborn. De Matteis maintains the feeling of enclosure, but by enlarging the Virgin and Child and tipping the ground up he leaves no ambiguity as to the Christ Child's divine nature.

Several other important treatments of this subject by De Matteis are known. They include two atmospheric, Giordanesque canvases, one in Spain and one in the J. B. Speed Art Museum, Louisville, and a canvas from the Cappella dell'Idria in the Neapolitan convent of San Gregorio Armeno (fig. 106). The first is dated to the 1690s, the second is undated, and the third, like the present picture, is dated 1712 (Pérez Sánchez 1965; Pane 1957).

245

Comparison of the Richmond *Adoration* with the San Gregorio Armeno painting shows the artist bringing different approaches to the same subject in the same year. Although they share features such as the stepped approach to a round manger and the overall circular organization of the scene, the San Gregorio Armeno version does not project the same devotional intensity as the Richmond picture. Rather, in this painting, which is one in a cycle of eighteen devoted to the life of the Virgin, the stress falls on the narrative, on the offering of gifts. De Matteis accomplishes this rather awkwardly; in accommodating the square shape of the canvas he cuts figures off in an idiosyncratic fashion and makes bold the gesture of the shepherd offering the typical southern baskets of ricotta cheese, while an irreverent and bewildered sheep stares out from under a shepherd's arm. The Richmond picture, in contrast, is finely choreographed for smooth transitions and the communication of a devotional mood, rather than being the explicit illustration of a historical event. EL

32 *St. Nicholas of Bari Felling a Tree Inhabited by Demons*

87.6 x 139.7 cm (34½ x 54⅝ in)

PROVENANCE: Lebel Collection, Paris; Frederick Mont, New York; Newhouse Galleries, New York

LITERATURE: Strazzullo 1964–65; Spinosa 1980, 459, fig. 4; Zafran 1984, 63ff., 22 (color plate); Petrelli in Galante 1985, 230n. 201; Spinosa 1986, 133, no. 129, and fig. 149

High Museum of Art, Atlanta; purchased with the Fay and Barrett Howell Fund 1982.21

This painting is a fully worked up bozzetto for the overdoor in the Neapolitan church of San Nicola alla Carità. According to De Dominici, De Matteis executed the overdoor and the cupola pendentives contemporaneously as an extension of his earlier commission to decorate the apse. The latter project, completed in 1707, consists of a large canvas behind the altar representing the *Death of St. Nicholas of Bari,* two narrow flanking canvases of *San Liborio* and *San Gennaro,* and fresco decoration above the large canvas representing a glory of angels, the glory of St. Nicholas, and various virtues.

De Dominici offers a lengthy account of De Matteis's work in the church as an illustration of the artist's less desirable qualities. Referring to the first part of the commission, he writes,

And certainly if he had been contented by what he had painted in that church, his praises would still be sung; and the disputes between the supporters of the one and the other painter [De Matteis and Solimena] *would still endure. But, as usual, inflated by excessive praise and giving too much credence to his adulators who told him he had surpassed Solimena's paintings* [in San Nicola alla Carità], *he wanted to paint the pendentives of the dome and the overdoor, which turned out so inferior to his own ability — so much had he believed that one work to be superior to all of the paintings made by that admirable painter* [Solimena]: *and he well realized the truth when the overdoor was revealed to the public and he saw it little praised by his own supporters* (De Dominici 1742–45, 3:524).

De Dominici's account perfectly encapsulates his primary complaint about the artist, namely that he was capable of great work but was often inconsistent. Although the fresco is quite

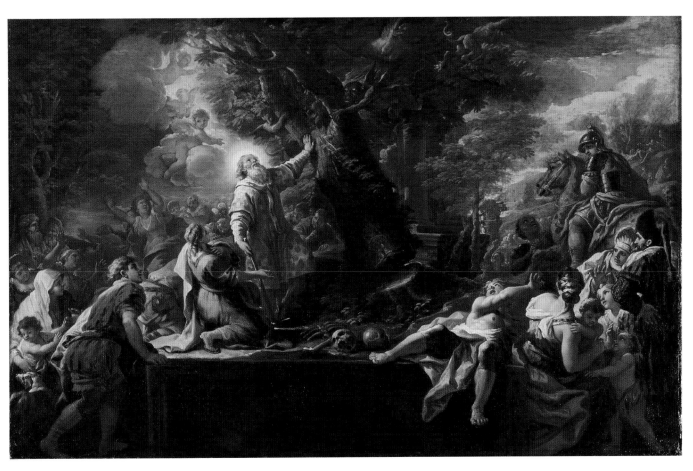

CAT. 32

deteriorated and difficult to judge, the compositional and figurative solutions reached in the bozzetto are undoubtedly more satisfying.

The primary changes from the sketch to the fresco include the figure kneeling to the left of the saint, who in the fresco faces outward and holds the addition of the bishop's crosier, the alteration of Nicholas's robe from Greek to the Latin type, the depiction of the tree demon as what appears to be a woman rather than a bark-covered monster, and the inclusion in the lower right corner of the fresco of an additional child. The placement of a glass entrance below the fresco makes the section above the door difficult to read, and damage due to the use of the choir balcony has obliterated the lower right section and part of the left, including the date, which should have appeared next to the signature on the lower left. According to Spinosa 1986, 133, the fresco was signed and dated 1712.

The construction of this abundant and vigorous composition is based on a series of contrapuntal diagonal movements. The central motif of the wildly falling tree throws the composition into motion but is stabilized by a diagonal running up the backs of the two figures in the left foreground, the arm of the saint, and the flight of the demons to the right. The grouping of figures on the right side in a compact triangle reinforces the diagonal movement upward from left to right but is held in check by the staffage figure closest to the frame. The tree is part of a larger triangular spatial unit fitting wedgelike into the rest of the composition. As in the *Miracle of St. Catherine of Alexandria* (cat. 29), De Matteis establishes a figurative presence outside of the picture space, in this case the figure that is dramatically thrown back on his perch; yet he uses this figure almost as a corrective to an overly dramatic use of space.

The work is particularly striking for the complexity and variety of its color. Painted on an orange-brown ground, the surface is fully built up in the foreground figures and thinly and more loosely sketched in the receding spaces. Local color is used for balance, and pentimenti here show the artist working out the following sequence: the mantle of the left foreground figure in red was begun in yellow and changed to blue, and the sash of the headless figure, originally blue, was changed to green. The scene is set in an unusually luscious landscape, thoroughly Cortonesque, above all in the execution of the trees and sky.

St. Nicholas was bishop of Myra in the province of Lycia in Asia Minor in the fourth century (Ševčenko 1983, 18ff.; Ševčenko 1984, 11ff.). Two centuries later events from his life were recorded in the compilation known as the *Praxis de Stratelatis*. By the tenth century his life was being conflated with that of the sixth-century abbot St. Nicholas of Sion in another document, the *Vita compilata*. There is evidence of the existence of Nicholas of Myra's cult in Italy earlier than the ninth century. At that time it became firmly established, reaching great prominence after the transfer of the saint's relics to Bari by the Normans in 1087. Subsequently he was referred to as both Nicholas of Myra and of Bari.

Eric Zafran has noted that this painting illustrates an episode in the life of Nicholas of Sion which came to be attributed to Nicholas of Bari (Zafran 1984, 63). It is an extremely rare subject for Italian painting and De Matteis's precise source is not known. According to the Greek account of Nicholas of Sion's life, men from the village of Plakoma begged him to fell a sacred tree inhabited by an unclean idol which destroyed fields, and anyone who approached it. The skulls of these victims are depicted in the bozzetto.

When he was about to fell this sacred tree, the servant of God said: "Assemble with one accord up the slope on the North side." For it was expected that the tree would fall to the west. The unclean spirit thought at that moment to frighten the crowd. And he made the tree lean toward the north up the slope where the crowd stood watching, so that they all screamed with fear in one voice, saying: "Servant of God, the tree is coming down on top of us, and we will perish." The servant of God Nicholas made the sign of the cross over the tree, pushed it back with his two hands, and said to the sacred tree: "In the name of my Lord Jesus Christ I command you: turn back and go down where God has ordained you." Forthwith, the tree swayed back by the will of God and moved toward the west, where it crashed. From that time on the unclean spirit was no longer seen within those parts. And they all glorified God, saying: "One is God, who gave power to his servant against the unclean spirits" (Ševčenko 1984, 17, 39).

De Matteis's sketch is an embellished version of this legend. People are assembled up the slope on the right, but the artist, needing to populate the foreground of the composition, he has sacrificed geographic precision. The possessed tree, nearing its destruction, emits flying demons. The moment De Matteis depicts is that of the greatest drama and meaning: when the tree threatens to crush the spectators, the unpredictability of evil and the miraculous powers of the saint are most fully at war.

De Matteis depicted St. Nicholas a number of times in Naples, where, as patron saint of sailors, his cult was extensive. In the Atlanta bozzetto the saint is wearing the short-sleeved Greek bishop's vestment identical to previous representations of the saint by Giordano, by De Matteis in his *Christ and the Virgin Bestowing the Episcopacy on St. Nicholas* (1693) in the Duomo, and in his *Death of St. Nicholas* (1707) in the Carità. De Dominici records that in his *SS Alberto, Angelo, Bartolo, and Nicholas* for Santa Maria della Concordia, the saint was depicted "with a displeasing appearance for having represented him as Greek" (De Dominici 1742–45, 3:528, 531). This work has been recently dated after 1716 for uncited reasons (Alabiso in Galante 1985, 247n. 195).

However, in a work securely dated to 1716, *SS Gennaro, Nicholas, and Biagio* in Santa Maria della Colonna, De Matteis depicted the saint in Latin robes. It was therefore probably painted after the picture in Santa Maria della Concordia that seems to have aroused controversy over the representation of the saint as bishop of the Eastern rather than the Western church. This shift in iconography is borne out by De Matteis's subsequent portrayals of him in Latin vestments in the *Madonna and SS Biagio and Nicholas* in San Michele in Anacapri from the end of the decade. In the *St. Nicholas* De Matteis painted for Le Crocelle (1726–27), the church in which he was buried and for which he provided almost all of the altarpieces, he did, however, revert to the Greek vestments.

The change from the latter, in the Atlanta bozzetto, to Latin vestments in the final fresco suggests that a theological discussion may have taken place after the original planning of the fresco and before its execution. As an alternative to Spinosa's dating of 1712, therefore, which is based on the fresco's long-effaced inscription, the bozzetto may well have been executed as De Dominici says, after the completion of the apse in 1707 and before 1716, and the fresco in or after 1716. EL

FRANCESCO DE MURA, 1696-1782

David Nolta

Francesco de Mura was born on April 21, 1696 to the wool merchant Giuseppe di Muro and his wife, Anna Linguito, in the Neapolitan parish of Santa Maria della Scala. De Dominici, whose brief commentary on De Mura in the appendix to his "Vita di Francesco Solimena" provides invaluable if occasionally confused firsthand information concerning the early life of the artist, and describes in detail the hardships he was forced to overcome in the youthful pursuit of his creative inclinations. Unlike the brutish master of the local elementary school who, we are told, beat the boy mercilessly for copying woodblock figures of saints, De Mura's father encouraged his son's artistic aspirations, sending him, upon the advice of a painter named Felice, into the studio of Cavaliere Domenico Viola.

De Mura was perhaps ten years old at the time, and Viola, who had been a pupil of Mattia Preti's, welcomed the diligent prodigy with great kindness, instructing him in the rudiments of disegno. The young student had served an apprenticeship of only a little more than a year when the beneficent Viola died. And so, in 1708 at the age of twelve, De Mura entered the studio of another artist, by far the most illustrious living in Naples: Francesco Solimena. Thus began a period of personal and professional intimacy spanning several decades, during which the older Francesco played an inestimable part in the creative development of his best-loved pupil, Franceschiello (De Dominici 1742–45, 3:692–94).

Within two years of his entrance into Solimena's famous *scuola* De Mura was copying the works of his master and, according to De Dominici, "it was a marvel to see a mere boy just past ten years old reproduce a half-length of the Virgin and Child with the young St. John . . . beautifully combining the tints with softness and sweetness, having accomplished already the design especially in the hands, which were well drawn and well painted" (De Dominici 1742–45, 3:694). The author goes on to relate an anecdote involving De Mura's ingenious copies of the works of Giustino Lombardo, who was much admired among Solimena's pupils for his draughtsmanship. Here and elsewhere in his commentary De Dominici emphasizes De Mura's study of disegno and thereby firmly aligns the artist with his teacher, Solimena (who had, according to the same writer, chosen for himself the tutelage of the expert draughtsman Francesco di Maria over that of the greatest colorist of the age, Luca Giordano [De Dominici 1742–45, 3:581]), and with Solimena's favorite painter of the previous century, Mattia Preti.

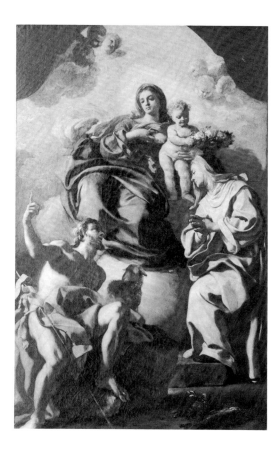

FIG. 107. Francesco de Mura,
Madonna delle Grazie, Pio Monte
della Misericordia, Naples

The lessons learned from Preti via Solimena — and no doubt introduced even earlier, during the year with Viola — can be seen in any number of De Mura's youthful works, from his first publicly exhibited picture, a *Crucified Christ with the Virgin and St. John,* executed in 1713 for the Chiesa di San Girolamo delle Monache, to the *Immaculate Conception* (ca. 1715–18) painted for the nuns of the Crocelle di Mannesi and now found in the sacristy of the Neapolitan Chiesa del Divino Amore, to the two small bozzetti, one of the *Madonna delle Grazie* (fig. 107) and the other a *St. Anthony of Padua,* left by the artist in his generous bequest of pictures to the Pio Monte della Misericordia in Naples. These early works display a crisp chiaroscuro, a dark and consequently somewhat grave atmosphere, a monumentalization of the human form, and a dramatic energy that are distinctly baroque — that is, decidedly seventeenth century in terms of style; and they were certainly painted in the studio of Solimena with Preti's example ever in mind.

So solidly was De Mura trained in the late baroque tradition of the seicento by one of its greatest masters that it was not uncommon for his earliest works to be mistaken for those of Solimena (De Dominici 1742–45, 3:695). Such misattribution, which may have helped to establish his fame in Naples, has nevertheless caused his reputation to suffer in the long run by casting upon him the wholly unwarranted stigma of being a mere copyist. It is true that De Mura's ever-evolving style of painting, especially through the 1720s but even as late as the 1740s,

bears the unmistakable stamp of an extended apprenticeship with Solimena; this can be seen in everything from the heroic, classicizing compositions (Solimena had been to Rome in 1702, where he was confirmed in his longstanding inclinations toward a grandiose, classical manner) to the actual physical types of many of his models. But while the influence of the older artist upon the younger was unquestionably multifarious and enduring, known instances of direct copying are rare and must in any case be considered a natural component of the maturing pupil's progress toward mastery. It was standard practice for assistants to contribute to the works of their teachers; and, since Solimena and the student whose talent most impressed him worked closely together for a number of years, well into the old age of the former artist, it is not inappropriate to speculate upon the extent to which the relationship between the two became collaborative. Thus in paintings by the mature De Mura, quotations or passages that seem to be derived from Solimena may actually be De Mura's own repetitions of figures or motifs which he himself had originally conceived; in any case, the matter of mutual influence, or at least of interaction which benefited both artists, has yet to be fully investigated. Finally, it is important to bear in mind what Raffaello Causa and others have noted, namely, that as early as the final years of the second decade of the settecento, De Mura was consistently adopting a far lighter chromatic scale for his paintings than was typical of Solimena; and that this was most likely in response to the works executed by Luca Giordano in the last (some would insist rococo) phase of his career (e.g., cats. 17, 18), and to those by Giordano's followers Paolo de Matteis (e.g., cat. 32) and Giacomo del Po (Causa 1970, 66; Rizzo 1978, 95ff.). It was chiefly by means of this highly personalized, luminous palette that De Mura distinguished himself as a purely eighteenth-century painter as well as one of the most advanced and poetic colorists of his age (see cats. 37, 38).

During the 1720s De Mura emerged from the shelter of Solimena's studio into the lively artistic milieu of Naples. By the middle of the decade the artist was independently executing major painting commissions, primarily ecclesiastical, in and around his native city. Among these were the two lateral images in the arch and the cupoletta of the chapel of the titular saint at San Nicola alla Carità, datable to the latter half of the decade (see Galante 1985, 221, and nn.); a few years later he returned to paint the cupola of this small but sumptuous church in the via Toledo. In 1727 De Mura completed five major works for the Duomo in Capua, which De Dominici identifies as a *Tobias and the Angel* and four large figures of saints (De Dominici 1742–45, 3:695). If Vincenzo Rizzo's suggestions concerning the chronology of the artist's early life are accurate (Rizzo 1978, 99), then it was also in 1727, the year of De Mura's marriage to Anna d'Ebreu, that he painted a series of pictures for the new sacristy of the church of the Annunziata in the provincial city of Airola. Because the complicated issue of De Mura's reliance upon Solimena is especially significant with regard to the crucial first years of the younger artist's independent career, it is worth pausing to consider the Airola pictures more closely. For they offer a paradigm of the relationship between the two painters at this stage in their respective development.

To begin with, the Airola *Adoration of the Shepherds* (fig. 108) is a distinctly Solimenesque work. What might be termed the neo-Pretian tenebrism — a dramatic pattern of sharply defined lights and shadows — can be linked to any number of Solimena's works from the 1680s

onward. Likewise, several of the figures in De Mura's picture have Solimena prototypes. For example, the rugged, windblown St. Joseph is more than slightly reminiscent of the figure of St. Peter in Solimena's *Madonna and Child with Saints,* painted for San Nicola alla Carità in 1684, and the kneeling, partly nude shepherd in the De Mura is nearly a mirror image of the same character in Solimena's *Adoration* for the church of the Annunziata at Aversa, ca. 1689. Most interesting of all is the very Romanizing (cf. Carlo Maratta's Uffizi *Madonna*) central group of the Virgin and Child in the painting at Airola, which is a replica of an earlier treatment of the same subject by De Mura (Rizzo 1978, 111n. 31), but which is also identical to a *Madonna and Child* painted by Solimena for Count Harrach during the *next* decade, that is, the 1730s (Lurie 1972); hence the difficult question of determining prototypes and the origin or earliest manifestation of influence.

In another of De Mura's Airola pictures, the altarpiece of the *Lamentation over the Dead Christ,* the same conservatism is evinced in the dark tonalities and in the handling of the monumental nude, both of which are rooted in the tradition of Solimena and perhaps also refer to the example of earlier painters such as Andrea Vaccaro (for example, the *Pietà* at the Pio Monte della Misericordia, Naples; see Causa 1970, pl. XIX). For the vault of the sacristy at Airola, however, De Mura has produced an *Assumption of the Virgin* (fig. 109) that seems to break with Solimenian convention in a variety of ways. In the first place a new chromatic lightness complements the airiness of the composition. Second, there is a newfound dynamism in the individual figures and in the larger arrangement of forms. It is revealing to compare this *Assumption* with a nearly contemporary (ca. 1725) rendition of the same subject by Solimena executed for the cathedral at Capua (fig. 77). The two works obviously have much in common — the large group of men surrounding the obliquely viewed sarcophagus, the female figure rising to fill the upper half of the space depicted, even the tower in the left distance — but given these basic similarities, the De Mura is far more animated, far less balanced and in this sense far less classical than the Solimena. In Solimena's version of the scene several of the figures remain rigidly upright, and one, the man who looks directly out toward the viewer, establishes a dominant fluid movement from the central figure on the ground up into the figure of the Virgin, whose own shape is that of a gracefully curved crescent maintaining a precarious but definite vertical balance. In De Mura's version, however, the crowd of earthbound holy men has been blown apart. Not one remains vertical, not one looks directly out at the viewer in order to provide a stable, predominating upward flow; instead there are volatile fragments of a composition in flux, above which the Virgin seems to bob and teeter more awkwardly but also more dynamically than in the Solimena. These traits, the dynamic imbalance, the contrapuntal groupings of figures, and the lightness of color and tone, are the qualities De Mura cultivates and makes his own throughout the greater part of his career.

At the end of the 1720s De Mura participated in the lavish redecoration of the church of Santa Maria Donnarómita in Naples, completing ten oil paintings of the Virtues for the interstices between the windows in the nave and a large canvas of the *Adoration of the Magi* to be placed above the choir. De Dominici bestows upon this *Adoration* the highest praise at his command by claiming that so beautiful was the composition, so magical the coloring, it was thought by many to be the work of Solimena (De Dominici 1742–45, 3:696). In fact, according to Rizzo,

*Francesco
de Mura*

FIG. 108. Francesco de Mura,
The Adoration of the Shepherds,
Chiesa dell'Annunziata, Airola

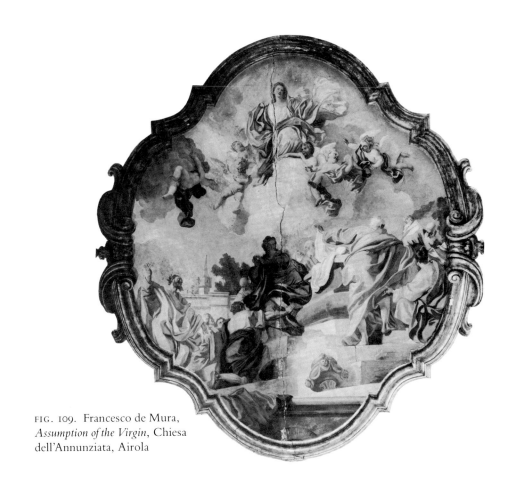

FIG. 109. Francesco de Mura,
Assumption of the Virgin, Chiesa
dell'Annunziata, Airola

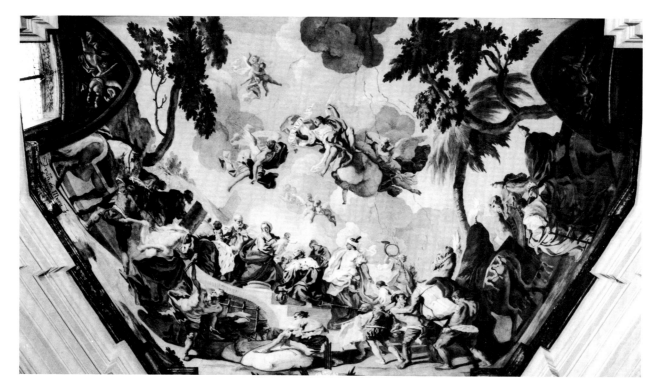

FIG. 110. Francesco de Mura, *The Adoration of the Magi*, fresco, apse, Chiesa della Nunziatella a Pizzofalcone, Naples

the group of the Madonna and Child in this picture reflects the more Giordanesque taste for robust, popular figural types, and the light, silvery tones are less a reminiscence of Solimena than an anticipation of De Mura's rendition of the same scene for the Jesuits in their recently constructed church for the novitiates of the order, the Nunziatella a Pizzofalcone (Rizzo 1978, 102). Painted in 1731, this fresco of the *Adoration of the Magi* (fig. 110) fills the rounded apse of the little Sanfelice edifice with light and movement and clearly represents both the culminating achievement of De Mura's early career and his greatest move toward stylistic independence to date. Compositionally the picture displays a dynamic diagonal sweep that exploits the concavity of the wall surface and subtly integrates the subsidiary zones of activity, from the foreground, comprising a number of lively genre scenes in which muscular male figures — timeless types of the working class no doubt modeled by De Mura upon the stevedores and street laborers of Naples — attend to horses and camels and carry the onerous trappings of royal itinerary upward into the middle left portion of the picture, where the Holy Family forms a broad triangle surrounded by the three regal visitors below and by an angelic host above. With regard to color De Mura has here continued to temper the warmth and brightness of his earliest work, as those qualities were loosely derived from the seventeenth-century pictures of both Solimena and Giordano, with something of the cooler pastel tonalities that characterize his masterpieces of the 1740s and 1750s.

Undoubtedly due to the success of such pictures as the Nunziatella *Adoration of the Magi,* De Mura's fame began to spread, reports of his virtuosity reaching the monastic patrons at Montecassino, birthplace and magnificent home of the Benedictine Order. On the seventh of March 1731, De Mura was officially engaged by the monks to decorate one of the chapels in the main church, and so entered into an affiliation with the abbey that lasted nearly a decade and resulted in the execution of over thirty separate oil paintings and frescoes (Ceci 1933, 43ff.; see the essay by Robert Enggass, above). Because the monastery at Montecassino, along with most of its precious contents, was destroyed in 1943, only the faintest impression of these pictures can be gleaned today from rare photographs and from bozzetti that exist for a few of the major works. Among these oil studies are at least two for the first commission, consisting of six pictures for the fourth chapel on the right side of the nave of the sanctuary, dedicated to the ninth-century Lombard saint, Bertarius. The influence of Giordano on these bozzetti is immediately recognizable in the glowing palette as well as in the highly charged compositions. This is not at all surprising, given the proximity of works by *Luca fa presto,* who had completed in a single year (1677) the decoration of the vault of the central nave of the immense abbey church, including five large bays, ten lunettes, twenty pendentives, and twenty window arches (Rusconi 1929, 52ff.). The as yet ever-recurring adherence to Solimenesque tradition is more apparent in the five pictures De Mura produced in 1735 for the chapter room, which complete the decoration of Paolo de Matteis, who had provided the same number of works in 1709 (Rusconi 1929, 82). When juxtaposed with the Giordanesque works of De Matteis, a painting like De Mura's *Rebecca and Eliezer* (fig. 29) seems far grander and more classical; nevertheless, it is, equally, more dynamic than Solimena's characteristic if somewhat earlier (1700) version of the same subject, to which it bears a general resemblance, especially in the figure of Rebecca. There is every reason to suggest that De Mura frequently transposed and synthesized stylistic traits of both Solimena and Giordano in the many other paintings he completed for Montecassino through the year 1738, among which were the lunettes in the chapel of the Angels, the altarpiece in the chapel of St. Carloman and the vault frescoes in the chapels of St. Gregory and St. Michael, to name only a few.

In terms of activity — in terms, that is, of the quantity of work he produced and the extent to which that work reflects the attainment of a style entirely his own — the years between 1738 and 1743 were the most significant of De Mura's career. At the outset the artist was employed by Carlo di Borbone, king of the Two Sicilies, on decorations in the royal palace at Naples. The most important of these was the monumental picture for the ceiling of what was known at the time as the second antichamber in the royal residence, depicting *The Glory of the Princes* (fig. 111). Executed, because of time pressures, in oil rather than fresco, this vast work of 1738 commemorates the marriage of Carlo to Maria Amalia of Saxony, which took place the same year. It represents the virtues of those two sovereigns, Carlo displaying the qualities of Fortitude, Justice, Magnanimity, and Clemency, while Maria Amalia is associated with Fidelity, Sublimity, Beauty, and Prudence. In the lower left portion of the picture an appropriate reference to the royal nuptials is made by the auxiliary scene of Hymen chasing away Calumny and Discord (De Dominici 1742–45, 3:698). De Mura did several preliminary oil sketches for this complex allegory as well as for the images of the *Four Seasons* and the *Four Parts of the World*

FIG. III. Francesco de Mura,
Bozzetto for *The Glory of the
Princes*, Pio Monte della
Misericordia, Naples

which completed the decoration of the room. These sketches, sent for official sanction to Charles's mother in Madrid, are much lighter and more graceful than the somewhat heavy and cluttered finished work in the Neapolitan palace, a fact which has been attributed to the intervention of the predominantly political-minded patrons at the Spanish court (Griseri 1962, 29ff.). Two studies for the ceiling are at the Pio Monte in Naples; in the center of each is a figure that reproduces almost exactly that of a woman leaning on a large medallion in another celebrated allegory, this one painted much earlier by Solimena for Louis XIV of France (Bologna 1958, fig. 119). The light palette and the overall arrangement of forms in these bozzetti, however, are liberated and airy and, according to Causa, display De Mura at his most mature (Causa 1970, 74).

In 1739 De Mura completed a large canvas depicting *The Young Christ among the Doctors in the Temple* for the chapter room of what was by this time a great treasure house of Neapolitan painting, the Certosa di San Martino (fig. 112). De Dominici describes the work as "one of the most beautiful painted by our Francesco, for the perfect composition as well as for the beauty, and the nobility of color which, with its sweet harmony, makes one miraculous accord of all" (De Dominici 1742–45, 3:697). The scene consists primarily of a crowd of agitated figures looming in the foreground, à la Preti, and culminates in the lovely, serene figure of Christ as a boy, seated at the upper right against a series of arches and columns which again recall the Veronese-inspired backdrops of Preti and, more specifically, the architectural configuration in Solimena's *Ratchis Becoming a Monk,* painted for the abbey at Montecassino. With its dynamic

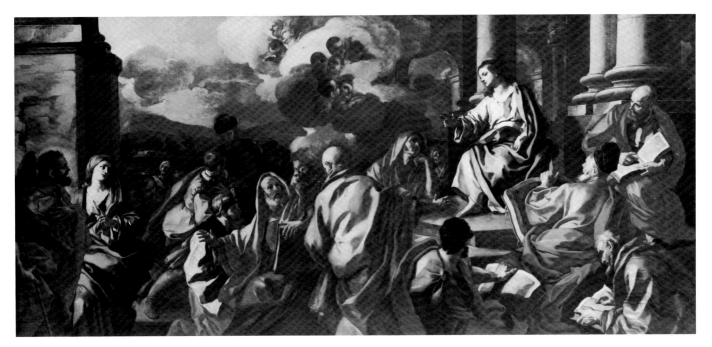

112. Francesco de Mura, *The Young Christ among the Doctors in the Temple*, Chapter Room, Certosa di San Martino, Naples

disposition of human forms towering in the immediate foreground, De Mura's Certosa picture is noticeably similar to several of the large frescoes he painted for the church of SS Severino e Sossio in Naples. The commission to redecorate the nave of this church, which had been nearly ruined by a succession of earthquakes, was one of the most important of De Mura's career and involved the execution of nine great scenes from the life of St. Benedict, the central work being a *Beatific Vision of St. Benedict* bearing the date 1740 (fig. 113). Along with these major frescoes were the usual accessory images of censer-bearing angels and the like. Today, despite their uneven state of conservation, it is still possible to appreciate these pictures for their grand operatic compositions as well as for their rich combinations of color — ranging from pale blue and green to rose to the deepest purples and grays and even black — nor is it difficult to believe De Dominici's description of the crowds of Neapolitan citizens who filled the church day after day in order to admire the newly ennobled vault (De Dominici 1742–45, 3:698).

In the summer of 1741, in the midst of frescoing the large cupola of San Giuseppe dei Ruffo, De Mura left Naples for Turin after repeated solicitations from the court of Charles Emmanuel III of Savoy, king of Sardinia. Charles Emmanuel had summoned noted architects, painters, and sculptors from all over Europe to build and embellish the royal edifices of his capital city, with the result that Turin became an extraordinary melting pot of mid-eighteenth-century culture. Though De Mura remained there only a year and a half, until the winter of 1743, the effect on him of his stay in the north was nothing short of epiphanic. In Turin the artist found that his instinctive preference for a lighter style of painting — a style both compositionally and

chromatically lighter than was typical of Solimena — was shared by a number of painters working in the same place at the same time, whose pictures provided him with vivid lessons in the contemporary taste for what has since come to be termed, however vaguely, the rococo (Griseri 1962).

During his eighteen months in Turin De Mura decorated six major ceilings in the royal palace; all of these dealt with classical subjects, and all reflected to some extent his daily encounters with various sophisticated manifestations of the international rococo style practiced by artists such as Claudio Francesco Beaumont, Corrado Giaquinto, Carle Vanloo, and others active in Turin or at least represented by major works there from the 1730s onward. The first of De Mura's ceiling paintings were the fresco of the *Deeds of Theseus* for the Sala delle Macchine and the *Stories from the Life of Achilles,* done in oil for the Gabinetto delle Miniature and now almost irretrievably damaged. In both of these works, as well as in each of those which followed (the ceilings of the third, fourth, fifth, and sixth Camere degli Archivi, representing, respectively, the *Olympic Games,* the *Heroes Presented on Olympus,* a second group of *Scenes from the Life of Achilles,* and another of *Scenes from the Life of Theseus*), the novel element in De Mura's style, according to Andreina Griseri, "consists precisely in his composition, before a broad background of trees and rocks, of a scene filled with sacrificial altars . . . and distant blue waters and people gesturing boldly in silky white draperies and fully foreshortened, all of which assumes the value of a clear homage to the sentiments of the late Giordano" (Griseri 1962, 35ff.). Even more current, and closer at hand than Giordano, was the example of Corrado Giaquinto, from whose seven scenes of the *Story of Aeneas,* painted in Turin around 1733, De Mura would have been able to adapt fresh ideas concerning the dramatic gestures and poses of figures and, most important, a sense of the airy, Arcadian landscape background characteristic of much mid-settecento European painting. During his visit to Turin De Mura seems to have discovered, for the first time in his own work, the possibilities of the pastoral landscape. These he continued to explore throughout the rest of his career. Giaquinto is directly behind this new interest; even the types of trees, such as the large, feathery palms found in De Mura's pictures of the 1750s, have as their prototypes trees by Giaquinto in, for example, the two great pictures he painted for the church of Santa Teresa in Turin at about the same time De Mura was working in the Palazzo Reale (Griseri in Turin 1963, 2:76ff.; compare also cat. 44 in the present exhibition). Giaquinto is also one of the artists in Turin who most emphatically validates De Mura's predilection for a light palette, as does Beaumont, in a work such as his ceiling at the royal armory (ca. 1736–43) depicting yet another *Deeds of Aeneas,* which is similar to De Mura's palace ceilings in its blend of rococo and neoclassical stylistic tendencies, its rendition of luminous, billowing draperies, and its dynamic arrangement of heroic forms within an animated and seemingly infinite landscape setting.

De Mura's sojourn in Turin, though brief, was a brilliant success. While there, he painted portraits of several members of the royal family, including at least one of Charles Emmanuel himself, and numerous honors were conferred upon him (De Dominici 1742–45, 3:701). When he returned to Naples in January 1743 he brought with him royal commissions for works to be sent back to the court of Savoy when he had completed them in his studio. It was there that De Dominici saw five of these Turin-bound pictures, which he identified as allegorical representa-

FIG. 113. Francesco de Mura, *Beatific Vision of St. Benedict*, ceiling fresco, SS Severino e Sossio, Naples

tions of *Education, Power, Magnanimity, Nobility,* and *Maternal Love* (De Dominici 1742–45, 3:701). If the *Education* is in fact an allegory of Wisdom then it is more than likely that the first three of these pictures correspond to the three large decorative overdoors still to be seen in the Sala delle Macchine at the royal palace in Turin. The last image listed, that of *Maternal Love,* may be identified or in some way related to the beautiful rendition of the theme now at the Art Institute of Chicago (fig. 114; London 1971a, no. 14). Beginning with his Turin visit in the early 1740s and continuing through the 1750s if not well beyond, De Mura produced a great many of these allegories. They are invariably conceived as single, monumentalized female figures either seated among the attributes of, or in the act of displaying, the particular quality (see the *Maternal Love* in Chicago) or geographical region (see the *Asia,* from the early 1750s, done as part of a decorative ensemble for the Palazzo Chiablese in Turin), or whatever else (see the lovely Louvre *Allegory of the Arts,* 1755–60, fig. 115; Detroit 1981, 1, no. 37) they personify. This manner of pictorial allegorization may have been introduced to De Mura in Turin, by Beaumont for instance, in his representations of *The Continents* in the Palazzo Reale; it may also have been influenced by similar works De Mura could have seen on his way to or from the northern capital, specifically by the allegories of Donato Creti in Bologna, painted much earlier in the century, with which certain of the Neapolitan artist's works possess striking affinities. Indeed, as my research continues, it becomes possible to speculate on a possible stay by De Mura in Bologna en route to Turin. In any event one thing is now clear, and that is the artist's interest in Bolognese art.

Aside from painting allegorical pictures destined for luxurious dwellings, De Mura continued to receive major commissions from the larger religious institutions in and around Naples. Having completed the cupola of San Giuseppe dei Ruffo immediately upon his return from Turin, the artist undertook several important works for the great Neapolitan church of Santa Chiara, including a vast picture for the high altar above the tomb of Robert of Anjou, *The Holy Eucharist Adored by Santa Chiara and Other Franciscan Saints,* executed between 1746 and 1748 and destroyed, like so much of the city's cultural legacy, during the bombings of the early 1940s (Rizzo 1980, 31, fig. 4). In 1750 the artist sent two enormous altarpieces to the church of the Annunziata in Capua; there are bozzetti for these pictures, a *Visitation* and a *Last Supper,* at the Pio Monte della Misericordia (Causa 1970, 114–15, pl. XLIV, fig. 43). Other works from this period include the overdoor for SS Severino e Sossio, representing *Christ and the Magdalen in the House of the Pharisee* (1745–46), and the *Penitent Magdalen* (fig. 116) and *St. Paul the Hermit,* both of the latter also at the Pio Monte. These last two works, with their emphases on design and the representation of the monumentalized human figure in a straightforward and uncluttered setting, have been dated by Causa to sometime around 1750, based upon the "extreme academic finish of the style" which, Causa feels, is in some degree due to De Mura's encounter in Turin with formalizing works by Beaumont and others (Causa 1970, 76, 114). These pictures also suggest a restrained reassertion of, or at least allusion to, the more formal style of Solimena, who had died in 1747, though they are no longer to be mistaken for the works of the revered master.

In 1751, at the height of his fame and creative powers, De Mura returned to the Nunziatella a Pizzofalcone, where he had transfigured the apse with his *Adoration of the Magi* nearly twenty

FIG. 114. Francesco de Mura, *Allegory of Charity (Maternal Love)*, Art Institute of Chicago, Illinois

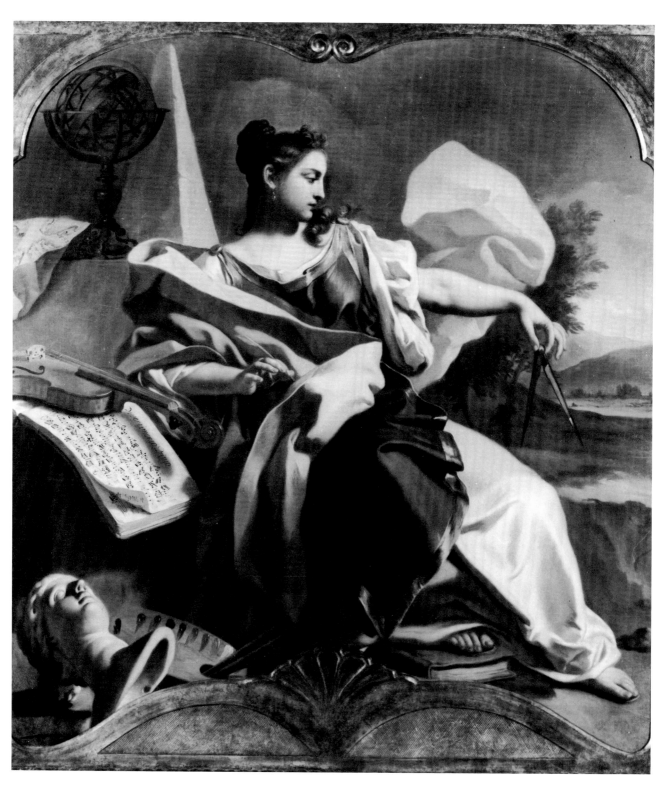

FIG. 115. Francesco de Mura, *Allegory of the Arts*, Louvre

Francesco de Mura

FIG. 116. Francesco de Mura, *Penitent Magdalen*, Pio Monte della Misericordia, Naples

years before, and where now he was employed to paint the vault of the nave. The decoration consists of a large ovoid fresco depicting the *Assumption of the Virgin* (fig. 117) flanked on either side by three single-figure female allegories of the Virtues — the four corner images in grisaille, the two intermediate images in color — along with a host of symmetrically arranged subsidiary frescoes, the majority of which portray putti, in groups or alone, in playful or prayerful attitudes. This ceiling, rarely seen by modern visitors to Naples, survives as a monument to De Mura's amazing virtuosity on a grand scale. The great *Assumption* represents a veritable explosion of the vault upward into the pale azure infinity of heaven. While the basic compositional framework of earlier renditions of the subject, by both Solimena and De Mura (see fig. 77 and cat. 36), recurs here, the dynamism has now reached its limits. No two figures move in the same direction; rather, all seem to collide with or repel one another contrapuntally in a magnificent dance of monumental, magnetically charged human forms. Near the center the Virgin rises to meet her son, each throwing one arm outward to form a kind of asymmetrical human chalice or monstrance above which gracefully undulates the aged figure of God the Father encompassing the dove of the Holy Ghost. All of the figures quiver with light, their draperies in silvery shades of rose, pale blue, violet, and green tending to snow white in the highlights. This vividly

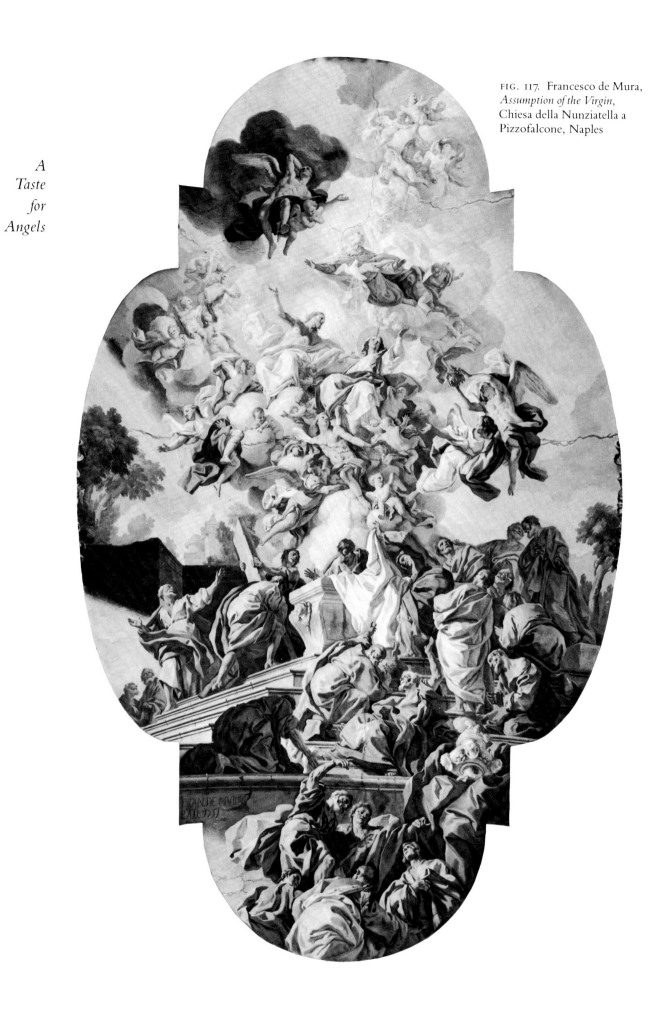

FIG. 117. Francesco de Mura,
Assumption of the Virgin,
Chiesa della Nunziatella a
Pizzofalcone, Naples

FIG. 118. Francesco de Mura, *Annunciation*, Certosa di San Martino, Naples

projected, electric luminosity pervades as well the allegorical figures in their ornate trompe l'oeil niches, not only the *Charity* swathed in pink and the *Faith* in blue, but also the *Divine Wisdom, Justice, Liberality,* and *Goodness* painted in monochrome. This is the masterpiece of De Mura's career, and one of the wonders of eighteenth-century Neapolitan painting.

Noticeable throughout the vault decoration of the Nunziatella is a relatively new or revived tendency in the art of De Mura toward greater solidity of form, a tendency that develops during the 1750s and which has been identified rather misleadingly as a neo- or protoclassical trend (Griseri 1963, 91; Rizzo 1980, 35). It is true that in works such as the *Annunciation* (fig. 118) and the *Visitation,* painted in 1757 along with an *Assumption* for a chapel in the Certosa di San Martino, the massive forms are balanced and somewhat simplified, and consequently classiciz- ing, but this classicism is exceedingly elegant and has been brought to life by the rich, silvery palette of deep rose, yellow-gold, and blue for which De Mura was by this time widely esteemed. Likewise in the nine overdoors depicting the deeds of Achilles, Alexander, and Caesar, sent to Turin from Naples in 1758, it is clear that the influence on De Mura of Giaquinto's quintessentially rococo figures of the 1730s and 1740s has waned considerably since the former's return from the court of Savoy nearly fifteen years earlier. The figures in these ornamental pictures by De Mura have become proportionally larger and more solid than those populating his ceilings at the royal palace in Turin but their graceful, often attenuated poses, their luminous draperies, and the Arcadian landscape settings in which they are placed continue to reflect a sensibility that had been profoundly affected by the artist's encounters with the northern Italian rococo. It is necessary, therefore, to qualify any conclusions as to the increas- ingly classical nature of De Mura's later style.

FIG. 119. Francesco de Mura,
*A Woman of Arezzo Offering Her
Son to Blessed Paolo d'Arezzo and
Blessed Giovanni Marinone,*
SS Apostoli, Naples

While the degree to which De Mura's manner became more formal during the last two decades of his life is debatable, there is no question that the artist himself became more academic, at least in the sense that he entered into an affiliation with the Neapolitan Accademia di Belle Arti, founded in 1752. After executing a number of major works in the early 1760s, including three very large canvases for the high altar and crossing chapels of the church of the Annunziata in Naples (left chapel: *Martyrdom of St. Barbara;* right chapel: *Massacre of the Innocents;* high altar: *Annunciation;* all commissioned in 1760; see Galante 1985, 178n. 164) and a large *Allegory of Chastity* for the Sala di Primavera in the Royal Palace at Caserta (1764; Rizzo 1980, 38n. 27), De Mura was clearly enjoying the official fruits of public success, one of which was his appointment in 1766 as president of the Academy, a post he shared with Giuseppe Bonito, a painter of genre scenes and of figure pieces in the late style of Solimena (Detroit 1981, 1:82–83.). There seems to have been a great deal of interest on De Mura's part in the establishment and teaching of artistic principles during these years, principles which, if his own works of the period are to be taken as examples, evince a conservatism in their emphasis upon the traditions of Neapolitan painting, alluding even to artists of the early seicento (e.g., the *Angelo custode* of ca. 1765 formerly in San Lorenzo Maggiore, or the *Penitent Magdalen* in San Pietro ad Aram, ca. 1770; both in Rizzo 1980, 38). With respect to his teaching De Mura's studio had long been a popular one, virtually all of the major Neapolitan artists of the late settecento having

spent some time with him. Among these pupils were Pietro Bardellino, Jacopo Cestaro, Giacinto Diano, Michele Foschini, Domenico Mondo, and the Ischian painter Alfonso di Spigna. Many of these artists continued to draw upon or invoke De Mura in their work right up to the end of the century (Rizzo 1980, 37–38).

Though De Mura relinquished the directorship of the Neapolitan Accademia in 1770 at the age of 74, his own atelier continued to function, completing several more commissions before the artist's death in 1782. It has been suggested, perhaps a little too casually, that one reason for the noticeable decline in the quality of De Mura's work during the last fifteen years of his life, aside from the obvious fact of his old age, was the excessive involvement in his work of less talented disciples. It is necessary, however, to define the nature of this change or decline. Many examples of the artist's late style are still to be found in the important churches for which they were originally painted, such as San Nicola alla Carità, where De Mura returned to decorate the chapel of San Liborio with three canvases of 1773 (Rizzo 1978, 110–11n. 22) and the Carmine Maggiore, where his altarpiece of *Sant'Andrea Corsini,* painted in the mid-1770s (see Galante 1985, 20n. 17) holds its own among the Solimenas that occupy several nearby chapels. Representative of this final phase of De Mura's career might be the large canvas in the chapel of the Blessed Paolo Burati at the church of the SS Apostoli depicting *A Woman of Arezzo Offering Her Son to Blessed Paolo d'Arezzo and Blessed Giovanni Marinone,* datable to ca. 1775 (fig. 119; Galante 1985, 43). Here the colors are classical, bright red, pale blue, and gold, but the entire work has taken on a silvery softness that is unlike the cool brilliance of the 1750s and which, in the figure of the woman at least, has affinities with late seventeenth-century French portraiture. There is undeniably a slight woodenness in the composition, above all in the disposition of the angels, but the countenances are, throughout, as lovely as ever.

Aside from the pictures for Neapolitan churches and private dwellings a large number of works were sent from De Mura's studio to provincial churches in Campania and Apulia during the last years of his life. On the whole these confirm the suggestion of a latent conservatism, alluding compositionally to the works of Giordano and Solimena and especially to De Mura's own earlier productions, while retaining to some extent the luminous palette which was his trademark. More thorough examination of these later pictures is currently under way and this will certainly result in a clearer assessment of their qualities; in the meantime it is fair to say that they represent a sophisticated, less innovative but still highly spirited finale to the long, brilliant career of an outstanding eighteenth-century artist.

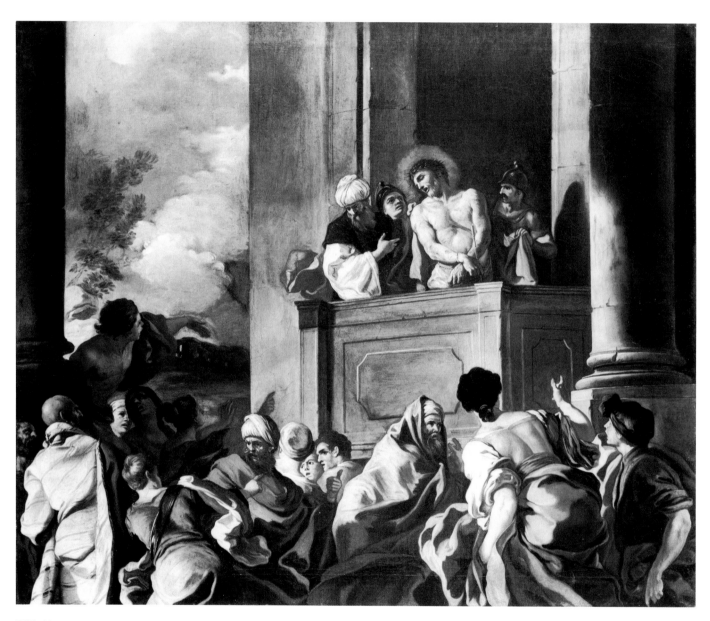

CAT. 33

33 *Ecce Homo*

62.2 x 74.9 cm (24½ x 29½ in)

PROVENANCE: John Levy Galleries, New York, 1951

EXHIBITION: Columbus Gallery of Fine Arts, Ohio, before 1954

LITERATURE: Bob Jones 1954, 84ff. (as Solimena); Bob Jones 1962, 1:161 (as Solimena); Naples 1980, 102; Raleigh 1984, no. 26; Bob Jones 1984, 80, no. 81.1; Spinosa 1986, 156, no. 239, and fig. 284

Bob Jones University

*De Mura
Paintings
Cats. 33–38*

Spinosa has identified this as a bozzetto for a painting in the Collegiata dell'Assunta at Castel-disangro, Isernia (Abruzzi), which is documented to 1725–27 (Naples 1980, no. 53, erroneously located at Oberlin). Before that, the present work had been given to Solimena or described, by Longhi (letter, registrar's files, Bob Jones University Collection), as an eighteenth-century copy after De Mura by another Neapolitan artist, perhaps Bonito. The Collegiata possesses a pendant, *Christ and St. Veronica,* also by De Mura, and works by Paolo de Matteis and Domenico Antonio Vaccaro that formed part of the same program. The bozzetto for the *Christ and St. Veronica,* which is the same size as the Bob Jones painting, is now in the Molinari Pradelli Collection, Marano di Castenaso.

As is often the case with Neapolitan versions of this scene (for instance, that by Luca Giordano, fig. 45), Pilate and Christ, with guards, are on an upper balcony with a varied crowd below. The purple robe that Christ wore (John 19:4–5; it is red in the painting) along with his crown of thorns, has been removed, as if Pilate's cry, "Behold the Man!" were a command to reveal, one last time, the physical body of Christ that constitutes the central sign of the Incarnation. The colorful priests and elders below, gesticulating and gazing searchingly at each other in discussion at this sight, will cry out, "Crucify him, crucify him!" It is a common subject in our period but was unknown to Early Christian, Byzantine, and trecento art (Réau 1955–59, 2, pt. 2, s.v. "Le Procès"). Many of the types in the scene are Solimenesque — the massive maiden in the right foreground, for example, in gold bodice and russet skirt who has turned from us and points to the bloodless figure on the balcony. But she and other Solimenisms in the scene are rendered with a morning clarity of light and abundance of local color that are fully of the eighteenth century and are foreign to the older master's style. One may also set down as De Muresque the simplified, almost schematic architecture, a far cry from the sumptuous exteriors in which Solimena specialized (cat. 26). Finally the concave grouping of the priests and elders, dipping down toward the center in a *V,* and the emphasis on turned backs seem individual to De Mura himself. For all its vigor it hasn't Solimena's almost angry power. GH / DN

271

34 *St. Carloman Dons the Benedictine Habit*

60.4 x 46.3 cm (23⅞ x 18¼ in)

Private Collection, New York

The tonality of the scene is warm, though there are no very bright colors. In the center the young saint kneels as the Benedictine habit is presented to him by the Pope and a group of ecclesiastics. St. Carloman, a monk of Montecassino, was born in ca. 715. He was the son of Charles Martel, king of the Franks, and the brother of Pépin le Bref. In 741 he inherited a part of his father's kingdom and during his rule reformed relations with the Church. His membership in the Benedictines began in 747 when, at Rome, he was granted the habit by Pope St. Zacharias. Subsequently he retired to Montecassino where he occupied himself with the humblest tasks, though on one or two occasions he traveled north on ecclesiastical missions. His remains are enshrined in the chapel at Montecassino for the altarpiece of which this bozzetto was made. The altarpiece was destroyed by the bombing in World War II (see essay by Robert Enggass, above).

As Enggass notes, Francesco de Mura continued the work of his master, Solimena, at Montecassino. This began in March 1731 and extended through the decade. More than thirty oil paintings and frescoes were finally produced (Ceci 1933, 43ff.; Caravita 1869–70, 3:456ff.). All were destroyed by Allied bombing. The New York picture is one of the few surviving bozzetti. In the present work we see De Mura still under Solimena's spell. He retains the black-edged solemnity of the older master, the complex overlapped groupings of figures, and the vivid brushwork. The wayward cloud-borne putti, themselves like confections of tawny cloud, and whose abandonment contrasts with the dreaming piety of the main scene, are typical Solimenesque touches. The wavy facture of hair and drapery are particularly reminiscent. Thus if the the large *Rebecca and Eliezer* for the monastery's chapter hall is, as Enggass says, like a scene from an eighteenth-century opera (fig. 29), the present work is more involved, intense, and liturgical, and represents the artist's earlier mode. GH

35 *Apotheosis of Sculpture*

160.6 x 100 cm (63¼ x 39⅓ in)

PROVENANCE: Sir H. W. Duff-Gordon; David M. Koetser

EXHIBITION: Baltimore 1959, no. 198, repr.

Museo de Arte de Ponce (Fundación Luis A. Ferré) 61.0202

The female personification of sculpture stands to the left, grasping her maul in one hand and chisel in the other, swathed in abundant blue, olive green, and white, and wearing a brilliant scarlet bodice. Immediately behind her a *guglia,* or curved free-standing obelisk — a characteristic type of Neapolitan memorial — curves upward. Cesare Ripa, the iconographer, describes

CAT. 34

Sculpture as a beautiful young woman, simply coiffed, negligently draped, and with a wreath of laurel on her head. She should hold instruments of her trade. In De Mura's painting, behind sculpture, on the left, is a palace with a trumpet-blowing putto above an elderly male god collapsing to the ground: Time vanquished by Fame. This too may reflect Ripa: "[Sculpture] lives against the malignity of time." The evergreen laurel, which in De Mura's painting crowns not Sculpture herself but the monument behind her, stands for the related fact that sculpture retains its freshness forever. The guglia would have the same intimations of immortality. Three geese flutter around the commanding seated female in the right foreground, clad in a rich red mantle and armor, who faces toward Sculpture and gestures towards her with a pointed finger. She is Ripa's *Guardia,* the allegory of vigilance. As Guardia's companions Ripa mentions the geese that Livy describes as giving the alarm to the sleeping Romans (the recumbent males on the left) on the Campidoglio whose cackling and flutter warned of an impending invasion of Rome (Ripa 1611, 210).

Twisting up into the sky, borne by a column of clouds and putti, is a basket of red and white roses that two figures of the Hours offer to Aurora in her chariot. As specified by Ripa Aurora is dressed in the tints of rose and gold, *rosa* and *aura* being tropes of her name, and she wears thin, revealing clothes, the colors of the dawn, her arms and knee revealed (Ripa 1611, 68). Her wings symbolize the speed with which she spreads forth the sun's rays. Also in accordance with Ripa's specifications, she has a crown of roses (being brought to her by Hours above her) and a lighted torch in her hand. Her chariot's horses, multicolored like the changes of skycolor that accompany the dawn, are led by Amor. As her chariot flies across the right-hand upper side of the picture she herself has turned in her seat to pay homage to the yet higher figure, Apollo, enthroned in a chariot on the upper left, almost lost in a golden haze. Thus does dawn precede and pay homage to the sun of the full day.

The allegory, then, is not a mere celebration of sculpture but places that art in the context of the ever-returning cycle of time. As Time on the left is defeated by Fame, the new day, on the right and above, dawns. And the new day's cynosure, Apollo, is also of course the god of the arts.

The composition and its iconography are close in feeling to those used by Girolamo Starace in the allegorical ceilings of the Royal Palace at Caserta — especially the entrance-hall fresco of *The Triumph of Apollo* (Hersey 1983, 196ff.). One should also mention Giaquinto's *Bacchus and Apollo* in the Hall of Columns, Palacio Real, Madrid (1759–60). But these are all later than De Mura's work, and in any case derive equally from De Mura's own allegorical frescoes at the Palazzo Reale, Naples, dating from 1738 on (see David Nolta's biographical essay above). The lightness of the palette, the preference for pastel colors, and the general barocchetto air suggest De Mura's current movement away from Solimena toward the newer art of his colleagues at Turin where, in the early 1740s, he was to paint similar scenes that were set alongside works by Claudio Francesco Beaumont and Giaquinto. Yet the figures of Sculpture and Guardia, in their massiveness and authority, still derive from Solimena. The Aurora, meanwhile, is lifted entire from Solimena's Getty *Tithonus Dazzled by Aurora* of 1708 (cat. 24), which De Mura copied on another occasion. Because of all this Solimenism I would date the Ponce picture in the late

CAT. 35

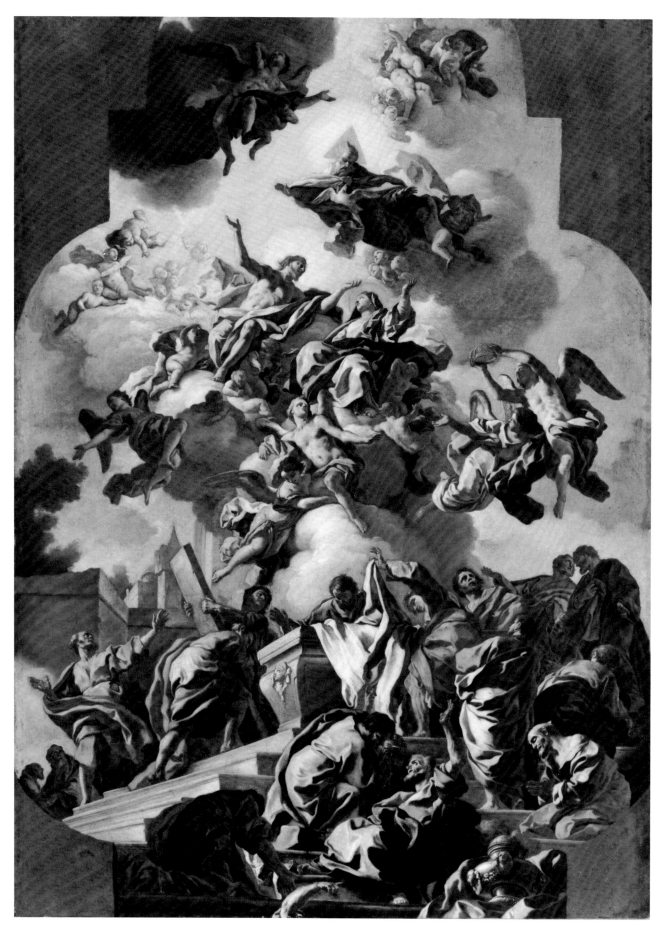

CAT. 36

1730s, before Turin. It could be the bozzetto for a scheme of allegories for some princely palace or villa in or near Naples.

But let us finally note that the device of the allegorical figure in front of an obelisk is also the central idea of De Mura's *Glory of the Princes* in the Palazzo Reale, Naples (Causa 1970, 110). The Ponce bozzetto (or ricordo) could therefore reflect a preliminary proposal for this program. It should be noted, therefore, that this program is entitled *Glory of the Princes,* one of Ripa's iconographies (Ripa 1611, 204ff.). Here as in Ripa's Glory of the Princes a female grasps an obelisk or tower just as does De Mura's. The structure symbolizes the great works that princes undertake — and the presence of a similar obelisk in the Ponce painting (rather than the work of sculpture specified by Ripa) could mean that here Sculpture appears as the creator of great works built by princes, works that survive time into a new day, that last forever. GH

36 *The Assumption of the Virgin*

130.2 x 104.1 cm (51¼ x 41 in)

PROVENANCE: Mrs. A. Ashton, Sotheby's, London, February 1950, lot 30 (as Preti); Colnaghi, London

EXHIBITION: Toronto 1981–82, 85, no. 101

LITERATURE: Toronto 1954, no. 23; *Art Gallery of Toronto: Painting and Sculpture,* Toronto, 1959, 13, repr.; Enggass 1964, 139, fig. 8; *Art Gallery of Ontario: Handbook,* Toronto, 1974, 56, repr.

Collection Art Gallery of Ontario, Purchase 1951 51/8

In 1751 De Mura was commissioned by the Jesuits in Naples to decorate the nave vault of the little Sanfelice church known as the Nunziatella a Pizzofalcone, which was then a seat of the novitiates of the order and today forms part of a military school. De Mura had frescoed the apse of the church with an *Adoration of the Magi* nearly twenty years before (fig. 110). His return, at the height of his maturity and creative powers, resulted in one of the great achievements of his career. The Ontario canvas is a version of the central scene of the frescoed vault, depicting the *Assumption of the Virgin,* the original of which, along with its subsidiary images and scenes, is discussed in detail above in the artist's biography (fig. 117).

While the precise relation of this picture to the fresco has long been debated, a majority of recent scholars are agreed that it is a good workshop copy of the original, frequently-published preparatory sketch for the finished work, now at Capodimonte (Causa 1957, 62; Naples 1980, 106, no. 58; Galante 1985, 252, and 260–61n. 48). Except that in the Ontario picture the image has been cut off above and below, the two canvases are nearly identical, though they both differ from the fresco in various ways. For example, in the Nunziatella ceiling, the Virgin looks outward and upward, while in the easel versions she looks into the face of Christ. Furthermore, in keeping with their smaller size, the Capodimonte and Ontario pictures seem somewhat simpler than the fresco; there are, for instance, fewer angels between the empty sarcophagus and the rising figures of mother and son in the two canvases, and the trees which appear beyond

the Apostles on the far right in the fresco have no equivalent in the smaller works. The Toronto picture is nevertheless an excellent representation of De Mura's masterpiece and as such maintains a special place among Neapolitan paintings in North America.

A number of interesting issues are raised by this picture, if in fact it is a replica of a bozzetto for a fresco. Above all it provides an example of the dissemination of an artist's treatment of a specific theme at a particular stage in his developing concept of that theme. De Mura, as one might expect of an eighteenth-century Italian painter, had been dealing with the subject of the Assumption for years, since the fresco in the sacristy at the church of the Annunziata in Airola ca. 1727 (fig. 109; a bozzetto for which, in the Pio Monte della Misericordia, was mistakenly identified by Causa as a study for the Nunziatella ceiling: see Naples 1980, 106). It is difficult not to perceive or interpret the series of De Mura's *Assumptions* as a gradual working out or development of an ideal image culminating in the Nunziatella fresco. The reproduction of a highly finished study for this definitive project, whether it is autograph or the work of studio assistants, whether it predates or postdates the actual fresco itself, is not unlike the sculptor's repeated casting, after various trials in terracotta or clay, of a successful idea in bronze.

Perhaps the most interesting thing concerning the provenance of the picture is the fact that it was sold in 1950 as the work of Mattia Preti, a misattribution which says a great deal about the progress that has been made during the last thirty years. DN

37 *Christ and the Woman of Samaria*

104.2 x 156.3 cm (41 x 61½ in); signed and dated, verso: "Franciscus de Muro Pingebat anno 1752"

PROVENANCE: Private Collection, Rome; Hazlitt Gallery, London, Jack Baer, owner; M. Knoedler & Co., Inc., New York

EXHIBITIONS: Chicago 1970, 234, no. 99; *European and American Paintings from the Seattle Art Museum Collection*, Bellevue Art Museum, Washington, Nov. 1975

LITERATURE: Wilson P. Boyd, *Christian Science Monitor*, June 25, 1971, 10

Seattle Art Museum, Gift of Dr. and Mrs. Richard E. Fuller 68.186

This picture illustrates the sequence of compelling and highly significant events which forms the greater part of the fourth chapter of the Gospel according to John. On his way from Judea to Galilee, Christ stopped in the city of Sychar in Samaria, a land whose inhabitants had long been at odds with the Jews. Wearied by his journey, Jesus sat down in the heat of the noontime sun beside the well of Jacob, where the following dialogue occurred:

There came a woman of Samaria to draw water. Jesus said to her, "Give me a drink." For his disciples had gone away into the city to buy food. The Samaritan woman said to him, "How is it that you, a Jew, ask a drink of me, a woman of Samaria?" For Jews have no dealings with Samaritans. Jesus answered her, "If you knew the gift of God, and who it is that is saying to you, "Give me a drink," you would have asked him, and he would have given you living water." The woman said to him, "Sir, you have nothing to draw with, and the well is deep; where do you get that living water? Are you greater than our father Jacob, who

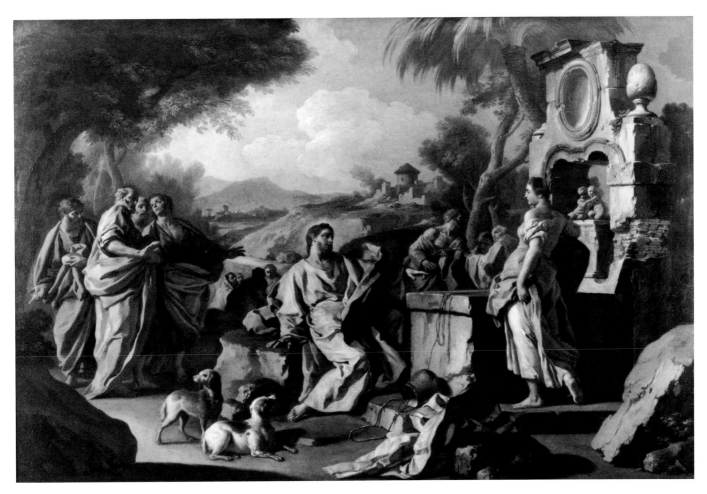

CAT. 37

FIG. 120. Francesco de Mura,
Christ and the Woman of Samaria,
Chapter House, Montecassino.
Destroyed 1944

gave us the well, and drank from it himself, and his sons, and his cattle?" Jesus said to her, "Everyone who drinks of this water will thirst again, but whoever drinks of the water that I shall give him will become in him a spring of water welling up to eternal life." The woman said to him, "Sir, give me this water, that I may not thirst, nor come here to draw" (John 4:7–15).

As this exchange continues Christ makes clear his omniscience by telling the Samaritan the facts of her own life (she has had five husbands, and the man she lives with now is not her true spouse), and proceeds to a brief summary of the controversy between her people and the Jews. The discussion concludes with a frank and profound disclosure: "The woman said to him, 'I know that Messiah is coming (he who is called Christ); when he comes, he will show us all things.' Jesus said to her, 'I who speak to you am he'" (John 4:25–26).

In this painting, with its graceful, balletic compostion, its muted pastel tonalities, and its overall porcelain finish, De Mura successfully translates into visual terms a disarmingly human yet poetic and revelatory conversation between a woman and God. He includes the entire episode. In the center Christ is shown as though collapsing from weakness against the massive gray rocks before the well. He is wearing a pink robe, thinly painted, with glazes of deep vermilion in the shadows, and a powder-blue cloak which cascades behind him and over his left arm. Facing him is the woman, whose raiment seems worldly if not luxurious in comparison to that of the thirsty traveler who addresses her. The white sleeve of her blouse falls over her bare shoulder as she stands with one foot planted firmly on the ground and gathers up in her

left hand the golden skirt lined in pale blue. On her head is a coral red cap of the type worn by women in numerous pictures by Solimena and De Mura. Her upright bearing is gracefully, even sensuously, bowed and provides a perfect visual counterpart to the concave attitude of Christ. The conversation between them is denoted by his extended left arm; this gesture, a convention in images of Christ and the woman of Samaria which appears as early as the sixth century, in the Byzantine mosaics of Sant'Apollinare Nuovo in Ravenna (Schiller 1972, 1:159ff., pl. 432), seems to indicate or involve the well, suggesting that the precise moment depicted here is early on in the dialogue, and may even be Christ's opening request for a drink. According to the evangelist, however, the disciples do not arrive until immediately after Christ's revelation that he is the Messiah, at the climactic close of the conversation. Shown in a group on the left, these men, draped in voluminous garments of gray-violet, turquoise, and dusty rose, marvel at their master's discoursing with a woman, and a Samaritan woman at that. One of these disciples, the one with his hand across his chest (another traditional figure in depictions of this story, with ancient prototypes [Schiller 1972, 1, pls. 432, 453]), is holding a loaf of bread, a pictorial reference to nourishment that forms the subject of the subsequent discussion complementing that on the water of life. De Mura has clearly conflated the lengthy Gospel narrative into a single scene rich in expression and incident, played out against a landscape backdrop of olive-green trees and gray-blue skies resembling more closely perhaps the hilly Campanian countryside than the land about Mount Gerizim in the Middle East. The picture is filled with lovely passages and details, from the meticulously rendered masonry of the well — an impressive, vaguely Hellenistic, semiruined structure with a central arch occupied by a pair of carved putti clasped in each other's arms — to the brace of noble and alert dogs at the lower left, to the large, heavily impastoed pearl drop dangling from the ear of the entranced Samaritana.

This is not the first time De Mura has illustrated the story of Christ and the woman at the well. In 1735, the artist produced five large canvases for the chapter house in the abbey at Montecassino, to complement an equal number of pictures executed for the same space by Paolo de Matteis in 1709 (Rusconi 1929, 82). Among De Mura's works for this commission, now known only from photographs, was a *Christ and the Woman of Samaria* (fig. 120) as well as a representation of an Old Testament incident which is to some extent a prefiguration of the Gospel episode, and bears obvious iconographical resemblances to it, that of *Rebecca and Eliezer* (fig. 29). This story, recorded in Genesis 24:11–27, concerns the encounter between Rebecca and the servant of Abraham, who recognizes in her the future spouse of his master. Just as Rebecca at the well confronts and comes to accept, if by proxy, her suitor and the House of Israel, so the Samaritan woman, representing all Gentiles, finds a new, symbolic husband in Christ, who invites her to partake of the water of life that sanctifies and restores mankind. The juxtaposition of these scenes is not uncommon in Italy during the sixteenth and seventeenth centuries, a famous precedent being two works by Veronese which, coincidentally, formed part of a group of ten pictures; seven of these, including the *Christ and the Samaritan Woman,* are now in the Kunsthistorisches Museum, Vienna, while the *Rebecca at the Well* is in the National Gallery of Art, Washington.

A number of notable similarities exist between this picture and both scenes of well-side revelation at Montecassino. For example, the dress of the female figure is basically the same in

FIG. 121. Francesco Solimena, *Christ and the Woman of Samaria*, Pisani Collection, Naples

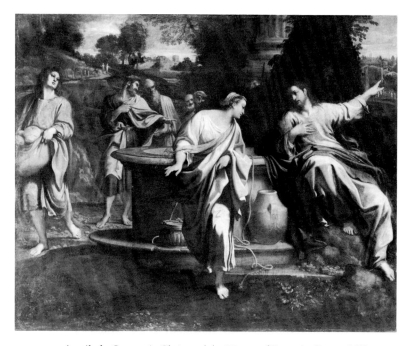

FIG. 122. Annibale Carracci, *Christ and the Woman of Samaria*, Brera, Milan

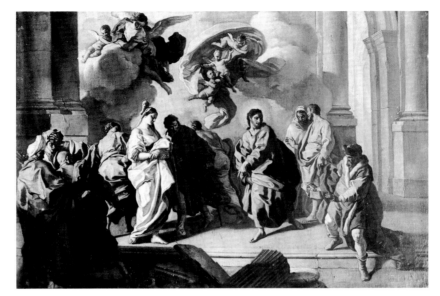

FIG. 123. Francesco de Mura, *Christ and the Woman Taken in Adultery*, formerly rector's apartments, Gesù Nuovo, Naples. Present whereabouts unknown

each, and, most striking of all, though reversed in the present picture, the pose of the Samaritan woman is identical to that of Rebecca in the earlier work. In terms of style, however, the Montecassino pictures are infinitely closer to the example of Solimena, whose own *Christ and the Woman of Samaria,* painted around 1730 and now in the Pisani Collection in Naples (fig. 121; Bologna 1966, no. 192), is far more static and classicizing than the present work. The exuberance of De Mura's picture is quite in keeping with the date of 1752 inscribed on its back. Here are the same apostles whirling and gesticulating only slightly less frantically than they do in the grandly conceived and choreographed *Assumption* on the ceiling of the Nunziatella, painted during the previous year. One possible source for this lively interpretation of Christ's meeting with the Samaritan woman is a version of the same subject by Annibale Carracci, executed as an overdoor for the Palazzo Sampieri in Bologna (fig. 122; Posner 1971, no. 77). Far from identical, the work by Carracci nevertheless shares with that of De Mura the elegant dancelike movements of the primary figures and the eloquent spirit of communion between Christ and the woman. Such an affinity between the eighteenth-century Neapolitan artist and his sixteenth and seventeenth-century Bolognese forebears can be found in other works (see De Mura biography), and lends credence to the speculation concerning De Mura's possible stay in the northern city on his way to or from Turin in the early 1740s.

A very close copy of this work by an unknown artist, faithful even down to the configuration of lichen-filled cracks in the well, was presumably once in Naples and is now lost (Archivio Fotografico della Soprintendenza alle Gallerie, no. 34701). Also at Capodimonte is a photograph (fig. 123) of a pendant to the *Woman of Samaria,* depicting *Christ and the Woman Taken in Adultery,* of the same dimensions as our Seattle picture. The present whereabouts of this latter picture are currently being traced. DN

38 *Bacchus and Ceres*

208 x 154.8 cm (81¾ x 60¾ in)

PROVENANCE: Private Collection, Germany; Heim Gallery, London, 1971

EXHIBITION: London 1971a, no. 131

LITERATURE: Spinosa 1986, 164, no. 266, fig. 319

The Snite Museum of Art, University of Notre Dame. Purchased with funds provided by Mr. Lewis J. Ruskin 72.2

This is a subtle and eloquent work, an understated vision of divine intimacy and a clear but soft-spoken allusion to the Arcadia of contemporary Italian poetry (Giannantonio 1962). As with most pastoral works, both literary and pictorial, the overall impression is more decorative than dramatic, and the accent is not so much on activity as it is on technical grace and harmony of forms. The palette, too, seems to be all in one key; like the psychological tone of the picture it is warm but restrained and ideally suited to the tranquil composition, a smoothly ascending S-curve of five figures in a wooded landscape setting. Within the limited spatial framework they occupy, these figures are fully modeled, even robust, and in this as well as in their general facial features they are reminiscent of Solimena during certain of his more classicizing phases (e.g., 1705–15). This is especially true of Ceres, goddess of grain and the earth, who is shown seated on a puff of rose-colored cloud at right against a sky of brilliant aquamarine. She wears a loosely fitting, lustrous white gown and a voluminous orange mantle billowing behind her and draped over her right arm, which is extended as though to reach for, or perhaps to brush aside, the sheaf of golden wheat borne by the cherub attendant hovering on diaphanous, delicately tinted wings nearby. The head of the goddess is seen in profile, her dark-eyed gaze directed toward the upturned face of the youthful Bacchus who lounges languidly if precariously on the gray rocks below. The nude body of the wine god, soft and curvaceous with ripples of tan flesh and slightly sagging musculature, is separated from the stones by a bright red cloth wrapped about and falling from his left arm; there is also a large pentimento on this cloth behind him to his right. His burly, rubiginous legs, one bent inward at the knee and dramatically foreshortened, the other partially swathed in a light olive fabric covering his loins, are positioned as though to brace or balance the swaying torso, while in his hands he raises an earthenware bowl of red wine to the goddess. The flushed and glassy countenance of Bacchus, crowned with the usual clusters of grapes and grape leaves, lolls backward, his glazed expression one of benumbed sensibility in the bonds of admiring rapture. The details of his head are particularly fine, as, for example, the hint of beard on his cheeks and chin. All in all, he presents a memorable study of early manhood in the first stages of debauchery.

In the right foreground a ruddy child satyr with pointed ears rests his hand upon the paw of a benign and very beautifully rendered leopard, the customary companion of Dionysus; both the animal and the half-animal are engrossed by the silent interchange taking place between the deities. A truly eighteenth-century tree with soft gray-brown trunk and branches and feathery yellow-green leaves suggests a sequestered bower and seals off the idyllic scene on the left. As

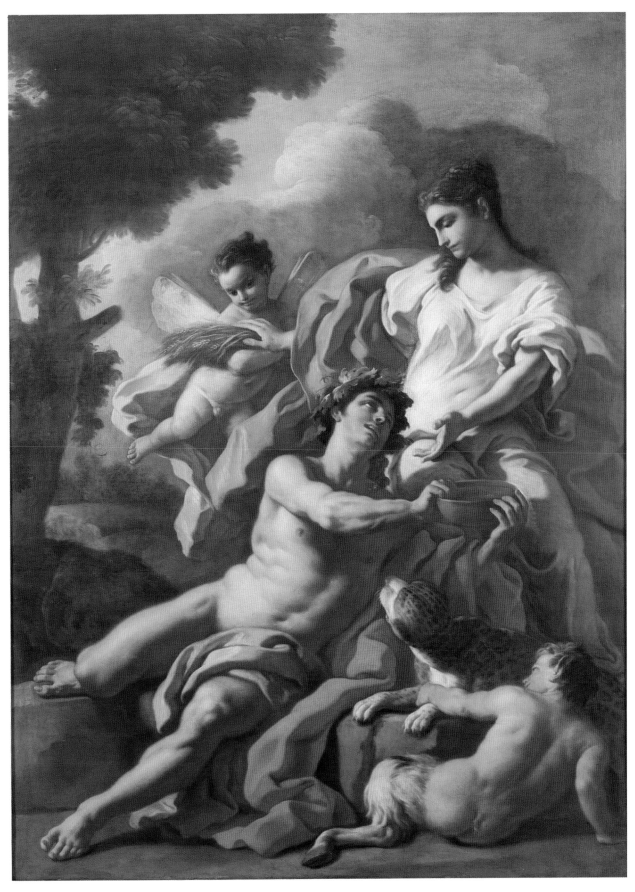

CAT. 38

befits a picture in which the inebriated Bacchus plays a major role, the predominant mood is one of languor and ease.

There are several reasons for linking Bacchus and Ceres pictorially. In antiquity the divinities of wine and grain were frequently associated, literally or figuratively. An actual familial link between the two can be found in the legend, recorded by Diodorus of Sicily and others, that Demeter, or Ceres as she was known to the Romans, was the mother of Dionysus, or Bacchus (Diodorus 1935, 287). There is perhaps a hint in the painting by De Mura that the relationship depicted is one shared by a temperate and dignified mother and her somewhat less mature and certainly less sober son, but this is hardly insisted upon. Various less specific but still literal conjunctions of the two gods occur in the works of other classical authors, such as Pindar (1947, 145), but by far the most numerous connections between Bacchus and Ceres are metaphorical (Hanfmann 1951, nos. 109, 123). For instance, the two most commonly meet as personifications of the seasons, Ceres as Summer and Bacchus as Autumn, an identification that seems to derive originally from Lucretius (1929, 178), and which is reiterated by myriad writers through the eighteenth century.

But it is rarer to see them as a pair in a single scene. Perhaps the most famous Renaissance example of such a pairing is the lunette fresco of *Summer and Autumn* by Veronese at the Villa Barbaro, Maser. Among the more interesting baroque works that link Bacchus and Ceres as seasonal personifications is an *Allegory of Summer and Autumn* by the Roman artist Luigi Garzi in the Galleria Spada, Rome, and a picture by Sebastiano Ricci of ca. 1710 now in the Fitzwilliam Museum, Cambridge. The former of these works, like the Veronese fresco, has a pendant *Winter and Spring,* which introduces the possibility that De Mura's work was originally one of a pair of allegories.

But the most promising key to the picture's meaning lies in Ripa's essay on Campania Felix (Ripa 1611, 281). Campania, the province of which Naples is the capital, had always been famous for its fertility equal in the production of wine and grain: hence, says Ripa, Bacchus and Ceres should represent the region as equals in abundance, or even gently but endlessly striving with each other for precedence; for no one, he remarks, will ever be able to decide which is better for mankind, bread or wine. Thus, too, in Euripides Tiresias says that Ceres and Bacchus are the things "first among humans" (*Bacchae* 266ff.; see also Ovid, *Met.* 6.157; Parini 1975, 173ff.). And there is of course the unmistakable opportunity to relate the pagan emblems to the bread and wine of the Christian eucharist (Bailey 1935, 151). Finally, in the *Georgics* of Virgil, who often uses the names of the gods to signify the forms of nourishment under their protection, a lengthy description of the Cerealia, or feast of Ceres, includes an admonition to the "country folk" to "worship Ceres; for her mingle the honeycomb with milk and mellow Bacchus" (Virgil 1960, 104ff.). Francesco de Mura's *Bacchus and Ceres* is very nearly a literal illustration of these lines; just as the Latin author verbally conflates the wine-offering with the god, so the Italian painter portrays the god in the act of offering to the goddess the substances with which he is synonymous.

More controversial than the iconographical interpretation of the work is the issue of dating and assimilating it into the broader context of De Mura's oeuvre, an issue that is further complicated by the fact that another version of the subject by the same artist was recently sold

by Colnaghi. The two pictures are by no means identical; in the Colnaghi canvas, Ceres is seated on the left in a light blue mantle, there are two satyrs rather than one sporting with a leopard before a still life of grapes and other fruit, and a somewhat less languid but more flaccid Bacchus is seated on the rocks facing the goddess. Despite these and other obvious discrepancies, the dimensions of the two paintings as well as the actions they depict — Ceres with her hand on the grain and Bacchus offering up the bowl — are virtually the same. The works are, moreover, sufficiently similar in style to warrant frequent scholarly reference to them as a pair (Naples 1979, 1:104). While there is no reason to suspect that two renditions of the same basic subject would originally have been intended to hang as pendants, it does seem probable that the pictures were executed at approximately the same time. The existence of two major paintings of this subject by De Mura strengthens the notion that the basic subject of both is Campania Felix, since this would have been an appropriate subject for any Neapolitan palace or villa.

Exactly when they were painted is a matter of considerable debate. Both the Notre Dame and the Colnaghi pictures have received dates ranging from the early 1730s to the mid-1760s. With the recent publications resulting from revived interest in De Mura, however, a clearer conception of his creative development can be formed, which allows a more precise and confident dating of both *Bacchus and Ceres* scenes. In the first place the 1730s seem highly unlikely. With the notable exception of the royal commissions later in this decade, De Mura does not seem to have been called upon to produce large-scale decorative works with mythological or allegorical themes until he was summoned to Turin in 1741 (De Dominici 1742–45, 3:692ff.). Nor do the figures of Bacchus and Ceres in either picture correspond to Spinosa's characterization of numerous allegorical personifications painted in the 1740s as being diaphanous, unreal "porcelain statuettes" (Spinosa 1975, 372). The portrayal of Ceres in the Colnaghi picture is very similar to that of Aurora in the bozzetti of *Aurora and Tithonus* now in the Pio Monte della Misericordia, Naples; Causa assigns these studies for a recently destroyed ceiling fresco in the Palazzo Reale to some time after 1744 (Causa 1970, 111–12). Perhaps the closest parallels can be drawn between the *Bacchus and Ceres* pictures and several allegories from the 1750s, such as the *Allegory of the Earth* in a private collection in Milan, which dates to shortly after De Mura's decoration of the vault of the Neapolitan church of the Nunziatella in 1751 (Spinosa 1975, 370). Finally, the female personification in the Louvre *Allegory of the Arts* (fig. 115), datable to the mid-1750s (Spinosa 1975, 368), appears to be identical to the goddess Ceres in our painting; such a coincidence would argue for a similar dating of the *Bacchus and Ceres* scenes. DN

CORRADO GIAQUINTO, 1703-1766

George Hersey

In his day Corrado Giaquinto was far-famed and wealthy and seems to have ranked with Giordano and Solimena (D'Azara 1783, 1:79). But his reputation, even more than that of some of the other artists in this exhibition, declined with the rise of Neoclassicism. And if neoclassical critics denounced him, later writers ignored him (D'Azara 1783, 1:79; Lanzi 1789, 5:39; Volpi 1958a, 282; Videtta 1965a, 44ff.). It was not really until the 1960s, in the wake of Mario D'Orsi's monograph (D'Orsi 1958), that he began to be rehabilitated along with other forgotten eighteenth-century Italian figure painters. The exception to this is Spain, where he has always enjoyed a considerable reputation (Volpi 1958b, 329; Videtta 1965a, 133ff.; García Sáseta in Molfetta 1971, 51ff.; Pérez Sánchez 1971, 389ff.). Still today the Prado is the only major museum with a representative group of Giaquintos on display. Indeed, the artist had many pupils and imitators in that country. Two of his assistants, Antonio González-Velázquez and Francisco Bayeu, were involved with Goya's training, and Goya himself borrowed much from him.[1]

But Giaquinto has not yet risen to anything like the prominence he possessed in his lifetime. Though Wittkower says that at times he is Boucher's equal (Wittkower 1965, 306), there has been no monograph on him since D'Orsi's. That book was valuable, illustrating more than 160 works. But scores of new paintings and facts have come to light since then. These, however, are published in scattered articles and, worse still, there has been no major Giaquinto exhibition.[2] The writings of Marisa Volpi, A. E. Pérez Sánchez, and Luigi Dania as well as those of D'Orsi himself, have increased our knowledge. But today only one younger scholar that I know of, Irene Cioffi, is working full time on Giaquinto. She is producing a dissertation on the Spanish period that will undoubtedly bring together and illuminate the fragmentary scene that, at the moment, constitutes Giaquinto studies.

Corrado Giaquinto was born in Molfetta, just north of Bari on the Adriatic coast, in 1703 (not in 1699, as in Thieme-Becker 13:587 [H. Voss, 1920]). According to De Dominici, who was his contemporary, he was at first destined for an ecclesiastical career. But from 1719 he was a pupil of Solimena's student Nicola Maria Rossi (1699–1755; note that the master was only four years older than the pupil). De Dominici adds that Giaquinto eventually joined Solimena's own studio (De Dominici 1742–45, 3:722), but even apprenticeship to Solimena, then at the height of his fame, did not provide the training in disegno that was considered necessary for an artist

of that generation. I know of no extant work by Giaquinto dating from this first Neapolitan period except for a copy after Solimena in a private collection in Naples: a *Visitation* in the Pucci Collection (Spinosa in Detroit 1981, 1:107). Other such works may exist, however, for De Dominici says that Giaquinto made pictures for churches outside Naples.[3] In any event one thing Giaquinto clearly did do in Solimena's studio was to stock up on the master's compositions and figures. He would draw on this supply throughout his life.[4]

If identified, Giaquinto's early paintings might help solve another problem — namely whether he should be considered a Neapolitan or a Roman artist. Admittedly his paintings seem to have more of the solidity, clarity, and loveliness of the Roman art of this period than of the Neapolitan with its somber magnificence. The late Anthony M. Clark has, without discussion, called Giaquinto Roman, and Cioffi has said the same (Clark in Chicago 1970, 226; Cioffi 1980, 5ff.). Yet the situation is more complex than one would at first think. The earlier authorities all call Giaquinto Neapolitan (Wittkower 1965, 386; Longhi 1954, 32ff.; Waterhouse 1971, 16ff.); indeed they are quite firm about the matter, and in a way justly so, for the idea than an artist takes on the nationality, or regionality, of the places where he lives rather than of his birthplace was foreign to Italian thinking. Jusepe de Ribera is an earlier parallel: he was born in the Spanish town of Játiva but spent most of his life in Naples. Yet he remained a Spaniard in his own eyes and those of his contemporaries, retaining the sobriquet "lo Spagnoletto" (Fort Worth 1982, 29ff.).

More particularly Louis Hautecoeur sees Giaquinto and his Neapolitan studio-mate in Rome, Sebastiano Conca, as importers or ambassadors of the Neapolitan style into the capital (Hautecoeur 1912, 143ff.; Moschini 1924, 123; Cantalamessa 1915, 345ff.; see also Olivier Michel in Gaeta 1981, 25, 35ff.). Mattia Loret has even claimed that, when Roman painting declined after Maratta's death (1713), the void was filled by works done in Rome in the Neapolitan manner. He maps out a three-way commerce: pictures brought from Rome to Naples, pictures by Neapolitans who came to Rome, and the work of artists like Paolo de Matteis who oscillated, stylistically, between the two cities (Loret 1934, 541ff.). So the question concerns not only Giaquinto, who though Neapolitan in origin spent most of his career outside Naples; it also concerns artists who remained in Naples but whose style, like Giaquinto's has Roman elements. I am thinking of De Matteis and De Mura.

More recently Antonio Videtta attempts to solve the problem by saying that Giaquinto could be either Neapolitan or Roman in style depending on the commission. Indeed Videtta sees Giaquinto as something of a maverick whose work nullifies normal art-historical method. He points out that since Giaquinto used the same figures and groups over and over again, it is impossible to date his drawings except when they relate to securely dated paintings. And even that may do no good, for Giaquinto (like most of the other artists in the exhibition) would often exactly repeat a given composition twenty or thirty years after he had first painted it (Videtta 1965a, 52ff.). Videtta likens Giaquinto's use of stock characters to the commedia dell'arte, the dramatic form in which standard personages improvised on preset scenarios (Videtta 1965a, 103). He also mentions the *presepi* — the dioramas of the Adoration of the Shepherds and of the Magi that featured dozens of figures in large landscapes bringing gifts to the Madonna and Child. The problem with these comparisons is that both the commedia and the presepi were

centered on figures from popular culture — the Capitano, Arlecchino, shepherds, water-carriers, and the like. So far as I know Giaquinto's authentic pictures do not contain such figures, though artists in his Spanish circle like Ramón Bayeu certainly did them (Palacio Villahermosa, Prado).

But though Giaquinto did not do genre scenes, it could well be right to associate the quickness with which he could elaborate an ambitious composition to this craft sensibility. Like the creators of the commedia and the makers of presepi Giaquinto was essentially a performer. His movements from Naples to Rome to Turin to Spain are like the tours of a musical virtuoso or troupe who performs the same repertoire in city after city. Indeed Lanzi says as much of Giaquinto's whole generation. He speaks of "the adventurers of painting, who voyage around, painting, or paint voyaging around; ready to repeat, in town after town, without new studies, the same figures and sometimes the same works" (cited by Videtta 1965a, 54). These works fit the innumerable replicas we see of Giaquinto compositions — replicas of Roman works in Spain, of works painted for Cesena that ended up in Rome, and on and on. Such an artist might well wish to have a repertoire of styles as well as repertoires of figures and groups.

In Rome, where he seems to have been living from about 1723 (Thieme-Becker, s.v. "Giaquinto") Giaquinto spent much time, we are told, drawing sculpture, which could of course be done there as nowhere else. Roman art and Roman art education were honored in Naples. And De Dominici makes it clear that Giaquinto needed more than Naples could supply in the way of training. After 1734 or so Carlo di Borbone even maintained an atelier in Rome for young Neapolitan artists (Spinosa 1973, 270n. 38). Conca's studio, too, might have served some such function, for besides Giaquinto, Conca had with him the young Neapolitan artist Giovanni Pandozzi (Napoli-Signorelli 1921, 151).

Giaquinto applied himself so arduously, we read, that he became ill.[5] But there is no doubt that his early training paid off in specific ways. He not only learned from drawing sculpture but quoted a specific statue, Michelangelo's St. Peter's *Pietà*, a number of times (cats. 39, 40). Closely allied in academic art training to drawing sculpture is drawing the nude — making academies, careful chalk or charcoal drawings of the nude human body. Giaquinto kept up this practice all his life and arrestingly introduced the nude into older types of composition (Videtta 1965a, 58).

He may also have studied contemporary Roman painters like Marco Benefial, who had a sculptural approach to the figure. Indeed this gives us a chance to define the Roman aspect of Giaquinto's art more closely. True Roman work like Benefial's has a solidity of outline, a disegno, lacking in Giaquinto even in his most "Roman" pictures. And Benefial's *Transfiguration* of ca. 1730 in the church of Sant'Andrea, Vetralla is much more concerned than Giaquinto ever was with the High Renaissance classicism of the early sixteenth century. Raphael's Vatican *Transfiguration* is quoted more than once. The truth is that Giaquinto was mainly interested in the calligraphy of Roman drawing — what in the period was called the *esprit du contour* (De Dominici 1742–45, 3:722; see Videtta 1965a, 46). He also mastered the close-knit symmetry and the glistening surfaces of Roman art.

In Rome Giaquinto painted the cupola and various altarpieces in San Nicola dei Lorenesi, the contract for which is dated 1731, and pendentives in the Cappella Ruffo, San Lorenzo in

Damaso (1735). The San Nicola dome is carried out in the spirit of Domenichino (Bonnard 1932, 78ff.; Moschini 1924, passim). The program consisted of large, vertical oil paintings on the side walls depicting the saint's miracles, these latter dating from 1746 (D'Orsi 1958, 68); also captives on the entrance wall (the Trinitarian Order devoted itself to the release of prisoners), modeled on figures in the Sistine ceiling, more miracles in the vault and, in the dome, a Solimenesque Trinity composition of Father, Son with cross, and dove that Giaquinto was often to reuse. Meanwhile in palette and mood as well as composition, the Old Testament women of the Ruffo chapel owe everything to the Solimena Virtues in San Paolo Maggiore, Naples (1689–90). These dainty, motherly ladies, mostly blue and gold, reappeared in Giaquinto's Spanish work, for example, in the figure of Faith in the chapel ceiling (1759–60) of the Palacio Real, Madrid (pointed out by Volpi 1958b, 332).

The Ruffo chapel contains an altarpiece by Sebastiano Conca, which brings up the question of influence from the older man, twenty-three years Giaquinto's senior. One of Giaquinto's earliest Roman commissions was for a series of Aeneas panels now in the Palazzo Quirinale. These are very close to Conca's art of the late teens. In such a later picture as the Chrysler *Adoration of the Magi,* meanwhile, we have Giaquinto's redaction of Conca's contemporaneous religious style (see discussion under cat. 44).

Giaquinto, I have said, was a voyager. In 1733 and 1735–39 he was painting decorations in the Palazzo Reale, Turin, and in villas of Cardinal Maurizio di Savoia and Queen Maria Cristina. On these occasions he encountered such colleagues as Conca (again) and another fellow-Neapolitan, Francesco de Mura. But the international group assembled by Victor Amadeus II also included the Sicilian Mariano Rossi, the Venetians G. B. Crosato and Sebastiano Ricci, and the Frenchmen Carle and Jean-Baptiste Vanloo (Volpi 1958a, 268ff.; Sylos 1901). The presiding genius was the court architect Filippo Juvarra. Together they created an Ovidian idyll in which painted panels and overdoors mirrored a court in many ways more French than Italian, people who led what Marisa Volpi has called a "choreographic existence" (Volpi 1958a, 268; see also David Nolta's essay on De Mura, above). It was perhaps this experience that gave so many of Giaquinto's later paintings their air of being *fêtes galantes* even when the subject is Christian (cats. 44, 45). Giaquinto's style, indeed, suits the ideals of the Arcadians more than that of any other artist in the present exhibition — though there is so far no indication that he was an official member.

After San Nicola dei Lorenesi, the visits to Turin, and the work at San Lorenzo comes a more ambitious program strongly linked to the present exhibition. This consisted of vault paintings and altarpieces for the Chiesa de' Fatebenefratelli, San Giovanni Calibita on the Isola Tiberina.[6] This charming chapel possesses a nave ceiling, the *Glory of San Giovanni Calibita* (cf. fig. 124), and a beautiful *Dead Christ with the Trinity* (see cats. 39, 40) in the apse vault. With its two altarpieces, two transept paintings and high altar *pala* (by Andrea Gennaroli, extended by Giaquinto), all set into sumptuous marble paneling, the chapel is one of Rome's eighteenth-century jewels. In the present exhibition the *Trinity* tondo from Rochester and the Minneapolis *Holy Trinity with Souls in Purgatory* (cats. 39, 40) are only two of the innumerable copies, *ricordi,* recensions, etc., of the scene that abound in Europe and elsewhere.[7]

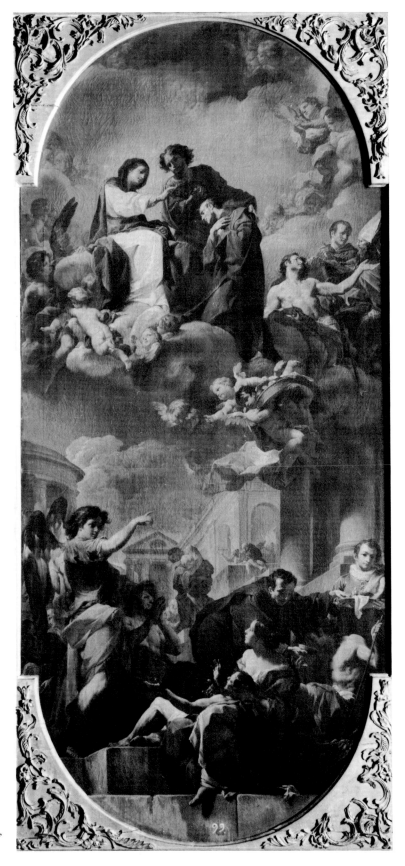

*Corrado
Giaquinto*

FIG. 124. Corrado Giaquinto,
*The Glory of San Giovanni
Calibita*, ricordo of the vault
fresco in San Giovanni Calibita,
Rome. Prado, Madrid

Giaquinto's major Roman commission was for Santa Croce in Gerusalemme. The work is discussed under cats. 42 and 43.

Another measure of the fame that Giaquinto now enjoyed, and the chief instrument of his influence on Neapolitan artists of the 1740s and 1750s, is an enormous canvas commissioned by the archbishop of Naples, Giuseppe Spinelli, for his cathedral sanctuary. It was delivered in the same year, 1744, in which the artist began work on Santa Croce in Gerusalemme. The painting, *The Translation from Pozzuoli to Naples of the Relics of SS Eutyches and Acutius* (two followers of San Gennaro), demonstrated, more than his previous work, Giaquinto's ability to translate the ponderous drama of seventeenth-century religious art into more dashing and colorful language.[8] One is tempted to read this picture as a monumentalizing of the lessons of Turin. The fact that a German dealer once attributed a drawing for the scene to Vanloo — which one was not specified — is indicative.[9] Solemn old men wrapped in stiff fabrics bear the reliquary forward into a palatial gate. The sense of a horizontal procession is varied by the presence of all sorts of upper and lower figures that give the event vertical dimensions. An angel floats on upper clouds, passionate gazes rise, swarthy nudes kneel or lie like river gods in the foreground. It all exists in a sea of opalescent light. The importance of Giaquinto's Duomo picture is not that it was the first picture in Naples to move in this manner toward the rococo — or better, the barocchetto — but that it did so and was also so monumental. It had austere and ceremonious subject matter yet was joyous in style. It was very different from the dark, violent scenes associated with Preti and so much earlier Neapolitan art. And it was placed in a central site only a few yards from that masterpiece of Italian seicento decorative painting, the Cappella San Gennaro, which had been frescoed in the 1630s and 1640s by Lanfranco, Domenichino, and others.

The Duomo painting may seem "Neapolitan" to us because later work by artists like Bardellino and Fischetti was influenced by Giaquinto. Through this picture, and through others sent to Naples,[10] Giaquinto gave a new direction, a new color, to Neapolitan painting. But, historically, the picture arrived as a specimen of Roman or at any rate non-Neapolitan art. It formed part of a remodeling of the Duomo's chancel, which had been damaged by an earthquake in 1732. Rebuilding was undertaken in 1739 by the architect Paolo Posij, who walled up a central window and oculi, removed tombs and paintings, and designed a new high altar. The new altar contains the relics of the saints in Giaquinto's painting. A sculptural group by Pietro Bracci was set in place, and Giaquinto's picture commissioned for the left-hand chancel wall. Opposite it was hung a painting by Stefano Pozzi of SS Gennaro and Agrippino liberating Naples from the Saracens (Grazioso 1967, 21; Strazzullo 1957, 182).

Posij came from Siena. Bracci and Pozzi were Romans. Thus with the addition of the now-Romanized Giaquinto, the whole program was the creation of "foreigners." Moreover, none of these men, except Giaquinto, ranked with the reigning local artists Solimena, De Matteis, and De Mura, nor with local architects like Cosimo Fanzago. The irony for Giaquinto is that in the very years in which he was introducing Solimenism to Rome, in Naples his major work was imported as part of a foreign, mainly Roman, embassy.

There was other work outside Rome. In 1751–52 Giaquinto painted the cupola of the chapel of the Madonna del Popolo in the cathedral at Cesena: a *Paradiso* in the manner of Correggio,

an artist obviously of the greatest importance for Giaquinto as for all his fellow-practitioners of the Italian and French rococo. The lunettes for this project depict four sets of Old and New Testament figures in heaven. A ricordo of one of them is the painting from Chicago in the present exhibition (cat. 45). Giaquinto was to paint another dome in a similar way, and at a grander scale, when he undertook the cupola of the Cappilla Real in Madrid in 1759–60.

The great moment in Giaquinto's life occurred, in fact, when he was summoned by Ferdinand VI to Madrid in 1753. He was fifty. He had become a leader of the artistic community in Rome (in 1740 he was admitted to the Accademia di San Luca, in 1748 he became one of its syndics, and in 1752 its chamberlain; Videtta 1965a, 97). In Spain he became Jacopo Amigoni's successor as *primer pintor de cámara* and worked on the programs of the Palacio Real.

Now we encounter another irony. The older accounts make it clear that Giaquinto was welcomed in Spain not as a Roman painter, let alone a rococo one, nor even as a Solimenista, but as the heir of Luca Giordano. Luca had spent a successful decade, toward the end of his life, painting in Spain (see the biography by Judith Colton, above). Since few Spanish artists at the time were adept at fresco it was particularly in this respect that Giaquinto became Giordano's continuator. Thus Lanzi, writing in 1789, remarks that Luca's "frankness, spirit, and velocity" were what the Spanish saw in Giaquinto's work (Lanzi 1789, 5:226). Ponz and Ceán Bermúdez make the same point.[11] The mid-nineteenth century Italian writer Giovanni Rosini, a full-blooded Neoclassicist, puts it with more hostility. He says that on arriving in Madrid and "finding that there taste had been corrupted, the example of Titian forgotten, and Giordanism in great vogue, [Giaquinto] adopted it, to continue until Mengs appeared to demonstrate its falsity" (Rosini 1847, 125ff.).

Thus if Giaquinto from 1723 to 1753 is a Romanized Solimena, after 1753 he is a hispanicized Giordano. Videtta's characterization of him as a sort of chameleon is not unjust; but such things can be said of our other artists. This is part of their charm. The outstanding example of Giaquinto's new Giordanism is the fresco in the Hall of Columns of the Palacio Real, Madrid (1759–60). Undoubtedly Longhi was thinking of such works when he called Giaquinto a rococo Giordano.[12] More Solimenesque, on the other hand, is the stair-hall fresco of *The Triumph of Religion and the Church*. The stair-hall itself, by Vanvitelli's former assistant Francesco Sabatini, is copied from Vanvitelli's mammoth structure at Caserta — right down to the pair of stone lions.[13] The fresco itself is basically a square version of the vault painting in Santa Croce in Gerusalemme.

But in Spain Giaquinto seems also to have recalled his work in Turin and to have moved further toward the fête galante, rendered in offbeat color and a new and clear disegno. Actually he is said by an early biographer to have first gone to Conca to learn *colorito* (Lanzi 1789, 5:208). What Conca had to teach him, however, was the standard red, blue, gray and flesh-color palette of the late baroque. In Spain Giaquinto goes off in a more personal direction, boldly exploiting violets, pinks, greens, azures, oranges. One of the masterpieces of this new manner, which is influenced also by eighteenth-century French art, is the *Justice and Peace* in the Prado (fig. 125), in which Peace sits on a salmon-colored cloud dressed in pink and in green-and-blue shadowed white, while Justice wears saffron and a moss green that shimmers into pale blue. Both ladies have delicately luminous flesh tones and carefully observe the *esprit du contour*. The *St. Cecilia* in

FIG. 125. Corrado Giaquinto, *Justice and Peace*, Prado, Madrid

the present exhibition could be their sister (cat. 47). It is this frequent but not invariable penchant for the color of the fashion plate rather than of the oil painting that separates Giaquinto from his rivals and precursors and that sets him apart even from his most gifted copyists.

At Madrid, while Ferdinand ruled, Giaquinto's career was a triumph. He was not only the *primer pintor* but director general of the Academia de Bellas Artes, charged with overseeing royal painting programs (figs. 126, 127) and also those involving sculpture and architecture (García Sáseta in Molfetta 1971, 84). He was also appointed director of the royal tapestry works at Santa Bárbara (García Sáseta in Molfetta 1971, 72ff.). He had many pupils and followers, a richly furnished house (Morales 1978, 88ff.), and all the commissions he could manage.

In 1759, however, Ferdinand abdicated, and his younger brother Carlo di Borbone, king of the Two Sicilies, became Charles III of Spain. While ruling in Naples Carlo had shown a distaste for the local artists, a tendency abetted by his Saxon wife (Spinosa in Naples 1979, 1:135ff.; Hersey 1983, 68ff.). Perhaps for this reason, perhaps for some other, with Charles's arrival Giaquinto began to lose status. Finally in December 1762 he asked the king for permission to leave his service and return to Italy. The request was granted (García Sáseta in Molfetta 1971, 89). He was replaced as court painter by Mengs, who had earlier worked in Naples for Carlo and was a German like the queen. Mengs was also more up-to-date than Giaquinto. His Spanish ceilings avoid Giaquinto's formula, which had been to design the ceiling in the form of a *quadro riportato,* or heavily framed painting set among elaborate architecture elements. Instead, Mengs turned the whole of the ceiling into a heavenly void, completely eliminating enframements.

When Giaquinto returned to Italy he painted an *Assunta* for the new cathedral in his birthplace, Molfetta, a *Madonna del Rosario* for the church of San Domenico, also in Molfetta, and returned to Rome, and thereafter to Naples. In Naples Vanvitelli became his mentor.[14]

In these last years of his life Giaquinto elaborated a major project with eventual links to north American collecting. This was his last great ensemble, a new sacristy for San Luigi di Palazzo, a Franciscan church opposite the Palazzo Reale. The building, now destroyed and

Corrado Giaquinto

FIG. 126. Corrado Giaquinto, bozzetto for *San Lorenzo in Glory*, Prado, Madrid

FIG. 127. Corrado Giaquinto, bozzetto for Stair-hall fresco, Royal Palace, Madrid

replaced by Pietro Bianchi's San Francesco di Paola and its colonnades, was designed by Vanvitelli. The interior was a hymn to the Virgin. Four of the original seven easel pictures still exist and they are now in North America. They depict *The Marriage of the Virgin,* the *Visitation,* the *Purification in the Temple,* and *The Rest on the Flight into Egypt.* There were in addition three lost oil paintings, three destroyed frescoes, and four large terracotta statues, also lost, of Humility, Perseverence, Innocence, and Prayer. Some of the work seems to have been carried out after Giaquinto's death. Vanvitelli's students made drawings recording this sumptuous interior, which was crowned by a vault fresco of the Assumption.[15] The new sacristy was dedicated in April 1766. All four of the pictures reflect the compositional schemes, color, shadow-play, and the figure scale and placement of Solimena's series for the Neapolitan church of Santa Maria Donnalbina (1696–1701), now in the Pinacoteca San Lorenzo, Naples. For a Giordanesque source, however, one can go back to such works as the older man's *St. Anne and the Virgin* in the Ascensione a Chiaia, Naples, which encapsulates the same ideas in a melodramatic, monochromatic world of heavy clouds and flying putti.

Just before the painter's death Vanvitelli and Giaquinto began to collaborate on another church, that of the Padri della Missione, not erected until 1788, and then to a different design. This is discussed under cat. 48. Giaquinto was apparently about to take up major commissions for Caserta when he died, probably of a stroke, on April 19, 1766. He was sixty-three.[16]

Let us ask what Giaquinto bequeathed to later art and how he summed up Neapolitan painting in the century preceding his death. Giaquinto, like De Mura, was at base a Solimenista. He carried his Solimenism to Rome, where it was Romanized, and to Spain, where as noted it appeared by itself but was also married to the local Giordanism. But Giaquinto's Solimenism remains in the area of figure types and compositions. In other respects his style is so fresh and in a way almost impudent, so brightened with pastel colors and softened with an entirely un-Solimenesque delight, that it becomes much more modern than Solimena's own style at the end of his life. And of course the overlap is considerable, for Solimena predeceased Giaquinto by only fourteen years. And then there was Giaquinto's rococo or barocchetto side — the barocchetto is a monumental, and Italian, version of the French rococo (Enggass 1983). Like De Mura Giaquinto brought currents of French sensibility to play on the Neapolitan scene. Through his Neapolitan work younger men could explore the pastel colors, shimmering sheets of pink, mauve, and aquamarine, the palms and parasols, and the gentle, bearded patriarchs in engulfing robes, and the sloe-eyed, black-haired ephebes with which Giaquinto populated his world. In Spinosa's words, "Neapolitan painting, moving off from Luca Giordano's fantastic luminous finale, and reacting with an ever more lucid critical consciousness against the recent purist diversions of Francesco Solimena, slowly opened itself . . . to embrace a new conception of the painted decorative ensemble" (Spinosa 1973, 272).

But perhaps Giaquinto's most important legacy to art was his sojourn in Spain. There his Arcadian visions were classicized by his followers Antonio González-Velázquez and Francisco Bayeu, who in turn, with Ramón Bayeu, were such great influences on the Goya of the Prado tapestry cartoons.

1. Gudiol 1970, 1:17, 24, 37. For bibliography on Goya's direct debts to Giaquinto, see Milicua 1954 and Arnaiz 1984.

2. There was a small exhibition of drawings and some bozzetti at Naples in 1953 (Causa 1953). Nicola Spinosa is now planning a small Giaquinto exhibition for Capodimonte. Its curator will be Irene Cioffi.

3. De Dominici 1742–45, 3:722. It is possible that a study of the Giaquinto drawings in San Martino, the Metropolitan Museum, the Biblioteca Nacional, Madrid, and in Molfetta, would throw light on some of Giaquinto's lost ecclesiastical programs.

4. Videtta 1965a, 109, 111, 113, 114ff., 166n. 103. See also this exhibition cats. 39, 40, and Bologna 1979, 66 for Giaquinto copies after Solimena.

5. De Dominici 1742–45, 3:722. The tale is curiously reflected in Conca lore. We read that Conca, "arrived in Rome in 1706, almost thirty, was so impressed by cinquecento art and Roman academicism that for five years he did nothing but draw, and only the French sculptor [Pierre] Le Gros persuaded him to take up his brushes" (Loret 1934, 541ff).

6. De Dominici 1742–45, 3:723; Huetter [1985], 71; Mariani 1963, 5:221; Poensgen 1969, 115ff. and fig. 46; "Arte e storia" 1982, 115ff.

7. In decorating the interior of the church Giaquinto seems to have painted over frescoes by the Cavaliere d'Arpino and Mattia Preti (Titi 1721, 60ff.). There is also a *Flagellation* by Preti in the chapter room.

8. Cf. *Apollo* 107 (March 1978):127, and *Burlington Magazine* 120 (March 1978):xxxii, for an ink drawing of the composition auctioned at Sotheby's, April 25, 1978. A bozzetto is in the Galleria d'arte della Sicilia, Palermo. See also D'Orsi 1958, 67ff., 76n. 4.

9. A large sketch in the hands of Lepke, a Berlin art dealer, in 1913 (Thieme-Becker, s.v. "Giaquinto"); I have not traced it.

10. Other pictures by Giaquinto in Naples, untraced, were in the church of Girolamini: *The Apparition of Christ to the Virgin, Jacob's Ladder,* and the *Nativity.* De Dominici 1742–45, 3:723 says he painted an *Assumption* with many figures for Don Nicola Pepe, 3 x 2 palmi, which was praised by Solimena. For his series for a third Neapolitan church, San Luigi di Palazzo, see below, this essay.

11. Ponz 1772, s.v.; Ceán-Bermúdez 1800, s.v.; Quillier 1825, 101; Pérez Sánchez 1971, 389ff.

12. Longhi 1954, 32ff. For the iconography cf. Fabre 1829. A sketch is reproduced in *Art and Artists* 14 (December 1979):15.

13. Hersey 1983, fig. 7.21; Girolamo Starace's fresco of ca. 1768, *The Kingdom of Apollo,* in the stair-hall vault at Caserta, owes much to Giaquinto's fresco, *Apollo and Bacchus* in the Hall of Columns in the Madrid Palacio Real (Madrid 1975, 86).

14. The architect seems in no doubt that the departure from Spain represented a fall in Giaquinto's fortunes. "I hear he is selling all [his] mountain properties and everything else. [In Rome] he's been getting half the amount of his life pension in Spain [and the same thing is happening to him] in Naples" (Vanvitelli 1976–77, 1059 [7 May 1763]).

15. Naples 1975, 139–40, nos. 159–61; Detroit 1981, 1:108ff.; Cioffi 1980; Rosenfeld 1976; Stoughton in Chicago 1970, no. 95. It would be interesting to reconstruct this ensemble and its architectural setting, utilizing not only the Vanvitelli-student sketches but the many preparatory drawings made by Giaquinto and his assistants now in the Museo San Martino, Naples, and the Spadavecchia Collection, Molfetta. See Videtta 1962, 1965a, passim, and 1965b.

16. Vanvitelli 1976–77, 1067, 1244, 1253. There is however a painting, *Forza e Vigilanza,* at Caserta by Giaquinto (D'Orsi 1958, fig. 149) made for a series of tapestries in the Palazzo Reale (Spinosa 1978).

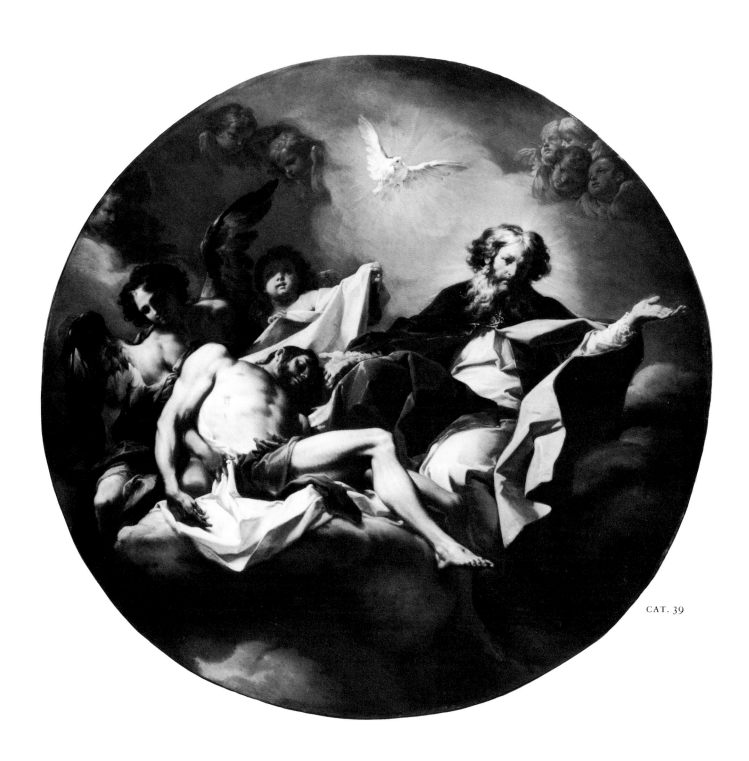

CAT. 39

39 The Trinity

Tondo 76.2 cm (diam. 30 in)

LITERATURE: *Gallery Notes,* Memorial Art Gallery, University of Rochester 46, no. 12, Sept. 1981

Memorial Art Gallery of the University of Rochester. Marion Stratton Gould Fund 81.2

40 The Holy Trinity with Souls in Purgatory

99.2 x 74 cm (39 x 29¼ in); signed l.l.: "C. G./Inv. F."

PROVENANCE: Vangelli, Rome, 1968; possibly London art market, 1978

LITERATURE: D'Orsi 1958, fig. 54; *Art Quarterly* 31 (1968):321; *Bulletin,* Minneapolis Institute of Arts 47 (1968):55ff.; *Apollo* 108 (1978):173

The Minneapolis Institute of Arts, The Putnam Dana McMillan Fund 68.2

The composition was earlier used in the dome of San Nicola dei Lorenesi, Rome (1731). Another version of the scene, by Giaquinto or an assistant, is in the Pinacoteca Communale, Montefortino (probably shop; D'Orsi 1958, fig. 53). There is a third version in San Cassiano, Grugliasco, near Turin, attributed to Giaquinto. The Prado owns a reversed oval version of the Rochester painting, now in the Palacio Villahermosa, Madrid (fig. 128) and formerly in the Museo de Bellas Artes, Córdoba. A line drawing corresponding to the Rochester variant is in the Spadavecchia Collection, Molfetta (Molfetta 1971, fig. 24).

On the right God the Father, in alb and red-lined cope, his head ringed with a Giaquintesque wreath of gray hair and long-locked beard, opens his arms like a priest when he consecrates the Host. As he does so he reveals Christ's body, which is further revealed by the two angels who remove the shroud from the limp form, its wounds still red, which occupies the left half of the scene. Above, in the center, as brilliantly white as the shroud, the dove of the Holy Ghost soars in a golden radiance that glows among the surrounding umber clouds of seraphim.

In this tondo form, the composition is basically that of the fresco in the apse arch in San Giovanni Calibita, Rome, 1741–42. The program at San Giovanni Calibita consisted of vault paintings and altarpieces for the chapel of a hospital — the famous Sacro Cuore — on the Isola Tiberina (De Dominici 1742–45, 3:723; Huetter [1985], 71; Mariani 1963, 5:221; Poensgen 1969, 33, and fig. 46; "Arte e storia" 1982). Besides the beautiful apse tondo which the Rochester picture recapitulates, there are two chapel altarpieces, two transept paintings, and the picture over the high altar (originally by Andrea Gennaroli, extended by Giaquinto). On the nave ceiling is a *Glory of San Giovanni Calibita* that has been badly treated by time but of which autograph copies and adaptations abound (D'Orsi 1958, 58ff.). A ricordo of this scene is in the Prado (fig. 124). Another version is currently on the London art market (Whitfield Fine Art Ltd.). All the paintings in the church are set into sumptuous polychrome paneling.

Aside from earlier use in his own oeuvre, the composition of the Rochester and Minneapolis pictures derives from Solimena's fresco in the chapel of San Filippo Neri in the Chiesa dei Girolamini, Naples. There are versions of this in North American collections. There is no mistaking the genealogy, for example, of Giaquinto's God: his right-hand gesture, his cloud of

hair, his encased body with cope clasped in a great bow at the breast, and his ponderous robes. The positioning of the dove and the seraphim on the right is also close. More loosely Giaquinto's concetto echoes a Lanfranco canvas of Sant'Agostino in the chapel of SS Agostino and Gugliel-mo, Sant'Agostino, Rome. The Girolamini fresco was also copied by Giaquinto's first teacher, Nicola Maria Rossi, in San Nicola alla Carità, Naples. The version illustrated, by Rossi or possibly by Solimena himself, is in the Indiana University Art Museum (fig. 129).

But when we compare the older Neapolitan composition with what Giaquinto was doing in 1741–42 we map the distance he had traveled from his origins. The Neapolitan works are characteristically rougher, blacker, and more violent. Giaquinto softens the figures inspired by Solimena and sweetens their harsh, sometimes scaly surfaces. However, the great difference between model and adaptation is that Giaquinto has replaced Solimena's living, rough-hewn, seated Christ with an elaborate recension of Michelangelo's St. Peter's *Pietà*. And it is not only this new pose that causes changes, nor the importation of a different iconography (Christ taken down from the cross after his death as opposed to carrying his cross on the way to Calvary). Detail and texture are added. The swarthy flesh in Solimena's Christ becomes a brilliant marble corpse. The Virgin's robe in the sculpture turns into a shroud in the painting. Giaquinto intensifies the contrast between God's heavily wrapped form and Christ's elegant nudity, revealed by the two angels, their living, ruddy flesh emphasizing Christ's pallor.

There can be no doubt that Counter-Reformation notions of the Incarnation, emphasizing the Saviour's true flesh-and-blood human body that suffered physically and died on the cross, are being proclaimed (Bellarmino 1617, 1:206ff.). The idea of such a tactile, fleshly yet marble body was frequently expressed in eighteenth-century art theory. Preciado de la Vega, a colleague of Giaquinto's in Conca's studio, pictures a "marble so white, natural and beautiful that on feeling it you will encounter with your touch the bulk of its members and the location of its muscles just the way a blind person replaces his sense of vision with his sense of touch." Similarly the skin of certain bronze sculptures appears to Preciado so tender that one feels one might scratch it with rose thorns (Preciado 1789, 12). These are effects Giaquinto has captured in his Christ.

The Trinity, presented as Giaquinto does with the dead Christ, is a Counter-Reformation subject (Ludovico Carracci, Vatican) that became popular in the eighteenth century. Indeed some writers have referred to this scene as a *Pietà* (Mariani 1963, 5:221). Few handbooks of Christian art discuss it (however, see Didron 1886, 2:1ff.). Sometimes God the Father is himself tending the body of his Son (*Apollo* 108 [November 1978]:173, a *Trinity* attributed to Giaquinto).

This later motif, Pietà-cum-Trinity, has at least two antecedents. One is the venerable *imago pietatis* (Panofsky 1927) in which God the Father is flanked by Christ with his cross. The other is the Throne of Grace, in which God comforts a crucified Christ, the Son pointing to his wounds and the Father to the Son's loins to emphasize the fact of the Incarnation (Steinberg 1983, 197ff.). It is my belief however that the image Giaquinto employs in these two paintings owes its increased popularity during the baroque era to the vision of St. Ignatius. This had occurred in November 1537 when the saint and some disciples were praying in a church at the gates of Rome (Mâle 1932, 432). On that occasion Ignatius saw God the Father in the heavens. God was pointing to Christ, who was holding his cross, and who said, "In Rome I shall protect

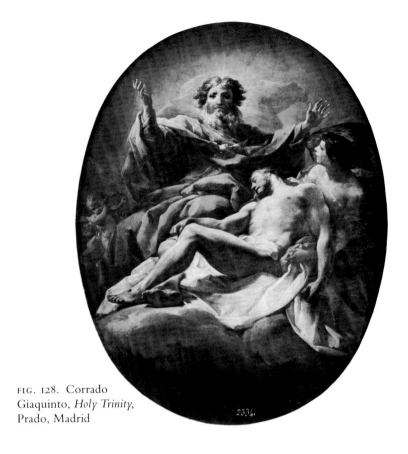

FIG. 128. Corrado
Giaquinto, *Holy Trinity*,
Prado, Madrid

FIG. 129. Nicola Maria
Rossi or Francesco
Solimena(?), *Trinity
with Angels*, Indiana
University Art Museum,
Bloomington, Indiana

you." Scenes of Ignatius's vision are common — for example, the version by Giovanni Battista Gaulli in the Worcester Art Museum. Obviously the scene is frequently found in Jesuit churches. But it is also frequent in churches of the Trinitarians, an order for which Giaquinto often worked. Given their name, this order would obviously approve of the addition of the dove that turns Ignatius's vision into one of the Trinity.

The painting in Minneapolis is almost certainly the work illustrated in D'Orsi (1958, fig. 54) and described as having formerly been in the Vangelli Collection, Rome, A variant of the preceding picture, this time the *Pietà*-derived Christ, God the Father, and the supporting angels comprise the scene's upper part, which becomes something of a nocturne. And this time God the Father, instead of showing forth his Son's body, points with his right hand to the dove and with his left makes a gesture of pacification to the souls below in Purgatory. And this time, too, the assisting angel is backed by the large, blocky form of the cross (taken directly from the cross in Solimena's composition, fig. 129). But now the cross penetrates down from the heavens, through the clouds, and into the midst of Purgatory.

As a result Calvary is equated with Purgatory, or else Calvary becomes Christ's Purgatory. Bellarmino speaks to this point. He says that Christ's descent into Hell, which took place after his burial and before his Resurrection, freed the souls in Purgatory who had come to believe in his passion (Bellarmino 1617, 1:286ff.). Thus one man, on the left, has embraced the foot of the cross. Behind him a woman flings her arms upward toward Christ, and a group of men, their faces and bodies lit with the glory above, gaze devotedly at God the Father.

A similar point is made in terms of color. While all above is radiant and intense with sumptuous fabrics and exquisite flesh, the souls below are dim, licked with reddish highlights and patches of gloom. The effect is the same as in the design of the vault fresco for Santa Croce in Gerusalemme (cat. 42); but in the latter the naked figures in brown light at the bottom of the scene are heretics being flung into the pit by St. Michael. The souls he deals with are a long way from the redemption implied here.

No specific purpose or destination for either the Rochester or Minneapolis pictures has so far been discovered. The latter cannot have anything to do with San Giovanni Calibita, since the church's marble decoration requires the tondo form. Anyway, the format of the Minneapolis scene demands a vertical setting such as a flat or barrel-vaulted ceiling. It is possible that the souls in Purgatory can be related to the work of the Trinitarians, who frequently employed Giaquinto in Rome. The order had been founded to ransom Christians taken hostage by Moslems — hence the captives Giaquinto painted in San Nicola dei Lorenesi, a church whose dome fresco is another variant on this Pietà–Trinity theme. GH

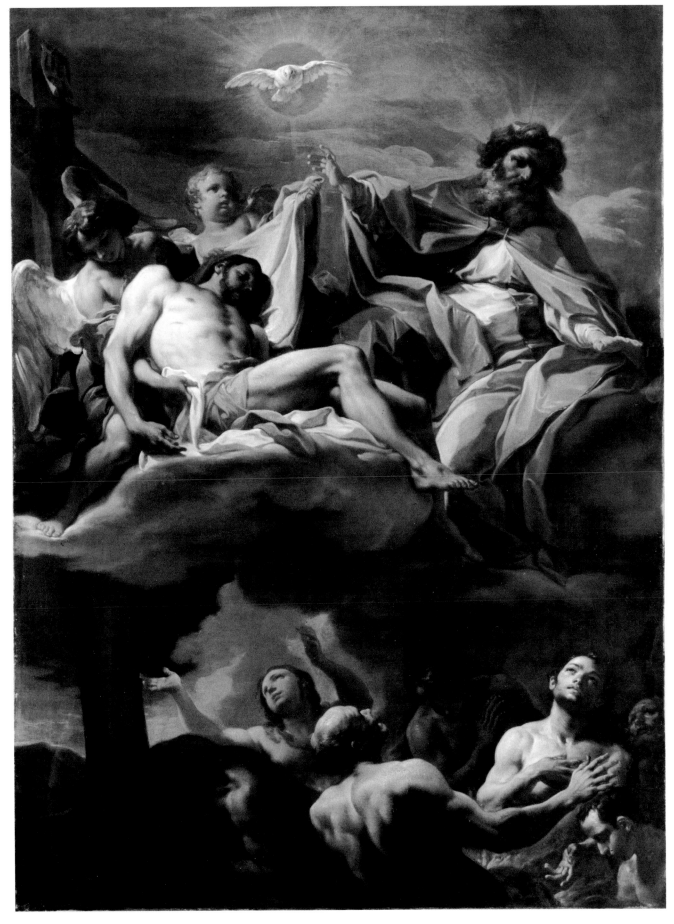

CAT. 40

41 *Bishop Saint in Prayer*

63.5 x 37 cm (25 x 14½ in)

PROVENANCE: Sotheby Parke Bernet, New York, 1980

LITERATURE: *Important Old Master Paintings and Drawings,* Sotheby Parke Bernet, Inc., New York, January 9, 1980, lot 106

Mr. and Mrs. Marco Grassi

The bishop, clad in full pontificals, kneels in the center, his arms spread wide in the classic gesture of early Christian prayer. Before him two putti on the altar footpace hold his crosier and missal. A censer smokes before them on the floor. The palms of a martyr lie beside it. Behind are two angels, one just in back of the bishop holding his mitre, and the other, more brilliant, floating on a cloud among putti. This angel echoes with a gesture of acceptance the bishop's gesture of prayer. Behind are details of classical architecture. I have no idea who the bishop may be. His pose is close to that of the Annunciate in Giaquinto's painting, cat. 48 in this exhibition. He does not have the attributes of San Gennaro (pair of phials of blood, severed head, fiery furnace, wild beasts, symbols of Benevento), though he is so identified in the Sotheby catalogue mentioned above.

In any event the picture is a beautiful and representative specimen of Giaquinto's art. Sometimes these figures are conceived as independent compositions, sometimes as studies for larger groups — for example, the similar praying saint in the Spadavecchia Collection, Molfetta, of 1741–42 (D'Orsi 1958, fig. 56). This study depicts another martyr, Sant'Ercolano, one of the victims in the San Giovanni Calibita legend, as he appears in the painting in the church. A presumably independent composition using an almost exactly similar pose in the *San Gregorio Magno* in the Busiri-Vici Collection, Rome (Molfetta 1971, fig. 51). Another similar composition, identified as St. Eustace, is published by Luigi Dania in Molfetta 1971, fig. 5. A fifth saint to be linked with the Grassi picture is the *Sant'Agostino* in the former Sangiorgi Collection, Rome (D'Orsi 1958, fig. 60). These all date to ca. 1741–42, which thus seems a good date for the Grassi picture. Yet the detail on the triumphal arch, with its spandrel relief of a Victory, is similar to the corresponding detail in the Montreal *Visitation* of the 1760s. Similar but not the same: the Grassi Victory twists her body to the right while that in the Montreal painting is all in one plane, offering a wreath with her right hand in a pose adapted from the Victories on the upper part of the Arch of Alfonso the Magnanimous in the Castel Nuovo, Naples (Rosenfeld 1976). The architectural order on the Grassi arch is different also, and the beautifully painted Corinthian capital is truncated in the middle, suggesting a change of mind, and so further suggesting that this is a bozzetto rather than a ricordo. GH

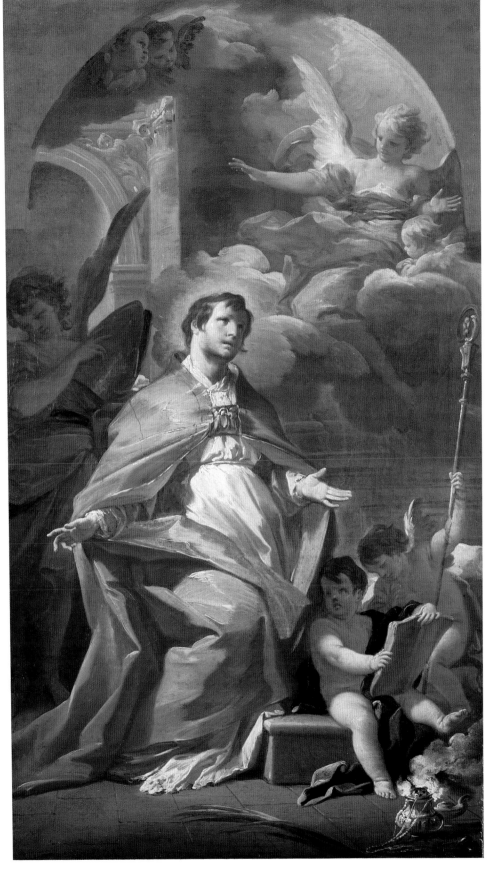

CAT. 4I

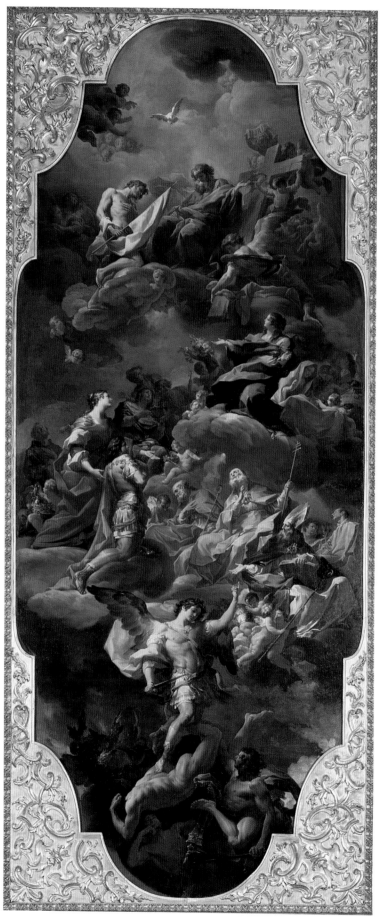

CAT. 42

42 *The Emperor Constantine Presented to the Holy Trinity by His Mother St. Helena*

346.8 x 143.5 cm (136½ x 56½ in)

PROVENANCE: Art market, Florence, 1860; Henry Inman; Albert S. Ludlow, variously of Ludlow, Kentucky, Cincinnati, Ohio, and Waukesha and Milwaukee, Wisconsin; Frederick H. Ludlow; St. Louis Art Museum, on loan from 1942; acquired June 1963

EXHIBITION: Metropolitan Museum of Art, New York, 1880

LITERATURE: *American Art News,* Feb. 6, 1915 (as G. B. Tiepolo); D'Orsi 1958, 63ff., 76n. 4; Laskin 1968

The Saint Louis Art Museum, Gift of Frederick H. Ludlow 31.63

Shown in Kansas City only

43 *The Apparition of the Cross to the Twelve Apostles*

82.5 x 136.6 cm (32⅜ x 53⅞ in)

PROVENANCE: Private Collection, Rome; Salvatore Romano, Florence

LITERATURE: D'Orsi 1958, fig. 67; *Nelson Gallery-Atkins Museum Handbook* 1, 5th ed. (1973):143

The Nelson-Atkins Museum of Art, Kansas City, Missouri (Nelson Fund) 47–6

These are modelli for two paintings by Giaquinto in Santa Croce in Gerusalemme, Rome. As to the St. Louis picture, a version of the top part, including the figures of Christ, God the Father, and the cross, is in the Galleria Estense, Modena (D'Orsi 1958, fig. 66). The Musée Vivant Denon, Chalon-sur-Saône, owns a smaller replica (Lossky 1961). A related *Apparition of the Cross* was in the Romano Collection, Florence, in 1958 (D'Orsi 1958, fig. 67). Laskin (1968, fig. 5) publishes these and another version from the Necchi Collection, Portalupa (Pavia). However he was not aware of the existence of the *Apparition of the Cross* modello, part of the same program, at Kansas City. There are what appear to be preparatory drawings in the Museo Nazionale di San Martino, Naples, inv. 20445 and 20456 (Videtta 1965b, cat. 32). The basic idea was used by Giaquinto's follower, Francisco Bayeu, in a painting in the Prado (fig. 130).

The Santa Croce commission was Giaquinto's major Roman achievement (Besozzi 1750). The command came from Benedict XIV who was rebuilding this pilgrimage basilica into a pantheon of Roman eighteenth-century art honoring the relics of the True Cross that had been brought back from Jerusalem by St. Helena and given to this church by her son, the Emperor Constantine. The definitive project dates from 1744 and is described by De Dominici (1742–45, 3:723).

The centerpiece is a high, magnificent nave vault, a huge canvas mounted on a wooden ceiling. It is an upward procession. It starts with a winged figure of St. Michael, shepherd of souls, who with drawn sword stands on the entangled bodies of naked heretics and pityingly indicates the glory of saints above. Lucifer is meanwhile toppled from his nearby throne. In the finished work the heretics occupy a dismal, brownish plain filled with smoke and the distant forms of demons. In the modello the demons are nearer to the picture plane and the tonality

FIG. 130. Francisco Bayeu,
Trinity with Angels, Prado,
Madrid

lighter. St. Michael rises into a whiter, more brilliant light and is alive with color. In the finished ceiling also, and not in this modello, he is in fact huge, the largest figure by far in the scene.

The next stage, to St. Michael's right, is occupied by St. Peter, St. Gregory the Great, and Sylvester I, pope during the reign of Constantine. The last appears in the guise of Benedict XIV, Giaquinto's patron. (Gregory had celebrated a mass at Santa Croce at which St. Michael miraculously appeared.) They are arguing the cause of Constantine, the first Christian emperor of Rome, who was converted by a vision of the True Cross. Above and to the left, stiffly kneeling, is the youthful Constantine, arms crossed on his breast in the Roman sacrificial gesture of *manus exsertae*. In the finished ceiling painting he is dressed in battle armor to remind us of his victory at the Milvian Bridge (312 A.D.), the occasion on which he received his vision — a vision now repeated in the scene before us, in that he again sees the cross in the heavens, though this time accompanied by the Trinity and angelic host. His crown and scepter lie before him as offerings to God. Helen, with the authority of a saint of the Church, stands behind Constantine in a grandly operatic costume. In the finished work it is her cape, not Constantine's, that is scarlet. Around her are other saints and martyrs also pleading the emperor's cause.

But his most potent advocate is the Blessed Virgin, who occupies the next stage. She, in glorious blue, kneels and spreads her hands in entreaty while just by her right hand a putto carries a dead tree trunk that has burst into flowery bloom. It is the Tree of Adam, from which the True Cross was made and which blossomed on the day of the Crucifixion. Nearby are SS Louis, Joseph, Anne, and Mary Magdalen. Above is the Trinity: on the left the kneeling, nude

Christ, his wounds still red and open, carrying the white banner of his resurrection. So this, with the Rochester and Minneapolis pictures already discussed, makes a third Giaquinto variation on the iconography of the Trinity in the present exhibition. Christ's pose reflects Constantine's and also that of San Giovanni Calibita in the nave vault at the church, which perhaps expresses the idea of the imitation of Christ. Yet by having Christ thus kneel, Giaquinto casts even the Saviour in the role of an advocate before God of Constantine's cause. Bellarmino had in fact emphasized that only Christ can plead the causes of human sinners before the throne of judgment. No man, he adds, and no being purely divine, can so mediate: only he who combines both, the Word incarnate in human flesh (Bellarmino 1617, 1:289ff.).

In the center is God the Father swathed in full robes and indicating the cross that occupies the right-hand part of the scene. Angels and putti swirl around it, removing the banderole proclaiming Christ king of the Jews and presenting the crown of thorns to God. Above, the dove of the Holy Ghost soars.

The mood of the picture reflects that of Constantine's most famous contemporary witness, the Church historian Eusebius (Drake 1975). Eusebius's oration on Constantine presents the emperor as a near-divinity whose throne is "the vault of heaven. . . . Him celestial armies encircle and supernatural power attend. . . . The infinite number of angels, the company of archangels and choruses of holy spirits gaze upon His gleaming presence as if drawing nourishment from ever-flowing springs of light" (Drake 1975, 84).

The style has been developed out of early Solimena at his most many-hued (D'Orsi 1958, figs. 62, 65; De Dominici 1742–45, 3:723; Besozzi 1750). Perhaps even hoping we will marvel at his audacious paraphrase Giaquinto has repeated, with partial reversals, Solimena's great *Triumph of the Dominican Order* (1709) in San Domenico Maggiore, Naples (fig. 72; noted by D'Orsi 1958, fig. 62, and Videtta 1965a, 63). God, the cross, Christ, the Blessed Virgin, St. Michael, and the heretics, all occupy the same positions and have the same, or analogous, poses within the energetic cloud-borne helix they form. As is appropriate, Helena and Constantine occupy the place Solimena had given to St. Dominic. The Solimenesque character of the painting is made clearer still when one confronts it with the great Roman ceilings of the epoch, such as Giuseppe Chiari's *Glory of St. Clement* in San Clemente (1714–19), Carlo Maratta's *Triumph of Clemency* in the Palazzo Altieri (1670s), or Luigi Garzi's *Glory of St. Catherine* in Santa Caterina a Magnanapoli, all of which consist of much more separated, centralized islands of floating figures (a device Giaquinto himself would borrow on occasion) without the sinuous, branching core and casual overlapping that Giaquinto uses here.

The Kansas City picture is a modello for the presbytery painting in Santa Croce (D'Orsi 1958, 142ff., figs. 63, 64, 66, 67). If the *Constantine* is in some ways a Solimena spinoff, this picture is a good example of Giaquinto at his most Roman. The three main groups, the saints left and right and the pair of angels in the center, form eddying silhouettes that now touch, now interlace, now break apart. Yet within those relationships the four groups are essentially symmetrical, the left-hand saints echoing those on the right and the nearly prone foreground angels making a fulcrum for the whole in their ecstatic but tightly central dance. The picture also shows off Giaquinto's penchant for high-fashion hues — St. Peter, on the left, being dressed in blue, orange, and pink, and St. John the Evangelist, to the right of St. Peter, in mauve

CAT. 43

and green. Similar colors abound, often shot through with shimmering white and gold. The left-hand group of apostles is powerful in color, and the right-hand group, a pastel counterpart — especially the pink-clad kneeling apostle on the far right. The climax comes in the pool of gold tone that bathes the cross and the angels who support it.

By adding this scene to the one just discussed Giaquinto is here relying on, and adding to, the many well-known histories of the cross in Roman churches, for example, the thirteenth-century series in the chapel of San Silvestro in the Church of the Quattro Santi Coronati (Künstle 1926, 295ff.). In style and type, however, the groups of apostles in the foreground recall the saints of Raphael's *Disputà,* though in comparison to the decorous majesty they possess there, they appear here in the disarray of extreme amazement. Like many such visions in the period, this is no ceremony but a bewildering event that elicits abasements, hand-claspings, and highly charged gazes.

What the apostles see is the cross after Christ's body has been taken from it, but with nails and crown of thorns intact. The legend of Helena specifically states that she found it thus (Künstle 1926, 295). The viewer cannot help linking these two visions of the cross, Constantine's and the apostles'. Like its mate, the scene takes place in the cloudy heights of heaven; the foreground trumpeting angel, indeed, points his instruments below the platform of clouds on which the scene unfolds, as if to acquaint those on earth below with the event. The event itself, like the nave painting, is uncommon iconographically because it is specific to this particular building, Santa Croce in Gerusalemme, where the True Cross's relics had been deposited by Constantine. The apparition of the cross to the apostles serves to involve them in the case being made for Constantine's salvation, and hence for Rome's primacy. GH / JDC

44 *The Adoration of the Magi*

151.1 x 114.3 cm (59½ x 45 in)

PROVENANCE: Dr. William Shapero, Cleveland, Ohio, 1953

EXHIBITIONS: Finch College 1962, no. 43; *The Christmas Story in Art,* IBM Gallery, New York, 1965–66, no. 16

LITERATURE: Zafran 1978, 248

The Chrysler Museum, Norfolk, Virginia, On loan from the Collection of Walter P. Chrysler, Jr. L77.359

Shown in New Haven and Sarasota only

Luigi Dania records a painting in London that replicates the central portion of the Chrysler Museum *Adoration* (Dania 1983). Giaquinto's Adoration scenes all have a certain family likeness. A number of them are reproduced in D'Orsi 1958, for example, two early *Adorations of the Magi,* one on the Roman art market and the other in a Roman private collection (D'Orsi 1958, figs. 4, 5). But so far the fleet of replicas and variants that float around other major Giaquinto compositions has not come into view for this one. I would place the Chrysler picture among

the more colorful and solidly constructed works that Giaquinto began to paint in Rome after he had taken leave of the early black-shadowed Solimenesque style of his youth. (He continued to borrow compositional ideas from Naples however. I thank David Nolta for pointing out to me that the kneeling king on the right is lifted straight from Domenico Antonio Vaccaro's Solimenesque *Solomon Worshiping Pagan Gods* in Detroit.) But we do not yet see the airiness that begins to appear at Cesena and that Giaquinto takes with him to Spain. This suggests a date of around 1750. Note, however, the similarity of the kings in the Chrysler picture to the three main apostles on the right in the Nelson-Atkins *Apparition of the Cross to the Twelve Apostles* (cat. 43), which is connected with a project of 1744.

The psychological center is on the left. The Virgin tenderly holds the Christ Child, leaning over him, her face half in shadow, her arms encircling the boy's white-and-pink-fleshed body. Behind, swaying back in the shadow, overcome with ecstasy, Joseph opens his arms in a gesture of wonder and acceptance. He stands before the dim, broken form of a fluted column and its podium. He looks from his world of shadowy half-light directly up at the shining, tender faces of a pair of seraphim or bodiless putti, their wings spread into a knot.

Yet most of the light in the picture emanates from the Christ Child himself. "And the peoples shall walk in thy light and kings in the splendor of thy birth," says Bellarmino, paraphrasing Revelation 21:24 and noting that those who came to adore the Christ Child came from all the then-known continents — Asia, Africa, and Europe (Bellarmino 1617, 5:92ff.). Indeed Bellarmino's sermon, which must have been preached toward the end of the sixteenth century, is a commentary on, or foretaste of, the many nocturnal Adorations of the baroque, including that by Paolo de Matteis (cat. 31) in the present exhibition, which illustrate the Child as a light shining in the darkness.

Nativities and Adorations gave birth to all sorts of clerical allegorizing. An eighteenth-century Spanish commentator (Villegas 1760, 64ff.) says the gold, frankincense, and myrrh stand for Christ's kingship, his divinity, and his mortality; for soul, body, and fortune; thought, word, and deed; mortification, prayer, and service; memory, understanding, will; youth, middle age, age: all these trios of qualities are the gifts we must bring to Christ as we, like the Magi, make our obeisances. Ultimately the gifts of the Magi are the whole of the world and its riches.

Below the stream of light that washes diagonally down the rear wall are the heads of an attendant group: on the left a soldier in plumed helmet and with a halberd gazing at one of the boxes of treasure brought by the royal visitors. Directly behind him is the bright face of an old bald man who looks in the opposite direction, up into the light; and, to complete the quartet, there are two young men with the round, ephebic faces that Giaquinto made his trademark. The composition, which, as we describe it, is forming a circle, flows down past the trunk of treasure carried by the second boy, is swelled by the presence of another young kneeling man, and comes into the brighter light that establishes the picture's foreground.

The foreground is occupied by the magnificence and brilliance of the Virgin, Child, and kings. On the right is a robed and kneeling ruler with cloth-of-gold sleeves, his face fair as he gazes intently across to the Child. He offers the thurible of frankincense. The second king bows down almost to the ground — a common thing in Giaquinto — hands clasped before him, his

CAT. 44

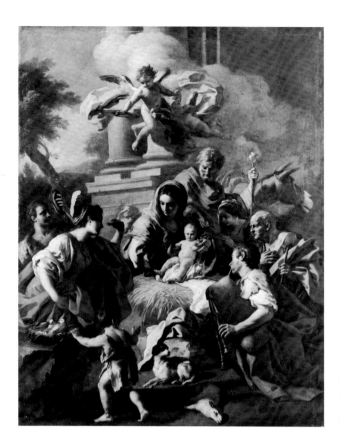

FIG. 131. Francesco de Mura, *Adoration of the Shepherds*, Museo di Capodimonte, Naples

body clothed in fur and velvet. Beside him on the rock is his gift of gold: his own crown and scepter, apparently, and other treasures. Above these two kings is the traditional black ruler, in gray-blue, with a fur cape and a white turban, his hands in the Roman gesture of prayer. His head creates the center of the composition, and his gift of myrrh, of course, predicts the Passion. He reaches back to the two trays borne by his servants, one containing the bowl of myrrh and the other an open coffer of gold chains, and brings one of the latter forth.

The Madonna's cloak dominates the palette. It envelopes her slight form in an enormous rose-shaped surround of brilliant blue. With infinite tenderness she holds the happy Child, her own face a serene hymn of admiration. She has removed his clothing to show forth his incarnate flesh. As Villegas puts it,

The most blessed Virgin, filled with celestial joy, removes the curtains of the sancta sanctorum, undoes the clothes which had covered the infant's body and, thus uncovered, the kings fasten their eyes upon him. And with the witness of the Holy Ghost who touches them from within, they clearly understand that what they see — a poor baby boy in a poor place, in a young girl's arms — is the True God (Villegas 1760, 64).

At her feet, as a pendant to the gold-clad king's crown and vessel, is a basket containing a pair of white doves partly covered with a large cloth that falls along the rough, rocky steps to a wooden staff. The doves are the offering made after the birth of a child under the law of Moses

(Luke 2:22, 24). They usually appear in scenes of the Presentation at the Temple, and so here they prefigure that event. The staff does the same for the Holy Family's journey to Egypt.

The Chrysler *Adoration* records the impact on Giaquinto of Conca's religious style. I have in mind the signed and dated (1720) *Epiphany* for the Church of the Annunziata, Gaeta (Gaeta 1981, no. 21a). Indeed, if one united the ceremonial magnificence of such pictures by Conca to the compositional formulas of the two early Giaquinto *Adorations* mentioned above, the result would be something like the Chrysler painting. In the latter the handsome, curly-haired king in the right foreground and the pedestaled column behind the Virgin seem particularly indebted to the Conca.

But despite these Roman, or at least Conca-esque qualities, the Chrysler painting makes clear Giaquinto's relation to his Neapolitan predecessors. Let us look at Solimena's *Birth of the Virgin* from the Metropolitan Museum (cat. 21) alongside the Chrysler picture. Though the latter is one of Giaquinto's firmest, most monumental pictures, though its personages are impressive as well as charming, there is a division of masses into grand but informal fragments that we see in much of the rest of his art (cf. also fig. 131). This relaxation contrasts with the direct magnetism of the Solimena. There the eye goes instantly to the infant Virgin. All supporting figures, all gestures, all gazes, all attitudes, all colors, all dispositions work to that end. The silhouette of Solimena's main group is an overwhelming circular shape; but Giaquinto's kneeling king on the far right, his handsome profile jeweled with backlighting, his left leg projecting from the picture plane, is at least as interesting as the Madonna and Child. The same may be said, mutatis mutandis, of the other two kings. GH

45 *Figures from the Old Testament*

40.8 x 104.2 cm (16 x 41 in)

EXHIBITION: *Masterpieces of the Old and New World,* Art Center, Decatur, Illinois, 1948, no. 9

LITERATURE: Chicago 1961, 177

The Art Institute of Chicago, gift of Mrs. Everett L. Millard and Mrs. John H. Harmon in memory of their mother, Mrs. Charles T. Boynton 41.830

We believe that this is a ricordo for one of the lunettes for the chapel of Santa Maria del Popolo in the cathedral, Cesena, a town not far from Bologna, near Italy's upper Adriatic coast. The chapel is rich with baroque marbles, especially the altar by Virginio Vespignani. The dome is painted with a circular *Paradise* composition; there are pendentives with prophets and lunettes with figures from the Old and New Testaments in Paradise. They are all by Giaquinto and date from 1750–51 (D'Orsi 1958, 82ff., 143). The dome itself is Correggesque in conception, much softer in style than Giaquinto's earlier work in Rome. One of the canons of the cathedral, Francesco Aguselli, composed a celebratory ode describing Giaquinto's frescoes (D'Orsi 1958, 159), and they were praised as well by Algarotti (1792, 7:181).

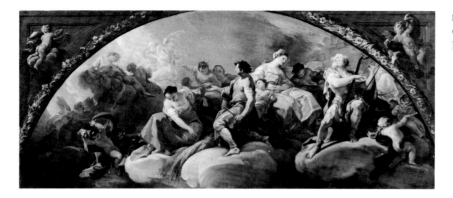

The question of bozzetti, modelli, and ricordi is complicated. D'Orsi publishes three modelli for the lunettes — one in the Villafalleto Collection, Rome, and two now in the Pinacoteca Nazionale, Bologna, all three signed and dated Rome, 1749 (fig. 132). (The Bologna pictures had been at Capodimonte, which in 1953 sold them to the Soprintendenza at Bologna [*Bollettino* 1953]. But D'Orsi in 1958 published them as still being in Naples. See also London 1961, 3, for a version of one of the lunettes entitled *Heroines, Prophets, and Sibyls*.) In 1924 two versions of the Cesena lunettes were in the Galleria Ugo Jandolo, Rome, and another, a more bozzetto-like variant, is or was in the Sutton Collection, London. (Cf. also Phillips, Son and Neale, *Fine Old Master Paintings*, London, December 8, 1981, lot 140.) A drawing for the Chicago picture is in the Moser Collection, Lawrence, Kansas, and a study for the figure of David is in the Cianfaroni Collection, Rome (information from the registrar's files, Art Institute of Chicago). Furthermore, as D'Orsi points out, Aguselli mentions bozzetti for some of the wall-paintings in a local collection in Cesena. Some of these may have made their way to the art market and may be identical with pictures in the above list. Giaquinto's assistants, especially Antonio González Velázquez, often made such copies, and Pérez Sánchez thinks the Chicago picture is probably by one of Giaquinto's Spanish pupils (on the basis of a photograph; personal communication).

The picture is a sparkling study in greens made more vivid by electric splashes of other colors. The dark brown, heavily painted spandrels of the panel are empty (some of the other versions of these lunette scenes have flowers and putti in the spandrels). The sky, or better the atmosphere, of the scene varies from rose to gray-white to orange and sienna. Skin tones on the woman are pearly, on the men ruddy, and clothes are electric green, or green-yellow moiré, or shot with crackling golden highlights.

The careful symmetry of such Roman works as the Rochester (cat. 39) and Minneapolis pictures (cat. 40) is not present in the Chicago design. It is replaced by an open tumble of overlapping figures whose gestures exist each in their own space, unlike those in the Kansas City picture, for example, where they interlace and interact. Each group has its own independent concerns, which makes sense since they are engaged in historically separated events.

The picture illustrates the episodes leading up to the reign of King David. The light shining on the left that illuminates praying angels signifies the messianic promises. The distraught nude

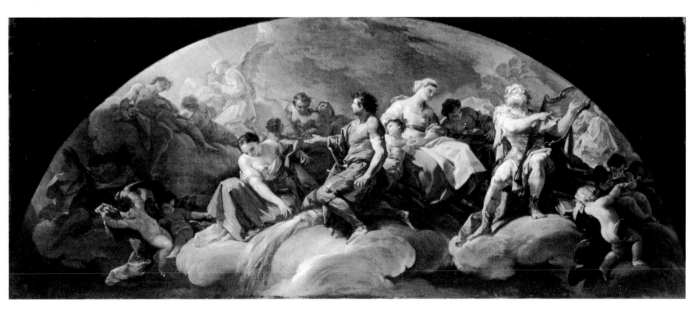

CAT. 45

male lying to their left and a reclining woman behind him nursing a baby are identified in the Art Institute registrar's notes as Hosea, his wife, and his child (Hosea 1:2). Hosea came long after David, but in Hosea 3:5 he did preach the return to an Israel that was unified, as it had been in David's time: "Afterward shall the children of Israel return, and seek the Lord their God, and David their king." Just beneath the praying angels, in the foreground, is Ruth with the sheaves given her by Boaz which she shared with her mother. Boaz was to become her husband and through that the ancestor of David (Ruth 2:12; 4:13). Above the central kneeling figure, on the right, is the infant Samuel and his mother, Hannah, and in the shadow leaning forward with a dish, is his stepmother, Peninnah. Samuel was born under a special dispensation after it seemed that Hannah would never have a child (1 Samuel 1:6). Even when still a child Samuel performs as a priest and offers sacrifices to God; eventually he becomes a great priest and judge during the battles with the Philistines (1 Samuel 7) and prophesies the coming of the kings of Israel (1 Samuel 8:22). In the center is the first of them, Saul (1 Samuel 9:17). He "turns his back on Samuel" but receives enlightenment from God (1 Samuel 10:9). On the far right is the most lovely part of the picture: Saul's successor, David, author of the psalms, singing and playing his harp, his kingly regalia and Biblical writings at his feet.

Given the immense popularity of the Cesena program it is not surprising that there should be many ricordi of it. If indeed the Chicago picture is by one of Giaquinto's Spanish followers it is probably by Francisco Bayeu (*Creation of Adam, Sacrifice of Mosaic Law, Adam and Eve, Abraham Praying,* Prado invs. 2482, 2480, 2491, 2493). Bayeu went in for the exaggerated roundness of the heads, features being brushed ever so lightly into the globe of the face, and the extremely feathery drapery that we see in the present picture. GH / DN

46 *Madonna and Child Adored by SS Peter, Abercius, Stephen, and Benedict*

48.7 x 22.7 cm (19⅛ x 8⅞ in)

EXHIBITION: Paris 1961, no. 8

Vassar College Art Gallery, Purchase, The Louise Woodruff Johnston Fund 69.9

This seems to be a copy by one of Giaquinto's Spanish followers of a picture in the collection of Denis Mahon, London. No documented commission has so far been linked to the original, which by all odds should be a bozzetto for, or ricordo of, an altarpiece or even conceivably a ceiling. Even the presence of an unusual quartet of saints, which ought to help, has not done so in this case. The lower saints in the pictures are excellent, practically good enough to be from Giaquinto's hand. The upper figures are weaker. They suggest the hand of someone such as Francisco Bayeu (1734–1795; *Assumption of the Virign,* Prado) or Thaddeus Kunz (1733–1793; *Moses on Sinai,* Prado).

Let us look at the composition as a composition, aside from considerations of hand. The Madonna, one of the girlish, round-faced *umiltà* types that Giaquinto seems mainly to have

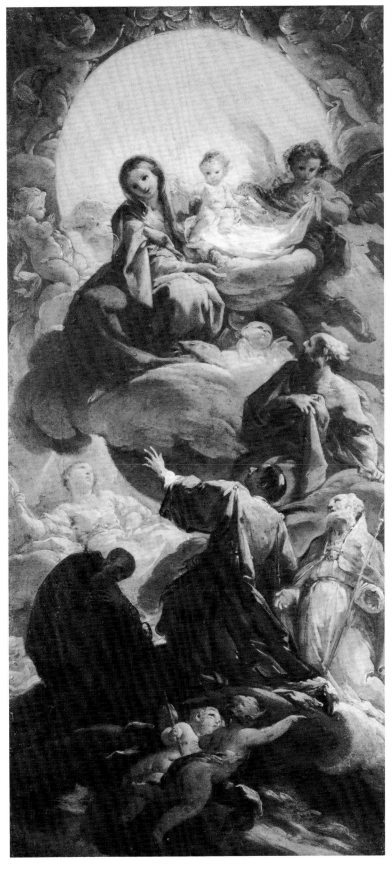

Giaquinto
Paintings
Cats. 39–48

CAT. 46

developed in Spain, dominates the upper part of the picture. She is backed by the moon above and the earth below (Künstle 1926, 1:652ff.). Here the crescent has become a full moon, obviously symbolizing the growth of the Child in his mother's womb and now his appearance in the world. Thus the real subject matter of the scene is the Incarnation, the miracle by which God became flesh. An angel assists the Madonna in unfurling the Child's garments from him, which underlines the point. Above, the sky is dense with the crystalline forms of putti. Below the cloud upon which the Madonna is enthroned the figures of the four saints gaze upward from various positions and angles, all kneeling and forming a chain winding down through dense pillows of clouds, gaining in darkness and becoming more and more silhouetted as it descends. Here, too, are putti, those omnipresent presences that so frequently serve to point out, emphasize, and display the chief events in baroque and rococo pictures.

The highest of the saints is Peter, grasping his key as he stares raptly at the vision. Just below him, in the center, is Stephen, a tonsured deacon (in Greek a tonsure is a *stephanos,* crown), who in Acts 7 preached a wonderful sermon that ends as "he looked up steadfastly into heaven, and saw the glory of God, and Jesus standing on the right hand of God" (7:55). But his auditors stone him from the city; yet he only kneels and prays to God that he will not lay this sin to their charge (7:60). To the right and further off is the elderly figure of Abercius, second-century bishop of Gerapolis in Phrygia. His *Life* (ed. Th. Nissen, Leipzig, 1912) informs us that he took a large club and broke up the interior fittings of a temple of Apollo. This brought out the enraged pagans of the place, and Abercius preached to them, miraculously curing certain of them who were possessed by demons. Later he cured the Roman emperor's daughter of a similar malady. The abject monk on the left, almost pure silouette, is apparently St. Benedict.

The sparkling jumble of the saints' highlighted robes, and their intense, beak-nosed countenances link the picture stylistically to the Chrysler *Adoration of the Magi* (cat. 44). So my inclination is to date the original of the Vassar copy to the 1750s. GH

47 *St. Cecilia*

63.5 x 48.2 cm (25 x 19 in)

D. Stephen Pepper, New York

The saint, of soft and ample form, is seated at the organ, fingers idly on the keys, her face suffused with dreamy prayer as if, in accordance with her legend, she heard some higher music in her heart. Around the tall lead organ pipes winds a gilded filigree. The atmosphere is that of a golden cloud. Cecilia wears a salmon-colored dress clasped with jeweled gold on the sleeves, white undersleeves, and a blue mantle tied with golden twine. Her underskirt is moss-green. Behind her a putto holds a sheet of music. A brilliant patch of crimson velvet shimmers on the gold arm of her seat.

The picture is particularly close in style to the Prado's *Justice and Peace* (fig. 125). The use of pastel colors — salmon, pale blue, pink, orange — is a noteworthy bond between the pictures, as are the firm, elegant, French-style drawing and clear flesh tonalities. This seems to be another

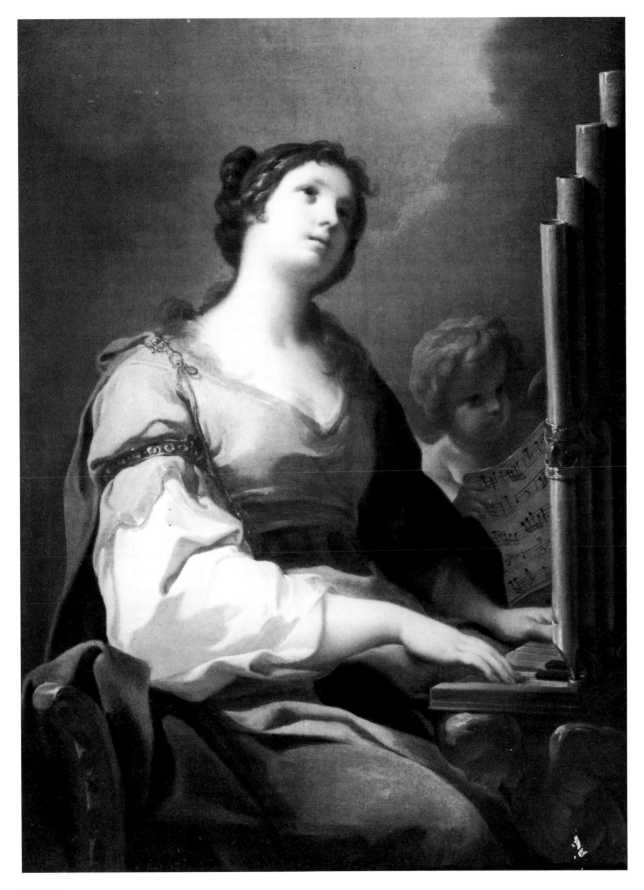

CAT. 47

picture from the early 1750s. It is a good specimen of Giaquinto at his most Roman, and particularly analogous to the *Circe,* a seated, three-quarter-length figure turned to the right from a book of astronomical signs, in the Pinacoteca, Montefortino (D'Orsi 1958, fig. 101), dated by D'Orsi 1751–52. Both have a sumptuous clarity worthy of Maratta or Sacchi. But as with the Chrysler *Adoration of the Magi* (cat. 44), the figure of Sebastiano Conca comes into play — not as a stylistic mentor but as a source of compositions, for example, in the Boston *Sibyl,* dating from 1726 — itself derived from Domenichino. The amplitude of flesh, the soulful orbs turned heavenward, the distant clouds are all family characteristics. Only Giaquinto's bold colors depart from Conca's prototype. One could mention also Conca's own *St. Cecilia,* also in Boston and also of these years (Gaeta 1981, nos. 34, 35). In a different way the *St. Cecilia* makes a good pair with Solimena's most Roman picture in the show, the *Abduction of Orithyia* from the Walters Art Gallery (cat. 22). Clear, classical colors, transparent shadows, smoothly rendered, exquisite surfaces, and pearly highlights are the hallmarks. Each in its way is an obeisance by a Neapolitan artist to the Roman manner.

St. Cecilia was a Roman girl described in the *Acts* of the Roman martyrs (see Künstle 1926, 146); she lived during the reign of Urban I (222–30 A.D.). Though destined to marry a certain Valerianus she was secretly a Christian and has vowed herself to a life of chastity. When the wedding day arrived, and while appropriate music played, she converted Valerianus to her religious beliefs. Or, to paraphrase the *Acts,* while the wedding music played Cecilia sang her prayer in her heart. Later she was decapitated by pagan persecutors. In the ninth century her remains were taken to the church of Santa Cecilia in Trastevere, and in 1595 her corpse was again exhumed. At this time Stefano Maderno carved a famous statue of her (1600) showing her recumbent body turned away from the viewer (Santa Cecilia in Trastevere, Rome).

In Giaquinto's period there was an office for the Feast of St. Cecilia which included the Collect: "Cecilia the virgin sang to the music of the organ and, in her heart, to God alone: 'Lord may my heart and body be immaculate, that I be not confounded'" (Künstle 1926, 149). Particularly rich musical services were celebrated in her honor and the era abounds with St. Cecilias; Domenichino painted an important cycle of her life in the Polet chapel, San Luigi dei Francesi, Rome (Spear 1982, 178ff.; Künstle 1926, 146f.). GH

48 *Annunciation*

63.5 x 36.2 cm (25 x 14¼ in)

Private Collection, New Haven

This small but captivating picture, as fresh and luminous as the day Giaquinto painted it, is remarkable for its simplicity, its bravura handling and harmonizing of brilliant colors, and above all for the impression of sudden and intense physical and spiritual movement that it conveys. At left is the angel Gabriel, afloat in windblown garments of gleaming white and yellow-gold with a rose colored sash tied about and streaming back from his waist. His wings

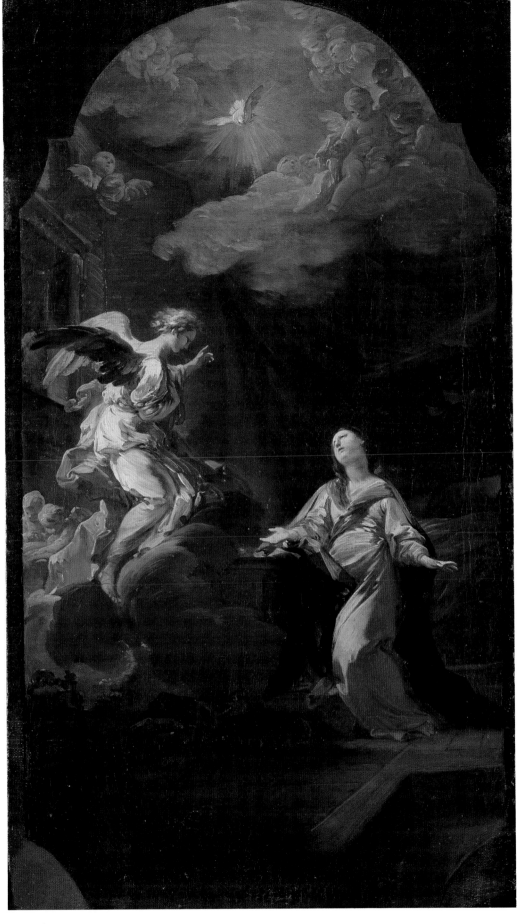

CAT. 48

FIG. 133. Luigi Vanvitelli, sketch
for altarpiece for the Chiesa dei
Padri della Missione, Naples.
Palazzo Reale, Caserta

are feathery and white in the light, gray-brown in the shade, and he is borne up on a large puff
of gray cloud tinted rose at the edges, with two pale cherubs tucked in among the billows on
the far left. These clouds suggest the ethereal, preternatural world that has just now over-
whelmed the corporal world of the Virgin: Gabriel says to her, "The Holy Ghost shall come
upon thee and the power of the Most High shall overshadow thee" (Luke 1:35). They engulf the
prie-dieu from which she seems to be rising, her arms thrown open in a gesture of prayer to
receive the spirit. Her dress, in a highly saturated shade of rose-pink, links her in color to
Gabriel and also to the foremost cherub above, forming a visual union between the human and
angelic spheres. Over this gown she wears a white, sleeved apron and her characteristic deep
blue mantle. The clouds also fill the arched upper zone of the picture, where the white dove of
the Holy Spirit hovers slightly off center in a golden haze thick with the winged heads and
plump limbs of cherubs. From this bird thin shafts of light radiate down upon the scene.

Despite the explosive drama of the event there are domestic touches: the open window or
door on the upper left, the heavy, dark-green draperies sealing off the room at the back, and the
barely discernible image of the bed in the shadows on the right, above which two angel heads
are dimly suspended. But these details, like the sewing basket, the unused cushion, and the
chair in the foreground, suggest in the sketchiness of their handling the scattered elements of a
half-remembered dream. This quality indeed suffuses the entire picture, coinciding with and

even enhancing the feeling of movement implicit in the blurred features of the figures, so typical of Giaquinto. Everything culminates in the long, curved neck and countenance of the Virgin, which turns upward to the angel like an offered white rose.

The spontaneous handling, the absence of clearly defined details, the intense color, and the impression of movement are all attributes of the bozzetto, and that is undoubtedly what this picture is. Just before his death in 1766 Giaquinto entered into a collaboration with Luigi Vanvitelli for new work at the Chiesa dei Padri della Missione, Naples. Though the present building was not erected until 1788, the drawings collection at Caserta preserves a longitudinal section by Vanvitelli showing an *Annunciation* in a transept chapel that is a mirror image of the present bozzetto (fig. 133; Naples 1973, 161). There is no such painting in the church today, and Giaquinto's bozzetto may be all he ever did for the project. The late dating is confirmed by the picture's style, which is notably similar to works completed toward the end of Giaquinto's sojourn in Spain. Note too that the Virgin almost exactly mirrors the pose of the bishop saint in the Grassi Collection (cat. 41). A copy of our painting is in the Borghese Gallery. This D'Orsi dates to 1753–62 (D'Orsi 1958, no. 317, fig. 163; Volpi 1958a, 233n. 67; Longhi 1928, 226, no. 553; Cantalamessa 1915). DN

Giaquinto
Paintings
Cats. 39 – 48

BIBLIOGRAPHY

MANUSCRIPTS

MS 1647 *Dell'avvenimenti più memorabili accaduti in Napoli nel tempo delle sollevazioni popolari degl'anni 1647, e 48. . . .* Transcribed by G. B. G. in four unpaged books. MS Biblioteca Nazionale. Napoli, XV G 29.

Böhler MS 1948 Julius Böhler. "John Ringling, Art Collector, Museum Builder." Ringling Museum of Art. Sarasota, Florida, 1948.

BOOKS AND ARTICLES

Ripa 1611 Cesare Ripa. *Iconologia, overo descrittione d'imagini delle virtù.* . . . Padua, 1611.

Bellarmino 1617 Roberto Bellarmino. *Opera omnia* [orig. ed. 1617–20]. 6 vols. Naples, 1856–62.

Marino 1619 Giovanni Battista Marino. *La galeria* [orig. ed. 1619]. Venice, 1647.

Tutini 1633 Camillo Tutini. *Memorie della vita miracoli e culto di S. Gennaro.* Naples, 1856.

Oliva 1659 G. P. Oliva. *Prediche dette nel Palazzo Apostolico.* Rome, 1659–77.

Malvasia 1678a Carlo Cesare Malvasia. *Felsina pittrice* [orig. ed. Bologna, 1678]. Bologna, 1697.

Malvasia 1678b Carlo Cesare Malvasia. *The Life of Guido Reni* [orig. ed. 1678]. Translated by R. and C. Enggass. University Park, Pennsylvania, and London, 1980.

Celano 1692a Carlo Celano. *Notizie del bello dell'antico e del curioso della città di Napoli* [orig. ed. 1692]. Edited by G. B. Chiarini. Naples, 1856–60.

Celano 1692b Carlo Celano. *Notizie* [orig. ed. 1692]. Edited with additions by A. Mozzillo, A. Profeta, and F. P. Macchia. Naples, 1970.

Sarnelli 1697 Pompeo Sarnelli, *Guida de' forestieri curiosi di vedere e intendere le cose più notabili della città di Napoli* Naples, 1697.

Palomino 1715 Antonio Palomino de Castro y Velasco. *El museo pictórico y escala óptica* [orig. ed. 1715]. Edited by M. Aquilar. Madrid, 1947.

Titi 1721 Filippo Titi, *Nuovo studio di pittura, scultura ed architettura nelle chiese di Roma*. . . . 1721.

Cybo 1725 D. C. Cybo, *Descrizione del viaggio fatto nel Regno da Mons. D. Camillo Cybo nell'anno 1725*. Partly published in *Napoli nobilissima*, ser. 1, 6 (1897): 46ff.

De Dominici 1728 Bernardo De Dominici. "Vita del cavaliere D. Luca Giordano." In *Le vite de' pittori, scultori, ed architetti moderni*, by Giovanni Pietro Bellori. 2d ed. Rome, 1728, 304–96.

Feroni 1728 Giuseppe Maria Feroni. *Sermoni sopra la vita della gloriosissima vergine, e madre di dio*. . . . Benevento-Florence, 1728.

Orlandi 1733 Pellegrino Orlandi. *L'abecedario pittorico con nuova e copiosa aggiunta di alcuni professori*. Naples, 1733.

Prenner 1735 Anton Joseph von Prenner and F. van Stampart. *Prodromus du Belvedere de Vienne*. 1735.

Casimiro 1736 F. Casimiro. *Memorie istoriche della chiesa e convento di S. Maria in Araceli di Roma*. Rome, 1736.

Pascoli 1736 Lione Pascoli. *Vite de' pittori, scultori, ed architetti moderni* [orig. ed. Rome, 1736]. Amsterdam, 1965.

De Dominici 1742–45 Bernardo De Dominici. *Vite de' pittori, scultori ed architetti napoletani*. Naples, 1742–45. 3 vols. in 2. The *permessi* are dated 1741, the title pages 1742, and the preface 1745. Reprint 1979.

Besozzi 1750 Raimondo Besozzi. *La storia della basilica di Santa Croce in Gerusalemme*. Rome, 1750.

Della Marra 1751 Flavio della Marra. *Descrizione istorica del sacro real monastero di Monte Casino*. Naples, 1751 (see also Della Marra 1775).

Dezallier d'Argenville 1752 Dezallier d'Argenville. "François Solimene." In *Abrégé de la vie des plus fameux peintres*, vol. 2. Paris, 1752.

Cochin 1756 C. N. Cochin. *Voyage d'Italie, ou receuil de notes sur les ouvrages*. . . . Paris, 1756.

Villegas 1760 Alonso de Villegas. *Flos sanctorum y historia general*. . . . Barcelona, 1760.

Passeri 1772 Giambattista Passeri, *Vite de' pittori, scultori, ed architetti che anno lavorato in Roma, morti dal 1641 fino al 1673* [orig. ed. Rome, 1772]. Leipzig, 1934.

Ponz 1772 Antonio Ponz, *Viaje de España* [orig. ed. 1772; 3d ed. Madrid, 1788]. Madrid, 1947.

Della Marra 1775 Flavio della Marra, *Descrizione istorica del sacro real monastero di Monte Casino*. 2d ed. Naples, 1775.

D'Azara 1783 Giuseppe Nicola D'Azara. *Opere di Antonio Raffaello Mengs*. Bassano, 1783.

Maronna 1787 A. da Maronna. *Pisa illustrata delle arti del disegno.* Pisa, 1787.

Comolli 1788–92 Angelo Comolli, *Bibliografia storico-critica dell'architettura civile ed arti subalterne.* 4 vols. Rome, 1788–92.

Orlandi 1788 Pellegrino Orlandi. *Abecedario pittorico . . . opera utilissima a tutti i dilettanti di belle arti ora notabilmente accresciuta fino all'anno 1775.* Florence, 1788.

Sigismondo 1788 Giuseppe Sigismondo. *Descrizione della città di Napoli e i suoi borghi.* Naples, 1788–89.

Lanzi 1789 Luigi Lanzi, *Storia pittorica d'Italia. . . .* [orig. ed. Bassano, 1789]. Milan, 1831.

Preciado 1789 Francisco Preciado de la Vega. *Arcadia pictórica en sueño. Alegoría o poema prosaico sobre la teórica y práctica de la pintura.* Madrid, 1789.

Algarotti 1792 Francesco Algarotti. *Opere complete.* Venice, 1792.

Galanti 1792 Giuseppe Maria Galanti. *Breve descrizione della città di Napoli e del suo contorno.* Naples, 1792.

De Brosses 1799 Charles de Brosses. *Lettres historiques et critiques sur l'Italie.* Paris, 1799.

Ceán Bermúdez 1800 J. A. Ceán Bermúdez. *Diccionario histórico de los más ilustres profesores de las bellas artes en España.* Madrid, 1800.

Lazzarini 1806 G. A. Lazzarini. *Opere . . . di belle arti.* Pesaro, 1806.

Romanelli 1815 Domenico Romanelli. *Napoli antica e moderna.* Naples, 1815.

Dibdin 1822 T. F. Dibdin. *Aedes Althorpianae.* London, 1822.

Riccardi Vernaccia 1822 F. Riccardi Vernaccia. *Galleria Riccardiana dipinta da Luca Giordano.* Florence, 1822.

Buchanan 1824 W. Buchanan. *Memoirs of Painting, with a Chronological History of the Importation of Pictures by the Great Masters into England since the French Revolution.* 2 vols. London, 1824.

Quillier 1825 F. Quillier. *Les Artistes italiens en Espagne ou histoire des artistes italiens qui contribuèrent à embellir les Castilles.* Rome, 1825.

Fabre 1829 F. J. Fabre. *Alegorías pintadas en las Bóvedas del Palacio Real de Madrid.* Madrid, 1829.

Dunlap 1834 William Dunlap. *A History of the Rise and Progress of the Arts of Design.* [orig. ed. 1834]. Boston, 1918.

Lanzi 1834 Luigi Lanzi. *Storia pittorica della Italia.* 5th ed. 3 vols. in 1. Florence, 1834.

Aguselli 1841 F. A. Aguselli. *Sul famoso dipinto a fresco della cupola di Maria Vergine del Popolo nella Cattedrale di Cesena.* Bologna, 1841.

Tosti 1842 Luigi Tosti. *Storia della badia di Monte-Cassino,* vol. 9. Naples, 1842.

Pugin 1843	A. Welby Pugin. *An Apology for the Revival of Christian Architecture in England.* London, 1843.
Rosini 1847	Giovanni Rosini. *Storia della pittura italiana esposta coi monumenti,* vol. 7. Pisa, 1847.
Apocrypha 1853	*Evangelica apocrypha.* Edited by C. Tischendorf. Leipzig, 1853, 1876.
Dalbono 1859	Carlo Tito Dalbono. *Storia della pittura in Napoli ed in Sicilia dalla fine del '600 a noi.* Naples, 1859.
Jarves 1860	*Descriptive Catalogue of "Old Masters" Collected by James Jackson Jarves.* Cambridge, Massachusetts, 1860.
Caravita 1869–70	A. Caravita. *I codici e le arti a Montecassino.* 3 vols. Montecassino. 1869–70.
Galante 1872	Gennaro Aspreno Galante. *Guida sacra della città di Napoli.* Naples, 1872 (see also Galante 1985).
Capasso 1878	Bartolommeo Capasso. "Sull'aneddoto riguardante il Cavalier Calabrese sopra le porte di Napoli." *Archivio storico di Napoli* 3 (1878): 597ff.
Nouvelles Archives 1880	*Nouvelles Archives de l'art français. Recueil de documents inédits.* 2d ser., vol. 2. 1880.
Faraglia 1882, 1883	Nunzio Federico Faraglia. "Le memorie degli artisti napoletani pubblicate da Bernardo de Dominici." *Archivio storico per le province napoletane* 7 (1882): 329ff.; 8 (1883): 83ff., 259ff.
Didron 1886	Adolphe-Napoléon Didron. *Christian Iconography,* vol. 2. English translation 1886. Reprint. New York, 1965.
Croce 1892	Benedetto Croce. "Sommario critico della storia dell'arte nel napoletano. I. Il falsario." *Napoli nobilissima,* ser. 1, 1 (1892): 122ff., 140ff.
Colonna di Stigliano 1895	F. Colonna di Stigliano. "Inventario dei quadri di casa Colonna fatta da Luca Giordano." *Napoli nobilissima,* ser. 1, 4 (1895): 29ff.
Massarenti 1897	*Catalogue du Musée de peinture, sculpture et archéologie au Palais Accoramboni. I. Tableaux.* Catalogue of the Massarenti Collection. Rome, 1897.
Filangieri 1898	Antonio Filangieri di Candida. "Le pitture di Marco del Pino nella Pinacoteca Nazionale ed in altri luoghi di Napoli." *Napoli nobilissima,* ser. 1, 7 (1898): 172ff.
Bailly 1899	Nicolas Bailly. *Inventaire des tableaux du Roy rédigé en 1709 et 1710.* Edited by Fernand Engerand. Paris, 1899.
Ceci 1899	Giuseppe Ceci. "Scrittori della storia dell'arte napoletana anteriori al De Dominici." *Napoli nobilissima,* ser. 1, 8 (1899): 163ff.
Cosenza 1900	G. Cosenza. "La chiesa e il convento di San Pietro Martire." *Napoli nobilissima,* ser. 1, 9 (1900): 115ff.
Venturi 1900	Adolfo Venturi. *La Madone. Représentations de la vierge dans l'art italien.* Paris, 1900.

Ceci 1901 Giuseppe Ceci. "La chiesa e il convento de Santa Caterina a Formiello." *Napoli nobilissima*, ser. 1, 9 (1900): 49ff., 67ff.; 10 (1901): 35ff., 101ff., 178ff.

Sylos 1901 Luigi Sylos. "Un pittore pugliese a Torino. Corrado Giaquinto." *Napoli nobilissima*, ser. 1, 10 (1901): 42ff.

Ruskin 1903 John Ruskin. *Works*. Edited by E. T. Cook and Alexander Wedderburn. 39 vols. London, 1903–12.

Metropolitan 1906 *Metropolitan Museum Bulletin* 1, no. 5 (1906): 72.

Ceci 1908 Giuseppe Ceci. "Il primo critico del De Dominici." *Archivio storico per le province napoletane* 33 (1908): 618–36.

Dimier 1909 L. Dimier. "Un Mot sur l'école napolitaine. La Galerie de S. A. le comte Harrach." *Les Arts* 8, no. 93 (September 1909): 18ff.

St. Petersburg 1910 *Les Anciennes Ecoles de peinture dans les palais et collections privées russes*. Brussels, 1910.

Hautecoeur 1912 Louis Hautecoeur. *Rome et la renaissance de l'antiquité à la fin du XVIIIe siècle*. Paris, 1912.

Budapest 1913 Museum der bildenden Künste, Budapest. *Katalog der Gemäldegalerie*. Edited by G. von Térey. 3d ed. Budapest, 1913.

D'Addosio 1913 G. B. D'Addosio. "Documenti inediti di artisti napoletani del XVI e XVII secolo." *Archivio storico per le province napoletane* 38 (1913): 490ff.

Longhi 1913 Roberto Longhi. "Mattia Preti detto il Cavalier Calabrese." *L'Arte* 16 (1913): 428ff. Reprinted in Longhi. *Scritti giovanili*. Florence, 1961, 41ff.

Meade 1913 George Meade. *The Life and Letters of George Gordon Meade*. New York, 1913.

Norton 1913 Sara Norton and M. A. DeWolfe Howe, eds. *Letters of Charles Eliot Norton*, vol. 1. London, 1913.

Scatassa 1913 E. Scatassa. "Benedetto XIII e i suoi artisti beneventani." *Rassegna bibliografica dell'arte italiana* 16 (1913): 111ff.

Cantalamessa 1915 A. Cantalamessa. "Divagazioni critiche a proposito d'un quadretto di Corrado Giaquinto." *Bollettino d'arte* 9 (1915): 345ff.

Ruffo 1916 V. Ruffo. "Galleria Ruffo nel secolo XVII in Messina." *Bolletino d'arte* 10 (1916): 318.

Petraccone 1919 Enzo Petraccone. *Luca Giordano*. Naples, 1919.

Ceci 1920 Giuseppe Ceci. "Un mecenate del secolo XVII: Gaspare Roomer." *Napoli nobilissima*, ser. 2, 1 (1920): 160ff.

Rouchès 1920 G. Rouchès. *La "Jérusalem delivrée" dans les arts plastiques. Etudes italiennes*, vol. 2. Paris, 1920, 193ff.

Marangoni 1921	M. Marangoni. "La raccolta Cecconi di pittura secentesca." *Dedalo* 2 (1921): 362ff.
Napoli-Signorelli 1921	Pietro Napoli-Signorelli. "Gli artisti napoletani della seconda metà del secolo XVIII." *Napoli nobilissima,* ser. 2, 2 (1921): 151.
Florence 1922	*La mostra della pittura italiana del sei e settecento in Palazzo Pitti.* Exhibition catalogue. Florence, 1922.
Borzelli 1924	Angelo Borzelli. *Perchè il pittore Paolo de Matteis da vecchio pensò stabilirsi in Roma.* Naples, 1924.
Moschini 1924	Vittore Moschini. "Giaquinto artista rappresentativo della pittura barocca tarda a Roma." *L'Arte* 27 (1924): 104ff.
Ojetti 1924	U. Ojetti, L. Dami, and N. Tarchiani. *La pittura italiana del seicento e del settecento alla mostra di Palazzo Pitti.* Milan-Rome, 1924.
Wharton 1924	Edith Wharton. *False Dawn.* New York, 1924.
Apocrypha 1926	*The Apocryphal New Testament.* Translated by Montague James. Oxford, 1926.
Croce 1926	Benedetto Croce. *I teatri di Napoli.* Bari, 1926.
Künstle 1926	Karl Künstle. *Ikonographie der Heiligen.* Freiburg, 1926.
Panofsky 1927	Erwin Panofsky. "Imago Pietatis." *Festschrift für Max J. Friedländer.* Leipzig, 1927, 261ff.
Sergi 1927	A. Sergi. *Mattia Preti detto il "Cavalier Calabrese": La vita, l'opera, catalogo delle opere.* Acireale, 1927.
Longhi 1928	Roberto Longhi. *Precisioni nelle gallerie italiane. R. Galleria Borghese.* Rome, 1928.
Dresden 1929	*Die Staatliche Gemäldegalerie zu Dresden. Erste Abteilung.* Dresden, 1929.
Frangipane 1929	A. Frangipane. *Mattia Preti.* Milan, 1929.
Lucretius 1929	*Titus Lucretius on the Nature of Things.* Translated by T. Jackson. Oxford, 1929.
Rusconi 1929	A. J. Rusconi. *Monte Cassino.* Bergamo, 1929.
Hartford 1930	*Exhibition of Italian Painting of the Sei- and Settecento.* Exhibition catalogue. Wadsworth Atheneum, Hartford, January–February 1930.
Nugent 1930	M. Nugent. *Alla mostra della pittura italiana del '600 e '700.* 2 vols. San Casciano Val di Pesa, 1930.
Wadsworth 1930	*Bulletin* of the Wadsworth Atheneum. Hartford, January 1930.
Bonnard 1932	F. Bonnard. *Histoire de l'église de Saint Nicolas "in Agone."* Rome, 1932.
Mâle 1932	Emile Mâle. *L'Art religieux après le Concile de Trente.* Paris, 1932.

Ceci 1933 — Giuseppe Ceci. "Lo studio di Francesco de Mura." *Rassegna storica napoletana* 1, no. 3 July-September 1933.

McComb 1934 — A. McComb. *The Baroque Painters of Italy.* New York, 1934.

Loret 1934 — Mattia Loret. "I pittori napoletani a Roma nel '700." *Capitolium* 10 (1934): 541ff.

Mauceri 1934 — E. Mauceri. Note in *Brutium*, vol. 4. 1934.

Bailey 1935 — C. Bailey. *Religion in Virgil.* New York, 1935.

Diodorus 1935 — Diodorus of Sicily. *Works.* Translated by C. H. Oldfather. London, 1935.

Duveen 1935 — James Henry Duveen. *Collections and Recollections. A Century and a Half of Art Deals.* London, 1935.

Naples 1938 — *La mostra della pittura napoletana dei secoli xvii-xviii-xix.* Exhibition catalogue. Castel Nuovo, Naples, 1938.

Wind 1938 — Edgar Wind. "Shaftesbury as Patron of Art." *Journal of the Warburg and Courtauld Institutes* 2 (1938): 185ff.

Pane 1939 — Roberto Pane. *Architettura dell'età barocca in Napoli.* Naples, 1939.

Pevsner 1940 — Nikolaus Pevsner. *Academies of Art, Past and Present.* Cambridge, 1940.

Wehle 1940 — Harry B. Wehle. *A Catalogue of Italian, Spanish, and Byzantine Paintings in the Metropolitan Museum.* New York, 1940.

Giannone 1941 — Onofrio Giannone. *Giunte sulle vite de'pittori napoletani.* Edited by Ottavio Morisani. Naples, 1941.

Golden Legend 1941 — Jacobus de Voragine. *The Golden Legend.* Translated by Granger Ryan and Helmut Ripperger. New York, 1941. Reprinted 1948, 1969.

Kishpaugh 1941 — Sister Mary Jerome Kishpaugh. *The Feast of the Presentation of the Virgin Mary in the Temple: An Historical and Literary Study.* Washington, 1941.

Heil 1942 — W. Heil. "Neapolitan Baroque Painting in the De Young Museum." *Pacific Art Review* 2 (1942): 10ff.

Longhi 1943 — Roberto Longhi, "Ultimi studi sul Caravaggio e la sua cerchia." *Proporzione* 1 (1943): 5–63.

Bardstown [ca. 1945] — *Saint Joseph's Proto-Cathedral, Its History and Paintings.* Bardstown, Kentucky, n.d. [ca. 1945].

Holt 1947 — Elizabeth G. Holt, ed. *The Literary Sources of Art History.* Princeton, 1947.

Mahon 1947 — Denis Mahon. *Studies in Seicento Art and Theory.* London, 1947 (see also Mahon 1971).

Pindar 1947 — *The Odes of Pindar.* Translated by R. Lattimore. Chicago, 1947.

Berenson 1948	Bernard Berenson. *Aesthetics and History in the Visual Arts*. New York, 1948.
Bierens de Haan 1948	J. C. J. Bierens de Haan. *L'Oeuvre gravé de Cornelis Cort, graveur hollandais (1533–1578)*. The Hague, 1948.
Golden Legend 1948	See *Golden Legend* 1941.
London 1950	*Exhibition of Works by Holbein and Other Masters of the Sixteenth and Seventeenth Centuries*. Royal Academy of Arts. London, 1950–51.
Commodo Izzo 1951	Maria Commodo Izzo. *Andrea Vaccaro*. Naples, 1951.
Hanfmann 1951	G. M. A. Hanfmann. *The Season Sarcophagus in Dumbarton Oaks*. Washington, 1951.
Prota-Giurleo 1951	Ulisse Prota-Giurleo. "Un complesso familiare di artisti napoletani del secolo XVII." *Napoli. Rivista municipale* 77 (1951): 19ff.
Steegmuller 1951	Francis Steegmuller. *The Two Lives of James Jackson Jarves*. New Haven, 1951.
Causa 1952	Raffaello Causa. "Per Mattia Preti: Il tempo di Modena ed il soggiorno a Napoli." *Emporium* 106 (1952): 212ff.
Hoffman 1952	Daphne M. Hoffman. "The Death of St. Joseph." *St. Joseph Magazine [American Catholic Family Monthly]* 53, no. 3, March 1952.
Oberlin 1952	*Exhibition of Italian Painting of the Seventeenth Century*. Exhibition catalogue. Allen Memorial Art Museum, Oberlin College, Ohio, 1952.
Rotili 1952	Mario Rotili. *L'arte nel Sannio*. Benevento, 1952.
Bollettino 1953	"Corrado Giaquinto: sei tele." *Bollettino d'arte,* ser. 4, 38 (1953): 379.
Briganti 1953	Giuliano Briganti. "The Mahon Collection of Seicento Paintings." *Connoisseur* 132, no. 532 (September 1953): 4ff.
Causa 1953	Raffaello Causa. "Corrado Giaquinto." *Rassegna mensile di disegni delle raccolte del Museo di San Martino in Napoli,* no. 12, December 1953.
Dayton 1953	*Flight, Fantasy, Faith, Fact. A Loan Exhibition Commemorating the Fiftieth Anniversary of Powered Flight, 1903–1953*. Dayton Art Institute, Ohio, 1953–54.
Frangipane 1953	A. F[rangipane]. "Nuovi contributi alla biografia di Mattia Preti: Cronologia (1613–1699)." *Brutium* 22 (September–October 1953): 5ff.; (November–December 1953): 5-8.
Prota-Giurleo 1953	Ulisse Prota-Giurleo. *Pittori napoletani del seicento*. Naples, 1953.
Schuster 1953	Alfredo Ildefonso Cardinal Schuster. *Storia di San Benedetto e dei suoi tempi*. 3d ed. Viboldone, 1953.
Bob Jones 1954	*Bob Jones University Collection of Religious Art*. Greenville, South Carolina, 1954.

Koenker 1954 Ernest Benjamin Koenker. *The Liturgical Renaissance in the Roman Catholic Church*. Chicago, 1954.

Longhi 1954 Roberto Longhi. "Il Goya romano e la cultura di via Condotti." *Paragone* 5, no. 53 (1954): 32ff.

Milicua 1954 José Milicua. "Anotaciones al Goya Joven." *Paragone* 5, no. 53 (1954): 5–28.

Parker 1954 K. T. Parker. *Italian Drawings of the 18th Century in the Ashmolean Museum*. Oxford, 1954.

Soria 1954 Martin S. Soria. "Some Paintings by Aniello Falcone." *Art Quarterly* 17 (1954): 3–15.

Toronto 1954 *Paintings by European Masters from Public and Private Collections in Toronto, Montreal and Ottawa*. Exhibition catalogue. Art Gallery of Ontario, Toronto, 1954.

Zeri 1954 Federico Zeri. *La Galleria Spada a Roma*. Florence, 1954.

Bologna 1955 Ferdinando Bologna. *Opere d'arte nel salernitano*. Naples, 1955.

Grabar 1955 André Grabar. "The Virgin in a Mandorla of Light." *Late Classical and Medieval Studies in Honor of Albert Mathias Friend, Jr.* Princeton, 1955, 305ff.

Prota-Giurleo 1955 Ulisse Prota-Giurleo. "Notizie su Massimo Stanzione e sul presunto suo manoscritto falsificato dal De Dominici." *Napoli. Rivista municipale* 81 (1955): 17ff.

Réau 1955–59 Louis Réau. *Iconographie de l'art chrétien*. 3 vols. Paris, 1955–59.

Bologna 1956 *Mostra dei Carracci*. Exhibition catalogue. Archiginnasio, Bologna, 1956.

Griseri 1956 Andreina Griseri. "I bozzetti di Luca Giordano per l'escalera dell'Escorial." *Paragone* 7, no. 81 (1956): 33–39.

Longhi 1956 Roberto Longhi. "Un collezionista di pittura napoletana nella Firenze del '600." *Paragone* 7, no. 75 (1956): 61–64.

Parker 1956 K. T. Parker. *Catalogue of Drawings in the Ashmolean Museum*. Vol. 2. Italian Schools. Oxford, 1956.

Pigler 1956 Andor Pigler. *Barockthemen*. 2 vols. Budapest, 1956 (see also Pigler 1974).

Sweetman 1956 J. E. Sweetman. "Shaftesbury's Last Commission." *Journal of the Warburg and Courtauld Institutes* 19 (1956): 110ff.

Breckinridge 1957 J. D. Breckinridge. "'Et Prima Vidit': The Iconography of the Appearance of Christ to His Mother." *Art Bulletin* 39 (1957): 9ff.

Causa 1957 Raffaello Causa. *Pittura napoletana dal XV al XIX secolo*. Bergamo, 1957.

Majdalany 1957 Fred Majdalany. *Cassino, Portrait of a Battle*. London, 1957.

Pane 1957 Roberto Pane. *Il monastero napoletano di S. Gregorio Armeno*. Naples, 1957.

Strazzullo 1957	Franco Strazzullo. "Le vicende dell'abside del Duomo di Napoli." In *Studi in onore di Domenico Mallardo*. Naples, 1957, 165ff.
Bologna 1958	Ferdinando Bologna. *Francesco Solimena*. Naples, 1958.
D'Orsi 1958	Mario D'Orsi. *Corrado Giaquinto*. Rome, 1958.
Gilbert 1958	Creighton Gilbert. "Italian Paintings at St. Meinrad Archabbey." *Gazette des Beaux-Arts* 52 (1958): 355–68.
Harlow 1958	Alvin F. Harlow. *The Ringlings, Wizards of the Circus*. New York, 1958.
Hartford 1958	*A. Everett Austin, Jr.: A Director's Taste and Accomplishment*. Wadsworth Atheneum, Hartford, 1958.
New York 1958	*Italian Baroque*. Exhibition catalogue. Wildenstein and Co., New York, 1958
Provincetown 1958	*Inaugural Exhibition, Chrysler Art Museum of Provincetown*. Provincetown, Massachusetts, 1958, with notes by Bertina Suida Manning.
Saarinen 1958	Aline B. Saarinen. *The Proud Possessors*. New York, 1958.
Strazzullo 1958	Franco Strazzullo. "La collezione d'arte del Marchese Dragonetti." *Il Fuidoro*, vol. 5, 1958.
Volpi 1958a	Marisa Volpi. "Corrado Giaquinto e alcuni aspetti della cultura figurativa del '700 in Italia." *Bollettino d'arte* 43 (1958): 263ff.
Volpi 1958b	Marisa Volpi. "Traccia per Giaquinto in Spagna." *Bollettino d'arte* 43 (1958): 329ff.
Baltimore 1959	*The Age of Elegance: The Rococo and Its Effect*. Exhibition catalogue. Baltimore Museum of Art, 1959.
Refice Taschetta 1959	Claudia Refice Taschetta. *Mattia Preti: Contributo alla conoscenza del Cavalier Calabrese*. Brindisi, 1959; 2d ed. Naples, 1970.
Bardstown [ca. 1960]	*St. Joseph's Pro-Cathedral: Its History and Paintings*. Bardstown, Kentucky, n.d. [ca. 1960].
Bottineau 1960	Yves Bottineau. "A propos du séjour espagnol de Luca Giordano (1692–1702)." *Gazette des Beaux-Arts* 56 (1960): 249ff.
Houston 1960	*Festival of the Bible in the Arts*. Temple Emanu-El, Houston, 1960.
Jarves 1960	James Jackson Jarves. *The Art-Idea*. Cambridge, 1960.
Virgil 1960	Virgil. *Works*. Translated by T. R. Fairclough, vol. 1. London, 1960.
Chicago 1961	*Paintings in the Art Institute of Chicago*. Chicago, 1961.
Griseri 1961	Andreina Griseri. "Luca Giordano 'alla maniera di'" *Arte antica e moderna* 11 (1961): 417ff.

London 1961 — *Seventeenth- and Eighteenth-Century Oil Sketches*. Hazlitt Gallery, London, 1961.

Longhi 1961 — Roberto Longhi. *Opere complete di Roberto Longhi*. Vol. 1. *Scritti giovanili, 1912–22*. Florence, 1961.

Lossky 1961 — Boris Lossky. "Une Peinture de Corrado Giaquinto au Musée de Tours." *Revue du Louvre et des Musées de France* 11, nos. 4–5 (1961): 207ff.

Olsen 1961 — Harald Olsen. *Italian Paintings and Sculpture in Denmark*. Copenhagen, 1961.

Paris 1961 — *La Peinture italienne au dix-huitième siècle*. Paris, 1961.

Pazzi 1961 — Santa Maria Maddalena de' Pazzi. *Colloqui*. Edited by C. M. Catena. Florence, 1961–62.

Sarasota 1961 — Creighton Gilbert. *Baroque Painters of Naples*. Exhibition catalogue. Ringling Museum of Art, Sarasota, Florida, 1961.

Wunder 1961 — R. Wunder. "Solimena Drawings in the Cooper Union Museum: A New Discovery and Others." *Art Quarterly* 24 (1961): 152.

Bob Jones 1962 — *Catalogue of the Bob Jones University Collection of Religious Art*. 2 vols. Bob Jones University, Greenville, South Carolina, 1962.

Bologna 1962 — Ferdinando Bologna. "Aggiunte a Francesco Solimena: I. La giovanezza e la formazione (1678–84)." *Napoli nobilissima*, ser. 3, 2 (1962): 1ff.

County Durham 1962 — *Neapolitan Baroque and Rococo Painting*. Text by Tony Ellis. Bowes Museum, Barnard Castle, County Durham, 1962.

Doria 1962 — G. Doria, F. Bologna, and G. Pannain. *Settecento napoletano*. Turin, 1962.

Fort Worth 1962 — *1550–1650: A Century of Masters from the Collection of Walter P. Chrysler, Jr.* Exhibition catalogue. Fort Worth Art Center, Texas, 1962.

Georgetown 1962 — *Georgetown University: Catalogue of the Art Collection*. Text by Erik Larsen. Washington, 1962, 41.

Giannantonio 1962 — Pompeo Giannantonio. *L'arcadia napoletana*. Naples, 1962.

Griseri 1962 — A. Griseri. "Francesco de Mura fra le corti di Napoli, Madrid e Torino." *Paragone* 13, no. 155 (1962): 29ff.

New York 1962 — *A Loan Exhibition of Neapolitan Masters of the Seventeenth and Eighteenth Centuries*. Exhibition catalogue by Robert L. Manning. Finch College Museum of Art, New York, October–December, 1962.

Schleier 1962 — Erich Schleier. "Lanfranco's 'Notte' for the Marchese Sannesi and Some Early Drawings." *Burlington Magazine* 104 (1962): 246ff.

Strazzullo 1962 — Franco Strazzullo. *La corporazione dei pittori napoletani*. Naples, 1962.

Videtta 1962 Antonio Videtta. "Disegni di Corrado Giaquinto nel Museo di San Martino." *Napoli nobilissima,* ser. 3, 2 (1962): 13ff.; 4 (1965): 174ff.; 5 (1966): 1; 6 (1967): 135ff.

Waterhouse 1962 Ellis Waterhouse. *Italian Baroque Painting.* London, 1962.

Haskell 1963 Francis Haskell. *Patrons and Painters.* New York, 1963 (see also Haskell 1980).

Mariani 1963 V. Mariani. *Le chiese di Roma dal xvii al xviii secolo.* Bologna, 1963.

Turin 1963 *Mostra del barocco piemontese.* Edited by V. Viale et al. Turin, 1963.

Bari 1964 *Mostra dell'arte in Puglia dal tardo antico al rococò.* Pinacoteca Provinciale di Bari, 1964.

Enggass 1964 Robert Enggass. "Francesco de Mura alla Nunziatella." *Bollettino d'arte* 49 (1964): 133ff.

Memphis 1964 Michael Milkovich. *Luca Giordano in America.* Exhibition catalogue. Brooks Memorial Art Gallery, Memphis, Tennessee, 1964.

Previtali 1964 Giovanni Previtali. *La fortuna dei primitivi: Dal Vasari ai neoclassici.* Turin, 1964.

Schlosser 1964 Julius Schlosser Magnino. *La letteratura artistica* [orig. ed. 1924]. Florence, 1964.

Strazzullo 1964–65 Franco Strazzullo. "Documenti per la chiesa di San Nicola alla Carità." *Napoli nobilissima,* ser. 3, 4 (1964–65): 114ff.

Attwater 1965 Donald Attwater. *The Penguin Dictionary of Saints.* Baltimore, 1965.

Detroit 1965 *Art in Italy 1600–1700.* Exhibition catalogue. The Detroit Institute of Arts, Michigan, 1965.

Milkovich 1965 Michael Milkovich, Howard Hibbard, and Milton Lewine. "Seicento at Detroit." *Burlington Magazine* 107 (1965): 370ff.

Millen 1965 Ronald Millen. *Luca Giordano a Palazzo Medici Riccardi.* Florence, 1965.

Pérez Sánchez 1965 Alfonso E. Pérez Sánchez. *Pintura italiana del s. XVII en España.* Madrid, 1965.

Videtta 1965a Antonio Videtta. *Considerazioni su Corrado Giaquinto.* Naples, 1965.

Videtta 1965b Antonio Videtta. *Disegni di Corrado Giaquinto nel Museo di San Martino. Catalogazione sistematica.* Naples, 1965.

Wittkower 1965 Rudolf Wittkower. *Art and Architecture in Italy, 1600 to 1750.* 2d ed. Harmondsworth, 1965.

Carandente 1966 Giovanni Carandente. *Mattia Preti a Taverna.* n.p., 1966.

Durham 1966 *18th-Century European Painting from the Collection of Robert L. and Bertina Suida Manning.* Exhibition catalogue. Duke University Gallery, Durham, North Carolina, 1966.

Ferrari 1966 Oreste Ferrari. "Una 'Vita' inedita di Luca Giordano [F. S. Baldinucci's 'Luca Giordano pittore napoletano']." *Napoli nobilissima*, ser. 3, 5 (1966): 89ff., 129ff.

Ferrari-Scavizzi 1966 Oreste Ferrari and Giuseppe Scavizzi. *Luca Giordano*. 3 vols. Naples, 1966.

Byam Shaw 1967 James Byam Shaw. *Paintings by Old Masters at Christ Church, Oxford*. London, 1967.

Grazioso 1967 Ugo Grazioso. *Guida del Duomo di Napoli*. Naples, 1967.

Norfolk 1967a *Bulletin*. Norfolk Museum of Science and Art, Virginia, 1967.

Norfolk 1967b *Italian Renaissance and Baroque Paintings from the Collection of Walter P. Chrysler, Jr.* Exhibition catalogue. Norfolk Museum of Science and Art, Virginia, 1967–68.

Ponce 1967 *Museo de Arte de Ponce. Fundación Luis A. Ferré. Catalogue*. Ponce, Puerto Rico, 1967.

Porcella 1967 A. Porcella. *Inediti di Luca Giordano*. n.p., 1967.

Posner 1967 Donald Posner and K. Weil-Garris Posner. "More on the Bob Jones University Collection of Religious Art." *Art Journal* 26 (1967): 144–53.

Stein 1967 Roger B. Stein. *John Ruskin and Aesthetic Thought in America, 1840–1900*. Cambridge, Massachusetts, 1967.

Storia di Napoli 1967–74 *Storia di Napoli*. 10 vols. Naples, 1967–74.

Waterhouse 1967 Ellis Waterhouse. "A Note on Giovanni Maria Morandi." In *Studies in Renaissance and Baroque Art Presented to Anthony Blunt on His Sixtieth Birthday*. London, 1967, 117ff.

Wethey 1967 Harold E. Wethey. "The Spanish Viceroy, Luca Giordano, and Andrea Vaccaro." *Burlington Magazine* 109 (1967): 678ff.

Bologna 1968a Ferdinando Bologna. "Solimena's *Solomon Worshiping the Pagan Gods* in Detroit." *Art Quarterly* 31 (1968): 35ff.

Bologna 1968b Denis Mahon. *Guercino. Catalogo della mostra*. Bologna, 1968.

Huntington 1968 *The Last Flowering of Religious Art*. Exhibition catalogue. Heckscher Museum, Huntington, New York, 1968.

Laskin 1968 Myron Laskin. "Corrado Giaquinto's *St. Helena and the Emperor Constantine Presented by the Virgin to the Trinity*." *Museum Monographs*, no. 1. City Art Museum of St. Louis, 1968, 28ff.

Minneapolis 1968 "Corrado Giaquinto's *The Trinity with Souls in Purgatory*." *Minneapolis Institute of Art Bulletin* 57 (1968): 54ff.

Pevsner 1968 Nikolaus Pevsner. "The Crisis of 1650 in Italian Painting." *Studies in Art, Architecture and Design* 1 (1968): 56ff.

St. Meinrad 1968 *Sixteenth- and Seventeenth-Century Italian Oil Paintings of the Neapolitan School from the Collection at St. Meinrad Abbey*. St. Meinrad, Indiana, 1968.

Bologna 1969 Ferdinando Bologna. *I pittori alla corte angioina di Napoli: 1266–1414*. Rome, 1969.

Büttner 1969 Frank Büttner. "Der Umbau des Palazzo Medici-Riccardi zu Florenz." *Mitteilungen des Kunsthistorischen Institutes in Florenz* 14 (1969–70): 393ff.

Cantone 1969 Gaetana Cantone. "Il complesso conventuale di Santa Maria Egiziaca a Pizzofalcone." *Napoli nobilissima*, ser. 3, 8 (1969): 93ff.

Chatsworth 1969 James Byam Shaw. *Old Master Drawings from Chatsworth*. Exhibition catalogue. International Exhibitions Foundation, 1969–70.

Knauer 1969 Elfriede R. Knauer. "Leda." *Jahrbuch der Berliner Museen* 11 (1969): 3ff.

Panofsky 1969 Erwin Panofsky. *Problems in Titian, Mostly Iconographic*. New York, 1969.

Poensgen 1969 Thomas Poensgen. *Die Deckenmalerei in italienischen Kirchen*. Berlin, 1969.

Bergin-Fisch 1970 Giambattista Vico. *The New Science of Giambattista Vico* [1744]. Translated by T. G. Bergin and M. H. Fisch. Ithaca and London, 1970.

Bernari 1970 Carlo Bernari. *L'opera completa del Tintoretto*. Milan, 1970.

Causa 1970 Raffaello Causa. *Opere d'arte nel Pio Monte della Misericordia a Napoli*. Naples, 1970.

Causa Picone 1970 Marina Causa Picone. "I disegni della Società Napoletana di Storia Patria." *Archivio storico per le province napoletane* 85–86 (1970): 131–77.

Chicago 1970 *Painting in Italy in the Eighteenth Century: Rococo to Romanticism*. Exhibition catalogue. Edited by John Maxon and Joseph J. Rishel. Art Institute of Chicago, Illinois, 1970.

De Filippis 1970 Felice de Filippis. "Introduzione." In Bernardo de Dominici, *Vite de' pittori, scultori ed architetti napoletani* (abridged edition). Naples, 1970.

Enggass-Brown 1970 Robert Enggass and Jonathan Brown. *Italy and Spain, 1600–1750: Sources and Documents*. Englewood Cliffs, New Jersey, 1970.

Euripides 1970 Euripides. *The Bacchae*. Translated by G. S. Kirk. London, 1970.

Ferrari 1970 Oreste Ferrari. "Le arti figurative." *Storia di Napoli*. Naples, 1970, 6, pt. 2: 1223–1363.

Gudiol 1970 José Gudiol. *Goya 1746–1828*. Barcelona, 1970.

La Valletta 1970 *The Order of St. John in Malta*. Exhibition catalogue. La Valletta, 1970.

Rizzi 1970 A. Rizzi. "Una tela inedita di Mattia Preti in Slovenia." *Napoli nobilissima*, ser. 3, 9 (1970): 20–23.

Storia di Napoli 1970 *Storia di Napoli*, vol. 6. Naples, 1970 (see *Storia di Napoli. 1967–74*).

De Maio 1971 Romeo de Maio. *Società e vita religiosa a Napoli nell'età moderna, 1656–1799*. Naples, 1971.

Felton 1971 Craig Felton. "Jusepe de Ribera: A Catalogue Raisonné." Ph.D. diss., University of Pittsburgh, 1971.

London 1971a *Fourteen Important Neapolitan Paintings*. Heim Gallery, London, 1971.

London 1971b *Faces and Figures of the Baroque*. Heim Gallery, London, 1971.

Molfetta 1971 *Atti Convegno di studi su Corrado Giaquinto*. (Conference held in January 1969). Molfetta, 1971.

Mahon 1971 Denis Mahon. *Studies in Seicento Art and Theory*. Westport, Connecticut, 1971. Reprint of 1947 ed.

Martinelli 1971 Valentino Martinelli. "Un disegno inedito di Mattia Preti per gli affreschi di San Biagio a Modena." In *Studi di storia dell'arte in onore di Valerio Mariani*. Naples, 1971, 193–200.

Pérez Sánchez 1971 A. E. Pérez Sánchez. "En torno a Corrado Giaquinto." *Archivo español de arte* 44 (1971): 389ff.

Posner 1971 Donald Posner, *Annibale Carracci*. 2 vols. London, 1971.

Schleier 1971 Erich Schleier. "Der heilige Michael: Ein unbekanntes Hauptwerk Luca Giordanos." *Pantheon* 29, no. 6 (November–December 1971): 510ff.

Sirri 1971 Raffaelle Sirri. "La cultura a Napoli nel settecento." *Storia di Napoli*. Naples, 1971, 8, pt. 1: 165ff.

Spinosa 1971 Nicola Spinosa, "La pittura napoletana da Carlo a Ferdinando IV di Borbone." *Storia di Napoli*. Naples, 1971, 8, pt. 1: 451–547.

Vitzthum 1971 Walter Vitzthum. *Il barocco a Napoli e nell'Italia meridionale*. Milan, 1971.

Waterhouse 1971 Ellis Waterhouse. "Painting in Italy in the 18th Century." *Museum Studies* 6 (1971): 16ff.

Wise 1971 Ellen Raab Wise. "An Egg of Myth: The Birth of Helen." Master's thesis, Institute of Fine Arts, New York University, 1971.

Archivio 1972 *Archivio storico del Banco di Napoli*. Naples, 1972.

Baer 1972 Winfried Baer. "Ein Bozzetto des Paolo de Matteis für die Kuppel der Jesuitenkirche Gesù Nuovo in Neapel." *Jahrbuch der Berliner Museen* 14 (1972): 194ff.

Büttner 1972 Frank Büttner. *Die Galleria Riccardiana in Florenz*. Bern and Frankfurt, 1972.

Caserta 1972 Aldo Caserta and Gastone Lambertini. *Storia e scienza di fronte al "miracolo di S. Gennaro."* Naples, 1972.

D'Argaville 1972 B. D'Argaville. "Current and Forthcoming Exhibitions: Neapolitan Seicento Painting, Additions and Revisions." *Burlington Magazine* 114 (1972): 808ff.

Fredericksen 1972 Burton B. Fredericksen. *Catalogue of the Paintings in the J. Paul Getty Museum.* Malibu, California, 1972.

Fredericksen and Zeri 1972 Burton B. Fredericksen and Federico Zeri. *Census of Pre-Nineteenth-Century Italian Paintings in North American Public Collections.* Cambridge, Massachusetts, 1972.

Galinsky 1972 Gotthard Karl Galinsky. *The Herakles Theme.* Oxford, 1972.

Levey 1972 Michael Levey. *The Seventeenth- and Eighteenth-Century Italian Schools.* Catalogue. National Gallery, London, 1972.

Lurie 1972 A. T. Lurie. "An Important Addition to Solimena's Oeuvre." *Bulletin of the Cleveland Museum of Art* 59 (1972): 217–27.

Manzitti 1972 Camillo Manzitti. *Valerio Castello.* Genoa, 1972.

Meloni Trkulja 1972 Silvia Meloni Trkulja. "Luca Giordano a Firenze." *Paragone* 23, no. 287 (1972): 25ff.

Pantoni 1972 Angelo Pantoni. "Descrizione di Montecassino attraverso i secoli." *Benedictina* 19 (1972): 539ff.

Pelaggi 1972 A. Pelaggi. *Mattia Preti e il seicento italiano.* Catanzaro, 1972.

Rotili 1972 Mario Rotili. *L'arte del cinquecento nel regno di Napoli.* Naples, 1972.

Schiller 1972 Gertrud Schiller. *The Iconography of Christian Art.* 2 vols. New York, 1972.

Wright 1972 C. Wright. "Preti's *Martyrdom of St. Bartholomew.*" *Bulletin.* Currier Gallery of Art, Manchester, New Hampshire, 1972.

Worcester 1972 *Woman as Heroine.* Exhibition catalogue. Worcester Art Museum, Massachusetts, 1972.

Brown 1973 Jonathan Brown. *Ribera Prints and Drawings.* Exhibition catalogue. Art Museum, Princeton University, New Jersey, 1973.

Chiarini 1973 Marco Chiarini. "Un episodio giordanesco a Pistoia." In *Festschrift Klaus Lankheit.* Munich, 1973, 173ff.

Graf-Schleier 1973 D. Graf and E. Schleier. "Guglielmo Cortese und Abraham Brueghel." *Pantheon* 31 (1973): 46–57.

Grassi 1973 Luigi Grassi. *Teorici e storia della critica d'arte.* 3 vols. Rome, 1970–79.

Levey 1973 Michael Levey. "Solimena's *Dido Receiving Aeneas and Cupid Disguised as Ascanius.*" *Burlington Magazine* 115 (1973): 385–89.

London 1973 *Paintings and Sculpture of the Italian Baroque.* Heim Gallery, London, 1973.

Naples 1973 *Disegni di Luigi Vanvitelli nelle collezioni pubbliche di Napoli e di Caserta.* Catalogue by Jörg Garms. Palazzo Reale, Naples, 1973.

Spinosa 1973 Nicola Spinosa. "Pietro Bardellino, un pittore poco noto del settecento napoletano." *Pantheon* 31 (1973): 264–86.

Detroit 1974 *The Twilight of the Medici: Late Baroque Art in Florence, 1670–1743.* Exhibition catalogue. Detroit Institute of Arts and Florence, 1974.

Enggass 1974 Robert Enggass. "Paolo Campi: An Introduction." *Hortus Imaginum.* Lawrence, Kansas, 1974, 185ff.

Garlick 1974–76 Kenneth J. Garlick. "Catalogue of Pictures at Althorp." *Walpole Society* 45 (1974–76): 33.

Millen 1974 Ronald Millen. "Luca Giordano in Palazzo Riccardi." *Paragone* 25, no. 289 (1974): 22ff.

Neilson 1974 Nancy Ward Neilson. "Acquisitions – The *Annunciation* by Paolo De Matteis." St. Louis Museum, *Bulletin* 10 (1974): 21ff.

Pigler 1974 A. Pigler. *Barockthemen.* 2d ed. Budapest, 1974 (see also Pigler 1956).

Salerno 1974 Luigi Salerno. "La collezione dei disegni, composizioni, paesaggi, figure." In *L'Accademia Nazionale di San Luca.* Edited by Carlo Pietrangeli. Rome, 1974, 323–68.

Thuillier 1974 Jacques Thuillier. *Tout l'oeuvre peint de Poussin.* Paris, 1974.

Baldinucci 1975 F. S. Baldinucci. *Vite di artisti dei secoli xvii-xviii.* Edited by Anna Matteoli. Rome, 1975.

Dania 1975 Luigi Dania. "Alcuni dipinti di Corrado Giaquinto." *Antichità viva* 14 (September–October 1975): 13ff.

De Martini 1975 Vega de Martini. "Introduzione allo studio di Paolo De Matteis." *Napoli nobilissima,* ser. 3, 14 (1975): 209ff.

Drake 1975 H. A. Drake. *In Praise of Constantine. A Historical Study and New Translation of Eusebius's Tricennial Orations.* Berkeley, 1975.

London 1975 *Paintings by Luca Giordano.* Heim Gallery, London, 1975.

Madrid 1975 *El Palacio Real de Madrid.* Madrid, 1975.

Parini 1975 G. Parini. "La vita rustica." *I giorni: le odi.* Milan, 1975.

Reynolds 1975 Joshua Reynolds. *Discourses on Art.* Edited by Robert Wark. New Haven, 1975.

Spinosa 1975 Nicola Spinosa. "A propos d'un tableau de Francesco de Mura au Louvre." *Revue du Louvre* 25 (1975): 368–76.

Enggass 1976	Robert Enggass. *Early Eighteenth Century Sculpture in Rome*. 2 vols. University Park, Pennsylvania, 1976.
Malanima 1976	Paolo Malanima. *I Riccardi di Firenze: Una famiglia e un patrimonio nella Toscana dei Medici*. Florence, 1976.
Meloni Trkulja 1976	Silvia Meloni Trkulja. "Nuove notizie su Luca Giordano (e sul Volterrano)." *Paragone* 27, no. 315 (1976): 78ff.
Millen 1976	Ronald Millen. "Luca Giordano in Palazzo Riccardi II: The Oil Sketches." In *Kunst des Barock in der Toskana. Studien zur Kunst unter den letzten Medici*. Munich, 1976, 296ff.
Tomory 1976	Peter Tomory. *Catalogue of the Italian Paintings before 1800*. John and Mable Ringling Museum of Art, Sarasota, Florida, 1976.
Rosenfeld 1976	Myra Nan Rosenfeld. "Problems of Iconography in Italian Painting." *Apollo* 103 (1976): 390.
St. Louis 1976–77	*The Charles Parsons Collection of Paintings*. Washington University, St. Louis, Missouri, 1976–77.
Toledo 1976	*European Paintings*. The Toledo Museum of Art, Ohio, 1976.
Vanvitelli 1976–77	Luigi Vanvitelli. *Lettere della Biblioteca Palatina a Caserta*. Edited by Franco Strazzullo. Galatina, 1976–77.
Zeri 1976	Federico Zeri. *Italian Paintings in the Walters Art Gallery*. Baltimore, 1976.
Bellini 1977	Paolo Bellini. *L'opera incisa di Carlo Maratti*. Pavia, 1977.
Catalani 1977	Luigi Catalani. *Discorso sui monumenti patrii* [orig. ed., Naples 1842]. Reprint with introduction by Roberto Pane. Naples, 1977.
Rome 1977	*Accademia di Francia a Roma. Nicolas Poussin: 1594–1665*. Rome, 1977.
Ruotolo 1977	Renato Ruotolo. "Aspetti del collezionismo napoletano: Il Cardinale Filomarino." *Antologia di belle arti* 1 (1977): 71ff.
Urrea Fernandez 1977	J. Urrea Fernandez. *La pintura italiana del siglo xviii en España*. Valladolid, 1977.
Chrysler 1978	*Chrysler Museum Bulletin*. May, 1978.
Fulco 1978	G. Fulco. "Il sogno di una 'Galeria': Nuovi documenti sul Marino collezionista." *Antologia di belle arti* 2 (1978): 84ff.
Gleijeses 1978	V. Gleijeses. *Chiese e palazzi della città di Napoli*. Naples, 1978.
Goldstein 1978	Carl Goldstein. "Art History without Names: A Case Study in the Roman Academy." *Art Quarterly* 1 (1978): 1ff.
London 1978	*The Baroque in Italy: Paintings and Sculptures, 1600–1720*. Heim Gallery, London, 1978.

Magagnato 1978 L. Magagnato. *La pittura a Verona tra sei e settecento*. Exhibition catalogue. Verona, 1978.

Mongelli 1978–79 Gaetano Mongelli. "Paolo De Matteis in Puglia." In L. Mortari, ed. *Ricerche sul sei-settecento in Puglia*. Bari, 1978–79, 1: 105–36.

Morales 1978 José Luis Morales. "Cinco documentos sobre Giaquinto." *Antologia di belle arti* 2 (1978): 88ff.

New York 1978 *Veronese to Franz Kline, Masterworks from the Chrysler Museum*. Wildenstein and Co., New York, 1978.

Pérez Sánchez 1978 Alfonso E. Pérez Sánchez. *I grandi disegni italiani nelle collezioni di Madrid*. Milan, 1978.

Rabiner 1978a Donald Rabiner. "The Problem of Antisolimenismo in Neapolitan Baroque Painting." *Phoebus: A Journal of Art History,* Arizona State University, 2 (1978–79): 8ff.

Rabiner 1978b Donald Rabiner. "Notices on Painting from the *Gazzetta di Napoli*." *Antologia di belle arti* 2 (1978): 325ff.

Rizzo 1978 V. Rizzo. "L'opera giovanile di Francesco de Mura." *Napoli nobilissima,* ser. 3, 17 (1978): 95ff.

Ruotolo 1978 Renato Ruotolo. *Santa Brigida*. Naples, 1978.

Spike 1978 John Spike. "Mattia Preti's Passage to Malta." *Burlington Magazine* 120 (1978): 497ff.

Spinosa 1978 Nicola Spinosa. "Gli arazzi del Belvedere a Palazzo Reale." *Antologia di belle arti* 2 (1978): 12–23.

Strazzullo 1978 F. Strazzullo. *La Real Cappella del Tesoro di S. Gennaro – Documenti inediti*. Naples, 1978.

Zafran 1978 Eric Zafran. "From the Renaissance to the Grand Tour." *Apollo* 107 (1978): 194ff., 242ff.

Bean 1979 Jacob Bean. *Seventeenth-Century Italian Drawings in the Metropolitan Museum of Art*. New York, 1979.

Bologna 1979 Ferdinando Bologna. "Solimena al Palazzo Reale di Napoli." *Prospettiva* 16 (1979): 53ff.

Borelli 1979 Gennaro Borrelli. "Il rococò napoletano." *Napoli nobilissima,* ser. 3, 18 (1979): 201–19.

Cantone 1979 G. Cantone. *Il Palazzo Maddaloni allo Spirito Santo*. Naples, 1979.

De Conciliis-Lattuada 1979 D. de Conciliis and R. Lattuada. "Unpublished Documents for Mattia Preti's Paintings in San Pietro a Maiella in Naples." *Burlington Magazine* 121 (1979): 294ff.

Dreoni 1979 Lucia Dreoni. "Paolo de Matteis e altri pittori a San Paolo d'Argon." *Paragone* 30 (1979): 70ff.

Ferrari 1979 Oreste Ferrari. "Considerazioni sulle vicende artistiche a Napoli durante il vice-regno austriaco 1707–1734." *Storia dell'arte* 35 (1979): 11ff.

Kris-Kurz 1979 Ernst Kris and Otto Kurz. *Legend, Myth, and Magic in the Image of the Artist* [orig. ed., Vienna, 1934]. New Haven and London, 1979.

Naples 1979 *Civiltà del '700 a Napoli, 1734–1799. Catalogo della mostra.* 2 vols. Florence, 1979–80.

Ruotolo 1979 Renato Ruotolo. "Brevi note sul collezionismo aristocratico napoletano fra sei e settecento" *Storia dell'arte* 35 (1979): 29ff.

Schleier 1979 Erich Schleier. "Paolo de Matteis e non Marchesini, Trevisani o Amigoni." *Paragone* 30, no. 355 (1979): 66ff.

Spike 1979a John T. Spike. "Mattia Preti, 'Il Cavalier Calabrese.'" Ph.D. diss., Harvard University, 1979.

Spike 1979b John T. Spike. "Documents for Mattia Preti and the Renovation of the Chapel of France, 1633–1668, in the Co-Cathedral of St. John, Valletta." *Storia dell'arte* 35 (1979): 5ff., 35.

Spike 1979c John T. Spike. "Mattia Preti's *Feast of Absalom.*" *Annual Bulletin.* National Gallery of Canada, 1979, 17ff.

Spinosa 1979 Nicola Spinosa. "More Unpublished Works by Francesco Solimena." *Burlington Magazine* 121 (1979): 211ff.

Barbera 1980 Gioacchino Barbera. "Ricci, Trevisani, De Matteis e Batoni per la Chiesa delle Anime del Purgatorio di Messina." *Quaderni dell'Istituto di storia dell'arte medievale e moderna* 4 (1980): 41ff.

Cioffi 1980 Irene Cioffi. "Corrado Giaquinto's *Rest on the Flight into Egypt.*" *Bulletin of the Detroit Institute of Arts* 58 (1980): 5ff.

Haskell 1980 Francis Haskell. *Patrons and Painters.* 2d ed. New Haven and London, 1980 (see also Haskell 1963).

Kassel 1980 *Staatliche Kunstsammlungen Kassel: Italienische, französische und spanische Gemälde des 16. bis 18. Jahrhunderts.* Fridingen, West Germany, 1980.

Naples 1980 *Pittura sacra a Napoli nel '700.* Exhibition catalogue. Palazzo Reale, Naples, 1980.

Nappi 1980 E. Nappi. *Aspetti della società e dell'economia napoletana durante la peste del 1656.* Naples, 1980.

Pavone 1980 M. A. Pavone. *Angelo Solimena e la pittura napoletana della seconda metà del seicento.* Salerno, 1980.

Princeton 1980 John T. Spike. *Italian Baroque Paintings from New York Private Collections.* Exhibition catalogue. Princeton, 1980.

Rizzo 1980 V. Rizzo. "La maturità di Francesco de Mura." *Napoli nobilissima,* ser. 3, 19 (1980): 31ff.

Rubsamen 1980 Gisela Rubsamen. *The Orsini Inventories.* Malibu, 1980.

Schleier 1980 Erich Schleier. "La pittura italiana del sei- e settecento nel Museo di Ponce: nuove proposte e problemi attributivi." *Antichità viva* 19 (1980): 20ff.

Spear 1980 Richard E. Spear. Review of *Italian Baroque Paintings. Burlington Magazine* 122 (1980): 720 (see Princeton 1980).

Spinosa 1980 Nicola Spinosa. "La pittura del '700." In *La voce della Campania,* 1980, 455–70.

Brejon 1981 Arnauld Brejon de Lavergnée. "La Peinture napolitaine du dix-huitième siècle." *Revue de l'art* 52 (1981): 63ff.

Detroit 1981 *The Golden Age of Naples. Art and Civilization under the Bourbons, 1734–1805.* Exhibition catalogue. 2 vols. Detroit Institute of Arts and Art Institute of Chicago, 1981–82.

D'Onofrio-Pace 1981 Mario d'Onofrio and Valentino Pace. *Italia romanica.* Vol. 4. *La Campania.* Milan, 1981, 43ff.

Enggass 1981 Robert Enggass. Review of Naples 1979. *Art Bulletin* 63 (1981): 340ff.

Gaeta 1981 *Sebastiano Conca 1680–1764.* Exhibition catalogue. Gaeta, 1981.

Lavin 1981 I. Lavin et al. *Drawings by Gianlorenzo Bernini from the Museum der Bildenden Künste, Leipzig.* Princeton, 1981.

Pallucchini 1981 Rodolfo Pallucchini. *La pittura veneziana del seicento.* Milan, 1981.

Safarik 1981 Eduard Safarik. *Catalogo sommario della Galleria Colonna in Roma: Dipinti.* Rome, 1981.

Toronto 1981–82 David McTavish, K. Corey Keeble, Kathryn Lochnan, and Sybille Pantazzi. *The Arts of Italy in Toronto Collections: 1300–1800.* Exhibition catalogue. Toronto, 1981–82.

"Arte e storia" 1982 "Arte e storia nella chiesa di San Giovanni Calibita." *Vita ospedaliera* 27 (1982): 115ff.

Carr 1982 Dawson W. Carr. "Fresco Decorations by Luca Giordano in Spain." *Record of the Princeton Art Museum* 41 (1982): 42ff.

Chrysler 1982 Thomas W. Sokolowski. "Paolo de Matteis's *Olinda* [sic] *and Sofronia Rescued by Clorinda." Chrysler Museum Bulletin.* Norfolk, Virginia. September 1982.

Cleveland 1982 *European Paintings of the Sixteenth, Seventeenth, and Eighteenth Centuries.* Catalogue of Paintings, Part Three. Cleveland Museum of Art, 1982.

D'Elia 1982 Michele D'Elia. "La pittura barocca." In *La Puglia tra barocco e rococò.* Milan, 1982, 162–320.

De Seta 1982 Cesare de Seta, ed. *Arti e civiltà del settecento a Napoli.* Rome–Bari, 1982.

D'Onorio 1982 Bernardo D'Onorio. *L'abbazia di Montecassino: Storia, religione, arte.* Rome, 1982.

Enggass 1982 Robert Enggass. "Visual Counterpoint in Venetian Settecento Painting." *Art Bulletin* 64 (1982): 89–97.

Ferrara 1982 Domenica Pasculla Ferrara. "Contributi a Giovan Battista Lama e a Paolo De Matteis." *Napoli nobilissima,* ser. 3, 21 (1982): 41ff.

Fort Worth 1982 *Jusepe de Ribera, lo Spagnoletto.* Edited by Craig Felton and William B. Jordan. Exhibition catalogue. Kimbell Art Museum, Fort Worth, 1982.

Gelao 1982 Clara Gelao. "Una statua d'argento di Paolo de Matteis nella Cattedrale di Bitetto." *Napoli nobilissima,* ser. 3, 21 (1982): 188ff.

Hersey 1982 George Hersey. "Ruskin as an Optical Thinker." In J. D. Hunt and Faith M. Holland, eds., *A Ruskin Polygon.* Manchester, England, 1982, 44ff.

Levey 1982 Michael Levey. *The Painter Depicted.* New York, 1982.

Miller 1982 Dwight C. Miller. "Franceschini's Decorations for the Cappella del Coro, St. Peter's: Bolognese and Roman Classicism." *Burlington Magazine* 124 (1982): 437ff.

New York 1982 *France in the Golden Age: Seventeenth-Century French Paintings in American Collections.* New York, 1982.

Norfolk 1982 *The Chrysler Museum. Selections from the Permanent Collection.* Norfolk, Virginia, 1982.

Rosand 1982 David Rosand. *Painting in Cinquecento Venice.* New Haven and London, 1982.

Ruotolo 1982 Renato Ruotolo. *Mercanti-collezionisti fiamminghi a Napoli. Gaspare Roomer e i Vandeneynden.* Massa Lubrense, 1982.

Spear 1982 Richard E. Spear. *Domenichino.* 2 vols. New Haven and London, 1982.

Stoughton 1982 Michael Stoughton. Review of *The Golden Age of Naples. Art Journal* 42 (1982): 54 (see Detroit 1981).

Corre 1983 *Da Carlevarijs ai Tiepolo. Incisori veneti e friulani del settecento.* Museo Correr, Venice, 1983.

Dania 1983 Luigi Dania. "Nuove aggiunte a Corrado Giaquinto." In *Scritti di storia dell'arte in onore di Federico Zeri.* Milan, 1983; 2: 820ff.

De Maio 1983 Romeo de Maio. *Pittura e controriforma a Napoli.* Bari, 1983.

Florence 1983 *Disegni di Giovanni Lanfranco.* Uffizi, Florence, 1983.

Goldberg 1983 E. Goldberg. *Patterns in Late Medici Art Patronage.* Princeton, 1983.

Goodstein 1983 *The David B. Goodstein and Edward C. Goodstein Collection.* n.p. 1983.

Hennessey 1983 Leslie Griffin Hennessey. "Jacopo Amigoni: An Artistic Biography with a Catalogue of His Venetian Paintings." Ph.D. diss., University of Kansas, 1983.

Hersey 1983 George Hersey. *Architecture, Poetry and Number in the Royal Palace at Caserta.* Cambridge, Massachusetts, 1983.

Hibbard 1983 Howard Hibbard. *Caravaggio.* New York, 1983.

Naples–Paris 1983 *Dessins napolitains des dix-septième et dix-huitième siècles. Collections des musées de Naples.* Naples–Paris, 1983.

New York 1983 John T. Spike. *Italian Still Life Paintings from Three Centuries.* Exhibition catalogue. National Academy of Design, New York, 1983.

Paris 1983 Musée du Louvre. *Les Collections du Comte d'Orsay: Dessins du Musée du Louvre.* Paris, 1983.

Ševčenko 1983 Nancy Ševčenko. *The Life of Saint Nicholas in Byzantine Art.* Turin, 1983.

Spear 1983 Richard E. Spear. "Notes on Naples in the Seicento." *Storia dell'arte* 48 (1983): 127–37.

Spinosa 1983 Nicola Spinosa, ed. *Il patrimonio artistico del Banco di Napoli. Catalogo delle opere.* Naples, 1983.

Steinberg 1983 Leo Steinberg. *The Sexuality of Christ in Renaissance Art and Modern Oblivion.* New York, 1983.

Turin 1983 *La pittura napoletana da Caravaggio a Giordano.* Turin, 1983.

Washington 1983 *Painting in Naples from Caravaggio to Giordano.* Exhibition catalogue. National Gallery, London, and National Gallery of Art, Washington, 1982–83.

Arnaiz 1984 Jośe Manuel Arnaiz. "Another Giaquinto Source for Goya." *Burlington Magazine* 126 (1984): 561.

Athens 1984 *Il secolo d'oro della pittura napoletana.* Exhibition catalogue. National Picture Gallery, Athens, 1984.

Bob Jones 1984 D. Stephen Pepper. *Bob Jones University Collection of Religious Art.* Greenville, South Carolina, 1984.

Cleveland 1984 *Bernardo Cavallino of Naples 1616–1656.* Exhibition catalogue. Cleveland Museum of Art, 1984.

Montclair 1984 *Master Paintings of the Spanish School from the Cintas Foundation Collection.* Montclair Art Museum, New Jersey, 1984–85.

Naples 1984 *Civiltà del seicento a Napoli.* Exhibition catalogue. 2 vols. Gallerie Nazionali di Capodimonte. Naples, 1984.

New York 1984 — *Italian Old Master Paintings: Fourteenth to Eighteenth Century.* Piero Corsini, Inc. New York, 1984.

Pane 1984 — Roberto Pane, ed. *Seicento Napoletano.* Milan, 1984.

Pepper 1984 — D. Stephen Pepper. *Guido Reni.* London, 1984.

Ponce 1984 — *Museo de Arte de Ponce. Fundación Luis A. Ferré. Catalogue.* Ponce, Puerto Rico, 1984.

Raleigh 1984 — *Baroque Paintings from the Bob Jones University Collection.* Catalogue by David H. Steel, Jr. North Carolina Museum of Art, Raleigh, and Colnaghi, New York, 1984.

Ševčenko 1984 — Ihor and Nancy Ševčenko. *The Life of St. Nicholas of Sion.* Brookline, Massachusetts, 1984.

Spinosa 1984 — Nicola Spinosa. *La pittura napoletana del '600.* Milan, 1984.

Willette 1984 — Thomas Willette. "Bernardo De Dominici, *Il Vasari napoletano* or *Il Falsario:* A Re-examination of the Sources for His *Lives of the Neapolitan Painters, Sculptors, and Architects.*" Paper presented in the Department of the History of Art, The Johns Hopkins University, December 1984.

Winston-Salem 1984 — *Treasures of Italian Painting from the Sarah Campbell Blaffer Foundation.* Wake Forest University, Winston-Salem, North Carolina, 1984–85.

Zafran 1984 — Eric M. Zafran. *European Art in the High Museum.* Atlanta, Georgia, 1984.

Burkert 1985 — Walter Burkert. *Greek Religion.* Cambridge, Massachusetts, 1985.

De Vito 1985 — G. de Vito, ed. *Ricerche sul '600 napoletano.* Milan, 1985.

Galante 1985 — Gennaro Aspreno Galante. *Guida sacra della città di Napoli.* Edited by Nicola Spinosa. Naples, 1985.

Getty 1985 — "Acquisitions in 1984: Paintings." *J. Paul Getty Museum Journal* 13 (1985): 206, nos. 128a and b.

Huetter [1985] — L. Huetter and R. U. Montini. *San Giovanni Calibita.* 2d ed. Rome, n.d. [1985].

Jodice 1985 — Mimmo Jodice. *Un secolo di furore. L'espressività del seicento a Napoli.* Naples, 1985.

Marciano 1985 — G. Marciano and M. Pasculli Ferrara. *Il Cappellone di San Cataldo nella Cattedrale di Taranto.* Taranto, 1985.

Near 1985 — Pinkney Near. "European Paintings and Drawings. The Williams Collection." *Apollo* 122 (1985): 440ff.

Pignatti 1985 — Terisio Pignatti, *Five Centuries of Italian Painting: 1300–1800.* The Sarah Campbell Blaffer Foundation, Houston, 1985.

Duluth 1986 — *A Collection Rediscovered: European Paintings from the Tweed Museum of Art.* Duluth, Minnesota, 1986.

Jeromack 1986 Paul Jeromack. "Hidden Treasures: Old Master Paintings in the New-York Historical Society." *Art and Auction* 8 (1986): 92ff.

Sarasota 1986 Anthony F. Janson. *Great Paintings from the John and Mable Ringling Museum of Art.* Exhibition catalogue. Sarasota and Washington, 1986.

Spinosa 1986 Nicola Spinosa. *Pittura napoletana del settecento dal barocco al rococò.* Naples, 1986.

Willette 1986a Thomas Willette. "The Origins and Early Reception of Bernardo De Dominici's *Vite de' pittori, scultori ed architetti napoletani.*" Paper presented at the John S. Singleton Center for Italian Studies, The Johns Hopkins University, Villa Spelman, Florence, March 1986.

Willette 1986b Thomas Willette. "Bernardo De Dominici e le *Vite de' pittori, scultori ed architetti napoletani:* Contributo alla riabilitazione di una fonte." *Ricerche sul '600 napoletano.* Milan, 1986, 255–73.

Bologna Forthcoming Ferdinando Bologna. "Bernardo De Dominici." *Dizionario biografico degli italiani.* Rome, 1960—Forthcoming.

Carr Forthcoming Dawson W. Carr. "Luca Giordano at the Escorial: The Frescoes for Charles II." Ph.D. diss., Institute of Fine Arts, New York University. Forthcoming.

Spike-Clifton Forthcoming John T. Spike and James D. Clifton. "New Documents Concerning Mattia Preti's Sojourn in Naples." Forthcoming.